# Here the Country Lies

# HERE THE COUNTRY LIES

---

## Nationalism and the Arts in Twentieth-Century America

---

**Charles C. Alexander**

INDIANA UNIVERSITY PRESS

Bloomington

Manufactured in the United States of America

Library of Congress Cataloging in Publication Data
Alexander, Charles C
    Here the country lies.

    1. Arts, American.   2. Arts, Modern—20th century
—United States.   3. Nationalism and art—United
States.   I. Title.
NX504.A5   700'.973   80-7681
ISBN 0-253-15544-4   1 2 3 4 5 84 83 82 81 80

For My Mother, and Again
for Jo Ann and Rachel

". . . here the country lies—huge, half formed, fundamentally various under the hasty superficialities of standardization, and fundamentally one country."

Ruth Suckow, 1930

# Contents

# Preface

Art—good and enduring art—is supposed to be universal, offering an appeal that transcends time, place, and circumstance. Nationalism, on the other hand, is supposed to be a modern atavism, a throwback to the nineteenth century, when civilization was ravaged by aggressive irredentist and imperialist rivalries. Even though political nationalism continues to be the most powerful secular emotion animating collective behavior in the late twentieth century, a common tendency within social thought in the Western world, at least since the end of the Second World War, has been to argue for the subordination of the affairs of nations to the common interests of humanity. Intellectually and culturally, that tendency has meant a disavowal of the belief that artistic expression can or should be understood primarily within the context of national identity. Today the idea of distinct, recognizable national (as opposed to tribal or provincial) cultures has fallen into fairly general disfavor; the prevailing view of the nature and function of the arts, at least in Western Europe and the United States, is more akin to the "classical" or universalist esthetics widely accepted in the eighteenth century than to the "romantic" or particularist esthetics that interacted potently with nineteenth-century political nationalism.

Yet if the conception of the arts as national expression often seems a quaint carry-over from the nineteenth century, in fact the idea of a national culture has proved remarkably persistent and persuasive in this century. The arts became a powerful weapon for mass indoctrination in the hands of the rules of Nazi Germany, and control of the apparatus of culture has seemed indispensable to the perpetuation of the Communist regimes in Russia, China, and the Eastern European countries. Even during its various wars, when restrictions on public dissent have sometimes been harsh, the United States has never had anything like an official cultural establishment and cultural policy.

Much of the time the most ardent advocates of a distinct, independent American culture have also been strong critics of the majoritarian values and assumptions presumably represented in the country's political and economic institutions. But if American cultural nationalism has usually had little connection with official policy, the yearning for a rich and mature American culture has nonetheless inspired many kinds of people.

The many and diverse seekers of an art by and for America and their complex, often contradictory attitudes and opinions are the subject of this book. My basic theme is that the vision of a genuinely native, nationally representative artistic expression was the single most significant feature of American cultural commentary in the years after 1900 and up to the Second World War. The contrary view is that international modernism has been increasingly the dominant influence in the Western countries, and that the decline of intellectual and cultural nationalism over the past thirty years or so has been a positive and necessary development. Accordingly, the history of Western culture in the twentieth century becomes a progression away from nineteenth-century nationalistic and other kinds of constraints on both thought and creative expression. Two qualifications are in order here. In the first place, forty or fifty years ago it was not at all clear that the story would turn out as it did—that the future belonged to avant-garde modernism. Moreover, up to the 1930s, at least in the United States, modernist and romantic nationalist attitudes were by no means incompatible and were often complementary.

My treatment involves three broad and frequently overlapping categories. The study begins with a reconsideration of the Genteel Tradition in the arts and the preference for formalized, academic styles and influences that was one of its major characteristics. I then describe the revolt against the Genteel Tradition in the decade or so before the First World War. That revolt—which I have alternately termed the Rebellion or the Insurgence—brought into prominence two other major bodies of American cultural opinion: romantic nationalism and avant-garde modernism. Epitomized by the group of intellectuals gathered around the magazine *Seven Arts* in 1916–17 and inspired largely by Walt Whitman's example, the romantic nationalists loudly and persistently sought the fulfillment of American cultural promise. In the period of the Rebellion, in the 1920s, and in some instances up through the thirties, romantic nationalists mingled with and frequently gained strong reinforcement from American proponents of avant-garde modernism. Generally speaking, the Genteel Tradition faded first; romantic nationalism, acquiring a strong element of political and social consciousness in the thirties, reached a peak around the time of Pearl

Harbor and then also faded; and formal modernism, for the most part divested of earlier concerns with national expression and social relevance, has been ascendant over the last generation.

Prefaces are frequently occasions for caveats and disclaimers; this one is no exception. My theme turned out to be remarkably inclusive, so that I have dealt with a great array of people and points of view—from arrogant elitists to broad democrats, from esthetes to comic-strip enthusiasts, from those who sought the spiritual regeneration of America through art to those who were content to gain critical recognition of American work on equal terms with that of Europe. I have not, however, written a textbook account of American cultural history in the twentieth century. While there is considerable need for such a general survey, my own treatment aims less for comprehensiveness than for thematic development. My major emphasis is not on the internal history of the arts, even though there is much discussion of the activities of particular creative figures: novelists, poets, playwrights, painters, sculptors, architects, dancers, conductors, composers, musicians, actors, producers, directors, teachers. Mostly, though, I am concerned with criticism and commentary—with the orientation of beliefs in and about the arts and expressly with the issue of when and how the United States might come to have its own definably national culture.

In general I have not tried to estimate the "American" content or lack thereof in particular creative works. I have taken at face value the explicit statements of people like the composer Aaron Copland, the novelist Thomas Wolfe, or the painter Thomas Hart Benton that they wanted to speak artistically as Americans and to Americans, to capture the spirit and pulse of the national life. In other cases such intent was clearly implicit, as in the early music of Charles Ives or the movies of Frank Capra. A while back an art historian acquaintance remarked to me that the last truly American painter was Thomas Eakins. Who can say? Such an issue would appear to be unresolvable empirically and thus ultimately a matter for personal taste and opinion. I offer no judgments about the extent to which somebody succeeded or fell short of his or her effort to express America or to help create an American art. The point is that *being* American was vitally important to a great number of people in the arts during the first four decades of the century. That quality of being—or trying to be—is what this book finally is about.

A word about the ambiguous terms "nationalism" and "culture." By nationalism I mean the amalgam of attitudes and emotions that has to do with the sense of belonging to a group of people who consider themselves a nation. If in the late twentieth century the word nationalism has mainly political connotations, it is nonetheless the

case that for most of the people in this book, nationalism had meaning primarily in terms of culture. And when they used the term culture they nearly always had in mind the old-fashioned notion of "high culture" or the "fine arts"—what Matthew Arnold meant when he referred to culture as the best that had been thought and said. Most of the time I have used the term in the same sense. I am also aware, however, that by the 1930s newer, broader concepts, drawn especially from the developing discipline of cultural anthropology, had already begun to affect long-standing assumptions about what art and culture actually were. Overall, that broadening framework for understanding the meaning of culture aided the cause of those who wanted to promote a more popular, presumably more democratic function and comprehension of the arts in modern American society.

A project going on intermittently for more than a decade and based at three different universities has put me in debt to a lot of people. I am especially indebted to the Ohio University Research Committee for its generous support of travel costs and other research-related expenses. I also owe much to Stephen B. Oates of the University of Massachusetts and Warren F. Kimball of Rutgers University/Newark College for again reading and substantially improving my work. Robert L. Daniel, my colleague at Ohio University, was an equally thorough reader and astute critic. And once again my loving appreciation goes to Jo Ann and Rachel, wife and daughter, for putting up with me.

# Here the Country Lies

CHAPTER **1**

# The
# Genteel Tradition
# in Sway

AT THE END OF THE NINETEENTH CENTURY THE PEOPLE OF THE FORTY-
five United States had just emerged from the harshest, most violent
economic depression they had known. That crisis had seemed, in the
mid-1890s, about to shatter the new industrial order. Along with the
economic recovery after 1896 had come a short, confused, but reward-
ing war with decrepit Imperial Spain, the settlement of which had
given the nation a collection of island possessions scattered halfway
across the earth's surface. Rich new markets, investment opportunities,
and sources of raw materials now awaited American men of enterprise,
or so it seemed in the aftermath of the victory over Spain. But pre-
sumably the overseas empire also imposed new international responsi-
bilities and new moral imperatives. At last the United States must
assume its proper and rightful place among the world's great powers.
It must also, as President William McKinley had come to believe as
he pondered whether or not to keep the Philippine Islands, endeavor
to "uplift and civilize and Christianize" backward peoples in remote
regions.

To be sure, end-of-the-century overseas expansionism ran into op-
position from a number of well-off and well-educated, often highly
respected Americans. Yet the preponderance of articulated opinion in
the country seemed to take pride and satisfaction in the new empire
and in other manifestations of mounting national wealth and power.
Long the most productive country in the world in agriculture, the
United States now led in manufacturing output as well. While most
Americans still lived on farms or in villages, the movement of the in-
digenous population into towns and cities and the tendency of most
newly arrived immigrants to settle in urban centers continued a long-

1

term demographic transformation that would culminate in the census of 1920, the first to show that a majority of Americans had become town- and city-dwellers. By 1900 New York, Philadelphia, and Chicago were among the major cities of the Western world.

Those cities, along with Boston, had symphony orchestras, concert halls, art museums and galleries, libraries, universities, and the other artifacts of an advanced civilization. Surely the American nation would come fully into its own in the twentieth century. And surely the fine arts, one of the historian's favorite measures of civilized achievement, would flower and flourish in the still-young republic. The war with Spain had proved that "a nation of lute-players can never whip a nation of machinists," wrote the esteemed Boston man of letters Edmund Clarence Stedman. Abundant with "brawn and force," America was "only entering upon her song. . . ." Though speaking to a small readership, an essayist in the *Sewanee Review* neatly summed up what appeared to be the prevalent outlook at the turn of the century: ". . . it seems certain that, for many a century at least, the efforts toward human happiness and larger freedom must center in our land."[1]

# I

The rationale behind Imperial America's surging nationalism was a compound of many elements in nineteenth-century American and European thought. For the purposes of this study, the most significant was the romantic philosophy that had served European nationalists, especially those in Germany and Italy, so well in the early and mid-nineteenth century. Convinced of the primacy of emotion over speculative reason, European as well as American romantic nationalists had conceived of the nation-state as a living, growing organism with its own collective mind and purpose. In the work of nation-building, moreover, the creative arts supposedly had a central role as the highest expression of that collective being.

Among the major influences on romantic esthetic theory in Europe and, to a lesser extent, in America were the late-eighteenth-century writings of the Germans Gotthold Ephraim Lessing and Johann Gottfried von Herder, both of whom did their major work in the generation after Jean Jacques Rousseau had developed the bases for romantic political and social thought.[2] Lessing, a dramatist as well as a critic, maintained that art should take as its proper materials a people's everyday experiences. Herder, though convinced of the superiority of literature over the other arts, viewed all creative expression as continually changing "in response to the languages, manners, and habits, to the

temperaments and climates, nay, even to the accents of different nations."[3] Thus the arts expressed the fundamental factors of "race" and "nation"—two terms that meant basically the same thing in Lessing's and Herder's time and throughout most of the next century.

After 1800 Madame de Staël in France linked the content of literature to the structure of different societies. Meanwhile, in England Samuel Taylor Coleridge, William Wordsworth, and other exponents of the body of ideas coming to be called romanticism wrote of the need for the artist to seek his inspiration in the "rustic" folk origins of his people. By the middle of the nineteenth century the French critic Auguste Saint-Beuve was insisting that art must be understood within the total context in which it was produced. Thus to fully appreciate an artist's work, one must study his whole life—his family and other personal relations, his circle of artistic contemporaries, his involvement with the events and attitudes of his times.

The general disposition to view the arts as organically and thus inseparably related to social, national, or "racial" experience reached a culmination in the influential work of the Frenchman Hippolyte Taine, who considered himself the logical successor to Saint-Beuve. Taine believed that not only individuals but civilizations and epochs as well possessed a "master faculty" or dominant trait. That master faculty expressed itself according to three basic circumstances—"le race, le milieu, le moment." Art was like any other "product" of a civilization—a consequence of education, custom, tradition, and all the other "little facts" affecting a given people at a given time and place.[4]

The tradition that produced Taine—the organic, socially, and historically based tradition in European esthetics—also powerfully and enduringly influenced American cultural spokesmen. Almost as soon as Americans won their political independence, patriots like Joel Barlow, Timothy Dwight, and Noah Webster began urging cultural independence of Europe as well. The calls for a native, national, genuinely and unmistakably American expression in the arts continued decade after decade, becoming especially strident and aggressive after 1820. In that year the British essayist Sydney Smith, reviewing the first *Statistical Atlas of the United States* in the prestigious *Edinburgh Review,* acknowledged the rapid accumulation of wealth and material well-being in the republic. But Smith then went on to scoff at American claims to have built a worthy civilization. "In the four quarters of the globe," he asked, "who reads an American book? or goes to an American play? or looks at an American picture or statue?" Americans should avoid superlatives, Smith advised, and instead "make it their chief boast . . . that they are sprung from the same race with Bacon and Shakespeare and Newton."[5]

Smith's remarks, widely read and quoted in the United States, stung a whole generation of educated Americans. Within a few years patriots could take satisfaction that plenty of Britishers and continental Europeans were reading Washington Irving's essays, sketches, and stories and James Fenimore Cooper's romances of the American frontier. But the widespread sense of national cultural inferiority persisted, as did demands for cultural autonomy. Thus Ralph Waldo Emerson's Phi Beta Kappa address at Harvard College in 1837 on "The American Scholar" was less the radical "declaration of literary independence" Oliver Wendell Holmes later called it than a ringing summation of a half-century of critical impatience. There was general agreement among Emerson's contemporaries that "We have listened too long to the courtly muses of Europe," that the American arts "cannot always be fed on the sere remains of foreign harvests." To Emerson and many others the time seemed near "when the sluggard intellect of this continent will look from under its iron lids and fill the postponed expectation of the world with something better than the exertions of mechanical skill."[6]

Yet it was in mechanical skill and inventiveness, the management of capital, the production of goods, and the pursuit of fortune that Americans continued to excel during Emerson's time. Emerson trusted that the essential spiritual goodness of Americans would finally win out over their obsession with money and power. He never lost his faith in such a national regeneration, even though he became increasingly disgusted by the tawdry, grubby side of American existence, especially in the post–Civil War years.

Walt Whitman, a younger friend and admirer of Emerson's, also managed to keep his faith. More passionately committed than Emerson to the new mass democracy ascendant in nineteenth-century America, Whitman strived in his unconventional free-verse poetry to write "the great psalm of the republic" and in his own unconventional life to take in as much as he could of the multiformity and adventure of "this huge world of peoples." In "this vast and varied Commonwealth," Whitman believed, the man who would produce great art must experience and encompass the particularities of section, class, party, and race. He must know the mass of common Americans and his art must speak to and for all. When he died in near poverty in 1891, Whitman still believed that Americans would rise above their selfishness and material preoccupations (and their sexual inhibitions) to achieve the "Ensemble" which was the taproot of an "autochthonous" art.[7]

In the years after Whitman's death, people writing about the American arts continued to stress the heroic role of the solitary creator— the great American composer or painter or playwright or even archi-

tect—laboring to produce America's epic masterwork. Discussions of prospects for the great American novel reached a peak in the decade before 1900. Recognizing that the novel had become the principal means of contact between writer and public, literary theoreticians in scores of essays and reviews argued issues of universalism versus particularism, nationalism versus localism or regionalism. The nationalists-universalists thought in terms of a novelist who could plumb the American spirit to illuminate larger, representative truths about mankind, thereby fulfilling Whitman's poetic ideal in "Song of Myself." For the particularists the novelist would voice a representative Americanism if he dealt with local and regional traits, attitudes, and customs. Presumably there might be many great American novels, each contributing to a grand national mosaic. Such an approach both derived from and buttressed the growing popularity of the surface realism in local-color fiction, with its concern for authentic settings, ordinary people, and predictable behavior.[8]

## II

The controversy over the great American novel juxtaposed a fading Emersonian-Whitmanian romanticism and an ascendant if limited realism. The kind of clamorous pursuit of an indigenous expression that had figured so strongly in the broad romantic nationalism of the early and mid-1800s had largely subsided by the end of the century. Americans, it was generally acknowledged, had made major contributions in all the arts. The suites and symphonies of Edward MacDowell or the dignified sculptural pieces of Augustus Saint-Gaudens and Daniel Chester French received much praise in the cultural affairs columns of newspapers and magazines. Students of the visual arts were usually willing to recognize work done earlier in the century by landscapists like Thomas Cole and Asher B. Durand, the watercolorist Winslow Homer, and genre painters like George Caleb Bingham and William Sidney Mount, as well as the technical expertness of contemporary impressionists like J. Alden Weir, Childe Hassam, and Alexander Wyant. The lavish productions of David Belasco got their due as good theater, if not dramatic art, while architectural periodicals were full of accolades for the sprawling residences designed by Richard Morris Hunt and the successful adaptations of classical forms for public buildings by the fashionable New York firm of McKim, Mead, and White. For many the crowning achievement in American architecture had come in 1893 with the glittering neoclassical "White City," erected in plaster for the year-late but triumphant World's Columbian Exposition in Chicago.

And of course it was impossible to deny that Americans had produced a sizable and estimable literature. The two or three decades preceding the Civil War already appeared as the nation's and especially New England's golden age of writing. Literary historians and anthologists still usually dismissed Herman Melville as a spinner of South Sea romances, were uncomfortable with Edgar Allan Poe's dark visions (not to mention his alcoholism), tended to frown on Whitman's sensuality and disregard of established verse forms, understood Mark Twain primarily as a humorist, and had scarcely even heard of Emily Dickinson. They were almost unanimous, though, in their admiration for Irving, Cooper, Emerson, Nathaniel Hawthorne, Henry Wadsworth Longfellow, Henry David Thoreau (appreciated mainly for his pictures of nature, not his radical individualism), and James Russell Lowell, often cited as the founder of literary criticism in America. The polite realism of William Dean Howells, widely regarded as the major novelist of the present era, and of such regional writers as Sarah Orne Jewett, Edward Kirkland, and Thomas Nelson Page also won general approval. Some assessments of significant American contributions to world literature included the intricately structured "international" novels of the expatriate Henry James.

Despite widespread satisfaction with American artistic achievements, the years around the turn of the century were not a time of marked concern for producing and exalting the uniquely American in the arts. Convinced, like Howells and many others, that "our novitiate has ended," E. C. Stedman nevertheless predicted in 1888 that American writing was about to enter an "interregnum," a time of consolidation if not relaxation.[9] Stedman's prophecy seemed at least partially confirmed with the passing three years later of Lowell and Whitman, the last surviving figures from the golden age.

Commentators on the other arts voiced a similar *fin de siècle* complacency, often coupled with a resignation that little more could be done anyway. The nation's geographical expanses and topographical and climatic extremes had always seemed to hamper the formation of a definite national character and the development of a distinctive national art. Then, too, Americans had supposedly been so preoccupied with quelling the Indians and taming the wilderness—"conquering a continent"—that they had had little time for the finer, nobler expressions. Another factor was "racial" diversity, more evident now than ever because of the record numbers of immigrants entering the country, including, for the first time, a majority of non-northern Europeans and non-Protestants. To the architectural critic Barr Ferree, the idea of an American style in architecture was "an illustration of the same delusion which animated people in the Middle Ages concerning the phi-

losopher's stone." Not long before his death in 1902, Frank Norris, the young novelist from the Far West, commented that "the United States is a Union, but not a unit." How could proponents of a national music "expect to have it before we have an American race?" asked Cora Lyman. And William Dean Howells saw the decline of Boston's and New England's cultural leadership during the previous quarter-century as symptomatic of the fact that "the whole present tendency in American life is centrifugal. . . ."[10]

Others pointed to the supposed lack of a long and rich American tradition in folklore, folk song, and folk craftsmanship. Back in the 1840s the sculptor Horatio Greenough had complained that while his country was young, its people were old, that "as Americans we have no childhood, no half-fabulous, legendary wealth, no misty, cloud-enveloped background." For the art historian Christian Brinton, writing in 1908, it was still the case that "We began at the top instead of at the bottom." Unlike European artists, who benefited from "the deep-rooted sympathies and patient hands of simple folk," creative Americans had to borrow from the past of other countries. And as James Russell Lowell had said, those "who have no past are pretty sure of having no future."[11]

In short, the immediate prospects were not particularly encouraging for the realization of a culture as identifiably "American" as the cultures of Europe were presumed to be identifiably national. The sculptor Lorado Taft's view was a widely shared one: "The American character is not yet fully formed; the very features are restless upon our unsettled faces."[12] In time, when it had digested its immigrants, consolidated its power, and absorbed the lessons of Europe, America would likely produce its own recognizably national culture. For now, one could be proud of the country's museums, libraries, and symphonies, its high rate of literacy and expanding public school system, its universities, its great buildings, and its many publishing houses.

### III

For probably a majority of collectors, conductors, performers, patrons, and teachers, it was enough that the country could show the artifacts of high civilization. Such people were content to possess, preserve, and perhaps diffuse "culture," which meant to late-Victorian Americans what the renowned British man of letters Matthew Arnold, speaking in New York City on his American tour in 1884, had said it meant: "the sum total of the best that has been thought and said in the world." Worried lest the influx of non-Anglo-Saxon peoples, the

pursuit of wealth, and the excesses of popular democracy destroy America's artistic potential, Arnold had called on the "saving remnant" of Americans to work incessantly against tastelessness and vulgarity and for the appreciation of what was fine, noble, and beautiful in coarse modern civilization.[13]

Those who shared Arnold's view of the opposition between beauty and modern American life, and who consequently felt obliged to safeguard the "fine arts" from popular debasement, made up what Henry May has called the "custodians of culture." According to May, the central beliefs of that self-assured minority had to do with the preservation and transmission of a received culture, with the inevitability of progress, and with the efficacy of a "practical idealism" in human affairs. Those beliefs constituted a basic "American innocence," which, May has contended, increasingly broke down in the pre–World War I years as new modes of thought, mostly European, penetrated American thinking.[14]

However "innocent" they may or may not have been, May's custodians of traditional culture did in fact dominate the American arts in the late nineteenth century and for at least a decade into the next. Although in general outlook and values they resembled the English Victorians, the members of the American cultural elite were "less relieved and softened by hypocrisy," as Malcolm Cowley has remarked.[15] In the American context the most descriptive designation is not "Victorian" but "Genteel Tradition."

Although it did not become part of American usage until after 1911, the term Genteel Tradition refers to a way of thinking and a segment of society identifiable in the United States since at least the middle of the nineteenth century. As Stow Persons has shown, by 1850 the triumph of the egalitarian ethos of mass democracy and the rise of a powerful new business class had ideologically and materially displaced the older gentry leadership, which had largely ruled American society in the eighteenth century. With power and wealth now divorced in many cases from such traditional considerations as family background and formal education, the American "gentility" came to identify itself mainly by polite manners, gracious though not ostentatious living, and the promotion of the arts. Conversely, the professional artist, finding himself allied to and frequently a product of the gentility, had to conform to its tastes and values. Like his patrons, the artist became a conservator of tradition, cherishing forms of beauty that had been understood, accepted, and refined by previous generations. The arts, like the behavior of individuals and groups in society, were supposed to accord with custom and precedent; art's worth should be measurable by long-established and widely recognized standards. The "cultured"

person, whether artist, scholar, critic, or patron, became "the apostle of culture in a world of democratic capitalistic mobility." Culture might be comprehensible only to an enlightened minority, but that minority must try to elevate the national mind by promoting the creative spirit and the love of beauty, even as it struggled to keep beauty from being corrupted by the uncomprehending masses and the philistine new rich.[16]

Thus the role of the American gentility was a paradoxical one. While the saving remnant was supposed to erect barriers against the surging vulgarity of the democratic age, it was also supposed to inspire and uplift, to teach the spiritually starved to appreciate and revere the truly beautiful. Instead of repudiating democracy, the older elite tried to come to terms with it by assuming the teachability and improvability of the uneducated common people. Meanwhile, the gentility also came to terms with the newly rich class, allying with holders of vast fortunes to promote the building of the great new universities, libraries, museums, and other carriers of culture.

The reconciliation of gentility, democracy, and corporate wealth went forward most spectacularly in Chicago. There what was locally termed the "upward movement" manifested itself not only in the opulent Columbian Exposition, in the founding of the University of Chicago, the Art Institute, and the Newberry Library, and in generous support for an opera company and symphony orchestra, but also in a vigorous campaign to reform the city's government. As the Chicago-based fortnightly *Dial* suggested in 1896, both art and politics must be "purified from the faults and excesses of the democratic spirit as now manifested in our national life."[17]

For cultural custodians as well as cultural consumers, therefore, the arts were both elitist and democratic, both the sacred trust of a dedicated minority and the means of edification that should be available to Everyman. Above all, the arts should teach the eternal verities— not only universally accepted forms of beauty but also universally desirable modes of conduct. Unless art inspired and uplifted, it was not truly worthwhile as art or anything else. As Howells declared at the end of his famous exposition of the principles of literary realism: "Neither arts, nor letters, nor sciences, except as they somehow, clearly or obscurely, tend to make the race better and kinder, are to be regarded as serious interests. . . ."[18]

More than anything else, it was the Genteel Tradition's characteristic optimism and moral idealism, which often appeared as smugness and stuffiness, that later provoked ridicule and fiery denunciation from insurgents in the arts. Successive generations of insurgent critics would alternately dismiss and denounce Howells's suggestion that

American novelists should "concern themselves with the more smiling aspects of life, which are the more American," and his belief in "the large, cheerful average of health and success and happy life" in his country. Nor would they be able to understand how Hamlin Garland, Howells's younger fellow midwesterner, could talk about the need for art "to embody the present . . . with the highest sincerity and the frankest truthfulness," and at the same time insist that the American artist should depict the fine and healthy, "the more wholesome and more humorous." Even as a young man Howells had seemed to typify the worst in the genteel outlook when, upon seeing a collection of nude portraits hanging in a palace in Germany, he had sniffed: "For my part, I like not over-ripe sausages and far-smelling cheese, nor their principles as developed in morals and aesthetics."[19] For all their prudishness, both Howells and Garland placed great value on craftsmanship and standards of excellence. In search of those qualities, both had proudly accepted admission to genteel eastern literary society.

In the twentieth century it would become fashionable for intellectuals and artists to blame what they understood to be the "Puritan influence" for nearly everything wrong in American life. Yet for a considerable number of the country's leaders in arts and letters at the turn of the century, "Puritanism" stood for most that had been good in the American past and that seemed to be disappearing in the present. To men like Barrett Wendell, a noted literary historian and an esteemed teacher at Harvard, and George Edward Woodberry, professor of letters at Columbia University, the Puritan type had represented order and stability, self-possession and self-restraint. Puritans had resisted the worst human impulses, impulses that later gained philosophical sanction in the romantic movement in Europe and ideological sanction in the democratic movement in America.[20]

Of course the Genteel Tradition was not coextensive with Puritanism, which had been and continued to be preeminently a religious outlook. Even so, there was much in the historic Puritan attitude toward all of life that coincided with the maxims of the Genteel Tradition. Like Puritanism, the Genteel Tradition emphasized the importance of continuity in the struggle to overcome the ugly and false and exalt the beautiful and true. Genteel spokesmen condemned the romantics' loudly proclaimed break with established notions of art and personal behavior. Rebellion was anathema; experimentation must proceed according to long-accepted canons and forms of expression. Men like the painters John La Farge and Kenyon Cox believed the artist was obliged to partake of and pass on the creative heritage dating from ancient Greece. However much he might strive to make

his own unique statement, an artist had to work with recognizable images and understandable symbols. Only thus could he fulfill his second major responsibility—to educate and raise the taste of the general populace.[21]

Such emphasis on continuity, tradition, and heritage also meant a reverence for the masterworks of the European past. Yet the creative artist should not just revere Shakespeare, Michelangelo, Rembrandt, Haydn, Beethoven, or Palladio. He must also study such masters for the immediate lessons they offered. The connection between past and present was living, practicable, usable. To deny the uses of the past was to deny the creative possibilities in the present.

Defenders of genteel culture talked a lot about standards. They insisted that artistic value had to be measured by commonsensically determined and commonly accepted norms. Usually artistic value was also a matter of artistic propriety, which in turn had to do with art's morally uplifting qualities. It was all right for those professing to be realists to deal with the undeniable ugliness in modern American life, as long as they went on to indicate a better, more beautiful prospect. "Has an ash-pile or a garbage heap necessarily more artistic value . . . than a lilac-bush or a pansy-bed?" asked a writer for the *South Atlantic Quarterly* as late as 1916. "Is not art, after all, more positive than negative?"[22]

There was, though, a great deal more to the genteel pursuit of standards than morality and uplift. Just as the romantics had thrown over intellect in favor of unbounded emotion, genteel critics charged, so they had also thrown over standards of excellence in favor of originality and free expression. The results had often been formlessness and self-indulgence. Genteel cultural leaders wanted to get back to form, fastidiousness, discipline, order. Howard Mumford Jones has defined the Genteel Tradition as "the fusion of idealism with craftsmanship that dominated high culture in this country from 1865 to 1915."[23]

Thus the creative artist should be knowledgeable about the best work of his own time, aware of the direct connection between the masterworks of the past and what he wanted to achieve, content to refine tried and tested modes of expression as he sought the ideal—in form, in morals, in humanity. Yet he must also recognize his responsibility to lead the general public toward higher levels of artistic appreciation. The Genteel Tradition had no room for dilettantism or estheticism. "Art for art's sake" might be the shibboleth for decadent Europeans and a few expatriate Americans like James A. McNeill Whistler, but the truly American artist should have grander purposes.[24]

## IV

James Fenimore Cooper had protested against being called "the American Scott" and Herman Melville had once declared, "We want no American Goldsmiths, nay, we want no American Miltons."[25] One might denounce genteel deference to Europe as servility, or willingly acknowledge that such deference was necessary to cultural uplift in America. In any case, the standard for defining "the best that has been thought and said" continued to be almost exclusively the cultural history of the British Isles and the Continent. Francis Fisher Browne, the *Dial*'s long-time editor, spoke as both a western cultural booster and a cultural traditionalist when he decried the "narrowness and provincialism" of western writers and insisted that "we must show that we are willing to [be] tried by the standards of world-literature, rather than by the standards of the back-settlement."[26]

Of course there was no substitute for direct, physical contact with the genius of Europe. Ever since the eighteenth century, numerous artistically inclined young Americans had gone to Europe for at least a *Wanderjahr,* often to study and work for extended periods. Many came back proud of their English or Continental speech and manners and their broader, more sophisticated outlook.[27] In general the young artists among them had not been exposed to the latest, most daring modes of thought and expression. Unlike the expatriates of the period 1910–30, earlier genteel travelers to Europe wanted to soak up tradition and masterworks, not make contact with the avant-garde.

Depending on the art form, the European locus of inspiration and knowledge shifted from country to country. American novelists, essayists, poets, and playwrights, for example, looked to Great Britain and the English literary heritage stretching back to Chaucer, although they were usually also conversant with the masterworks of French, German, Spanish, and Italian literature, at least through the eighteenth century. French and Italian theory and design dominated American architectural thinking. The preferred institutional architecture—for major government buildings, libraries, universities, churches, and hospitals—was commonly either Italian or French baroque, Renaissance or École des Beaux Arts neoclassicism, or French and maybe English Gothic. Admired new residences might look like French chateaus, Italian villas, or English Tudor houses. Even the dramatic office buildings in steel and concrete rising ever higher in the larger cities usually featured an amalgam of traditional styles and influences.

The French and Italian heritage was also strongest in the training

and outlook of American painters and sculptors. Sixteenth- and seventeenth-century Dutch and Spanish masters were important sources of knowledge as well. After the 1860s French impressionism was a major influence in American painting. By and large, though, the work of the American impressionists, while technically adept, lacked the exuberance and zest of Renoir, Degas, Monet, and the other French innovators.

By the inevitable comparison with Europe (and with the possible exception of drama), music appeared to be "our most belated art."[28] At the same time, as the most abstract, emotionally affective of the various arts, music was the form of expression in which romanticism had made its strongest inroads on genteel culture. Although some American composers drew directly on baroque materials for chamber and choral works and others were acquainted with Claude Debussy and French impressionist music, the romantic influence, especially German romanticism, was clearly preeminent in American formal composition. Meanwhile opera, from anywhere (except America) and in any language (except English), had gained a respectable following, particularly in New York and Chicago.

## V

Among the most powerful vehicles of genteel culture were the artistic academies. Modeled on European cultural and learned societies, the academies, with their carefully controlled memberships and their prizes and medals, perpetuated firm notions of what was good and bad in art. In general the academies served to discourage both frankness in subject matter and radical departures in form and technique.

Literary culture, for example, was the province of the National Institute of Arts and Letters, formed in 1898 when the Department of Arts and Letters of the American Social Science Association withdrew from the parent body. The institute and the even more august American Academy of Arts and Letters, established in 1904 as an upper chamber of the institute, remained bastions of genteel letters well into the 1930s. Skeptical of popular democracy and downright afraid of the vast numbers of eastern and southern European immigrants, revering the English literary heritage and enshrining that of New England, the memberships of the institute and the academy seemed resistant to change in both culture and politics. The aging Hamlin Garland's campaign against the corruption of "pure English" by vulgar Americanisms typified the academy's posture in the first decades of the twentieth century. Of the academy's admissions practices, Charles Fenton

has observed that its "hopeful reliance on such ingredients as Eastern birth, Ivy League education, and Anglo-Saxon parentage was painfully transparent."[29]

Avant-gardism, both in primary creativity and in critical thought, flourishes within American universities today. Such was hardly the case early in the century. The tradition of polite letters and Anglophilia was comfortably ensconced in the literature departments of the leading colleges and universities. If anything, the gentlemen-scholars who staffed the literature courses were even more standpat in their cultural values than the gentlemen-critics who did not teach for a living.

Harvard's Charles Eliot Norton in many ways epitomized the genteel professoriat. Regarded as the foremost American authority on the medieval and Renaissance arts, Norton had ancestral ties going back to earliest New England. In their reminiscences of their Harvard years, Norton's students made famous his convivial "Dante evenings." Convinced that the end product of education should be the well-rounded gentleman and saddened that democracy usually worked "ignobly, ignorantly, brutally," Norton lamented that "the old America, the America of our hopes and dreams, has come to an end." He nevertheless gave his support to a variety of political and social reforms, thereby affirming the genteel faith in democratic uplift. From the arts, though, Norton expected little of consequence in the near future. "Nowhere are the practical concerns of life more engrossing," Norton wrote in 1895; "nowhere is the poetic spirit less evident, and the love of beauty less diffused. The concern for beauty . . . hardly exists among us, and forms no part of our character as a nation."[30]

Norton was too gloomy for other genteel literati like James Brander Matthews, professor of literature at Columbia University. Matthews privately described Norton as "really ignorant—especially of American history and American feeling," as an "evil" and "pernicious" influence who had helped to make Harvard "very 'colonial'. . . ." Yet Matthews believed as much as Norton that American literature was still a lesser branch of British letters. Like Sydney Smith eighty years earlier, Matthews urged Americans to take pride in being part of English culture.[31]

Henry Alden Mills, editor of the dignified and influential *Harper's Monthly Magazine* for half a century, went even further. In 1903 Mills prophesied that what he saw as an emerging Anglo-Saxon literature was but part of the larger movement toward a trans-Atlantic Anglo-Saxon community. In literature, as in commerce, the barriers between peoples speaking a common language would eventually vanish. Mills was convinced that "there can be but one literature of the English-speaking race, with no separate limbo to be styled American."[32]

The steadily improving political relations between the United States and Great Britain in the twenty years or so before the First World War helped make the atmosphere in genteel intellectual circles more Anglophilic than ever. Such an atmosphere was hardly conducive to the separate study of American literature. With the exception of Emerson, Longfellow, Lowell, and a few other New Englanders, American writers received but passing mention in college and university courses in literary history. Malcolm Cowley recalled that when he was at Harvard in the teens he learned that "America was beneath the level of great fiction. . . . the only authors to admire were foreign authors." Van Wyck Brooks, who finished at Harvard in 1907, could not remember hearing Melville mentioned once during his undergraduate days. F. O. Matthiessen discovered when he completed his A.B. there in the early twenties that "I knew very little of our literature except some contemporary poetry that I had read with my friends."[33]

Fred Lewis Pattee, laboring at Pennsylvania State College, might argue that British and American writing constituted "two independent literatures within the same language." But writers and teachers of American literary history—insofar as there were any—remained preoccupied with the Anglo-American connection as manifested mainly in New England's golden age. Pattee even wryly suggested that Barrett Wendell's *Literary History of America,* published at the turn of the century, should be renamed "A Literary History of Harvard University, with Incidental Glimpses of the Minor Writers of America."[34]

William Dean Howells believed that the rudest work of art was superior to any criticism. James Russell Lowell, however, had urged a more demanding attitude toward native writing and had declared, "Before we have an American literature, we must have an American criticism." One man who took Lowell's admonition to heart, so much so that he affixed it as a motto to the title page of his first major book, was Paul Elmer More. Born in 1864 in St. Louis, More was among the minority of American literary scholars holding the Ph.D. He nonetheless seems to have had little taste for formal pedagogy. After only three years as an assistant in Sanskrit and classical literature at Bryn Mawr and Harvard, More left teaching to take on the literary editorship of first the weekly *Independent* and then the New York *Evening Post.* From 1909 to 1914 More was editor-in-chief of the *Post*-affiliated weekly *Nation,* after which he moved to Princeton, New Jersey, where he occasionally lectured at the university.[35]

In 1904 More published the first of his many volumes of *Shelburne Essays,* named after his New England retreat. More joined Professor Irving Babbitt of Harvard in despising equally the excesses of romanticism, the sticky sentimentalism often favored by the Genteel

Tradition, and the ill-informed, slovenly criticism they thought prevalent in America. Yet both More and Babbitt were insistent moralists, wedded to the thesis that the principal effect of the artist's labors should be moral improvement. For Babbitt, who was little interested in American writing, the literary apex of Western civilization had come in the eighteenth century, especially in France, just before the romantic onslaught. For More, as for most of his generation, American letters had crested in mid-nineteenth-century New England, which had possessed "the highest and most homogeneous culture this country has yet produced."[36] As much as Barrett Wendell, More idealized the Puritan virtues of clear-headedness, self-denial, and self-discipline. Increasingly he and Babbitt would be linked in the struggle against the forces of intellectual and cultural insurgency, until by the late 1920s they would be the acknowledged commanders of the rearguard action called the New Humanism.

The kind of sentimentalism in primary work and slovenliness in critical evaluation that so irked More and Babbitt was nowhere more apparent than in dramatic art. Measured by either the European standards of the day or by subsequent American achievements, creditable indigenous drama—as opposed to effectively produced, designed, directed, and acted theater—was a scarce commodity. In his *Devil's Dictionary*, Ambrose Bierce had defined an American dramatist as "one who adapts plays from the French." When queried about what he was working on, James Gibbons Huneker, the genial, cosmopolitan art and music columnist for the New York *Sun*, had replied that he was doing a book about the drama. "American?" he was asked. "I said about the drama," Huneker replied.[37]

American productions did well by Shakespeare, Sheridan, Molière, and other dramatic masters, but native contributions consisted mostly of broad farces, sentimental, moralizing comedies, and heavy-handed melodramas. Even when American playwrights like Clyde Fitch, Charles Klein, and Edward Sheldon wrote "problem" plays on such themes as prostitution, labor strife, or race relations, they resolved matters in ways that were inoffensive to majoritarian values. "The drama," an unhappy observer wrote in the monthly *Forum* in 1902, "is in precisely the condition in which [other] literature would be if the reading public were limited to the ten-cent magazines."[38]

The genteel outlook also still prevailed among dramatic critics, who showed less concern for the development of the dramatic art than for the spectacle of the theater. At the turn of the century probably the most respected American dramatic critic was William Winter, who had written about plays for the New York *Tribune* over three decades.

Winter set the tone for other critics by concerning himself mainly with production, performance, and personality, while he disdained the realism of such European dramatists as Henrik Ibsen, August Strindberg, and George Bernard Shaw. After Winter's semiretirement in 1909, Brander Matthews moved to the forefront of American stage critics. Like Winter, Matthews treated plays primarily as theater, with emphasis on the "well-made play." Matthews did want more realism in subject matter and characterization and more recognition for American work. Yet he generally ignored the newer European dramatists before the First World War and the newer American playwrights in the postwar period. For third-generation American theater critics like George Jean Nathan, the white-goateed Matthews became a symbol of the Genteel Tradition.[39]

## VI

Painters and sculptors restive under genteel dominance had plentiful symbols of their own for what was wrong. An even more powerful body than the National Institute of Arts and Letters was the National Academy of Design. Founded in 1826 in New York and located in a dazzling edifice styled in Venetian Gothic, the NAD was at the center of an artistic establishment that had come to full maturity in the late nineteenth century. The NAD never gained recognition as *the* national academy, but, together with art academies in Chicago, Philadelphia, and Boston, it was able to dominate painting and sculpture in the United States. With their closely controlled memberships and their jury method of determining which members' works would be shown at exhibitions, the NAD and the other city academies maintained a high standard of professionalism.

Artists following many different tendencies made up the NAD and its sister academies. Disciples of the French Barbizon school of landscapists, bravura portraitists, impressionists, followers of the German school of genre painting, École des Beaux Arts classicists—they all found places in the academies. Even so, academy members displayed an overriding conventionality in their opinions and their work. The nudes they painted were ethereal, idealized, and sedate; their landscapes were idyllic; the murals they did for new public buildings depicted themes from classical mythology and employed well-worn symbolism. Academy sculptors did compositions that were deft, dignified, correct.

The strain of rugged native realism, extending from George Caleb Bingham to Winslow Homer, Thomas Eakins, and a few others, had

grown quite weak by the turn of the century. Homer lived until 1910 and Eakins until 1916, but their concern with the actuality of people and places in America found little favor in academy circles. A "quality of restraint" permeated American painting, one critic wrote in 1907, a restraint that was "a desideratum of the fine arts, as it is of the refined social life." What was most admirable about the sculpture of Augustus Saint-Gaudens, thought another commentator, was that Saint-Gaudens "has always kept his mind and soul apart from everything that was common and vulgar, and . . . therefore he has vibrated only to all that was best and finest in our national life."[40]

The maturation and solidification of the American artistic establishment had come at the expense of the broad tolerance and even enthusiasm for indigenous visual art that had characterized the early decades of the nineteenth century. In 1852 the American Art-Union, a well-established, successful market for American work, had to close after a New York court ruled that it was operating as an illegal lottery. Later on, the academy art exhibitions and sales partly filled the role of the Art-Union, but the newly rich families of the post–Civil War period heeded the advice of their well-paid experts on art investment and lavished their money on the work of famous Europeans. Ironically, as American visual art became more institutionalized and professionalized, its share of the art market at home steadily declined.[41]

"The nineteenth century," a leading historian of American painting and sculpture has written, "closed with the cosmopolitan tendency in the ascendant. The conspicuous effort from 1875 to 1900 had been to link our painting with that of Europe and to make American talents part of the international life of art."[42] Samuel Isham was able to conclude his pioneering history of American painting in 1905 with the observation that the present situation was, "on the whole, sound and satisfying." Twelve years later Charles L. Buchanan, an avowed foe of what was by then a rapidly spreading rebellion in the arts, could still remark smugly that "American painting has chosen to express itself through the medium of imitation rather than through the medium of individual anarchy." American art was conservative and traditional, according to Kenyon Cox, because America was still a young country whose people "have not yet had enough of the old and fine things to be wearied of them." The task before creative artists in America, added Paul Elmer More's *Nation,* was to "enter reverently into the heritage of the past and live in its best spirit and add little by little their own interpretations and make their slight additions or variations. . . ." Working with modesty and restraint, they would "do more to create a veritable national art than they could by wild experimentation and sensational innovation."[43]

## VII

A tasteful open-mindedness to the world's diverse masterworks, a healthy, ready eclecticism, a modesty about individual accomplishment, a disdain for radical innovation, a hopeful yet patient belief in the ultimate realization of a national art—these were also the prevailing themes in American architectural thought at the turn of the century. The United States had no official academy for architects on the order of the National Institute of Arts and Letters or the National Academy of Design. The American Institute of Architects, founded in 1857, had a broader membership and was concerned more with promoting the professionalization of architecture than with perpetuating traditional values through a distinguished elite. A growing number of American architects, however, boasted a common background of architectural study at the École des Beaux Arts in Paris. Others migrated to Italy to study in the American Academy at Rome, established in 1894 under the leadership of the neoclassicist Charles Follen McKim to foster the Renaissance artistic values of the Columbian Exposition's White City. For McKim and his followers there could be no worthy architecture of the present that was not based firmly on the great architecture of the past.

In the late nineteenth century groups of American architects and builders in various places turned against such thinking, sometimes in response to building exigencies and opportunities, sometimes as an act of conscious rebellion. They achieved their most spectacular results with tall commercial buildings, which by 1900 were already popularly called skyscrapers. Especially in and around Chicago, designers had minimized or abandoned outright masonry construction, heavily ornamental effects, and the conventional base-shaft-capital scheme and had realized nearly unbroken verticalities in steel, concrete, and glass. One of the Chicago group, Louis H. Sullivan, had emerged as an indefatigable spokesman against orthodox design and for an architecture that would be functional and thereby, he fervently believed, suited to American democracy. After 1900 Frank Lloyd Wright, Sullivan's onetime apprentice and eventually even more of a malcontent, also began to attack the existing architectural order for its irrelevance to the needs of modern America.

Regardless of what men like Sullivan and Wright might say, the taste of affluent Americans continued to favor "the architecture of choice," and architects continued to do imaginative work in a variety of historical styles.[44] Sullivan and Wright were convinced that the styles and methods of the past must be thrown over. Other spokes-

men, however, saw not a contradiction but a vital connection between reverence for a traditional architecture and the patient pursuit of a national architecture.

That was the way Herbert Croly saw the issue. From 1900 to 1913 Croly was first editor and then a frequent contributor to the monthly *Architectural Record,* the leading magazine of its kind in the country. Thirty-one years old in 1900, Croly was a Harvard dropout whose Irish-born father and English-born mother had both been outstanding New York journalists. A homely, shy, rather colorless man who wrote even more colorless prose, Croly was nonetheless an intense and unabating American nationalist. Croly is best known, of course, as a political thinker and publicist—as the author of *The Promise of American Life* and as the cofounder in 1914 and chief editor until his death in 1930 of the weekly *New Republic,* the magazine that quickly became the voice of advanced political, social, and economic reform. Yet Croly's political and economic nationalism, as Charles Forcey has pointed out, was both the outgrowth and the instrument of his more basic cultural nationalism. Behind Croly's advocacy of a strong, interventionist national government, empowered to oversee and to some extent police corporate business and other economic activity, was a deep yearning for national excellence as manifested in a cohesive, brilliant civilization. To revitalize American democracy was to vitalize American culture and realize the full promise of American life.[45]

For Croly as much as for Charles Eliot Norton, the first measure of the greatness of a civilization was its achievement in the creative arts. And when Croly thought of great art, he thought first of great buildings. The task before American architecture, in Croly's view, was basically to adapt the best of the past to the needs of the present. Artistic Americans, he acknowledged, had had a hard time of it in the new "modern national democratic society." Because they had had no "national artistic experience," Americans lacked "any instinctive sense of good form. . . ." That they could acquire only by having objects embodying good form liberally placed before them, such as the Renaissance-inspired designs of McKim, Mead, and White. "What American art needs at present," Croly wrote in 1902, "is the informing and refining presence of the best European models, so that it may start upon its career with a solid ground of safe, if not of brilliant achievement." To "make out of repetition a conviction and ideal" was the only sensible way finally to reach American artistic independence.[46]

"Servile copying" from the past should be avoided, Croly granted, but that was preferable to borrowing from contemporary eccentricity or blindly seeking originality. Rampant individualism, the bane of American life not only in art but in politics and economics as well,

must give way to cooperation among architects willing to work with generalized, proven concepts. By taking account of local-regional needs and circumstances, yet still striving for "traditional dignity" and "a finer aesthetic propriety," designers could in fact arrive at something approximating a national architecture.[47]

Croly specifically answered the romantic rhetoric of George W. Maher, a Chicago-area contemporary of Sullivan and Wright's, who argued in behalf of an indigenous way of building that would break with history and deal with "the grandeur of actual existence." A truly national architecture, Croly calmly observed, would come only through "the slow accumulation of a new set of precedents." On another occasion, putting about as much distance as he could between himself and Sullivan, Wright, Maher, and other proponents of an "organic" architecture supposedly based in nature and everyday existence, Croly argued that more than any other kind of artist, the architect depended on precedent. "The material of his work is not derived from nature or life, but from the work of his predecessors."[48]

Style, precedent, tradition, using the creative past to insure the creative present—such were Herbert Croly's artistic values and the values of the reigning designers and critics of his generation. McKim, Mead, and White put up stately examples of neoclassicism, Ralph Adams Cram designed churches and college halls in modernized Gothic, others worked in Georgian, Tudor, Romanesque, Spanish Colonial, Moorish, even Egyptian and oriental modes. Style—historically identifiable and verifiable style—remained the proper way to design and build, at least for those who did most of the designing and building in America during the half-century before the First World War. Over time, by seeing examples of the finest building art Western civilization had produced, the American public would presumably come to understand and accept enduring beauty. Perhaps then it would be possible to arrive at a truly American art, the crowning achievement of a truly American civilization.

## VIII

Even from the perspective of fifty years of an increasingly influential artistic modernism, much of the traditional architecture of the pre–World War I period—structures like the Boston Public Library, the Woolworth Building in New York, or the Pan American Union in Washington—is still impressive for both its formal attractiveness and its serviceability. Almost exactly the opposite is true for music. What now seems most interesting about the musical activity of that period

—maybe even most characteristically American—was generally unknown or unacknowledged by learned scholars and critics at the time. Today one looks back to blues songs, to ragtime, to the patriotic marches of John Philip Sousa, to the discordant, long-unperformed works of a Connecticut insurance executive named Charles Edward Ives as the major examples of musical creativity in early twentieth-century America. Then, however, the issue was not whether such innovations led anywhere but whether America's mostly European-trained composers, working within established European compositional forms, would some day be able to give their country parity with the musically creative nations of Europe.

Composers the United States had in considerable number, as well as notable conservatories in Boston and New York, fine symphonic and operatic groups in those cities and elsewhere, numerous high-minded local music societies, a spreading movement for required musical instruction in the public schools, and even several academic professorships of music. This substantial apparatus was supposed to transmit an acquaintance with "good music," meaning the best that had been written and performed in Europe, to a benighted but improvable public.

Of good American-made music, though, there seemed to be relatively little. Henry T. Finck, the New York *Evening Post*'s windy and pompous music columnist for more than four decades, recalled that at the turn of the century he declined a publisher's request for a one-volume history of American music "on the ground that there wasn't enough of it to go 'round." "The best we have done so far is to approximate the quality of the second best foreign," was the estimate of W. S. B. Mathews in 1901. "The best foreign . . . we have nowhere equaled or approached." The "seeds of characteristic nationality" to be found in the best foreign works were also lacking in American compositions.[49]

Mathews's reference to a characteristic nationality in music suggests an attitude that was basic to musical thinking in the nineteenth and early twentieth centuries. The conquest and continued dominance of Western formal music by romanticism meant, for one thing, general acceptance of the belief that music expressed the deepest spiritual being of particular peoples. Many composers assiduously sought out and self-consciously used melodies and rhythms from folk song and dance. Even if they deliberately avoided folk elements and tried to escape national identifications, composers were still likely to see their works labeled "German" or "Russian" or "Spanish" or "Bohemian."

Given the strength of the romantic nationalist influence in European music and the sparse American contribution to Western musical litera-

ture, there was an understandably widespread impatience for the country's formally trained composers to produce works that would be both "American" and up to European qualitative standards. The issue of musical nationalism had taken on new vitality in the early 1890s through the influence of the famed Bohemian composer Antonín Dvořák, who for several years was director of the National Conservatory of Music in New York. Dvořák became avidly interested in black spirituals, about the only kind of American folk music recognized as such by musicologists of the period. In 1893 he finished his *New World Symphony,* whose themes, though not quoting literally from the spirituals, clearly showed their influence.[50] While some objected to a foreigner's using such native materials, others hailed Dvořák's composition as a brilliant example of what American composers should themselves do.

Three years later Dvořák published a famous article in which he exhorted Americans everywhere to translate their patriotism and youthful enthusiasm into the furtherance of a great national music. He insisted that there was plenty of native folk song that American composers could use as the basis for such a music. Besides "plantation melodies and slave song," he suggested the possibilities in Indian chants, New Orleans creole songs and dances, and "the plaintive ditties of the homesick German or Norwegian." The American composer should listen to whistling boys, to street singers, to organ grinders. Because "the best of music lie [sic] hidden among all the races that are commingled in this great country," sooner or later, as had already happened in the Slavic countries, "the music of the people . . . will creep into the books of composers."[51]

The man mentioned almost invariably as America's foremost composer, Edward MacDowell, was not impressed. MacDowell, in fact, seemed the most likely candidate to become *the* Great American Composer if the country were ever to have one. Thirty-eight years old as the new century began, MacDowell already had produced an impressive body of work. Trained mostly in Germany, MacDowell had lived abroad for twelve years before reluctantly returning to the United States in 1888. He brought back with him the heavy musical baggage of German romanticism. Following a period as a private teacher in Boston, MacDowell accepted Columbia University's first professorship of music in 1896. Eight years later he quarreled with President Nicholas Murray Butler over plans for the reorganization of the university and resigned in an atmosphere of high controversy. MacDowell and his wife went to live in rural New Hampshire, where the composer became ill with a malignant brain tumor. He died in New York early in 1908.[52]

For MacDowell, romanticism—German romanticism—was the only music of any consequence. One followed the lead of the German masters and expressed the only "vital element" in music—individual personality. MacDowell had no use for Dvořák's or anyone else's efforts to write a "purely national music," something that "may be duplicated by anyone who takes the fancy to do so." "Masquerading in the so-called nationalism of Negro clothes cut in Bohemia will not help us," he huffed. If there was anything American for music to express, it was —MacDowell phrased it as an almost Whitmanian abstraction—"the youthful optimistic vitality and the undaunted tenacity of spirit that characterizes the American man."[53]

MacDowell did make use of Indian-derived melodic fragments in his effective Second ("Indian") Suite and in several charming shorter pieces, notably his Woodland Sketches. In his concertos, sonatas, and symphonies, however, he continued to write under the dominance of central Europe. Gilbert Chase has seen MacDowell's borrowing from Indian sources as "at last an attempt to get away from secondhand romanticism and genteel sentimentality." Henry T. Finck, though, wrote at the time of the composer's death that MacDowell had shown "the only way in which it is possible to build up a white man's American music; for the negro and Indian melodies are not ours; they should be left for the negro and Indian composers. . . ." Whatever broader conceptions MacDowell may or may not have had, he doubtless would have agreed with Charles Buchanan that all great art was "an adroit and exquisite exploration of individual experience and of individual emotion."[54]

If MacDowell denied any special obligation to compose as an American for Americans, there were several others who might have the makings of the Great American Composer. The Bostonian George W. Chadwick, seven years MacDowell's senior, had shown a marked concern for American themes in his Symphonic Sketches and an opera dealing with the lives of Italian immigrants. Henry F. B. Gilbert, MacDowell's first American student, had dug deeply into creole and black music for such works as The Dance in Place Congo and Negro Rhapsody. Gilbert, along with composers like Arthur Farwell and Charles Wakefield Cadman, had also done considerably more than MacDowell to exploit Indian and pseudo-Indian materials.

The French composer Vincent d'Indy reminded Americans in 1906 that the United States, like Italy in the sixteenth century, Germany in the seventeenth, and France in the eighteenth, was still a young country filled with scattered "art forces" waiting to be marshalled. Etude magazine, chief spokesman for genteel music education, pointed out that it took Germany seven hundred years to produce a Beethoven. Accord-

ing to *Etude*'s formula, a nation had to have one thousand "cultured musicians" to produce one good composer and then one thousand good composers to produce one great composer. Some day such a man, combining "sentiment, technic, and originality," would make himself known. In the meantime, argued musical patriots, American composers should receive every encouragement. Their work should be given frequent performances by the country's best orchestras, opera from other countries should be sung in English translation to encourage the development of native opera, and the whole institutional structure of formal music training and popular music education should be greatly expanded. Some archnationalists went so far as to denounce overseas study and to exhort young musicians to stay at home for all their training.[55]

In the first decade of the new century, despite MacDowell's death, the future looked reasonably promising for both music in America and the development of an American music. Nationalistic elements in American musical thinking remained strong, whether as a cosmopolitan vision of the American composer as "the truest representative of universal art," as an older inclusivist pride in America's mixture of "races," or as a newer exclusivist insistence on a white man's music.[56] As in the other arts, nationalism in music was still mostly genteel nationalism—deferential to Europe, wary of experimentation, elitist in its view of art and society yet dedicated to spreading beauty to the backward. In music as in the other American arts, the Genteel Tradition was still very much in sway.

## IX

Not for much longer, though. In retrospect it is clear that the Genteel Tradition was already pretty shaky at the turn of the century. A succession of challenges to established modes of thought and expression was already under way across the intellectual and cultural spectrum. "Formalism" was everywhere coming under attack.[57] Even within the traditional culture there were growing signs of discontent. "Is not personal life of the intenser sort exactly what one misses from our contemporary art?" wondered *Harper's Weekly* in 1903. "When we try to touch the depths of our experience we betray our weakness. . . . Our spiritual life seems to have grown in a thin soil." Two years later a writer in the sedate *Dial* complained that "Our poets are driven into business, our artists into exile. Our thinkers become college professors, where they dry up and blow away."[58]

Such sentiments, much like what the rebelliously nationalistic "young intellectuals" would say again and again in the next decade, suggest the way the tide was running in American cultural life. It was not, though, one of the insurgents who finally and lastingly named the enemy but a man who once described his relationship to America as that of "a permanent guest, familiar, appreciative . . . but still foreign."[59]

Late in August 1911 George Santayana, finishing a summer visiting professorship at the University of California, addressed a society of Berkeley academicians and educated laity called the Philosophical Union. Santayana was about to return to the Harvard philosophy department, a department that was still, despite the death of William James a year earlier, perhaps the most remarkable group of technical philosophers ever assembled at an American university. Born in Madrid in 1863 of a Spanish father and an American-Spanish mother, Santayana had received his secondary schooling in Boston and then taken A.B., A.M., and Ph.D. degrees at Harvard, where he joined the faculty in 1889. Urbane, stylish, Mediterranean in appearance, taste, and outlook, Santayana had never really felt at home in Anglophilic New England or in the United States as a whole. At the most he managed a detached cordiality toward a country where "cultivated society happened to contain little but youth and ladies; the older men seemed animals of another species."[60]

Santayana's address to the Philosophical Union was called "The Genteel Tradition in American Philosophy." What he had in mind was not the technical discipline of philosophy but broad social philosophy—the complex of widely shared values, ideals, biases, and mores that Santayana saw at the center of the life of the mind in America. Santayana perceived America in terms of dichotomies—the "hereditary spirit" versus the younger generation, intellect versus will, feminine versus masculine. Half of American thinking was preoccupied with practical matters; the other half was "slightly becalmed." The country's architecture—the reproduced "colonial mansion" alongside the skyscraper—symbolized the split in American thinking. "The American Will inhabits the sky-scraper; the American Intellect inhabits the colonial mansion. The one is the sphere of the American man; the other, at least predominantly, of the American woman. The one is all aggressive enterprise; the other is all genteel tradition."[61]

The tradition of aggressive enterprise—stern, single minded, self-denying—was half of what had come down from early Puritanism. The other half was a Puritanism stripped of its concern with sin and retribution but retaining its "abstract piety." In the previous century this denatured Puritanism had mingled with German idealistic philos-

ophy to produce American Transcendentalism—rarefied, "cheery," "impervious to the evidence of evil," personified in Emerson. Here was the foundation for Santayana's genteel tradition, for the philosophy that "forbids people to confess that they are unhappy. . . ."[62]

Among American literary men only Whitman had managed completely to shake the Genteel Tradition. The best of the rest—Emerson, Hawthorne, Poe—all had had "a certain starved and abstract quality." Whitman's "poetry of crude naturalism" had represented one kind of revolt against the dominant culture; a little later William James's radical empiricism, with its uncertainties, contingencies, and open-endedness, had represented another. Yet the Genteel Tradition had continued to subsist among the academically minded "for want of anything equally academic to take its place."[63]

Santayana taught at Harvard only one more semester, at the end of which, secured by a substantial legacy, he resigned and returned to his native Europe to reflect and write for the rest of his long and eminent life. He left Americans a vivid, appealing analysis of what looked like a deepening malaise in the nation's cultural life. And he left a useful label for what was wrong, a descriptive term that could be stretched to cover a multitude of sins against American creative life and thus against the fulfillment of individual and national potential. Genteel cultural nationalism was about to confront a revivified romantic nationalism allied to, sometimes interchangeable with, a radical artistic modernism.

# CHAPTER 2

# The Genteel Tradition at Bay

SOME CALLED IT A RENAISSANCE. FOR OTHERS IT WAS MORE PROPERLY the Little Renaissance, at least in its New York phase. For still others it was the Liberation or the Rebellion or the Resurgence. Ezra Pound, with his penchant for Italianisms, announced the "American Risorgimento." Edna St. Vincent Millay wrote a poem in 1912 about the freeing of the creative spirit entitled "Renascence," and some interpreters thought that the best of all descriptive phrases. In his memoirs Van Wyck Brooks, borrowing Emerson's term for Transcendentalism in the 1830s, called it "the newness." However one chose to describe what happened, somewhere around the beginning of this century's second decade, it became apparent that American intellectual and cultural life was changing in unforeseen ways and moving with accelerating velocity in uncharted directions.[1] The radical questioning process at work since well before 1900 in technical philosophy and the newly emergent social sciences had finally begun to transform creativity and criticism in the arts as well. The hold of the Genteel Tradition was already beginning to slip badly by the time George Santayana named it in 1911. Although the older cultural order proved more durable than its enemies foresaw, it was never the same after the multifarious revolt that flared in the pre–World War I years. Ever since then, as Santayana later said, the Genteel Tradition has been "at bay."[2]

I

The broad-based assault on the Genteel Tradition was closely related to what Christopher Lasch has termed "the emergence of the

intellectual as a distinctive social type." Toward the end of the nineteenth century, according to Lasch, a sizable number of young men and women raised in generally comfortable middle-class circumstances began to resist and then reject their paternally dominated, morally absolutist, property-oriented family environments. The result of this generalized revolt against established values and beliefs was to produce a self-conscious minority of Americans determined to make criticism of their country a sustaining vocation. Taking the French term "intellectual" to distinguish themselves from the older learned elite, these "new radicals," as Lasch calls them, lived and worked in at least partial estrangement from the larger society, sometimes in total alienation.[3] Rebelling against both the traditional genteel culture and the commercially dominated, formularized, and standardized modes of thought and behavior in modern mass society, the "intellectuals" found themselves at the same time liberated from convention and cut adrift from the firm station and role that men and women in arts and letters had occupied under genteel dominance. In a sense, therefore, the new class of intellectuals and the rebellious artists they allied with became a "beleaguered minority."[4]

Kenneth Lynn has significantly revised Lasch's thesis by studying 141 men and women who settled in Greenwich Village, the center of cultural dissent in the years before the First World War. Contrary to Lasch's contention that the dissenters were in revolt against stern Victorian fathers and repressive middle-class upbringing, Lynn finds that many of them had weak, often financially unsuccessful fathers. They also frequently had spirited, strong-willed mothers and came from remarkably tolerant, independent-minded families. Lynn has also challenged one of the hoariest notions about the early intellectual and cultural rebels: that, as Carl Van Doren said in 1922 in a survey of the new fiction some of them were producing, they were in "revolt from the village"[5] and thus were a part of the "young man from the provinces" tradition so prominent in Western world literature. In fact, Lynn shows, migrants to Greenwich Village commonly had grown up in sizable towns and cities, frequently in New York itself. In the "Bohemian" environs of Washington Square, they sought the very network of personal relationships and the community cohesiveness traditionally associated with small-town and rural life. Lynn concludes that "most rebels, no matter where they came from, hoped and believed that Greenwich Village was in some sense still a village."[6]

Whatever it was in their personal backgrounds that caused them to come to Manhattan either directly or by way of Chicago or someplace else, they came. And while they may sometimes have thought of themselves as a beleaguered minority, it was the established order—in

politics, economics, morals, education, and the arts—that was actually under siege in the years before the First World War. The romantic cultural nationalism of the period flowered in a climate of general agitation—against the Genteel Tradition and practically everything else of an institutional character in American life.

Unless one understands the connections between a resurgent cultural nationalism and the broader movement of radical cultural protest in the years up to 1917 or so, it is impossible to understand why the issue of an indigenous art then seemed so urgent to such a considerable number of people. In 1913 the journalist Hutchins Hapgood, an habitué of the Village scene, caught the mood of the Rebellion: "We are living at a most interesting moment in the art development of America. It is no mere accident that we are also living at a most interesting moment in the political, industrial, and social development of America. What we call our 'unrest' is the condition of vital growth, and this beneficient agitation is as noticeable in art and in the woman's movement as it is in politics and industry."[7] There was some overlap between such "unrest" and the "progressive movement" in politics and government. Yet progressivism, emphasizing moderate reform and moral improvement through the political-legislative process, was generally unacceptable to the prewar rebels. Fusing radical politics with innovative art and personal behavior, the Rebellion disdained both genteel political and social reform and genteel cultural values and traditions.

Meanwhile, as Henry May has shown, all sorts of upsetting ideas from Europe had begun to alter American intellectual and cultural life. In the sexually based psychology of Sigmund Freud and Havelock Ellis, in the brooding antirationalism of Friedrich Nietzsche, in French symbolist literature and postimpressionist painting, in the thematic and technical innovations of the composers Richard Strauss, Igor Stravinsky, Arnold Schoenberg—in these and other sources there was plenty that would help undermine orthodoxy in social theory and the arts. At home, William James, John Dewey, and George Santayana in philosophy and Thorstein Veblen in economics had also weakened conventional notions about thought and behavior.[8]

All these various elements contributed to a general ferment, an anticipation that big, dramatic changes were in the offing and that the days of the old order in politics, morals, and culture were numbered. Or so it seemed to those who gathered in the little flats and cheap restaurants of Greenwich Village to talk about Freud's theories, social revolution, or cubist painting; to the equally voluble people who manned the Chicago outposts of the Rebellion; to the small groups of students, mostly in the eastern colleges and universities, who toler-

ated and perhaps even grudgingly admired their genteel professors but were often impatient with what they offered. Advocates of women's rights, exponents of free love and companionate marriage, educational experimenters struggling to maintain their "child-centered," "life-centered" little schools, socialists, anarchists, poets, painters, playwrights, actors, camp-followers, hangers-on—all contributed to the insurgent spirit of the prewar years.

## II

The origination or transformation of a succession of periodicals was symptomatic of growing unhappiness with the existing state of affairs in politics, society, and culture. In 1910 Mitchell Kennerley bought the earnest, genteel *Forum* and soon made that monthly a transmitter for new European conceptions in ideas and the arts. Under the aegis of George Jean Nathan and Henry Louis Mencken, the monthly *Smart Set* added its voice to the protest against the constraints of conventional manners and morals on personal expression. The lavish and expensive *Vanity Fair* (which got under way in 1913) was dedicated, said editor Frank Crowninshield, to eradicating "the ravages of bad taste," meaning the vulgar excesses of a people dominated by the ethic of material success. In Greenwich Village, meanwhile, the monthly *Masses,* edited by Max Eastman and Floyd Dell, proceeded on the unstated assumption that revolution should be fun, or at least witty and stylish. Linking radical politics, radical arts, and radical life styles, the *Masses* served as the focus of the "lyrical left" until wartime repression took the fun out of being a revolutionary.[9]

The prewar insurgent spirit also produced several lively "little magazines." Such publications came into being to propagate new theories of art and life and to publish writers whose work was too technically experimental to find an outlet in the established periodicals or even in the mildly innovative *Smart Set* and *Masses.* Poetry and criticism by such people as T. S. Eliot, Ezra Pound, William Carlos Williams, Hart Crane, E. E. Cummings, and Kenneth Burke first appeared in ephemeral monthlies like the *Little Review, Pagan, Others,* and *Glebe.*

The long-term survivor among the assorted prewar little magazines was *Poetry*, a monthly started in 1912 in Chicago by Harriet Monroe. Monroe's persistent preoccupation was the desire to bring attention to the finest native poets, even when, as in the case of Pound and Eliot, they became permanently estranged from their country. Besides Pound and Eliot, such widely different poets as Carl Sandburg, Wallace Stevens, and Robert Frost showed up regularly in *Poetry*. Monroe's

magazine quickly became the foremost vehicle for promoting a strong American literary expression that both Americans and Europeans would recognize as such. By 1917 Monroe was ready to pronounce America's new poets superior to England's. If such an attitude suggested provincialism, she added, then provincialism was better than colonialism. It was "better to brag than to apologize."[10]

Even more pronounced in its cultural nationalism was the *Craftsman,* a monthly originating in upstate New York and then moved to Manhattan in 1906 by its founder, a former Wisconsin cabinetmaker named Gustave Stickley. Influenced by the writings of William Morris and John Ruskin, Stickley sought to inspire a handicrafts revival in the United States on the order of what the followers of Morris and Ruskin had done in England. After he moved his magazine to New York, however, he broadened its content to include original poetry and a great amount of critical writing on the arts. Soon the *Craftsman* was espousing a vociferous if not always consistent nationalism, based on the premise that, as Stickley declared, "the national character is beginning to take shape and to absorb into itself the many elements that go to make it up. . . . In our national life . . . there is a deep, steady undertone which is the voice of a nation finding itself. . . . And this sense of national individuality is even now expressing itself in a steadily growing tendency toward a vigorous and distinctive national art."[11]

The *Craftsman, Poetry,* and the other new magazines each contributed to the process of probing, questing, and questioning going on in all the arts. The Irish painter John B. Yeats, father of the poet and playwright William Butler Yeats and a fixture in Greenwich Village, remarked to a group of young admirers that "The fiddles are tuning, as it were, all over America." To Monroe's request for advice about starting her new poetry magazine, Ezra Pound replied from London that the "American Risorgimento" was inevitable and "dear to me." "That awakening," Pound was convinced, "will make the Italian Renaissance look like a tempest in a teapot!" Sheer numbers were not important to people like George Cram Cook, soon to have a major share in transforming American drama. "An American Renaissance of the Twentieth Century is not the task of ninety million, but of one hundred," Cook declared in 1912. "Does that not stir the blood of those who know they be of that hundred?"[12]

## III

The widespread confidence among insurgent elements about prospects for an American Renaissance was quite different from the optimism that characterized the thinking of both genteel cultural nation-

alists and political progressives in the pre-World War I period. For upholders of the Genteel Tradition, there need be no great urgency or anxiety on the question of a national art. The amalgamation of the immigrant masses, the careful, correct adaption and refinement of well-established European ways of thought and expression, a patient, presumably protracted effort to educate public taste to beauty—these were the prerequisites of cultural maturity, as the genteel traditionalists saw things. In time a great American art, building on the accumulated genius and wisdom of the past, would finally come into being.

The insurgents were doubtful. How could one seriously counsel patience and talk about cultural progress? There was too much wrong with American life—too much cheapness and ugliness, too much grinding, single-minded pursuit of what William James had called "the bitch-goddess Success," too much aimless hustle and squandering of energy and talent. Most of all, what was wrong was what they understood as "Puritanism." The Puritan example of piety, restraint, and perseverance was dear to many genteel creators and critics. But insurgents, almost to a person, shared Walt Whitman's conviction that "the puritanical standards" were "constipated, narrow, and non-philosophic," unsuited to the vast and complex needs of "these States."[13] By the time Santayana identified seventeenth-century Puritanism as the source of the split between the American will and the American intellect, between aggressive enterprise and the Genteel Tradition, fiery denunciations of the "Puritan influence" had become commonplace.

A later generation of American historians has carefully reexamined the early New Englanders, finding much to admire in the original Puritans' commitment to their holy cause, in their intellectual prowess, and in their realistic, practical understanding of man. Their intolerance for people who believed and behaved differently has been put in the context of an "age of faith," a time long lost, when men and women agonized over their relation to their God and their prospects for the hereafter. By consigning the Puritans to their proper place in history, present-day scholars and critics have been better able to understand them for what they were—in their own time.[14]

For the pre–World War I rebels, however, as well as for large numbers of American interpreters over the next twenty-five years at least, the term "Puritan" described a living presence, an oppressive, self-righteous, menacing force that had throttled American spiritual growth and continued to hamper free thinking and creative genius, not to mention ordinary personal pleasures.[15] For the painter Robert Henri, trying in the tradition of Whitman to teach that beauty was to be found in the everyday lives of the common people, the Puritan, past and present, had "sought peace in bondage and his spirit became a prisoner." To neoromantics like Henri, "restrictions hid vice, and

freedom alone bears morality." The Puritans, said the playwright
Percy Mackaye, had "thought it well for one-half of man's nature to
starve." There had never been "a more arrogant, self-willed people,"
declared a contributor to the *Craftsman,* summing up what had become
the standard insurgent view of the seventeenth-century New England
settlers and their descendants. "They were determined to have a re-
ligious debauch, and instead of loving beauty, they had the excitement
of condemning it, they had the haunting interest of hiding it. . . .
[They] were taught that goodness was negative and beauty evil, that
human delight was to be burned at the stake. . . ."[16]

It did not seem to matter that the American Puritans never actually
burned anybody at the stake, or that one rather small group of people
who had settled one part of the country nearly three hundred years
earlier could hardly be responsible for all the ills and evils of modern
American existence. H. L. Mencken was convinced that Puritanism,
in combination with mass democracy, explained just about everything
about the present awful state of the nation's affairs. Among the Puri-
tan's major traits, as Mencken itemized them, were his "utter lack of
aesthetic sense, his distrust of all romantic emotion, his unmatchable
intolerance of opposition, his unbreakable belief in his own bleak and
narrow views, his savage cruelty of attack, his lust for relentless and
barbarous persecution. . . ." Down to the present, Puritanism had
"put an intolerable burden upon the exchange of ideas in the United
States."[17]

Original American Puritanism, according to Mencken, had flourished
into the mid-eighteenth century before giving ground to the secular
rationalism of the Revolutionary-Constitutional period. Resurgent in
the great religious revivals after 1800, Puritanism had then, with
the triumph of mass democracy and the enthronement of the common
man in the era of Andrew Jackson, degenerated into philistinism, a
mindless "exaltation of the mob's distrust of good taste. . . ." In the
post–Civil War years philistinism, typified by the sentimental claptrap
of popular fiction and poetry, and Puritanism, powered by Anthony
Comstock and the Society for the Suppression of Vice, had overwhelmed
all opposition. Now, well into the twentieth century, the twin forces
of Puritanism and philistinism were still dominant in the country's
thought and art, manners and morals.[18]

Mencken's analysis of the Puritan menace was one of the key docu-
ments in the prewar Rebellion. By the 1920s Mencken's diatribes
against American conventions had made him virtually the high priest
of the continuing revolt against the Genteel Tradition. Yet in the
teens and twenties Mencken always seemed more of a radical than he
really was. In fact he shared much of the middle-class sentimentalism
of the Victorian age, particularly in his strong attachments to his

mother and a large circle of other relatives, in his fondness for manly companionship and his solicitousness for genteel womanhood, and in his early developing nostalgia for his youth and early manhood in Baltimore. Despite his continual association with New York magazines from 1908 into the 1930s, he remained on the staff of the daily Baltimore *Sun*.[19]

Mencken was also intensely proud of his German ancestry and cultural heritage. His great passion was the music of the German romantic composers. Besides being a notably unmusical people, the Anglo-Saxons, he thought, were incurable meddlers and moralizers. Mencken was even more contemptuous of popular democracy. The American experience had proved that popularly based government inevitably led to the tyranny of an ignorant, narrow-minded majority. An undisguised elitist, Mencken had no faith whatsoever in social progress or genteel cultural uplift.

Yet for all his blasts at dim-witted democrats and pestilential Puritans, in his own way Mencken liked his country. He was utterly fascinated by the sheer spectacle of life in America, particularly its boisterous politics and bewildering array of religious groups. Mencken's delight in the vulgar wonders of his native land should have demonstrated to his contemporaries that he was hardly the man to lead the Rebellion.

Menkcen was nonetheless a formidable foe of the established order. Widely but not deeply read, he was a brilliant polemicist and something of a scholar if not an original thinker. At the age of twenty-five he wrote the first book-length criticism of George Bernard Shaw's plays; three years later, in 1908, he published the first American study of Nietzsche. In 1919, moreover, Mencken put together a spirited, entertaining, and much-acclaimed study of the American language. Revised in various subsequent editions, Mencken's book did much to extend the idea that American speech was so divergent from British English as to constitute a separate language.[20] Thus Mencken simultaneously furthered the cause of American literary independence, indulged his fondness for American history and folklore, and dealt a blow to the hated Anglo-Saxons—all at a time when Hamlin Garland and other genteel nationalists in the American Academy of Arts and Letters were trying to exorcise the Americanisms that were debasing proper English.

## IV

Whereas Mencken was a cultural nationalist only reluctantly and obliquely, Van Wyck Brooks was a willing, determined, and tireless seeker of the American renaissance, most especially an efflorescence of

American literary genius. Deadly serious where Mencken was characteristically mirthful, reticent where Mencken was expansive, eloquent and analytical where Mencken was bombastic and bludgeoning, Brooks figures even more prominently than Mencken in the initial assault on "Puritanism" and in the invigoration of an inclusive cultural criticism.

Born in the then-fashionable suburban city of Plainfield, New Jersey, in 1886, Van Wyck Brooks grew up in a family that had, as Brooks's biographer has phrased it, "on the one hand, an upper class lifestyle and social status, and, on the other hand, middle class anxieties and economic insecurity."[21] Brooks fits most of Kenneth Lynn's typology for the prewar Village rebel. By Plainfield standards his father, who had lost out on a fortune in western mining and had to work as a clerk in a New York brokerage house, was a failure. Sickly and retiring, in parental matters Charles Brooks deferred to his attractive, forceful wife, who was determined that Van Wyck and his elder brother would grow up to be both cultured and financially successful. On Charles Brooks's modest salary and with some money of her own, Sallie Brooks managed to take the boys on European travels and give them other genteel advantages, although Van Wyck went to public school in Plainfield. There was also enough money for Harvard, which Van Wyck entered in 1904.

By the time he finished his A.B., after only three years, Brooks had made up his mind to become a literary critic. Although he took classes with Irving Babbitt and with George Lyman Kittredge, the renowned specialist in early Anglo-Saxon literature and folklore, and also attended a couple of Charles Eliot Norton's Dante evenings, Brooks was most influenced at Harvard by the austere Barrett Wendell. It was, though, less Wendell's affection for the early Puritans that came across to Brooks than his contempt for the preponderance of American writing. When he left Harvard Brooks had already developed the first signs of what would soon become a profound unhappiness with American literary culture and with the country's intellectual and artistic life as a whole.

Brooks quickly moved away from the unemotional, morally didactic approach to art he had encountered in most of his Harvard professors. From his earliest post-Harvard writings, Brooks operated firmly in the romantic tradition of "organic" criticism—the tradition of Herder, Saint-Beuve, and Taine, as well as Emerson and Whitman. Art, Brooks agreed, grew out of particular social environments—the accumulated customs, traditions, and values of different peoples. Thus by definition, criticism had to be historical and biographical, and must concern itself not only with artists and their work but with the broad context in which they strived to create. "For great works of art," Brooks later

wrote, "are great not, first of all, for technical reasons, but because they express the ethos of the race behind them."[22]

To Brooks, moreover, being a critic meant more than making a living from writing criticism. To be a truly great critic was to be something of a prophet, a man who was able to synthesize, interpret, and clarify a whole people's experience. Whitman, Brooks's foremost American hero during his early career, had tried to do that in both his poetry and his essays. Implicitly Brooks agreed with what James Russell Lowell had said and what Paul Elmer More took as his motto: Before the United States could have a great literature it must have a great criticism. And like Matthew Arnold, Brooks believed that it was up to the critic to cultivate feeling and appreciation, to prepare the soil for the seeds of creativity. The question, as Brooks later put it, was "how to change the whole texture of life at home so that writers and artists might develop there."[23]

Throughout his long critical career Brooks never seemed to make up his mind whether great American artists would be able to transform American society, or whether the transformation of society had to come before there could be great art. In his early grapplings with American culture, Brooks inclined toward the second proposition. *The Wine of the Puritans,* an extended essay Brooks wrote in England the year after his graduation and published in New York with Mitchell Kennerley in 1909, was Brooks's first serious effort to answer the question he later remembered so many of his contemporaries asking: "What is wrong with American living?" Still flavored by his Harvard estheticism, written in the form of a clumsy dialog between two languorous young Americans in Italy, *Wine* was nevertheless in some ways Brooks's most forthright indictment of his country.

Brooks's "wine" was old New England Puritanism, which exploded when put in the new bottle of the modern age. In describing the escaping aroma as airy and abstract Transcendentalism, Brooks anticipated by three years the more elaborate dichotomy of Santayana (with whom Brooks had taken no classes at Harvard). Brooks believed that, as Horatio Greenough had said in the 1840s and as Christian Brinton also wrote in 1908, the American people had had no national childhood. They thus lacked color, enriching experience, and maturity. "American history is so unlovable!" Brooks had one of his two young interlocutors complain. Hard-working, clever in material matters, Americans nonetheless lacked the instinctive perceptions necessary to great art. As a consequence they were uninspired and unfulfilled. "I am sure," Brooks's other spokesman declared, "that there is less happiness in America than in any other country in the civilized world." Brooks had no prescription for the American malaise except a kind of intense, Whit-

manian inner concentration. Americans should stop being self-conscious and "simply *be* American, teach our pulses to beat with American ideas and ideals, absorb American life, until we are able to see that in all its vulgarities and distractions and boastings there lie the elements of a gigantic art."[24]

The period from *Wine* until 1915 was a time of intellectual growth, some confusion, and much disappointment for the young critic. While he earned a meager living at hack work for publishers and magazines in New York, Brooks acquainted himself with the cultural radicalism of Greenwich Village (where J. B. Yeats did portraits of him). He married, tried two years of teaching in California at Stanford Universtiy, and published two obscurely written, poor-selling studies in European criticism and a somewhat better book on the English Socialist H. G. Wells.[25] Respect, notoriety, and influence eluded him. Yeats's portraits and photographs from the period show Brooks as a rather frail-looking young man with delicate features, which were improved by the moustache he sported part of the time. Shy, somewhat prudish, brusque at times, and slow to form friendships, Brooks had two consuming ambitions: to be the kind of prophetic figure for America that Matthew Arnold had been for England, and to promote and witness America's coming of age.

That was the anticipatory title of the book that finally brought Brooks a measure of fame, if not fortune. Written in New York in 1915 after the outbreak of war had forced Brooks to return with his family from Europe, *America's Coming-of-Age* came to be widely thought of as the manifesto of the prewar Rebellion. If it was not fully that, it was certainly the major statement of the revived romantic cultural nationalism of the period.

In *America's Coming-of-Age* Brooks returned to the dichotomy first he and then Santayana had established between the thin moralism of Transcendentalism and the ruthless practicality of commercialism. Brooks now saw the split as between "Highbrow" and "Lowbrow." One was epitomized in the humorless, abstruse piety of the eighteenth-century Puritan preacher and theologian Jonathan Edwards and then in "the fastidious refinement and aloofness" of Emerson and most of the other leading American writers. Perhaps better than anyone, Brooks summed up his intellectual generation's bitter view of the Genteel Tradition: ". . . American literature has had the semblance of one vast, all-embracing baccalaureate sermon, addressed to the private virtues of young men. It has been one shining deluge of righteousness, purity, practical mysticism, the conduct of life, and at the end . . . the highest ambition of Young America is to be—do I exaggerate?—the owner of a shoe factory."[26]

The archetypal Lowbrow was Benjamin Franklin, from whom "the current of catchpenny opportunism" had flowed to the modern American business elite. Brooks made clear his distaste for American capitalism and his commitment to socialism. For Brooks, though, as for other prewar romantic insurgents, socialism would be more the result than the cause of the full realization of individual and national personality. Strongly influenced in this area by John Ruskin, perhaps a little by H. G. Wells, and not at all by Karl Marx, Brooks saw socialism as the substitution of "self-fulfillment" for "self-assertion." Economic change had meaning for Brooks only insofar as it was part of the general spiritual renewal of the American people. Many years afterward Brooks described himself as being a socialist "on the understanding that the leveling was to be not down but up."[27]

Whitman, for all his faults, mainly in his indiscriminate praise for things American, had been the "precipitant" of the modern national character, the great exception to the split between gentility and vulgarity. The Whitmanian synthesis in the national life was yet to be. At present, Brooks lamented, America was like "a vast Sargasso Sea—a prodigious welter of unconscious life, swept by ground-swells of half-conscious emotion." But, quoting J. B. Yeats's remark about America's tuning fiddles, Brooks suggested that the future was opening, that there were breaks in the Puritan wall. After all, Brooks said at the end of his book, "humanity is older than Puritanism."[28]

From Chicago, Sherwood Anderson, struggling to establish himself as a novelist, spoke for a wide range of cultural dissidents when he called *America's Coming-of-Age* "the only note in American criticism ... worth a damn."[29] Yet as studies by James Hoopes and Peter Dowell, in particular, have brought out, Brooks always had at least one foot in the nineteenth century and in the Genteel Tradition.[30] Though vaguely a democratic socialist, Brooks was also very much an elitist, a man who conceived of his role as that of pathfinder and prophet. In his own way Brooks was as devoted to the idea of cultural uplift as any of Henry May's custodians of culture. Moreover, despite his complaints about the paucity of new thinking in America, Brooks's own tastes were rather conventional, as he would later demonstrate by his stern strictures against literary naturalism and experimentalism. Brooks never really came to terms with the twentieth-century avant-garde, nor did he have any use for the permanent expatriation undertaken by such avant-gardists as Ezra Pound, T. S. Eliot, and Gertrude Stein. The expatriate had no country, and Brooks was convinced that "a man without a country could do nothing of importance, that writers must draw sustenance from their own common flesh and blood and that therefore deracination also meant ruin."[31]

For all his passionate nationalism, Brooks's artistic values remained Eurocentric in this early period. "Art is a property of Europe," he wrote to a friend in 1919; America could not be inspired to greatness "except through a conception of the literary life we can gain only by our contact with Europe."[32] For Brooks as for the genteel critics and artists, Europe remained the measure of artistic achievement. At least up to the 1930s, Brooks was unwilling to take American creativity on its own terms. He was able to condemn Mark Twain for failing to become the American Rabelais, Cervantes, or Swift, and then to condemn American society for producing a Twain rather than a Rabelais, Cervantes, or Swift. For all his admiration for Whitman, Brooks's romantic nationalism had been finely strained through the Genteel Tradition.

## V

The key element in the insurgent indictment was the charge that the American arts were not an organic part of American life. As Sherwood Anderson once described his early ambition, "I did not want to be merely a writer living in America, but wanted to be an American writer, wanted to make my tale telling fit me more snugly into the life about me." It distressed Anderson that "culture is not a part of our lives out here, in Mid America. We are all . . . a little ashamed of trying for beauty." Because America had no art "that springs from the full self-consciousness of the people," declared a young New York painter, "there are in reality no American artists." Malcolm Cowley remembered that when he was an undergraduate at Harvard just before the war, his teachers influenced him to think "that literature in general, and art and learning, were things existing at an infinite distance from our daily lives. . . ."[33]

Nowhere was there more determination to connect art to life than at the *Craftsman* magazine. Before it folded in 1916, the *Craftsman* campaigned ceaselessly to promote an understanding of beauty in practical, ordinary, organic terms, and to promote a national art grounded in such an understanding. Publisher Gustave Stickley described the obligations of the artist in ways that ran directly counter to the Genteel Tradition's idealism and insistence on formal excellence. What was art after all, asked Stickley, but "just being honest with yourself, with your country, with your art?" Stickley was tired of "all this fussing about the place of art. . . ." The artist's first task was to know the life of the people. "We have got to learn to believe in ourselves and

express what we believe in order to paint or build or model a lasting art in America."[34]

Just after the new century began, the architectural critic Montgomery Schuyler had lamented that while the best American country houses had "a familiar and vernacular and . . . autochthonous air," in civic building "there are no longer evidences even of an aspiration toward a national architecture."[35] Nobody was more unhappy with the present state of American architecture than the archromantic Louis Henry Sullivan. Forty-five years old in 1900, the New England–bred Sullivan had started out as a proud product of École des Beaux Arts neoclassical training. By 1880, however, when he came to a Chicago still rebuilding from the great fire of 1871, Sullivan was already well on the way toward developing a theory of design that, at least to Sullivan's satisfaction, harmonized modern building techniques, modern civic and commercial needs, and the opportunity for highly personal artistic expression. Sullivan's professional success had much to do with the practical wisdom of his partner, Dankmar Adler. It was Sullivan, though, who gained a reputation as the most brilliant of the remarkable group of architects who within two decades made Chicago the world's most architecturally advanced city. Sullivan's most pleasing design was the Wainwright Building in St. Louis, finished in 1890. Light, graceful, topped by a beautiful ornamental cornice, the Wainwright Building demonstrated not only Sullivan's and Adler's mastery of steel-frame commercial architecture but also Sullivan's personal fondness for elaborate, personalized decorative effects and thus the persistent influence of his base-shaft-capital Beaux Arts training.[36]

Famous for his dictum that "form follows function," Sullivan has often appeared to be a forerunner of the austere modernism that came to dominate architecture in the middle decades of the twentieth century. But Sullivan was anything except a utilitarian. His dictum actually meant, as his chief biographer has paraphrased it, that architecture should be "an emotional synthesis of practical considerations."[37] The operative word here is emotional. Like Whitman, who was little less than a god to Sullivan, the Chicago architect had a mystical, unshakable confidence in the ability of the truly American artist to intuit, absorb, and minister to the needs of democracy. The architect must not be content to design buildings; he had "to vitalize building materials, to animate them with a subjective significance and value, to make them a visible part of the social fabric, to infuse into them the true life of the people, to impart to them the best that is in the people." For the architect was *"a poet who uses not words but building materials as a medium of expression.*[38]

Even though Sullivan worked with the grand assemblage of architects who put together the 1893 Columbian Exposition and designed the striking Transportation Building himself, he disagreed vehemently with the prevailing neoclassicism of the White City. Architectural historians would later see the principal significance of the Exposition in the impetus it gave to city planning and civic beautification enterprises, but Sullivan came to believe that the Chicago spectacle had set back the cause of a progressive, democratic, national architecture many years.[39]

Actually the "Chicago School" continued to flourish for at least another decade; in the mid- and late 1890s Sullivan and Adler executed two of their finest designs: the Guaranty Building in Buffalo, New York, and the Schlesinger-Mayer (later Carson-Pirie-Scott) department store in Chicago. After a subsequent break with Adler, however, Sullivan seemed to lose much of his inspiration and drive. Repeatedly overlooked for the big commissions, he mostly had to content himself with designing a series of splendid small-town bank buildings scattered across the Middle West. He was hardly forgotten in architectural circles, despite the myth of his being a prophet spurned by his own people, which some of his admirers, notably Frank Lloyd Wright, would later tirelessly propagate. Both Sullivan's earlier work and his recent little banks received praise in such conventional publications as the *Architectural Record* and *House and Garden*. And besides Wright, younger men whom Sullivan had influenced in one way or another did impressive and lucrative work from the Middle West to the Pacific Coast.[40]

Sullivan himself, moreover, produced a steady stream of published or publicly delivered exhortations, admonitions, and accusations. Over the years he became increasingly harsh in his judgments on American building. In typically midwestern fashion, Sullivan hated New York, which he called "the plague spot of American architecture," because even in its tall buildings it preferred traditional and therefore decadent styles. Sullivan followed Hippolyte Taine, whom he had read avidly as a young man, in assuming that a people's art directly and reflexively expressed their collective life. That was true most of all in architecture, the most intimately, organically related of all the arts to everyday human existence. To the extent that Americans were content with an architecture of imitation, of the past—a "finished" architecture—they were unfit for democracy. "Whichever way our architecture goes," Sullivan believed, "so will our country go." At present his countrymen tolerated an architecture of "stupor" and "betrayal"; Americans were not yet "American in our thought, but Mediaeval European. And our civilization is not democratic, as we fondly suppose, but utterly feudal through and through."[41]

As was true with Van Wyck Brooks and romantic nationalists generally, Sullivan's writings suggest confusion about whether a people's art was deficient because the people were deficient, or whether the people were deficient because their artists had let them down. But neither Brooks nor Sullivan had any doubt that, as Sullivan said, the artist should be "an interpreter of the national life of his time." As Brooks idealized the messianic hero-critic, Sullivan looked to the hero-architect, the man who would design for democracy—sanely, logically, humanely, according to American needs in his own time.[42]

Whether Frank Lloyd Wright, Sullivan's former pupil and draftsman, might fill such a role seemed the obvious question to many of Sullivan's admirers. For his part, Wright was ready at almost any time after 1900 to inspire a transformation of American architecture, American popular thinking, and American society. Where Sullivan was modest about his own abilities but sometimes overbearing in the cause of a democratic, American architecture, Wright was arrogant and overbearing about both his abilities and his cause. That cause was basically the same for both men, although their architectural interests and inclinations differed significantly. Wright, especially in his early career, was drawn more to suburban residential than to urban commercial building. Wright was in fact consistently antiurban in both thought and practice, whereas Sullivan willingly worked within the environment of the city. His tall buildings emphasized lightness and verticality; Wright's designs commonly featured massive projecting horizontals. Sullivan remained the devoutest of Whitmanians; Wright, though an admirer of Whitman's democratic, robust spirit, admired the vociferous individualism of Thoreau even more.

Neither Sullivan nor Wright had any use for the ways of Europe or the eastern United States. Alongside Sullivan's sneer at New York as a plague spot, one can put Wright's well-known quip that America began west of Buffalo or his 1918 declaration to the Chicago Women's Aid Society that "Chicago is the national capital of the essentially American spirit."[43] Both men were organicists, obsessed with concepts of function, unity, and wholeness in human society as well as in art and nature. Finally, as Alan Gowans has pointed out, neither Sullivan nor Wright was content to let his designs make his statement; each felt compelled to justify on podiums and in print what he had done and to explain its larger significance. And since both men were trying to explain the intuitive, emotional, and instinctual, their efforts, like so much romantic utterance, were characteristically epigrammatic and polemical, often ponderous, abstruse, and confusing.[44]

Wright was thirteen years younger than the man he called "lieber meister" and, unlike Sullivan, a native midwesterner. Enjoying an ex-

panding practice while Sullivan fell on lean times, Wright executed one brilliant residential design after another and also produced such gems as the Larkin Administration Building in Buffalo and Unity Church at Oak Park, the Chicago suburb already dotted with his houses. Prosperous and confident, Wright expounded the interrelatedness of machine processes, the intimate family unit, democratic society, and nature. Here was the basis for an indigenous architecture that would bespeak democracy, "the highest possible expression of the individual as a unit not inconsistent with a harmonious whole." In 1908, writing passionately "In the Cause of Architecture," Wright proclaimed that "The average of human intelligence rises steadily." Ultimately, he argued, "we will have an architecture with richer variety in unity than has ever arisen before. . . ." For Wright, always a regionalist, always sensitive to local climate, materials, and terrain, American architecture must "find expression in more diverse and splendid ways than could be expected in a more narrowly nurtured race." Such a variegated architecture would be America's own contribution to the world's art, "not a servile extraction!"[45]

By 1914, however, with his personal life scandalized by a sensational divorce and with his wealthy Chicago-area clientele turning elsewhere, Wright had come to share much of Sullivan's discouragement and bitterness. In a second "Cause of Architecture" essay Wright again exalted democracy, but now he described democracy as "the highest form of Aristocracy conceivable," a system based not on birth or wealth but on "the honesty and responsibility of the absolute individualist. . . ." "The 'Democracy' of the man in the American street," on the other hand, was "no more than the Gospel of Mediocrity."[46]

Wright never lost faith in the prospect of a democratic architecture based on the principle of variety in unity. Over the next decade and a half, however, he became increasingly self-centered, dogmatic, and elitist as he remained generally out of favor in his own country, even while he was hailed in Europe and Japan as a genius. Wright's eclipse in America was part of the general retreat of Chicago School premodernism before the last great surge of eclecticism, lasting through the 1920s. For the present, eclecticism, the architecture of choice and adaptable style championed by Herbert Croly and other genteel nationalists, was the regnant mode.

Even so, romantic nationalism, intertwined in early twentieth-century architectural thinking with the esthetics of modernist functionalism, remained vocal and discontented. Not only Sullivan and Wright but also a strong contingent of other dissidents continued to push for an architecture integrated into and growing from the American environment, both natural and social. As the Chicago partners and Sulli-

van disciples William G. Purcell and George Elmslie wrote in the *Craftsman,* America had to look not to what it imported but to what it could not import for its architectural inspiration. And even such an established and respected man as Irving K. Pond, president of the American Institute of Architects in 1910–11, was convinced that American designers had to "break away from models of Rome, a slave-making state. . . . We are untrue to our environment when we allow our architectural ideal to be expressed . . . in terms . . . of any other life or civilization than our own."[47]

## VI

In architecture the urgings of people like Sullivan, Wright, or Pond were not enough to reverse the preference for tradition and established style. In American painting and sculpture, by contrast, combined pressure from romantic nationalists on the one hand and technical experimentalists on the other greatly weakened, if not broke, the hold of the Genteel Tradition and academic art.

Romantic insurgents in all the arts were much quicker to proclaim what was wrong with conventional work than they were to set down the specific qualities they wanted to see realized in books, plays, pictures, buildings, or musical compositions. Giles Edgerton, a frequent *Craftsman* essayist, came about as close as anyone to specifying what he and his brethren were looking for when he described the dominant qualities in American painting as a sense of humor and "a very sincere love of nature." Mostly, though, romantic nationalists were as negative as Mencken or Brooks, as nebulous as Sullivan or Wright. Pictorial art, like other forms of expression, was supposed to be robust and organic, "grown out of its own soil, so that it partakes more and more of the nature of the land from which it springs," as the *Craftsman* said in 1909.[48]

Depicting their own land, especially the landscapes and people of the modern American city, was the conscious intent of a small group of insurgent painters centered first in Philadelphia, before the turn of the century, and then in Manhattan. The group's inspiration and informal leader was Robert Henri, a man who, primarily because of his ideas and opinions rather than his own work, was for a generation one of the most influential figures in the American arts.

Tall and lanky, with dark hair and almost oriental facial features, Henri had been born Robert Henry Cozad in 1865 in Cincinnati. He grew up mostly in the Middle West and Colorado, the son of an ex-gambler who became fairly wealthy in land speculation. After the

elder Cozad killed a man in a quarrel in Denver, the family moved back east and the two Cozad sons, at their father's behest, changed their names. Thus Robert Henry Cozad became Robert Earl Henri (pronounced Heń-rye). When Henri determined that he wanted to become a professional painter, he began his preparation at the respected Pennsylvania Academy of Fine Arts in Philadelphia. There he studied mainly with Thomas Anshutz, who had been a student and then a colleague of the powerful realist Thomas Eakins until the academy trustees fired Eakins for using nude models in classes that included both men and women. In some ways Anshutz's methods were even more outré. Dissecting cadavers, for instance, was his way of getting his students to understand bone structure, skin texture, and musculature. Henri's training in the technique of realism was reinforced by avid reading in Walt Whitman and John Ruskin, who influenced him to believe that the artist should work from the familiar materials of his native land.[49]

Henri's realist proclivities stayed with him through several years of study in Paris at the Académie Julian and Écoles des Beaux Arts and then a period of experimentation with impressionism. By the mid-1890s Henri was doing quite well painting and teaching in Philadelphia and had gained admission to the National Academy of Design, which meant that his work would be shown in the formal exhibitions so crucial to painters' careers in that period. Yet he had become increasingly dissatisfied both with impressionism, which he thought too fashionable and conventional, and with the academy system, which in Henri's view excluded much new talent and tended to inhibit that of the artists it admitted.

Although Henri never abandoned the bravura brushwork favored by so many NAD painters, over the next decade his palette became steadily darker and his technique more closely representational. In New York, Henri continued his close association with William Glackens, John Sloan, George Luks, and Everett Shinn, all of whom had studied at the Pennsylvania Academy with Anshutz. Only Henri was a member of the NAD, although the others were fairly well known. Glackens and Sloan, in fact, both received honorable mention for their pictures at the Carnegie International Exhibition in Pittsburgh in 1905.[50]

The group wanted more than just personal recognition. All of them were convinced that the general enterprise of painting in America was held back by the restrictiveness of the academies, especially the jury system and the exhibition privileges enjoyed by academy members. When two of Luks's paintings were turned down for the eighty-second NAD exhibition in 1907, Henri, one of the minority jurors, angrily withdrew his own paintings. After a well-received exhibition at the

National Arts Club the following January, Henri and his cohorts, together with Maurice Prendergast and Ernest Lawson, both polite impressionists, and Arthur B. Davies, who favored dainty nudes set against mystical landscapes, hired the Macbeth Gallery in Manhattan. There in April 1908 "The Eight," as the critics quickly dubbed them, staged a full-fledged "independent" show. Frankly intended as a protest, the Macbeth exhibition served formally to initiate the protracted insurgent campaign against the genteel artistic establishment in America.

In the 1930s leftist writers labeled Henri and his associates the "Ashcan School" in an effort to establish historical continuity between current social-protest realism and the realism of the earlier dissenting artists, who had supposedly "discovered the cruel landscape of America's cities."[51] Ever since the thirties, the Ashcan label has helped perpetuate various mistaken notions about the men who staged the Macbeth show. First of all, the eight were The Eight for only that one occasion, after which they mostly went their separate ways. Luks, Sloan, and Shinn remained close to Henri, but Glackens became more and more of an impressionist and especially a follower of Renoir. Prendergast, Lawson, and Davies had had little in common with the Henri group to begin with except a shared dislike for academy ways.

The second misconception has to do with how and what Henri and his circle painted. He, Sloan, Luks, Shinn, and Glackens were unquestionably realists in 1908, but with their thick applications of oils, their broad brush strokes, and their affinity for rich colors, they were hardly grim realists painting the suffering masses. The term romantic realist more aptly describes both their technique and their social outlook. Henri and the others were fascinated by the people and scenes of Manhattan, and in general they were content to observe and describe without editorializing. Working girls drying their hair on a tenement roof, an early evening crowd flooding out of the subway, a bored woman and her avid escort at a cheap restaurant, wrestlers, street urchins, the interior of a favorite bar—these were the kinds of subjects they chose to put on their canvases. And they painted not a single ashcan. Henri might write Whitmanian rhapsodies to "my people," but Sloan, even though he was a socialist and became one of the *Masses'* outstanding illustrators, later reminisced, "If anything we were snobs about labor." The urban poor appealed to him and the others, said Sloan, because like the rest of urban humanity, "they were interesting as life." Or as Shinn expressed his romance with New York's common people, "they collect in little knots—groups so eloquent in attitude that you can't help but paint them. . . ."[52]

Another erroneous notion is that The Eight horrified the critics, most of whom, so the story goes, either gasped or snarled when con-

fronted with the pictures of the city realists. In fact the critical response to both the National Arts Club and Macbeth showings was generally evenhanded, often quite favorable. It was mostly Henri's fellow academicians, not the critics, who threw around such epithets as "revolutionary black gang" and "apostles of ugliness." Clearly what had happened was that many critics had gotten tired of conventional academic art and were ready to welcome new choices in subject matter, if not daring technical departures. After 1908 the most consistently praised American painting was that of Henri's group, together with the similar work of such romantic realists as Jerome Meyers, Glenn O. Coleman, and particularly George Bellows, who had studied with Henri and like Henri was a native Ohioan. In fact, Bellows, with his rough manners and rugged personal appearance, his affinity for portraying boxers and other vigorous subjects on huge canvases, had convinced some critics that he was the greatest of all American painters by the time he died in 1925.[53]

Bellows proudly accepted election to associate membership in the NAD in 1909 (when he was only twenty-six), and for that matter Henri never formally resigned from the organization. Like Van Wyck Brooks, Henri and Bellows never broke completely with the Genteel Tradition. All the same, the growing notoriety of the city realists made Bellows the leading practitioner and Henri the leading spokesman for a democratic and basically romantic nationalism in the field of painting. Setting himself squarely in the tradition of Whitman, Henri announced that "In this country we have no need of art as a culture; no need of art as a refined and elegant performance. . . . What we do need is art that expresses the *spirit* of the people of today." Before there could be a truly American art, Henri believed, "the men who become the artists must feel within themselves the need of expressing the virile ideas of their country . . . and then, what they paint or compose or write will belong to their own land."[54]

But a new way of thinking about the purposes of art was one thing; a new art was something else. The romantic realists and their supporters remained unconvinced that there was anything they could learn from the cubists, expressionists, fauvists, futurists, and sundry other "schools" of nonrepresentational painting and sculpture in Europe. And they were not happy with efforts such as those of the photographer Alfred Stieglitz to promote the new art in America. When Stieglitz put on a show of Henri Matisse's etchings, sketches, water colors, and lithographs, the *Craftsman* deplored "that sickening malevolent desire to present the nude (especially women) so vulgarized, so hideously at odds with nature, as to suggest . . . the loathsome and the abnormal. . . ." Matisse and the rest of the "ultra-modern French-

men" combined "great gifts with tragically decadent souls." Henri thought that "a fanciful, eccentric technique only hides the matter to be presented and for that reason is not only out of place, but dangerous, wrong."[55]

When Henri wrote that in 1915, the world of American pictorial and sculptural art was being pounded by the first wave of post-impressionist modernism, the effects of which were to weaken the foundations of academic art as well as undermine the popularity of romantic realism. The American encounter with modernism was the result of two major developments: the sensational Armory Show of 1913 and the unflagging labors of Alfred Stieglitz and the small group of painters and patrons around him.

## VII

The Armory Show was the work of a group of artists who in 1911, under the leadership of Jerome Meyers and Walt Kuhn, had formed the Association of American Painters and Sculptors to bring attention to "progressive and live painters, both American and foreign." Early the next year Arthur B. Davies, one of The Eight a few years earlier but now increasingly drawn to the new European work, became president of the AAPS. He and Kuhn determined that the organization's first exhibition should exemplify the finest contemporary art from both the United States and abroad. For the rest of the year the two men traveled over western Europe, securing objects on loan from collectors, dealers, and in some cases artists themselves. At home, meanwhile, other AAPS members brought together about twice as many contributions from American artists, including a substantial representation of the work of the city realists.[56]

On February 17, 1913, the International Exhibition of Modern Art, containing about thirteen hundred separate pieces by some three hundred artists, opened at the Sixty-ninth Regiment Armory at Lexington Avenue and 25th Street in Manhattan. The popular response was slow in coming, but the critical reaction was immediate and pronounced. Whereas the art columnists for the New York newspapers and the genteel magazines had received the Macbeth and other displays of nonacademic realism with equanimity, most of them were shocked and dismayed by a great deal of what greeted them at the Armory Show. Nearly all the American and much of the European work was fairly conventional. Attention focused, however, on the contributions of such European avant-gardists as Matisse, Auguste Rodin, Paul Cézanne, Pablo Picasso, Georges Braque, André Dérain, and

Francis Picabia. Marcel Duchamp's cubistic *Nude Descending a Staircase* particularly outraged both those who were used to idealizations of the female figure and those who, drawn by the wild publicity, expected something erotic.

Ultimately the Armory Show, in New York and on tour, exposed some three hundred thousand Americans to a kind of art only a few of them had known about before 1913. It would be a vast exaggeration to say that the majority of those who took in the Armory Show were suddenly converted to new concepts of visual experience. Yet the exhibition did help make artistic taste a more personal and less official matter, diminish the prestige associated with collecting masterpieces, and establish a steadily widening public tolerance of modernism.[57] To genteel critics like Royal Cortissoz, all this amounted to a disaster for "honest workmanship and spiritualized art. . . ." What had happened, according to Cortissoz, was an invasion of America by the immigrant art of Ellis Island. George Luks and Everett Shinn were so unhappy that they quickly resigned from the AAPS, which broke up completely in 1914. Jerome Meyers later lamented that Davies and the other organizers of the exhibition had "unlocked the door to foreign art and thrown the key away. Our land of opportunity was thrown wide open to foreign art, unrestricted and triumphant; more than ever before, our great country had become a colony. . . ."[58]

Meyers was being melodramatic. The ironic truth, though, was that a display of contemporary international painting and sculpture, staged mainly to gain wider public acceptance for the newer American work, actually served to increase still further the American demand for European visual art. To a considerable extent the American market was back where it had been in the late nineteenth century, except that now a new group of collectors began spending large sums on the products of the European avant-garde. For the next thirty years, until after the Second World War, the preference for European over American painting and sculpture would persist.[59]

Beyond that, the Armory Show, more than any other single event, established visual modernism in the United States. Aside from radical departures in form and technique, modernism usually suggested a basic change in both social and esthetic assumptions. Most of all modernism meant a repudiation of convention and continuity. In the United States, and in Great Britain as well, that meant a break with both the Genteel Tradition and major elements of the romantic nationalist outlook. Both genteel traditionalists and romantic nationalists had assumed that the creative artist should have a central role in effecting desired changes in the general society—whether moral uplift and spiritual refinement, the winning of intellectual and cultural

independence, the realization of personal and national fulfillment, or the progressive increase of human happiness. The artist was supposed to acknowledge and willingly take on his larger responsibilities; in discharging those responsibilities he could never afford to lose contact with his public. Thus his art must remain recognizable and understandable.

Modernism, preoccupied with technique and idiosyncratic statement, relieved the creative individual of any obligation to make himself understood. Thus the burden of communication was shifted from artist to audience, whereas traditionally artist and audience had at least shared that burden. Now the audience—readers, viewers, listeners—had to take upon itself the task of understanding. The essence of modernism, in Milton Brown's words, was "its arrogant disregard for the public and its militant exaltation of the artist as a genius above the judgment of the philistine mass. . . ."[60]

The audience's task became all the harder because it was continually encountering the unfamiliar—kinds of art that seemed unconnected to anything that had come before (even if that was usually not the case). Avant-gardists thought of themselves quite literally as pioneers, and like pioneers, when they seemed threatened with domestication by more conventional people, they were ready to push still further into the artistic wilderness. So the avant-gardist moved restlessly from innovation to innovation, briefly eluding critical understanding and sometimes hopelessly outdistancing the public. The question of the collective role and responsibility of the artist—to nation, to cause, or to anything but himself and his fellow creators—came to seem a nagging distraction from the work at hand.

One American perfectly at ease with the implications of modernism was Alfred Stieglitz. Even though he refused to involve himself with the Armory Show, out of a dislike for big, general exhibitions, Stieglitz and his associates were the principal beneficiaries of the awareness of modernism it prompted. Stieglitz was born of well-fixed German Jewish parents at Hoboken, New Jersey, in 1864. Though older than most of the participants in the intellectual and artistic Rebellion of the pre-1917 period, Stieglitz exemplified one of its most sociologically significant features: the growing prominence in American ideas and art of non-Anglo-Saxons, including substantial numbers of Jews. Stieglitz was also typical of the Rebellion in that he was preeminently a New Yorker at a time when Manhattan was coming to dominate the nation's cultural life.[61]

Stieglitz attended not one of the older eastern colleges but the City College of New York, after which he studied engineering, chemistry, and photography in Berlin. In the decade following his return to the

United States in 1890, Stieglitz became perhaps the country's most imaginative and forceful photographer. Going against the preference of the period for pastoral settings and blurry, luminous effects intended to achieve photographic equivalents of impressionist paintings, Stieglitz produced sharp, often stark images of the industrial landscape, the modern city, and ordinary people doing ordinary things. In fact, much of Stieglitz's photography around the turn of the century was closely analogous to what Henri and the city realists were doing with oils and brush. Years later Stieglitz remarked that in this early period, "I was endeavoring to find a place in my country, to find a job for which I was fitted amongst my own people." He loved America, he said, as "those who love wish to free what they love."[62]

One of Stieglitz's two major life goals was to see photography become an independent medium, a fully expressive and creative art. Largely because of his promotion of his own work and that of likeminded photographers such as Eduard Steichen, Clarence White, and Paul Strand in his magazines and galleries, still photography had evolved into that independent art form by the time Stieglitz died in 1946. His other major goal was to bring about the realization of a level of artistic achievement in the United States equal to that of contemporary Europe. Despite or maybe because of the similarity in mood and subject between Stieglitz's photographs and the work of the city realists, his instincts and enthusiasms in painting and sculpture were with the experimental, largely nonrepresentational art of the avant-garde. "Since Stieglitz knew what photography was," one admiring historian has remarked, "he knew quite naturally what painting was not."[63]

For Stieglitz as much as for any academician or genteel critic, Europe provided the measure of quality. But for Stieglitz it was not Europe's historic masterworks by which American accomplishments should be judged but the finest art currently being produced on the Continent. As Herbert Croly urged the exposure of Americans to examples of traditional artistic excellence, Stieglitz undertook to insure that his countrymen, or at least those who were intelligent and sensitive enough to understand it, had access to the work of the avant-garde. "Stieglitz' ambition," Barbara Rose has said, "was to defeat the provincialism of American art by uniting it to the mainstream of Western art—without, however, sacrificing its distinctively American qualities."[64]

Stieglitz was a striking figure—a slender man with a bushy moustache, bushier hair, and piercing eyes only slightly masked by steel-rimmed spectacles. By nearly all accounts, he was dogmatic, pompous, arrogant, and uncompromising—but also devoutly loyal to the people he believed in. Like Frank Lloyd Wright, another monumental egotist, Stieglitz

took as his principal American hero Henry David Thoreau. And like H. L. Mencken (and eventually Wright as well), Stieglitz had little faith in the capacity of the masses for rational understanding or informed judgment. Even the elite that might be able to comprehend the new concepts and forms in art had to be reinvigorated after decades of atrophying academism. In 1913 he complained to Gertrude Stein that in the United States art "is still considered a great luxury; something which is really not necessary." For Americans, he said three years later, art "is the equivalent in society to what the appendix is to the human body."[65]

Stieglitz had no patience with people who did not share his vision of an America liberated from nineteenth-century conventions in both art and personal behavior and led in the new century by its own native avant-garde. In 1902, fed up with what he saw as hopeless conservatism in the Camera Club of New York, he resigned from the Club and the editorship of the Club's *Camera Notes*. Soon he, Steichen, White, and a few others founded their own group called Photo-Secession, and the next year Stieglitz began publishing *Camera Work*, a big, beautifully designed magazine which appeared irregularly in a total of fifty issues over the next fourteen years. In 1905 Stieglitz turned his studio at 291 Fifth Avenue into the Little Galleries of the Photo-Secession.

Within the intimate confines of "291," as his gallery was commonly known, Stieglitz exhibited an increasing amount of advanced European visual art by such men as Rodin, Matisse, Picasso, and Constantin Brancusi. Eventually he began showing the work of a succession of previously little-known American painters, each of whom, in his own highly individualized way, helped to found an American style of expressionism. First Alfred Maurer, John Marin, and Marsden Hartley, then Arthur Dove and Max Weber, and finally Georgia O'Keeffe received their first one-man showings at "291." These artists constituted the basic group whose work Stieglitz zealously pushed and whose careers he nurtured and to some extent protected. In turn they accepted Stieglitz as their patriarch and made "291" the focus of their professional lives. Mainly because of Stieglitz's efforts, each of them gained substantial prominence; Marin as well as O'Keeffe, who became Stieglitz's second wife, came to be recognized as commanding figures in twentieth-century American painting.

At "291" and in *Camera Work*, Stieglitz and his modernist associates carried on a none-too-friendly rivalry with Henri and the city realists, whose main booster was the *Craftsman*. While romantic nationalists in the *Craftsman* called for heroic efforts by artists to portray the American democratic spirit, *Camera Work* spokesmen complained about America's spiritual desolation and declared that "Stupidity and Vul-

garity, thy name is America!"[66] What the *Camera Work* and *Craftsman* groups had in common was their detestation of what they understood as Puritanism, their contempt for academism, and their profound unhappiness with the presumed isolation of the creative individual in America and the lack of connection between art and life.

In March 1916 Dove, Hartley, Maurer, and Marin participated in a highly successful exhibition of seventeen American modernists, sponsored by *Forum* magazine and warmly supported by Stieglitz. Henri was willing to serve with Stieglitz on the jury for the *Forum* show. And in 1917 Henri, Sloan, Glackens, and a number of other realists, together with several of the "291" modernists and a group of recently arrived European exponents of the absurdist art called Dada, organized the Society of Independent Artists. Under the banner "no jury, no prizes," the SIA that same year staged an exhibition of twenty-five hundred works by thirteen hundred artists, both European and American. The 1917 SIA show, a vast cross-section of just about every kind of nonacademic painting and sculpture extant, seemed to portend a coalition of "progressive" American artists, a unified front against the academies and in support of an art that was European-influenced, perhaps, but nonetheless predominantly native and independent.

Nothing like that happened, though. Marcel Duchamp withdrew from the SIA when President Glackens and the rest of the leadership banned a urinal he wanted to exhibit as *Fountain* under the name "R. Mutt." Soon the rest of the incorrigible Dadaists followed. Henri was displeased with much of what did get exhibited and let it be known that he thought some of the members had gone too far. Before long most of the modernists had left the SIA, which carried on into the twenties with the realists, by this time frequently labeled "conservatives," in firm control.[67]

Despite signs of cooperation in the *Forum* and SIA shows, the artistic dichotomy personified in Henri and Stieglitz persisted through the First World War, the twenties, and into the thirties. Realism never completely lost contact with romantic nationalism and the tradition of the Ashcan School. Later American modernism, by contrast, would lack the messianic, essentially nationalistic quality Stieglitz brought to his work at "291." Stieglitz himself gave up on *Camera Work* in the summer of 1917 with the magazine losing subscribers and hopelessly behind in its publication schedule. That same summer he closed the "291" gallery. The year before, Gustave Stickley had also stopped publishing the *Craftsman*. Already the city realists had become virtually unidentifiable as a group; in the years to come they would paint less of the city and more still lifes and portraits. Thus the first sharp clash between realism and modernism in American visual art

was about over by 1917. One thing seemed certain: academic art, the mutual enemy of both realists and modernists, of both democratic nationalists and avant-gardists, would never again be able to dominate painting and sculpture.

## VIII

American music in the pre–World War I years involved three major categories of taste and opinion: romantic traditionalism, exemplified in the compositions of Edward MacDowell; the romantic nationalism of composers like Arthur Farwell and Henry F. B. Gilbert; and, although its existence was acknowledged only grudgingly, the variegated offerings of commercial popular music.

From the perspective of the late twentieth century, one of the most vital and fascinating features of the American musical landscape around 1900 was the emergence of ragtime. To its leading practitioner and even to some musical critics, that kind of popular music seemed to have a potential for becoming something bigger and more "serious" than mere entertainment. Ragtime was preeminently piano music, although it could be and often was scored for performance by bands and small orchestras. Characterized by clever syncopation, or "ragging," and complex yet distinct rhythms, ragtime was written mainly by performing black musicians. Developing in the dance halls and saloons of Chicago, St. Louis, Kansas City, and other mid-American centers, ragtime was a formally composed music that was influenced by band marches, polkas, European salon and waltz melodies, the cakewalks and "coon songs" of the blackface minstrel shows, and a variety of other sources.[68]

Ragtime had already gained national popularity by the time Scott Joplin, a thirty-year-old native of Texarkana, Texas, then living in Sedalia, Missouri, published *Maple Leaf Rag* in 1899. Joplin's composition was a huge commercial success and became the best known of all ragtime pieces. It made a Sedalia music dealer named John Stilwell Stark the country's leading ragtime publisher and launched Joplin on a prolific and profitable career as a popular composer. Other men like Louis Chauvin, James Scott, and Joseph Lamb also became major figures in ragtime. Joplin, though, produced the largest body of work that was both popular in its time and admired by musicologists and musical historians later on.

Being a successful composer of popular music was not enough for Joplin. His career closely coincided with what was probably the most intensely racist period in the nation's history, a time when black

Americans everywhere, especially in the southern states where most of them lived, were steadily losing ground in their long struggle for full citizenship. It was during these same years that white composers and critics were debating Antonin Dvořák's contentions that a genuinely American formal music could be developed by turning to black spirituals as well as other "music of the people." Whether Joplin knew Dvořák's writings or was even familiar with his *New World Symphony* is not known. He must have been generally aware of the bustling controversy over whether and how an American national music would develop. Joplin was a product of both the half-hidden black musical world and, as a fairly well-grounded if mostly self-educated musician, of the genteel musical environment of the late nineteenth century. While he never stopped writing popular rags, he was intent on disproving the stereotype of the untutored, instinctively musical black person—the happy primitive possessed of "natural rhythm." He would try, in fact, to make his own ragtime the basis for a full-fledged, natively American "art" music.

As early as 1903 Joplin wrote the first of his two "ragtime operas," *A Guest of Honor*. Never published, the composition was performed only once, in St. Louis, after which Joplin apparently lost the manuscript. Eight years later in New York, Joplin wrote *Treemonisha*. Published at his own expense, the work was set in southwestern Arkansas in the 1880s and depicted a young black woman who helps her people overcome their superstitions and strive for a better life. *Treemonisha* had only one performance, in Harlem in 1915, with Joplin himself at the piano to provide the sole instrumental accompaniment. Incorporating ragtime and climaxing with the singing and dancing of "A Real Slow Drag," *Treemonisha* may indeed have been "the first demonstrably great American opera," one that combined a genuine American idiom with conventional operatic forms.[69] Certainly it had more substance than such contemporary American operatic efforts as Frederick Converse's *The Pipe of Desire* (1910), the first native opera to be performed at the Metropolitan Opera House, or Horatio Parker's *Mona* (1912).

Evidently the critics' refusal to take notice of *Treemonisha* was too much for Joplin, who had focused his whole existence on writing a great American opera from American materials. Both his mind and his physical condition began to fail rapidly; two years later he was dead. Virtually forgotten for a half century, *Treemonisha* was finally revived in Atlanta in 1972, this time with widespread publicity and critical acclaim.

By the time Joplin died, ragtime itself was about finished. Since the 1890s it had been the main influence at work in American popular music, and in fact the term "ragtime" had come to be generic for

most of what was produced by the New York popular publishing firms. Irving Berlin's tuneful "Alexander's Ragtime Band," which had no musical connection with ragtime at all, was a good example of the kind of exploitation that had steadily subverted the original form. At the other extreme, the European postromanticists Claude Debussy and Igor Stravinsky had experimented with elements of ragtime in some of their compositions.

Most American formal musicians and musical critics, still planted firmly in the Genteel Tradition, disdained both ragtime and pseudo-ragtime. A few, though, looked closely at the music and found promising signs. Probably the earliest critical appreciation of ragtime was written in 1899 by Rupert Hughes, later a prominent journalist and biographer but then just finishing his M.A. degree at Yale. Unlike most whites, Hughes recognized that ragtime was basically black music. He disagreed with Dvořák that an American national music could ever base itself on spirituals and slave songs, because, "after all, to the average American the music of the slaves is almost as curious and as foreign as [that of] the Egyptian. . . ." Ragtime, on the other hand, was something which could be taken on its own terms, a music that was "young, and unhackneyed, and throbbing with life." Destined "to be handled with respect, not only by a learning body of negro creators, but by the scholarly musicians of the whole world," ragtime had "come to stay. . . ."[70]

For all his astuteness about the origins of ragtime, Hughes proved a poor prophet. Within ten years original ragtime had become thoroughly hackneyed and denatured. Later admirers of "ragtime" were generally unable to distinguish between actual ragtime and the torrent of music accompanying the current social dance craze, or even the popular blues songs written by W. C. Handy. Ignoring Joplin and the other major ragtime composers, such writers as Hiram K. Moderwell and Carl Van Vechten praised the pseudoragtime of popular dance music and the songs of Berlin or Louis A. Hirsch as "the soul of the epoch," the "folk-music of the American city," "the beginnings of American music," and "the only music produced in America today which is worth the paper it is written on." Moderwell thought "ragtime" embodied the "jerk and rattle" of American life, a national personality trait no European-derived music could possibly capture. Van Vechten was convinced that if American formal composers would give themselves over to "the rhythms and tunes that dominate the hearts of the people," then "a new form would evolve which might prove to be the child of the Great American Composer. . . ."[71]

The usual counter to such panegyrics was either to blast, as did Charles Buchanan, "the totally erroneous assumption that great art finds its inspiration in the soil of a nation and amongst a nation's

people," or to attack popular music itself. "Ragtime" according to Professor Daniel Gregory Mason of Columbia University, was "a meaningless stirabout, a commotion without purpose, an epilepsy simulating controlled muscular action."[72] Such upholders of traditional musical standards overlooked a much more significant matter: the increasing tendency of expansive critics to confuse folk culture, which was supposed to be "primitive," "spontaneous," and expressive of "the people," with commercial popular culture—manufactured and formularized yet at the same time all-consuming in its appetite for what was novel, if not new.

Admittedly the line between the two would become less and less discernible as the century progressed. Yet alongside the common confusion of ragtime and other kinds of commercial popular music with folk music was a growing scholarly effort to identify and define authentic American musical folk expressions. As early as 1867 the publication of a volume of *Negro Slave Songs of the United States* had precipitated an endless controversy over whether the music of the slaves was primarily of African origin, modified by contact with European influences in America, or the result of the adaptation of Western music to the needs and uses of blacks. By the first decade of the twentieth century, folk-song study was in a flourishing condition. Some of the landmarks in American folk-song collecting date from the period before the First World War, including John A. Lomax's *Cowboy Songs and Other Frontier Ballads,* Henry E. Krehbiel's *Afro-American Folksongs,* and Cecil Sharp's *English Folk Songs from the Southern Appalachians.*[73] Meanwhile there appeared a spate of collections of American Indian tribal music, paralleling both an "Indian intermezzo" fad in popular songwriting and the exploitation of Indian chants and melodies by MacDowell and various other composers.[74]

In the face of all this accumulation of native materials—from Indian, black, and white sources—there seemed less excuse than ever for bemoaning the lack of authentic folk inspiration for American formal music. Presumably American composers also had less excuse for not producing original, indigenous American compositions. That was the conviction of the Boston-bred, MacDowell-trained Henry F. B. Gilbert. Gilbert acknowledged that in the order of development of a civilization's arts, music usually came last, and that imitation always preceded creation. But the time for imitation was over. Instead of drawing on their own history and folk sources and "the exultant life of America throbbing vigorously about them," American composers still turned to Europe not only for their technique, which was all right, but also for their ideals of beauty, which was fatally wrong. "While music is quite universal in its appeal," Gilbert wrote, "it is not universal in its ex-

pressive power but in some esoteric manner reflects that particular racial spirit of which its individual composer is a fragment and as it were a mouthpiece."[75]

Gilbert himself drew on a variety of "racial" sources—Indian, black, Louisiana creole, even Latin American. One of his compositions was a set of three *American Dances in Ragtime Rhythm*. Moreover, Gilbert was a strong ally of the period's outstanding promoter of an American national music, Arthur George Farwell.

Farwell was born in St. Paul, Minnesota, in 1872, the son of parents who were both native New Englanders. Although Farwell took a degree in engineering from the Massachusetts Institute of Technology, his real objective was to become a composing musician. After six years of music study in Berlin and Paris, Farwell returned to the United States to confront what he later exaggeratedly described as "the non-existence of the American composer in the American social scheme." He soon found that while he could make a decent living as a performing pianist or as a teacher, lecturer, and writer, "composing was expected from others," namely Europeans. "I was just plain mad," he related to a friend, "and I vowed I would change the United States in this respect. I was not willing to live in a country that would not accept my calling." In 1901, after finishing a series of lectures at Cornell University, Farwell moved to Newton Center, Massachusetts, his family's ancestral home. There he founded a publishing firm called the Wa-Wan Press, taking the name from an Omaha tribal ceremony that spoke of "peace, fellowship and song." His goal was to publish only the works of American composers and thereby lead "a progressive movement for American music, including a definite acceptance of Dvořák's challenge to go after our folk music."[76]

During the eleven years of its existence, the Wa-Wan Press published original music by thirty-seven different American composers, headed by Gilbert, who early became Farwell's close if informal associate. Farwell said that there were two major elements in his scheme: to publish American work in general, all that showed "progress along any of the parts of musical tradition," and in particular to provide an outlet for "all interesting and worthwhile work done with American folk-material as a basis."[77]

Farwell himself was much caught up in the Indianist enthusiasm. He wrote a number of compositions incorporating melodies and rhythms borrowed particularly from Alice C. Fletcher's collection of North American Indian music. Yet the music of the tribes was only a part of America's inexhaustible resource in folk song, which also included the contributions of Negroes, cowboys, woodsmen, mountaineers, sailors, and creoles, as well as the "ragtime" of the day. All

of this the American composer could work with, in his own country and his own time. Ultimately a truly American music would emerge, one that featured "the spontaneous introduction of national spirit into music through the independent musical thought of our composers."[78]

Farwell always vigorously denied that he was trying to promote any special kind of music or that he was a cultural jingoist. He was, he said, only upholding "the composer's perfect moral and artistic right to use native folk songs . . . if he wishes."[79] Farwell's tastes were expansive and eclectic, if his own music was not. A distinctly minor and conventional composer, he never really moved outside the well-worn grooves of nineteenth-century German, and to some extent French, romanticism. While his melodies were often appealing, students of his music find it generally deficient in harmony, perhaps because he took up music full time relatively late.[80]

Farwell's main achievement was the publicity he brought to the cause of the American composer and American music. Trying in 1903 to interest composers in the Wa-Wan Press, Farwell called for a music that "will not be a mere echo of other lands and times, but shall have a vital meaning for us, in our circumstances, here and now." As Stephen Foster had done in the previous century with his simple songs, America's contemporary "composers of culture" must "come close to the people. . . . Music which most directly touches America must rise up from our own soil." Or as he exhorted a colleague in 1907, "Our life, our home, is here."[81]

In that year Farwell and his nationalist campaign were both at their peak. His newly founded Wa-Wan Society claimed to have musical centers operating in six different cities. The Wa-Wan Press was publishing both a monthly volume of new music and a monthly magazine. Farwell was always plagued by money troubles, though. His magazine, merged in 1908 with the *Bulletin* of the American Music Society of Boston, soon disappeared altogether; and the Press's volumes of American compositions came out less and less regularly until 1912, when Farwell sold his copyrights to a New York company and closed the Wa-Wan Press.

Farwell spent the next several years working with New York City's municipal music program and as a staff writer for the monthly *Musical America*. Besides coauthoring a major statement of the romantic nationalist position in Daniel Gregory Mason's "Art of Music" series, Farwell continued to write music and became especially active in the community pageant movement in the immediate pre–World War I years.[82] After the war he taught on the West Coast and at Michigan State College, worked with local music societies, and wrote occasional essays on his favorite theme—the relationship between folk song and

a nation's formal music. But the currents of twentieth-century music had already moved far beyond him. By the time he died in New York in 1951, both his romantic music and his romantic nationalist esthetics were long out of date.

## IX

If Farwell was preeminently the composer as public man—as promoter and propagandist—then Charles Edward Ives epitomized the intensely private artist who worked mainly for his own satisfactions, apparently uninterested in promoting either his own work or the cause of American music. Yet while Farwell had been all but forgotten many years before his death, Ives lived to see himself lauded as one of the handful of major composers the United States has produced.

Like Louis Sullivan, Frank Lloyd Wright, and to some extent Alfred Stieglitz, Ives was both a philosophical romanticist and a technical modernist. Like romantic nationalists in general, Ives apotheosized American democracy. And for Ives, as for Sullivan, Wright, and Robert Henri, democracy was not primarily a system of politics and government but a collective spiritual condition.

Born in Danbury, Connecticut, in 1874, Ives grew up under the musical tutelage of his father, a robust bandmaster and teacher. He early showed an affinity for what were then—and to many people still are—peculiar musical effects. At the age of twenty, for example, he composed a piece for voice, cornet, trombone, and organ, each to be performed in a different key. At Yale College, however, Ives turned out proper compositions for his major professor, Horatio Parker, and dutifully earned his degree in 1898. But since he was interested neither in composing the conventional music that would make him a living nor in starving while he wrote what he wanted to, Ives went into the life insurance business, eventually becoming a partner in a highly successful Hartford firm.[83]

Composing in whatever time he could manage away from his business affairs, Ives produced some of the most difficult compositions ever written. His music actually seemed unplayable to musicians early in the century. Most of his major pieces were not performed until anywhere from twenty to fifty years after they were written. His *Fourth Symphony*, for example, finished in 1916, had its first complete performance in 1965, eleven years after Ives's death. Somewhat before and completely independent of Europeans like Stravinsky and Schoenberg, Ives developed dissonances, polytonalities, atonalities, and various other strange and striking musical inventions.[84]

Yet for all the esoteric technical qualities in his music, Ives went as much as any American composer to the materials of his own country. Especially in his early career, Ives grounded his works in the life of his native New England. His Second ("Concord") Sonata, for example, consisted of four movements entitled "Emerson," "Hawthorne," "the Alcotts," and "Thoreau." In such compositions as the First Piano Sonata, *Three Harvest Home Chorales,* a symphony he called *Holidays,* and another he called *Three Places in New England,* Ives tried to capture the moods, sounds, even the sights and smells of the small towns and countrysides of his boyhood and the visits he had made as a youth to his region's historic sites. He quoted extensively from popular songs, revival-meeting hymns, band music remembered from patriotic holidays and circus parades. His *General William Booth Enters Heaven,* usually done with solo voice and piano but originally written for voice and brass band, was based on an old Salvation Army hymn and took its words from Vachel Lindsay's poem.

Ives did not worry about whether his materials were authentically or synthetically folk, as long as they were American and bespoke what he believed to be the ethos of democracy. He remained content to write his own abstruse music, not even bothering to copyright his works and, when they began to be performed occasionally starting in the 1920s, refusing to accept royalties. For Ives there were no formulas, no specific elements such as Negro spirituals or Indian melodies, that made it possible to capture the American spirit in music. What was important was substance, not manner. With Whitman, Ives believed that in understanding and expressing the democratic spirit of the nation— in being "true to none but the highest of American ideals"—the artist would also speak universally.[85]

Ives's music remained unknown to more than a few of his countrymen. His ideas and work were thus of no use to the revolt against convention and tradition, in music and in the other arts, during the pre–World War I years. Ives's rebellion was uniquely his own, an unself-conscious insistence on writing what he alone heard.

Farwell and Gilbert, on the other hand, rebelled against European domination and quite self-consciously sought to compose and inspire others to compose a distinctly American music. But they lacked the imagination and daring to throw off the concepts and methods of European romanticism. Scott Joplin had the imagination and daring to try to base opera in its conventional form on his own ragtime inventions, but as a black man with a background as a popular musician, he was unable to get the critics' attention. By the time the United States entered the European war in 1917, also the year of Joplin's death, a new kind of basically black music was in the offing, one des-

tined, like ragtime, both to be confused with popular music in general and to prompt visions of a great national musical art built on its foundations. The first age of jazz, however, was still a few years into the future.

<div align="center">

X

</div>

In 1916 Paul Rosenfeld, one of the young intellectual rebels writing for the new *Seven Arts* magazine, declared that American music's "fatal shortcoming" was "its utter innocence of any vital relationship to the community."[86] That was, of course, essentially what Van Wyck Brooks had been saying about American literature, Wright and Sullivan about architecture, Henri about painting, Gilbert and Farwell about music. All of them fretted endlessly over the absence of an organic interplay between art and people's actual lives. To a considerable number of people in the arts in the period after 1900, including Farwell, it seemed that at least a partial remedy for the hiatus between art and everyday life lay in the promotion of community pageants, grand theatrical spectacles combining original, American-written music and drama.

Usually performed outdoors, planned, organized, and rendered in particular localities, made up of substantial numbers of local people, and commonly based on the history of a particular place or region, pageants would be a way to give popular meaning to an art that had long lagged in the United States. The country already had excellent playhouses, sumptuous productions of European dramatic masterpieces, and well-paid performers, as well as an abundant annual crop of ephemeral comedies and melodramas by native playwrights. But even plays of substance were virtually monopolized by the New York theatrical syndicates. Pageants were an alternative to plays written, as Farwell indignantly put it, "to lure the dollars out of the pockets of a jaded, neurotic and sensation-hunting throng in a garish Broadway theater." The pageant was "a drama of which the place is the hero and its history is the plot."[87]

For the most part drama in America had followed the general historical trend in the Western countries—from outdoor to indoor theater, from community gatherings to paying audiences, and from an emphasis on size and spectacle to an emphasis on plot and character. The years after 1900 brought a determined effort to regenerate and restore the dramatic pageant to something approximating the central importance it had had in medieval society and continued to have, albeit nearly always as a religious observance, in the predominantly Roman Catholic countries of Europe and Latin America. Nothing better illustrated the

strongly democratic element in the resurgent cultural nationalism of
the period than the pageant movement. Pageant enthusiasts aimed to
bring the art of drama directly to the American people, and to enlist as
well as edify them. The growing interest in pageantry, Mary Fanton
Roberts of the *Craftsman* wrote in 1909, was the great hope for a
"Drama of Democracy." Brought to their highest development, pageants
would "so embody the history of the country, the quality of our civiliza-
tion, the impulse of the people toward art and the right artistic expres-
sion as to offer us the real beginning of a national drama. . . ." And to
Randolph Bourne, a bright young critic for the *Seven Arts* and the *New
Republic,* the spread of the pageant movement was convincing evidence
"that a new social art [is] in the American world, something genuinely
and excitingly new."[88]

Thomas H. Dickinson, surveying the American dramatic situation in
1915, proclaimed that what ten years earlier had been an "obsolete
ceremonial" had now "woven itself into the fabric of society." Dickin-
son dated the renascence of pageantry in the United States to the out-
door spectacle honoring August Saint-Gaudens, staged at the esteemed
sculptor's estate near Cornish, New Hampshire, in 1905.[89] The Saint-
Gaudens pageant brought into prominence thirty-year-old Percy Mac-
Kaye, who both coauthored and appeared in the drama. Over the next
several years MacKaye became the outstanding figure—as writer, direc-
tor, producer, and promoter—in the American pageant movement.

Percy MacKaye was the son of Steele MacKaye, one of the leading
actors of the post–Civil War period as well as a theatrical producer
and manager and founder of the country's first school of acting. Percy
MacKaye finished his A.B. at Harvard in 1897. Like his father, Percy
MacKaye conceived of the drama as ideally a great public art, acces-
sible and accommodative to mass audiences. A fervent democrat, a
devout believer in the uniqueness of the American experience and a
superior American collective morality derived from the historic inti-
macy between the people and their natural environment, MacKaye
wanted to get drama back to its original function as communal ex-
pression. What made current America drama so insubstantial and
inconsequential, he thought, was not only its obsessive commercialism
but also its centralization in New York and thus its remoteness from
the overwhelming number of Americans.[90]

First in his plays—the superb romantic dramas *The Scarecrow* (1907)
and *Yankee Fantasies* (1912)—MacKaye went to New England history
and folklore for his materials. Later in his career he exploited the same
kind of materials from southern Appalachia for *This Fine-Pretty
World* (1923) and *Kentucky Mountain Fantasies* (1928). In such
plays MacKaye intended, as he said in 1907, "to interpret our Ameri-

can people to themselves in terms of all time, to illumine and body
forth our own life in perennial symbols of power and beauty."[91]
MacKaye was striving for an equivalent in the dramatic arts to what
Whitman, Sullivan, Wright, Henri, and Ives had sought in their
respective art forms—to bespeak the universal in the particular, to
suggest what was common in mankind by focusing on what was char-
acteristically American.

It was in outdoor drama, though, that MacKaye had his major suc-
cesses. Between 1914 and 1920 he organized, produced, and wrote the
script for seven separate community dramatic projects. The biggest
and most publicized was *Saint Louis: A Masque of American Civiliza-
tion,* held in the late spring of 1914 with a cast of some seventy-five
hundred. That spectacle's five performances drew an estimated half-
million people. Two years later, at the request of U.S. Immigration
Commissioner Frederick C. Howe, MacKaye also wrote *The New
Citizenship: A Civic Ritual,* first performed at the City College of New
York Stadium on Independence Day, 1916.[92]

Meanwhile MacKaye published books and gave lectures extolling
outdoor community drama as "the ritual of democratic religion" and
proclaiming that "The use of a nation's leisure time is the test of its
civilization." MacKaye predicted that the spreading enthusiasm for
community drama would "redeem our agricultural communities, sub-
stituting for languor, social decay, alcoholism, morbidity, and joyless
individualism, the cooperative joys of festival, and pageantry—the
imaginative ritual of play."[93]

For all his trumpeting of an art democratized and localized, Mac-
Kaye shared a good deal of the elitism and academism of the Genteel
Tradition. The American theater should be a "civic agency" in the
tradition of the civic drama of ancient Greece, "an agency of guidance
and liberation to the people." It was the duty of the creative artist to
give the public what was best, *"not merely what the people may sup-
pose to be best."* Thus in art as in government, the country had to
have experts to guide taste and judgment. "In the arts, these experts
are called *Artists;* in the state, Representatives." The kinship of the
artist and the statesman was obvious to MacKaye; both were "children
of the Commonweal. And the noblest function of democracy is to bear
sons who shall excellently express—for their countless brothers that
are dumb and incapable—the excellent beauty of their common
mother."[94]

What MacKaye wanted in the way of a democratic dramatic art
depended, he argued, on public endowment of "a civic theatre for
the people" in every sizable American city. Ironically, in a period of
revolt against the conventions of institutionalized art, MacKaye fa-

vored a national system of jury selection by "master craftsmen," who would make awards to playwrights for the artistic quality of their work, not its commercial appeal. No longer worried about whether their plays would make money, dramatists would be free to guide instead of having to cater to public taste. The result would be to erase the dichotomy between art and democracy and thereby realize in full "the renascence which already lives and throbs to be born."[95]

MacKaye's grand vision never wholly came to pass, although he himself would enjoy a long career as playwright, professor, and folklore researcher. After the war the pageant movement generated considerably less enthusiasm than it had before 1917, when even Greenwich Village's radical intellectuals and artists had organized and presented a pageant on the theme of social revolution to raise money for striking textile workers at Paterson, New Jersey.[96] To be sure, community pageants have continued to figure in the American theater situation, and some of them have turned into popular summer tourist attractions. But the great promise pageantry once seemed to hold—as a form of drama that would be both democratic and decentralized, artistically elevating yet appealing to the masses—scarcely outlived the century's second decade.

## XI

The pageantry movement manifested what by 1910 or so had become a mounting discontent with New York's dominance of American theater and Europe's dominance of American dramatic taste. MacKaye grumbled that "a majority of the educated, and the intellectual amongst us . . . remain, in art and aesthetic aspiration, suburbanites of Paris, Berlin, Rome, London." "New York is now the least American of American cities," wrote the theater critic Clayton Hamilton in 1916, "for the very reason that it has become the most cosmopolitan." Hamilton was convinced that "For a true interpretation of . . . our national life, we should look to the provinces. . . ."[97] Promoting pageantry was one way of looking to the provinces for inspiration and talent. Over the long run, though, a much more effective and significant revolt against the hegemony of New York—or at least Broadway—was the movement sometimes called community drama, sometimes local theater, but most commonly little theater.

The basic mission of the little-theater advocates was to break the hold of Broadway commercialism and thus open the way for more innovative and challenging drama, including more American plays. They got much of their inspiration from the famous Irish Players of Dub-

lin's Abbey Theatre, who toured the United States in 1909. The Irish
Players excited drama devotees everywhere with their vigorous, au-
thentic renderings of works by such Irish playwrights as William Butler
Yeats and James Millington Synge. The lesson of the Abbey Theatre
experience seemed to be that small, dedicated repertory companies,
working with original native material, could help spark a national
cultural awakening in America similar to what had already happened
in Ireland.[98]

A remarkable proliferation of local semiprofessional and amateur
theater groups followed the Irish Players' tour. In 1912 Maurice
Browne, an Englishman who had settled in Chicago, started up the
Little Theatre, thereby providing the generic label for the whole
movement. That same year also saw the founding of the Toy Theatre
in Boston and another Little Theatre in New York. The Neighbor-
hood Playhouse, an outgrowth of the Henry Street Settlement House
in lower Manhattan, got under way in 1915, as did Stuart Walker's
Portmanteau Theatre, which featured portable sets and offered fare
for children as well as adults. Local repertory groups also appeared in
such cities as Baltimore, Detroit, St. Louis, and New Orleans, and in
out-of-the-way places like Duluth, Minnesota; Galesburg, Illinois; and
Hollis, Maine.

Meanwhile the college and university dramatic scene livened con-
siderably. At Harvard, George Pierce Baker's English 47 playwriting
course—the "47 Workshop"—became famous for its talented products,
including the playwrights Eugene O'Neill, Sidney Howard, and S. N.
Behrman and the designers Robert Edmond Jones and Lee Simonson.
Percy MacKaye was one of Baker's first students at Harvard, Thomas
Wolfe one of his last. At Columbia, Brander Matthews gave strong
courses on stage history and technique (if not dramatic content), while
at the University of Wisconsin Thomas H. Dickinson acquainted his
students with contemporary European drama and helped organize
the Wisconsin Players. At the University of North Dakota a young
English instructor named Frederick H. Koch organized the Dakota
Players to bring the light of modern drama to the northern plains.
In 1918 Koch moved to the University of North Carolina, where he
founded the Carolina Playmakers, subsequently famed for their origi-
nal "folk plays" about the people of the upland South.[99]

The little-theater groups of the pre-1917 period usually modeled
themselves on such contemporary European repertory companies as
the Petit Théâtre du Vieux Colombier in Paris, the Kleines Theater
in Berlin, the Moscow Art Theatre, and of course the Abbey Theatre.
They sought an intimacy among their players and between players
and audience, a dramatic expression unencumbered by profit considera-

tions, and either original performances of original plays or fresh renderings of masterworks.

They were staunchly supported in their efforts by the Drama League of America, founded in 1910 at Evanston, Illinois. Aiming to establish a chapter in every city and town in the nation and to encourage the production of "good" drama, the league always had a big proportion of genteel clubwomen and a strong flavor of genteel uplift. Yet its quarterly and then monthly magazine, *The Drama,* printed translations of avant-garde Continental plays, essays on experimental theory and technique, and reports on the work of the leading little theaters. The Drama League also encouraged community pageants and, through its local chapters, provided the nuclei for quite a number of community playhouses. In 1916, moreover, the league helped bring into being the monthly *Theatre Arts Magazine.* Edited by Sheldon Cheney and frankly dedicated to promoting the new influences in European and American drama, *Theatre Arts* soon became the leading publication of its kind in the country. In short, the Drama League of America, until its disbandment in the early 1930s, served as the single most effective force for the development of decentralized and decommercialized theater in the United States.

The majority of the early-century little-theater companies began with high hopes but little capital and were soon gone. The Toy Theatre, for example, lasted only two and a half years, the Portmanteau Theatre slightly longer, Browne's Little Theatre in Chicago only five years. Besides the university-affiliated Carolina Playmakers, only two significant groups survived the early years of the little-theater movement. Both did much to energize American drama for decades.

Early in 1915 Lawrence Langner, a New York patent lawyer and sometime playwright, got together a group of friends to form the Washington Square Players. Composed of "individuals who believe in the future of the theatre in America" and initially intending to give preference to American plays, the Washington Square Players opened at the Bandbox Theatre on East 57th Street.[100] Relying on subscription sales, the Players had two successful seasons before moving to the larger Comedy Theatre, closer to and partially in competition with Broadway. In their new surroundings, the Players did almost nothing but well-known (if still not commercially reliable) plays by the major modern European dramatists—Shaw, Chekhov, Andreyev, Ibsen, Maeterlinck. Thus, while the Players provided a forum for talented young performers like Katherine Cornell and designers like Robert Edmond Jones and Lee Simonson, the company's commitment to the furtherance of American-written drama turned out to be quite weak. The same was true of the successor to the Players, the Theatre Guild. Formed

eight months after the Players disbanded early in 1918, by much the same group that had operated the Players, the Theatre Guild would soon develop into the most prestigious producing company in the nation. It would be frequently criticized, though, for not doing enough American drama.

The other prewar little-theater company with long-term significance was the Provincetown Players. Among those who had a hand in its birth were the producer George Cram Cook and his wife, the playwright Susan Glaspell; the journalist Hutchins Hapgood; and John Reed, who would later die in Russia while both reporting and participating in the Bolshevik Revolution. Founded in the summer of 1915 by these and other restless Greenwich Villagers summering on Cape Cod, the Provincetown Players got fully under way the next year at a rehabilitated fish house they named the Wharf Theatre. That summer's offerings included two one-act plays by the twenty-eight-year-old Eugene O'Neill. The following winter the Provincetowners moved their company to the Village, established themselves on Macdougal Street, and remained in business there for the next thirteen years.

The new company's announced objective was "to encourage the writing of American plays of real artistic, literary and dramatic—as opposed to Broadway—merit." At first the Provincetown Players concentrated on new plays by American authors, including, besides O'Neill, Susan Glaspell, Edna St. Vincent Millay, and Floyd Dell.[101] Like the Washington Square Players and the Theatre Guild, however, the Provincetown subsequently went to an increasing number of established European plays. But if the Provincetown did less than it might have done to foster new American playwriting talent, the fact that it gave O'Neill his start and, by the early twenties, had made him the country's foremost dramatist was enough to justify its existence.

The Provincetown and Washington Square Players and the whole impulse toward the establishment of small, independent dramatic companies were part of an international phenomenon that Sheldon Cheney hailed in 1914 as "the new movement in the theater." What was happening in America, according to Cheney, was a process of catching up with developments under way for a decade and more in Europe. One aspect of the new movement was the transformation of the visual art of the theater—design, decoration, staging—by such innovators as Max Reinhardt in Germany, Leon Bakst in Russia, and Gordon Craig in England. The other was the transformation of dramatic content, beginning with Henrik Ibsen and August Strindberg and continuing after 1900 with such men as John Galsworthy, George Bernard Shaw,

Leonid Andreyev, and Arthur Schnitzler. From extravagant productions and melodramatic plot contrivances, first European and now American drama as well had moved to the exposition of ideas and motives and the realistic development of character. Both visually and dramatically, the trend in the new theater was toward a sparser, more straightforward, more intellectually demanding art.[102]

Accompanying the rise of the little-theater movement was a substantial amount of quasi-populistic rhetoric in favor of bringing drama to the provinces and ending Broadway's dominance of the American stage. At the same time, the movement embodied the same modernist impulse that was at work in the other arts in the first part of the twentieth century. With a few exceptions, most notably the Carolina Playmakers, the new producing companies surfacing in the period around 1910–20 seem not to have been self-consciously nationalistic. The intellectual heritage of such moving spirits as Cook, Glaspell, Langner, Jones, Simonson, and O'Neill, according to Joseph Wood Krutch, "was contemporary literature as a whole. . . ."[103]

Like most of those who edited and wrote for the avant-garde magazines, like Stieglitz and the "291" group, like Charles Ives, the little-theater enthusiasts wanted more than anything else to have the freedom to express themselves in their art as they wished. Mainstream American commercial theater, they believed, was a refuge for attitudes and sentiments long outmoded in the best fiction and poetry. At the same time, they fervently wished to bring into being a serious and powerful dramatic literature written and presented by Americans, a literature for the stage that could take its place as part of the varied corpus of worthy American writing. The revolution they sought, moreover, would contribute to the overall improvement of the climate for creative artists in America.

Alongside, sometimes intermingling with, but usually distinguishable from the emerging artistic modernism of the period after 1900 was a strident and vigorous romantic nationalism. Modernism shared with the Genteel Tradition a basically elitist outlook and often a willingness to look to Europe for artistic inspiration and leadership. Romantic nationalism shared the Genteel Tradition's belief in the improvability of mass taste and sensitivity and the public responsibilities of the creative individual. Romantic nationalism and modernism merged in Sullivan and Ives; elements of both were evident in the thinking of Mencken, Monroe, Frank Lloyd Wright, and even Stieglitz. By about 1917, however, the romantic nationalist—modernist dichotomy—represented on the one hand by Brooks, Henri, Farwell, MacKaye, and the *Craftsman,* and on the other by the "291" group,

the Washington Square Players, and most of the little magazine peo-
ple—was pretty firmly established. For the next twenty years and more,
that dichotomy would largely determine the history of the American
arts. Meanwhile the Genteel Tradition, much battered by rebellious
elements in all the arts, survived into the post–World War I years.

# Thorough
# Malcontents

OF THE VARIOUS NEW OR REVAMPED MAGAZINES THAT APPEARED IN the years before 1917, two turned out to have especially significant consequences for the history of American ideas and art. One was the weekly *New Republic,* first published in November 1914, near the mid-point of Woodrow Wilson's first presidential term. The *New Republic* marked the ideological culmination of political progressivism in the period before the United States formally entered the war in Europe. The other magazine was the monthly *Seven Arts,* begun exactly two years later and less than six months before Wilson led the country into war. The *Seven Arts* marked the high tide of cultural nationalism in the pre-1917 period. In their largely shared outlooks but different emphases, the *New Republic* and the *Seven Arts* encompassed the major issues in prewar politics and culture. Their contrasting responses to the war itself foreshadowed some of the characteristic features of American intellectual and cultural life in the 1920s, especially that decade's insistent separation of the concerns of art from the issues of politics and public policy.

I

At least during its early years, the *New Republic* was very much part of the prewar Rebellion. Originally it mingled art and politics almost as much as the *Masses,* although the *New Republic* remained sober and serious in contrast to the *Masses'* lighthearted revolutionism. The *New Republic* took its tone from its three very serious-minded founders, Herbert Croly, Walter Weyl, and Walter Lippmann. Al-

though he still contributed to the *Architectural Record,* Croly had made a considerable reputation as a political thinker. His program for the concentration and coordination of economic activity under federal government supervision, articulated most cogently in 1909 in *The Promise of American Life,* had supposedly had a strong influence on Theodore Roosevelt's 1912 presidential campaign. Weyl and Lippmann had also written major statements of advanced progressivism— Weyl in *The New Democracy* (1912), Lippmann in *A Preface to Politics* (1913) and *Drift and Mastery* (1914).[1]

For all their agreement on political goals, the three founders had little in common when it came to cultural matters. Weyl, content to pursue the statistically grounded economics he had learned from Simon Patten at the University of Pennsylvania, was not particularly interested in the arts. Lippmann had been a member of the unusually luminous Harvard class of 1910, which also included T. S. Eliot, John Reed, and Robert Edmond Jones. Briefly a socialist, Lippmann became a familiar figure around Greenwich Village and an active sympathizer with the Rebellion. Croly's interests in the arts, especially architecture, were explicit and pronounced. For Croly the political awakening he and his colleagues hoped to bring about was only part of a broader awakening that would culminate in the building of a brilliant American civilization. Yet Croly's artistic values remained firmly grounded in the Genteel Tradition's morality, formal idealism, and deference to the European heritage. He was unable to share the young Lippmann's enthusiasm for the new values in both art and personal behavior. Presumably in accordance with Lippmann's wishes, Croly was willing to open the *New Republic*'s pages to modernists and romantic nationalists, but he could endorse little of what they had to say. Those who wrote in the spirit of the Rebellion generally dominated the cultural columns of the *New Republic.* Croly was evidently satisfied to concentrate on politics and government in his particular contributions to that magazine and express his artistic opinions in an occasional piece for the *Architectural Record.*[2]

From the outset, therefore, the *New Republic* was a strong ally of the insurgent movement in the American arts. As early as its third issue the magazine editorially condemned "Our Literary Poverty" and demanded an end to America's "cultural vassalage" to British letters. Americans must "consciously and definitely refuse to take England's achievements for our own." In 1916 John Dos Passos, just out of Harvard, called on America's creative artists to fashion an "autochthonous" culture out of their own materials, as Walt Whitman had challenged them to do in the previous century. And in the spring of the next year, as the United States went to war, George Soule made the

common insurgent complaint about the "chasm between most of the genuine aesthetic expression and the national life. . . ." Soule perceptively posed the question that was then and would continue to be central to American cultural criticism: "How is art to be at the same time derived out of the complex and over-burdened consciousness and made natural to a community without the ability to specialize in it?"[3]

Already by that time a number of the cultural critics who had earlier gladly associated themselves with the *New Republic* had begun to drift away. By 1916–17 the magazine was increasingly preoccupied with matters of public policy and the United States' relation to the conflict in Europe. Such men as Dos Passos, Lee Simonson, Paul Rosenfeld, and especially Randolph Bourne had become disturbed by the editors' growing conviction that to be able to shape the outcome of the war and build a better world based on President Wilson's idealistic principles, the United States would have to enter the fighting on the side of the European democracies and against Imperial Germany.[4] The *New Republic* never entirely abandoned its cultural orientation and would become more receptive than ever to avant-gardism in the postwar years. For the time being, though, younger insurgents shifted their hopes for cultural leadership to the new monthly, the *Seven Arts*.

## II

With the *New Republic* deemphasizing cultural content yet with the country still at peace, the time seemed opportune for a new magazine that would focus on the arts in relation to American society. Such a publication should be unabashedly and forthrightly nationalist in its cultural objectives, but should also acknowledge a community of interest with formal experimentalists in all the arts (as, for the most part, the late *Craftsman* had not). That was the basic scheme of the three men who met in Greenwich Village in the summer of 1916 to plan their new magazine. The eldest, at thirty-four, was James Oppenheim, who had attended but not finished at Columbia University and had then spent several years as a social worker and settlement-house teacher before concentrating on a literary career. Although he had published a novel and some short stories, Oppenheim considered himself first of all a poet.

Waldo Frank, twenty-seven, was the son of a prosperous New York importer. In 1911 Frank had taken both B.A. and M.A. degrees at Yale, and then had spent a summer working on a ranch in Wyoming. After that unlikely interlude, he had put in a desultory two years as a theater critic for the New York *Evening Post* before heading for

Europe. Back in New York, he joined H. L. Mencken and George Jean Nathan on the *Smart Set* and got to know Alfred Stieglitz. America was "in travail of culture," Frank believed. The lions of the genteel establishment "had been marooned on a desert isle by tides they did not even know existed."[5]

The twenty-six-year-old Paul Rosenfeld had already made something of a reputation for himself with his explorations—many of them pieces written for the *New Republic*—into the work of Schoenberg and other European musical avant-gardists. Like Frank, Rosenfeld was a Yale graduate with a short period of New York newspaper experience. Dazzled by the vastness and richness of European culture during a year in Italy, Rosenfeld nevertheless returned to his country determined to work for an American-style renaissance. That necessitated not only a familiarity with the European heritage but also a close involvement with the most powerful contemporary influences on the Continent. At the same time, it was necessary to break the genteel Anglo-American connection and end European hegemony over America's cultural life.[6]

"A Jew without Judaism, an American without America." That was the way, decades later, Waldo Frank described his early outlook. He, Rosenfeld, and Oppenheim, as well as others like Lippmann, Weyl, and Stieglitz, were all examples of the rapidly growing number of intellectually and artistically prominent Jewish Americans. Yet as products of basically secular Jewish families of central European ancestry, such people were able to identify closely with neither the Anglo-Saxon–dominated genteel culture nor the supranational heritage of orthodox Judaism. Whether fervent democrats like Weyl or elitists like Stieglitz, Jewish intellectuals in the pre–World War I years often sought an American national awakening—a marshalling of energies and talents from the country's diverse peoples.

In their letter to prospective contributors (which subsequently appeared as the *Seven Arts'* first editorial), Oppenheim and his associates proclaimed their "faith . . . that we are living in the first days of a renascent period, a time which means for America the coming of the national self-consciousness which is the beginning of greatness." No longer private matters, the arts in America had become "not only the expression of the national life, but a means to its enhancement." The *Seven Arts* intended to be "an expression of our American arts which shall be fundamentally an expression of our American life," not a magazine for artists but "an expression of artists for the community."[7]

The first issue of the *Seven Arts* in November 1916 listed Oppenheim as editor, Frank as associate editor, and Van Wyck Brooks among the advisory editors. The *Seven Arts* seemed the logical furtherance of

Brooks's work, an effort to speak collectively for a national awakening as Brooks had spoken individually in *America's Coming-of-Age*. Within a few months Brooks became the magazine's second coeditor. The *Seven Arts'* diverse contributors represented a major portion of the established and emerging literary talent of the day: Robert Frost, Floyd Dell, Amy Lowell, H. L. Mencken, Theodore Dreiser, Sherwood Anderson, Carl Sandburg, Eugene O'Neill, John Dos Passos, John Reed. From Europe, D. H. Lawrence, Bertrand Russell, Romain Rolland, and other notables sent occasional stories and essays. At home, Rosenfeld, Hiram K. Moderwell, and Lee Simonson, who had all published in the *New Republic,* wrote on music and the visual arts and kept the *Seven Arts'* coverage from being exclusively literary. Before long it was evident that the *Seven Arts* was a magazine of exceptional intellectual substance, a powerful vehicle for those who believed in a coming American renaissance.

The most explicit and incisive formulations of that cultural promise came from the men who ran the magazine. Oppenheim, besides printing some of his own rather bad poetry, wrote a succession of lyrically confident editorials. At the beginning of 1917 he admonished American creators not to despair because they worked in different circumstances from those of their European counterparts. The American artist might have no rich national heritage, "no ready-made American legendry and mythology, no echoing words and colors out of dim and distant epochs," but he could see his dream of the future in "the life flowing vividly and rankly around him. . . ." America every day offered as much inspiration as any artist should need.[8]

In his *Seven Arts* years, Waldo Frank's mysticism had not yet become as deep and pervasive as it would in his later novels and critical writings. He was straightforward in scolding the Washington Square Players for doing mostly foreign plays and American fiction-readers for preferring contemporary English novelists like Arnold Bennett and John Galsworthy to their own writers. Frank also called on Americans to recognize that the national traditions of other countries, as well as their current milieus of revolt against tradition, were for other peoples. Americans must build their own traditions, must carry out their own revolts.[9]

Paul Rosenfeld, as Sherman Paul has pointed out, was the only one of the *Seven Arts* group who really came to terms with European and American avant-gardism. While Frank became Stieglitz's warm friend, it was Rosenfeld who actually served as the conductor of ideas from the "291" modernists to the *Seven Arts* romantic nationalists.[10] Yet Rosenfeld was as ardent in his pursuit of the ideal of an American culture—particularly the realization of a self-fulfilled American music—

as any of the others. The blame for America's musical backwardness, he wrote in the first issue of the *Seven Arts,* should properly settle on the American composer himself. Sufficient learning and technical skill he already had, but he was unable "to draw the substance of his art from the life that surges about him," as had Stravinsky or Brahms or Bach. The most tragic example of the American composer's "divorce from life" was Edward MacDowell, "who on contact with his own land retired further and further into himself, at last with shattering completeness." What the American composer must do was what Stravinsky said he had done in writing *Le Sacre du Printemps:* perform an act of faith. Once he "touches the life that nature spends so prodigally here," Rosenfeld exulted, "what power!"[11]

Van Wyck Brooks's *Seven Arts* essays brought him to the apex of his early career as an American critic. Later collected in a volume entitled *Letters and Leadership,* Brooks's contributions treated the same basic questions he had dealt with first in *The Wine of the Puritans* and then in *America's Coming-of-Age:* the nation's spiritual poverty, the relationship between the artist and general society, the inspirational, redemptive role of the critic.[12] Focusing more than he had up to then on the shortcomings of contemporary American criticism as a reflection of the shortcomings of American life as a whole, Brooks solidified his reputation as the prophet of the Rebellion.

Brooks and his *Seven Arts* colleagues were fully aware that their quarrel with the cultural gentility was not only intellectual and esthetic but generational as well. Clinging to stale and stuffy nineteenth-century modes of thought and expression, "the old gang" was incapable of achieving the radical perspective only youth could bring to the task of building an American culture. In the second *Seven Arts,* Brooks lamented the passing of the ebullient, expansive "Young America" movement of the pre–Civil War years, a hopeful restlessness with things as they were, which had paralleled political and cultural stirrings in mid-nineteenth century Germany and Italy. Brooks thought he saw signs of an "epilogue" to the Young America story in a current growing sense that material enterprise was inadequate to America's more vital needs. There was in America "the certain visible sign of some prodigious organism that lies undelivered in the midst of our society, an immense brotherhood of talents and capacities coming to a single birth."[13]

There was also plenty to be discouraged about. It was as if American thinking had "a splinter of ice buried in the midst of it, a splinter that literature has never been able to melt." Emotionally starved, Americans had seized on the West, the vast American wilderness, where they had sought fulfillment in rapacious material accumulation.

Paralleling the physical escapism of the westering impulse was America's literary escapism, summed up in William Dean Howells's famous epigram that the "smiling aspects" of life were the more American. Howells had thereby, Brooks said, "virtually declared the bankruptcy of our literature."[14]

The fact was that at all levels American life was in "a state of arrested development," Brooks wrote in "Toward a National Culture"—a phrase that could have served well as a motto for the whole *Seven Arts* venture. Unable to develop its "latent greatness," America had lost "an army of gifted minds," creative people who had chosen to live abroad rather than remain in a country "impoverished in will and impulse. . . . " America was thus "rapidly breeding a race of Hamlets." Overcome by "Puritanism" and the "possessive instinct" while he habitually repressed the "creative instinct," the American, Brooks complained a month later, was "physically sane but neurotic from the denial of his impulses, a ragbag of inherited memories and unassimilated facts, a strange, awkward, unprecedented creature, snared by his environment. . . ." There was no use looking to "our critics" for leadership. Irving Babbitt, Paul Elmer More, William Crary Brownell, George Edward Woodberry, and the other putative bulwarks of established criticism were men bound to the outworn tradition of a genteel class, to "a culture [that] never was and never became organic. . . ." They talked about the need for "an extension of taste," not realizing that there must be a "profound transmutation before taste in the organic sense will be really possible to the American public."[15]

Brooks saw encouraging signs as well. Over the last few years America had become "under our eyes a living entity, visibly in process of developing a third dimension. It used to be a map, it has become a swarm; it used to be a bare place we moved about in, it has become a jungle of shoots." But ultimately it was up to the prophet-critic to illumine the path out of the nation's spiritual stagnation. Criticism had to shake free of both disconnected genteel moralism and disconnected estheticism and become a vigorous *social* criticism, dedicated to building an organic civilization. The task of criticism was nothing less than "to make a situation of which the creative power can profitably avail itself."[16]

## III

Brooks published this reaffirmation of criticism's prophetic function shortly before the Congress heeded Wilson's call for a declaration of

war against Germany. The fact that his own country was at war seems to have had no great effect on Brooks's thinking. All along, ever since the nations of Europe had marched on each other in 1914 and he had hurried home from France, Brooks had hoped that the war, by forcing Americans to draw on their own creative resources and depend less on European leadership, would aid his program for an American culture. "Besides," he asked rhetorically in his memoirs of the period, "was not Pan-Germanism a terrible menace?"[17]

The other *Seven Arts* editors disliked the war and shared the widespread dismay in insurgent circles over the drastic wartime curtailment of civil liberties. Yet they did not actively oppose American participation in the conflict. The main opposition to the war among the *Seven Arts* group consisted of the bitter essays on American policy and opinion written by Randolph Bourne. Those essays were also the main reason the magazine came to an end.

In many ways Bourne was the most brilliant of the young men associated first with the *New Republic* and then with the *Seven Arts*. Born in 1886 in Bloomfield, New Jersey, three months after Van Wyck Brooks's birth about forty miles away in Plainfield, Randolph Silliman Bourne grew up in a staunchly Republican and Presbyterian family. Bourne's father, like Brooks's, was unlucky in his business ventures; but whereas Brooks's parents at least managed to stay together, Bourne's parents separated when he was a small child and Bourne and his mother moved in with his grandparents. About that time Bourne, his face already disfigured by an injury at birth, fell victim to a disease that left him with double curvature of the spine, a severely hunched back, and an obvious limp. The long illness also retarded his growth, so that Bourne grew little taller than a dwarf. Yet his deformed and undersized body did not keep him from having a vigorous and, by his own account, happy childhood and adolescence. Exceptionally bright, Bourne also possessed a great deal of personal warmth and charm. Once new acquaintances got over the initial shock of his appearance, they usually became his friends.[18]

Bourne's uncle managed to finance one year of college at Princeton. After that Bourne worked for six years at a variety of tedious, sometimes gruelling jobs, such as piano accompanist in vaudeville shows and movie houses and roll-puncher at a player-piano factory. By 1909 he had enough money to resume his education. Enrolling in Columbia University, he encountered the intellectual prowess of people like the historians Charles A. Beard and James Harvey Robinson, the anthropologist Franz Boas, and most of all the philosopher John Dewey. Bourne enthusiastically embraced Dewey's variety of pragmatism,

which held that the only reality was actual experience, that the test of a belief was the practical consequences it had for the individual in society, that all existence was an ongoing experiment.

In 1913 Bourne left Columbia with his M.A. (after taking his B.A. a year earlier) and also published his first book. *Youth and Life* was a collection of his essays that had appeared since 1911 in the genteel but increasingly tolerant *Atlantic Monthly*. Bourne's book was a paean to the youthful spirit—to adventure, friendship, the experimental approach to living, the necessity for youth to be uncompromisingly radical in its attitude toward established institutions. Concluding with Bourne's poignant explanation of his own "philosophy of handicap," *Youth and Life* was one of the first statements of what was then still an unusual, college-bred awareness shared by thousands of confident, often iconoclastic young men and women across the country.[19]

A Columbia traveling fellowship enabled Bourne to spend nearly a year in Europe. He was in Germany when the war began and, like Brooks and a lot of other Americans abroad in the summer of 1914, got home as quickly as he could. That fall, in an essay in the *Atlantic*, he made explicit his own cultural nationalism and provided one of the best statements of the characteristic romantic nationalist view that art was the cutting edge of national fulfillment. Bourne had come home feeling contempt for "our almost pathetic eagerness to learn of the culture of other nations, our humility of worship in the presence of art that in no sense represents the expression of any of our ideals and motivating forces." All this self-consciousness about what Europeans thought, this stuffing of American museums and millionaires' homes with old masters, medieval armor, and rare porcelain, amounted to a gross perversion of the Arnoldian meaning of culture. In fact the only "sincere culture" America could have must come from the development of its own "inner taste" and from the willingness of its artists to work within the "hot chaos" of their country. What America needed at present was to "shut ourselves in with our own genius, and cultivate with an intense and partial pride what we have already achieved against the obstacles of our cultural humility."[20] Thus, unlike Brooks, whose goal was to regenerate America so that his countrymen could match the cultural achievements of Europe and thereby overcome their humility, Bourne saw the problem of a national culture in terms of the necessity for Americans to overcome their humility and then go on to great achievements in the arts. A subtle point, perhaps, but nonetheless an important distinction in the thinking of two of the most powerful spokesmen for an American renaissance.

With the help of Charles Beard and Ellery Sedgwick, editor of the *Atlantic*, Bourne became an associate editor of the nascent *New Re-*

*public.* He wrote scores of essays and reviews for that magazine over the next two and a half years. It was the *Atlantic,* however, that published perhaps his foremost contribution to American thought—a version of what later came to be called "cultural pluralism." As a practical alternative to either the Americanization—really Anglo-Saxonization—of the nation's many different peoples or the amalgamation of the various ethnic ingredients in a national "melting pot," Bourne proposed the concept of "trans-national America." Acknowledging that the masses of recent immigrants were neither assimilating to Anglo-Saxonism nor melting together to form one uniquely American type, Bourne suggested that the people of the United States should recognize they already constituted a "world-federation in miniature." Efforts to force Anglo-Saxon ways on people from other traditions would only "create hordes of men and women without a spiritual country, cultural outlaws, without taste, without standards but those of the mob." Instead, America had the unique historical opportunity to achieve a kind of cosmopolitan nationalism, thereby providing a model of what strife-torn Europe could be. Within the framework of "the first international nation," each racial, religious, and linguistic tradition could make its own particular contribution to a national culture such as the world had never seen.[21]

Bourne was preeminently an American nationalist, albeit a man with his own special understanding of *e pluribus unum.* He had no use for those who talked about an Anglo-Saxon community spanning the north Atlantic, or those who trumpeted the United States' moral obligations to save democracy in Europe and extend democracy elsewhere in the world. By the spring of 1917 Bourne had had enough of the *New Republic*'s increasingly messianic rhetoric and had shifted his loyalties and talents to the *Seven Arts.* There he wrote a succession of sardonic, devastating, relentless examinations of the Wilson administration's war policies and the fallacies in the position of prowar progressives, most notably John Dewey—although not once did Bourne expressly mention either the *New Republic* or his once-revered mentor. Bourne's writings steadily angered Mrs. A. F. Rankine, the wealthy patroness of the *Seven Arts.* When she finally withdrew her subsidy in September, the magazine was doomed. In the next and last monthly issue, Oppenheim announced that while the *Seven Arts* had taken "a true course toward the cultivation of a native art in America," because of "the awakening of tribal consciousness in the madness of war," there was no longer "that generous allowance for free expression, for diversity of opinion."[22]

Bourne's wartime essays eloquently revealed the raw wound the war had torn in the corpus of American intellectual opinion. His

denunciation of intellectuals who would be not only opinion-makers but policy-makers exemplified the splintering of political from cultural radicalism that was one of the fateful consequences of the war experience in both America and Europe. Yet Bourne did not really mean it when he declared in September that "the effect of the war will be to impoverish American promise," and that Americans had to choose between having their war or their national fulfillment. In fact Bourne was already looking beyond the war to the renewal of the struggle for the American promise by those whom he described, in the final *Seven Arts,* as "thorough malcontents."[23]

Bourne expected such malcontents to make known their "disgust at the continual frustrations and aridities of American life, [their] deep dissatisfaction with self and with the groups that give themselves forth as hopeful. . . ." Perhaps out of such chronic choler "there might be hammered new values." Mocking and irreverent, unable to take established institutions seriously, Bourne's malcontents would "be glad if they can tease, provoke, irritate thought on any subject." After the war they would neither go to Europe, as had many of their talented predecessors, nor starve submissively at home. "So they are likely to go ahead beating their heads at the wall until they are either bloody or light appears." What the country needed now, Bourne wrote, was not optimism but a "skeptical, malicious, desperate, ironical mood. . . ." Therein might be "the sign of more vivid and more stirring life fermenting in America today. It may be a sign of hope."[24]

So the *Seven Arts* died at the age of one year, about the same time that the *Masses,* harassed by federal charges of sedition and denied its indispensable second-class mail rates by Wilson's Postmaster General, also had to shut down. The *Seven Arts* and *Masses* intellectuals and artists scattered to a variety of different jobs and activities. Bourne, Brooks, and Frank, as well as young Harold Stearns, an occasional *Seven Arts* contributor, became associated with the fortnightly *Dial,* which in 1918 was moved to New York from Chicago by its new owner, Martyn Johnson. In New York, Johnson completed the transformation of the *Dial,* formerly the Middle West's leading organ of gentility, into a general journal of opinion rivaling the *New Republic* and the *Nation,* the latter also recently rejuvenated under Oswald Garrison Villard. Between 1918 and 1920 Johnson's *Dial* largely filled the void left by the passing of the *Seven Arts.*[25]

It was in the *Dial,* not long before its move to New York, that Brooks published probably his best-known single essay, "On Creating a Usable Past." In a fashion similar to the reform-minded "New History" advocated by historians like Robinson and Beard, Brooks sought in American literary history those "tendencies" that best clarified the

present predicament in American letters and pointed the way toward
a national literary culture. Creating a past with "living value" meant
first of all understanding failure: the inability of men like Emerson,
Thoreau, and even Whitman to realize their full gifts. Searching for
the causes of the successive failures of their most talented forbears,
America's creators might have to invent a new past, one that would give
them for the first time "that sense of brotherhood in effort and in
aspiration which is the best promise of a national culture." Here
Brooks reiterated a theme he had touched upon in various previous
writings and would return to repeatedly in the years to come: the
need for a feeling of shared purpose—a brotherhood—among the na-
tion's creative minority. Such a brotherhood, he hoped, would be one
outcome of the kind of critical leadership he was trying to exert.[26]

Meanwhile, Randolph Bourne tried to fulfill his own ideal of the
thorough malcontent. After the war, he wrote Brooks, "The country
must be dotted with dissatisfied people who cannot accept any of the
guides offered to them." The most valuable kind of person in the years
ahead, he said in the *Dial,* would be "that desperate spiritual outlaw
with the lust to create."[27] Bourne himself, though, would not be
around to lash at those who confused pragmatism with prowar ex-
pediency or to help sustain the spirit of the prewar Insurgency. On
December 22, 1918, six weeks after the Armistice that brought an end
to the war he despised, Bourne became one of the nearly seven hundred
thousand Americans who died in the great influenza epidemic of that
winter. Although the legend later grew that because of his antiwar
opinions he was denied work, reduced to poverty, and hounded by the
authorities, in fact the war affected Bourne's personal circumstances
hardly at all. Up to the end his literary services were in regular de-
mand and his pay was steady. There was little real tragedy in either
his life or his death, but there was pathos in the fact that he did not
live into the postwar decade, when the country would be dotted with
dissatisfied people and at the same time flowering with native creative
genius.

## IV

Bourne never expected anything from the war but frustration, dis-
traction, and delay in the work of building a national culture. Oswald
Garrison Villard's *Nation* was also convinced that American involve-
ment was a mistake. A few months after the United States went to
war, that magazine made it a point to repudiate "that old and dis-
honored fallacy which hopes for a great art born out of the horrors of

war." It was necessary to keep in mind, quipped the *Nation,* that "the Civil War was not fought so that Lincoln could make his Gettysburg Address."[28] The more usual response, though, was that of Brooks, whose hope that the war would focus and direct American creative energies was widely shared among both political and cultural commentators.

In genteel critical circles, moreover, the United States' active participation in the conflict on the side of Great Britain reinforced the Anglo-American connection and made literary Anglophilia more fashionable than ever. Since the first months of fighting in 1914, defenders of traditional culture had usually equated the Allied cause with the preservation of the moral and ethical values of Western civilization, and had identified Imperial Germany with a lust for power and the cynical use of naked force. A clamorous hostility to German influences in the American arts became a central feature of the nationwide official and unofficial anti-Germanism of 1917–18.

Anti-Germanism was especially rife in the field of music, where central European romanticism had long been ascendant. The Metropolitan Opera, for example, stopped performing works in German for the duration of the war. Karl Muck, German-born conductor of the Boston Symphony, lost his post when he refused to open the symphony's performances with *The Star-Spangled Banner.* Across the country orchestral groups as well as school music programs dropped German works. A writer in the normally suave *Vanity Fair* summed up popular feeling when he hoped that curbs on German performances and performers would help America shake free of "the arrogant and narrow notion that all music made in Germany is divine and all music elsewhere mundane. . . ."[29] The war-sparked campaign against everything German dealt German romantic music a blow from which it never fully recovered in the United States.

Other than that, however, the consequences of the war for the American arts were not momentous. The conflict affected American literary development mainly insofar as a whole generation of young writers acquired a rich fund of imaginative material from their wartime experiences, often as ambulance drivers. A few European figures in the arts—most notably the French Dadaist painters Marcel Duchamp and Francis Picabia and the French composers Edgard Varèse and Carlos Salzedo—immigrated to the United States during the war period. Conservative academicians hoped that the war would purge Europe and America alike of the very modernism that, as it turned out, avantgardists like Duchamp and Varèse came to foster. At any rate, American talents proved generally unresponsive to the upheavals of the war period. The record left from those years in the visual arts, Milton Brown has remarked, amounted to little more than "a series of com-

pletely mediocre posters, a few isolated paintings and prints, and, subsequently, a series of sculptured memorials which are indeed war atrocities."[30]

Even so, Van Wyck Brooks could recall a widespread belief in the immediate post-Armistice period that the war had finally ended America's literary dependence on England. It seemed to Brooks that "this country [was] starting, artistically, afresh." Paul Rosenfeld thought that "the present has the look of a time of transition. . . . to-day so many little water-fowl have been hatched and are swimming about, marvellously, automatically, in the American mill stream!" Sixteen days after the Armistice, Waldo Frank articulated his own buoyant feelings in a letter to Brooks, who had sought temporary respite at Carmel, California. "Do you not feel that with the ending of the butchery in Europe," Frank asked, "the sun of our generation dawned over the rim of the world?" Up to 1918 their generation had endured its adolescent preparation. "Now, we are mature, we are men: it is a thrilling prospect. . . . we are now the masters of the day, and this world at last our Dominion." "I feel with you that a new age has absolutely begun," Brooks wrote Frank the next year, "and that within our lifetime America is going to be one of the great cultural facts of the world."[31]

## V

Such sentiments were hardly those of people who had had their hopes crushed by the war experience or anything else. The staggering carnage of 1914–18, the vicious popular intolerance and stifling of civil liberties, the thwarting of Wilson's visionary peace plans at the Versailles Conference, and the severe economic and social turbulence in the war's aftermath are among the factors offered to explain the disillusionment, despair, and cynicism that allegedly settled over American intellectual and cultural life in the postwar decade. F. Scott Fitzgerald supposedly caught the prevailing mood when he declared that his was "a new generation . . . grown up to find all gods dead, all wars fought, all faiths in man shaken." "You are all a lost generation" was Gertrude Stein's observation, quoted and immortalized at the front of Ernest Hemingway's first novel. The quickly forming image of a class of rudderless men and women got its most potent historical sanction in Frederick Lewis Allen's 1931 best seller, *Only Yesterday,* a brilliant evocation of the decade just ended. In his lively chapter on the country's intellectual and artistic elite, Allen maintained that "the highbrows" had suffered from an "aching disillusionment" and

a "spiritual paralysis," that they had found "no solid thing on which a man could lay hold and say, This is real; this will abide."[32]

By and large, both popular writers and scholars have taken Allen's generalizations at face value.[33] Of the numerous misunderstandings and half-truths that encrust the nation's history, the legend of the Lost Generation had proved one of the most durable. Even Henry May, while demonstrating with great effectiveness that disillusionment with the genteel faith in progress, moral absolutes, and a traditional culture dated from the prewar years, has also implicitly endorsed the customary view of the twenties as marked by "frustration and bitterness" and a "rejection of the past."[34]

One can leave aside the question whether it is ever possible for ambitious, creative people to work without some values, ideals, hopes, and even some sense of the past. The essential point is that the prevailing intellectual and cultural mood of the period after 1918 just was not gloomy, despondent, or cynical. Interpreters of the twenties have been too much occupied with a portion of the period's literature —particularly the highly quotable epigrams of older expatriates like Ezra Pound, T. S. Eliot, and Gertrude Stein or younger talents like Fitzgerald, Hemingway, E. E. Cummings, and John Dos Passos. They have usually overlooked the confidence and optimism expressed in the other arts, as well as the broadening conception of "art" and "culture" that was part of the growing intellectual interest in commercial popular culture. Most of all, the usual view of the postwar decade misunderstands, downgrades, or ignores altogether the persistent presence and concerns of the prewar romantic nationalists.

The *Seven Arts* writers and other prewar cultural nationalists may have seemed an older generation to men like Fitzgerald and Hemingway, but they still considered themselves the younger generation. Waldo Frank, for example, had just turned thirty in the fall of 1919, when he published *Our America,* the foremost restatement of the romantic nationalist outlook. Frank had originally undertaken the book at the request of the editors of the *Nouvelle Revue Française,* who wanted something that would help them better understand the "new" America. *Our America* reiterated the now-familiar theme of a people bursting with creative potential yet still confused, inarticulate, held back by their heritage of "Puritanism" and an obsessive commercialism. "The problem," Frank announced, "is . . . to lift America into self-knowledge that shall be luminous so that she may shine, vibrant so that she may be articulated."[35]

Frank was convinced that while America's leaders of yesterday had been devoted to politics, its future leaders would be men of letters. The revolt of young Americans was still going forward against "the

stale realities current fifty years ago when our land in all but the political surface of its life was yet a colony of England." His was "the first generation of Americans consciously engaged in spiritual pioneering." Frank praised Brooks for his efforts to find an American cultural tradition, Bourne for creatively fusing art and politics, Mencken for his iconoclasm and his transmission of new ideas, Stieglitz, Rosenfeld, and Oppenheim for contributing to "the Jew's renascence in his new free world." As yet, however, Whitman's cry—for the whole man and whole nation, for the liberated personality, for an America free spiritually as well as politically—had gone unanswered. America remained "a promise and a dream," awaiting the time when the creative impulse would be joined to the material for the creative act.[36]

Van Wyck Brooks hailed *Our America* as "the Bible of our generation. . . . To me this book is the first clear, sure note of our new day."[37] Other books appearing in the immediate postwar period—especially Harold Stearns's *Liberalism in America,* which came out shortly after Frank's volume, and Louis Untermeyer's *The New Spirit in American Poetry,* published the previous spring—also testified to a continuing belief in the potential for a creative awakening in America.[38] Brooks himself edited an assortment of Bourne's published and unpublished writings, consciously striving to perpetuate his dead friend's and his own sense of a national coming of age—delayed but not stymied by the agonies of war.[39]

The war and the frustration of Wilsonian idealism at Versailles did appreciably weaken the romantic nationalists' amalgam of socialism and cultural insurgency. The political content of their criticism, never explicit and always secondary, virtually vanished as the twenties progressed. The early promise of the Bolshevik Revolution in Russia dazzled them, but the postwar Red Scare at home was still another blow to their brand of idealism. Yet somehow, and sometimes unsteadily, the romantic nationalists managed to keep their faith in a coming American renaissance.

In an effort to extend that faith, early in 1920 Brooks and Stearns joined up with a new weekly magazine called the *Freeman.* Financed mainly by the American wife of Francis Neilson, an expatriate Britisher, and edited mainly by Albert Jay Nock, the *Freeman* was published at Westport, Connecticut. (Brooks and his family and a growing number of other people in the arts and professions settled there in the twenties.) Nock described the *Freeman* as "a radical paper" that would take its place in "the virgin, or better, in the long-neglected and fallow field, of American radicalism."[40] Yet the *Freeman*'s "radicalism," if it may be called that, was hard to define. Nock was a radical libertarian and eventually a philosophical anarchist rather than a socialist. Most

of the people grouped around the magazine seemed more interested in social and cultural issues than in politics. The *Freeman* did offer considerable commentary on public affairs nationally and internationally, in the fashion of the *New Republic* and *Nation*. Its political posture at a given time, however, seemed to be a matter of who was writing its editorials. Brooks wrote some of them, but mostly he tended to his increasingly burdensome chores as the *Freeman's* literary editor. The magazine published contributions from established European figures like Bertrand Russell, Arthur Symons, and George Russell, established Americans like Carl Sandburg and Percy H. Boynton, and new writers like John Dos Passos, Malcolm Cowley, Vernon L. Parrington, and Brooks's special favorite, the brilliant young Lewis Mumford.

In general the *Freeman* followed the *Seven Arts* line of cultural criticism. Like the *Seven Arts*, its main orientation was toward literature. Little concerned with the avant-garde, its literary tastes ran to what Susan J. Turner has called "Main Street realism."[41] Similar to the heroine in Sinclair Lewis's best-selling novel *Main Street*, published the same year the *Freeman* was founded, the magazine was discouraged and dismayed by the main tendencies at work in American life but still hopeful of reversing them. Yet the overall tone of the *Freeman's* cultural criticism was considerably less upbeat than that of the *Seven Arts*. For the next generation, the *Freeman* predicted, the "tyranny of anemia" in American life would continue.[42]

*Freeman* essayists repeatedly returned to the subject of the "quality of life" in America. Young people were leaving for Europe, the magazine editorialized in mid-1921, because, for all its technical achievement and material abundance, "there is a sterile hardness and dullness in American life which they feel they must escape at any cost." Echoing generations of commentators on America, Brooks's friend Mary M. Colum, a native of Ireland living in New York, lamented that when life was "a conquering physical adventure, as it has been for too long in this country, people's energies are too much absorbed for them to demand anything from life except living."[43]

The eventual American discovery of the quality of life, the *Freeman* critics sensed, would have much to do with the passing of the nation's physical frontier in the West. While the frontier generally appeared as a positive element in interpretations of American political and economic development, for the cultural critics of the twenties the frontier and the westering movement accounted for much of the country's emotional deprivation and artistic immaturity. Taking their cue from what Brooks had said in his 1917 "Splinter of Ice" essay, the twenties critics commonly added the stereotypical pioneer, continually in flight from civilization, obsessed with wrenching wealth

from nature, to the stereotypical Puritan moralizer and meddler. According to Frederick Jackson Turner and many other historians, the pioneer had exemplified the highest national virtues—both democratic individualism and democratic egalitarianism.[44] But for Brooks and most of the *Freeman* group, for H. L. Mencken, and for other "thorough malcontents" in the twenties, the combined pressures of eastern Puritanism and western pioneering had almost squeezed dry American sensibility. Now it was up to Waldo Frank's generation of spiritual pioneers to lead the struggle against the malign tradition of pioneer anti-intellectualism and acquisitiveness. "Depressing in its illiberality as the American atmosphere to-day is," the *Freeman* editorialized early in 1921, "we can not help feeling that the closing of the frontier destines us to an intensive life." One could look forward, "two or three generations" hence, to "some sort of spiritual maturity."[45]

## VI

One *Freeman* critic who got tired of waiting and joined the postwar intellectual-artistic migration to Europe was Harold Stearns. After publishing *America and the Young Intellectual,* a collection of essays and reviews he had done mostly for the *Freeman,* and making final arrangements for the volume he had edited called *Civilization in the United States,* Stearns boarded ship for France on July 4, 1921.

Stearns was thirty years old when he left the United States for what turned out to be an eleven-year overseas stay, broken by only one trip home. Born in Barre, Massachusetts, Stearns had grown up in the Boston area without a father and with an unstable mother who was in and out of mental hospitals. He nonetheless did well enough in the public schools to get into Harvard, where he took his A.B. in 1913. After that he followed the route common to so many of the "new intellectuals" in the century's early decades: an unrewarding try at newspaper work in New York, a year abroad (Paris in Stearns's case), return home and settlement in Greenwich Village for a period of free-lance literary effort, then association with one or more of the magazines. Stearns had written for both the *Seven Arts* and the *New Republic.* In 1917 he moved from New York and the ill-fated *Seven Arts* to Chicago and an associate editorship on the refurbished *Dial,* returning east the next year when Martyn Johnson moved his weekly to Manhattan. When Johnson sold the *Dial,* Stearns went over to the new *Freeman.*[46]

*America and the Young Intellectual* was written firmly within the critical tradition of the nineteenth century and especially of Hippolyte Taine. Like much of what the romantic nationalists had to say, Stearns's

book illustrated the common concerns of insurgents and genteel traditionalists. Stearns explicitly agreed with the contemporary conservative critic Stuart P. Sherman that the creative artist "cannot in any final sense put by the civilization he lives in." A truly great artist would speak for all humanity, to be sure, "yet usually in a provincial accent." Great art, moreover, was an "art of acceptance and fulfillment of life; rarely of repudiation and contempt, and never of indifference." Yet "honest work, serious work, intelligent work" was impossible unless art was free, and futile unless it was welcome. There was nothing in the American environment to challenge young creators, "no flexibility, no colour, no possibility for adventure, no chance to shape events more generously than is permitted under the rules of highly organized looting." Every day it became harder to have "any other kind of life than the monotonous majority-ruled, unimaginative existence of the great average." So, Stearns asked in his final essay, "What Can a Young Man Do?" His answer was simply to get out, at least for the time being. No longer really young himself, Stearns nevertheless still identified with America's "rebellious youth," which was "rushing to live with youth of its own kind" in Europe. There Stearns hoped to live the creative life, to do serious, honest work.[47]

*Civilization in the United States,* the book that was the main reason for Stearns's reputation among the twenties intellectuals, was published the year after his departure. Stearns planned it as a collection of essays that, taken together, would "make a fair study" of American civilization. He envisioned a volume, he wrote H. L. Mencken, "so well-balanced and firmly knit together, that 50 years from today when one wants to know what American life was really like in the decade following the great war—well, they will have to rely on this book."[48] The result was hardly so definitive, but *Civilization in the United States* has often been cited as the classic expression of disillusionment and alienation in the twenties, the summary statement of an intellectual and artistic elite that found itself irreconcilably at odds with the rest of the country.

The book was really nothing of the kind. Its thirty contributors, mostly men who had figured in the prewar Rebellion, expressed basically the same ambivalent but ultimately hopeful feelings about America that had characterized insurgent criticism for more than a decade. As Stearns announced in his preface, "We wished to speak the truth about American civilization as we saw it, in order to do our share in making a real civilization possible—for I think with all of us there was a common assumption that a field cannot be ploughed until it has first been cleared of rocks. . . ." United in their conviction that whatever else it might be, American civilization was "not Anglo-Saxon,"

the contributors were also convinced, Stearns said, that "the most mov-
ing and pathetic fact in the social life of America to-day is emotional
and aesthetic starvation." The people of America had to "exorcise
these painted devils we have created to frighten us away from the
acknowledgement of our spiritual poverty." To help them do that,
to understand what was wrong and state the matter as clearly as
possible—that was the purpose of this "inquiry" by thirty Americans.
"For American civilization is still in the embryonic stage, with rich
and with disastrous possibilities of growth."[49]

The thirty essays covered or at least touched upon most aspects of
American life. Stearns himself wrote on the intellectuals, Van Wyck
Brooks on American letters, H. L. Mencken on politics, George Jean
Nathan on the theater, Lewis Mumford on the city, Deems Taylor on
music, Walter Pach on visual art, Conrad Aiken on poetry. Other
essayists dealt with such areas as education, immigration, medicine,
the law, economics, business, engineering, sex, the family, the small
town, sport and play, humor, and "nerves." The tone of the various
pieces ranged from grim to scholarly to tongue-in-cheek to indignant,
but overall they expressed a basic, if sometimes carefully guarded,
optimism.

That positive outlook was most apparent in the essays on the arts.
Taylor, for example, complained loudly that American music had been
"completely Teutonized," and that it still lacked its own folk-song
repository of "common *racial* emotions." Yet he held out the prospect
that the nation's composers "may succeed in saying something that is
of America, and of nowhere else, and that other Americans will hear
and understand." Brooks's essay was vintage Brooks, replete with
references to "the blighted career, the arrested career, the diverted
career" as the rule in America, to American literary history as "one
long list of spiritual calamities," to American writers as dividing into
two categories: "Weeds and wildflowers! Weeds without beauty or
fragrance, and wildflowers that cannot survive the heat of the day."
Still, Brooks took heart from the passing of the frontier, the anticipated
waning of the pioneer and Puritan traditions, and the ferment within
the younger generation. The present age was admittedly "an age of
reaction," but such a time "stirs the few into a consciousness of them-
selves." That consciousness had already arrived in poetry, said Conrad
Aiken, pointing to the creative outburst of the previous decade. Char-
acterized by an "essential anarchy" rather than a "clear percussive
signal," American poetry was still "at the moment extraordinarily
healthy. Its virtues are the virtues of all good poetry, and they are
sufficient to persuade us that the future of English poetry lies as much
in America as in England."[50]

*Civilization in the United States* remains one of the landmarks in the history of American thought and culture in the 1920s, however much the ideals and assumptions of most of its contributors have been misunderstood. Among other things, the volume demonstrated the continuing appeal and prominence of the romantic nationalist creed in American critical writing.

## VII

The man still commonly acknowledged to be the foremost spokesman for that creed, still the most powerful protagonist in behalf of a national culture, was Van Wyck Brooks. Since the war Brooks had undertaken to apply his theory of arrested development and artistic failure in particular cases. When he wrote his piece for Stearns's symposium, Brooks had recently published a biographical study of Mark Twain and was at work on a similar study of Henry James. As weak in actual literary analysis, as psychoanalytically simplistic, and as plainly unfair to two major writers as the Twain and James books were, they nevertheless were crucial to Brooks's increasingly agonized search for a usable past for himself and his country's creative leadership.

In other words, Brooks's studies of Twain and James told considerably more about their author than about their subjects. Brooks later said that when he wrote about Twain, he had thought of him as "a well-known abstract character, the typical American author as we knew him at the moment."[51] Brooks's psychoanalytical interpretations, drawn not from Sigmund Freud but from Bernard Hart's long-forgotten *The Psychology of Insanity* (1912), were more window dressing than anything else. His basic argument, pursued relentlessly, if not always with logical consistency, was little more than an elaboration on what he had been saying about American writers in general for more than ten years. Twain's personal development—as both man and artist— had been thwarted by the stifling moral and intellectual climate of nineteenth-century America. In particular, Twain was victimized by his repressive mother, by his genteel wife, and by his sunny-dispositioned friend William Dean Howells. Howells, according to Brooks, could "neither see in America nor . . . say about America anything that Americans in general did not wish to have seen or said." The quintessential Lowbrow, Twain nevertheless wanted to write and live like something besides what he was. He thus became "the chronic victim of a mode of life that placed him bodily and morally in one situation after another where in order to survive, he had to violate the law of his spirit." Potentially America's supreme literary artist, Twain had

never realized his full talents and thus had ended up a bitter old man, "a balked personality, an arrested development. . . ." Such had been the "ordeal" of Mark Twain.[52]

Already in Brooks's time there were plenty of people who viewed Twain as just what Brooks believed he had failed to become—an artist of world stature. Whereas Brooks gave only passing attention to Twain's *Huckleberry Finn*, years earlier H. L. Mencken had called that book "one of the greatest masterpieces of the world. . . ." To Mencken, Twain was "the true father of our national literature, the first genuine American artist of the royal blood," and "the full equal of Cervantes and Molière, Swift and Defoe." When the Twain book was published, Brooks's friends Sherwood Anderson and Waldo Frank both scolded him for not acknowledging the greatness of *Huck,* and a few years later Ernest Hemingway offered his famous opinion that all modern American literature came from Twain's novel.[53]

For Brooks, though, Twain's blighted career was another chapter in the long story of American artistic failure. Understanding that failure was basic to the creation of a usable past. Henry James was part of the story as well, though in quite a different way. James, as Brooks treated him, was the quintessential Highbrow, possessed of a rarefied intellect and an overrefined esthetic sense. Whereas the westerner Twain had too much come to terms with his age and environment, the easterner James had been in the wrong place from the outset. Unable to endure the "implacable emptiness," the "commonplace prosperity" and chronic immaturity of America, James had undertaken his "pilgrimage" to Europe. Living almost all his adult life in self-imposed exile, no longer American but never fully European, James had eventually given himself over to writing highly mannered, abstruse, technically masterful but emotionally sterile fiction.[54]

So Brooks saw James in 1925. Whereas *Twain* had been a fairly straightforward if heavy-handed effort at psychoanalysis, *The Pilgrimage of Henry James* was actually a novelization of James's life. By freely putting unsubstantiated thoughts in his characters' minds and unsubstantiated words in their mouths, Brooks evidently hoped to get closer to the predicament of the creative individual in tension with American society. Despite its dubious method, *James* was a superior book to *Twain*, more incisive, more convincing. It was also closer to Brooks's own experience and his own ambivalent feelings toward his country.

Unable to compromise his talents as Twain allegedly had, Brooks was yet unable to turn his back on America as had James. Seeking a synthesis from the Twainian thesis and the Jamesian antithesis, Brooks began a study of Ralph Waldo Emerson, whom he had redis-

covered—or truly discovered for the first time—largely through the influence of Lewis Mumford. Eventually, in 1932, Brooks would publish his full biography of Emerson—an intimate, affectionate, admiring portrait that demonstrated Brooks's abandonment of his long quarrel with America and his reconciliation with his country's cultural past. But before he could finish the Emerson book, he had to work his way out of a severe mental breakdown suffered in 1925–26. Although it would be melodramatic to explain Brooks's schizophrenia (as his illness was finally diagnosed) in terms of his still-unresolved intellectual conflicts, his inability to achieve some kind of equilibrium in his critical outlook must have added to his intensifying emotional distress. At any rate, as Brooks found his way back to sanity, he also found his way to a positive, often celebrational treatment of the national literature. His book of essays called *Emerson and Others,* published in 1927 in the throes of his illness and containing much that would later show up in the Emerson biography, clearly indicated the direction Brooks was heading.[55] Despite its harsh closing chapter on "The Literary Life in America," *Emerson and Others* was a turning point in Brooks's career, the beginning of a process of rediscovery, reappraisal, and reconciliation that would occupy him for nearly the rest of his life.

## VIII

Brooks had first met Lewis Mumford in the spring of 1921 at the *Freeman* offices. He had been quickly impressed by the tall, dark-haired, strikingly handsome Mumford, a native New Yorker nine years Brooks's junior. The enormously gifted Mumford had the distinction of being neither a high school nor a college graduate. Initially intending to be an electrical engineer, he had left public high school in 1912 determined to become a writer. While he worked as an inspector in the garment industry, as a laboratory helper for the U.S. Bureau of Standards, and as a naval radio operator, he accumulated credits at the City College and at Columbia and New York universities but never finished a degree. Mumford got on as an associate editor of the *Dial* in 1919 and then came to the *Freeman.* After the *Freeman* ceased publication early in 1924, Brooks and Mumford continued their association in various ways, including an initial collaboration on *The American Caravan,* a series of annual anthologies of new American fiction and poetry.[56]

Mumford's interests were far ranging, much more so than Brooks's or the other prewar and postwar cultural nationalists'. Besides a thorough grounding in American literary history, which the others

generally lacked, Mumford also was knowledgable in the nonliterary arts and in science and technology. His *Sticks and Stones* (1924) was the first effort to survey the development of American architecture and building techniques from their beginnings.[57] After the twenties Mumford became increasingly preoccupied with the historical study of the city, the humanistic implications of technological change, and the cause of regional and urban planning.

Yet Mumford's writings on American literature were among the most significant of the postwar decade. Though younger than the *Seven Arts* critics, Mumford shared their passion for an American renaissance and their conviction that it was first necessary to confront American failure before there could be a freeing of the creative spirit. At the same time, he did not share their rabid anti-Puritanism, their belief that America's spiritual ills could be explained by reference to something called the Puritan tradition. In his architectural writings, in fact, he praised the careful planning and orderly development of seventeenth- and eighteenth-century New England towns and the functional beauty of Puritan building.

More broadly, it was the destruction of the "medieval synthesis" by the Protestant Reformation and the transference to America of "an abstract and fragmentary culture" that explained the inability of Americans to achieve an organic, harmonized civilization. In the context of the American wilderness, the worship of a compartmentalized, practical knowledge had reigned supreme. Only in the middle decades of the nineteenth century had some creative Americans—most of all Emerson, Whitman, Melville, Hawthorne, and Thoreau—been able to rise above the prevailing utilitarian ethic and strive for "a complete society" by themselves "carrying on a complete and symmetrical life. . . ." Those men had been at the center of the literary flowering that Mumford called "the golden day."[58]

The triumph of business enterprise in the post–Civil War period had submerged the spirit of the golden day. The utilitarian ethic gained new sanction in the philosophical pragmatism of James and Dewey, with their insistence on the primacy of concrete experience, their rejection of a priori values, and their affinity for the empirical method. The pre–World War I progressive reformers—for all their well-intentioned efforts to expose political corruption, improve government, and better the material conditions of Americans—had not understood that "the essential poverty of America was a qualitative poverty, one which cut through the divisions of rich and poor; and it has been this sort of poverty which has prevented us from projecting in the imagination a more excellent society." Thus while contemporary American life was more complicated than in Emerson's day, it was

not more significant; richer materially, it was not richer in creative energies.[59]

Mumford's major purpose was to demonstrate to his contemporaries, maybe most of all Brooks, that if constructing a usable past was a matter of confronting creative failure, it was also a matter of identifying and making use of creative success. Excessive concentration on the frailties of Twain, Howells, or Henry James—frailties Mumford did not dispute—obscured "the afterglow of a far more brilliant sunset," America's earlier golden day.[60] Mumford actually succeeded twofold— not only in providing a remarkable reinterpretation of the literary past but also in strongly influencing the literary present, to the extent that he altered the thinking of Brooks, the most influential interpreter of the past for a generation of insurgent Americans. "In your glowing appreciation of the *golden age*," Brooks wrote Mumford in the summer of 1926, "you have done the *positive thing* which the rest of us have mostly left out."[61]

Mumford's other main contribution to American literary opinion in the twenties was his biography of Herman Melville. Published in 1929, Mumford's book capped a decade of growing recognition that Melville was one of the country's most powerful and profound literary artists.[62] After 1919, the centennial of Melville's birth (as well as Whitman's), and especially after the publication of Raymond Weaver's major biography in 1921, Melville's reputation was thoroughly rehabilitated.[63] No longer dismissed as chiefly a writer of South Seas adventures, Melville came to appear as a towering literary presence, a man whose creative powers reached their peak with *Moby Dick* in the 1850s but by no means ended there.

At the same time, Melville, the rebel against literary conventions, the critic of American social values, the mystic seeker, became another part of the usable past, another study in the frustration and anguish that had so often been the lot of the artist in America. Melville now joined Whitman as a gallant battler against the overbearing Puritanism and philistinism of his day. That was the way Weaver saw Melville in 1921 and basically the way Mumford saw him eight years later, except that to Mumford, Melville's chief enemies had been utilitarianism and materialism. By that time, it might be added, not only had Brooks come to share Mumford's admiration for Emerson but some of Mumford's enthusiasm for Melville had rubbed off as well. While Brooks remained convinced that *Moby Dick* was Melville's only major achievement, he did describe that book in *Emerson and Others* as "our sole American epic. . . ."[64]

Brooks's volumes on Twain and James, Weaver's and Mumford's on Melville, and other literary biographies written in the twenties, like

Joseph Wood Krutch's study of Edgar Allan Poe and Newton Arvin's of Hawthorne, in effect offered a case-study approach to the task of finding a usable past and laying the bases for a national culture. Contemporary reviewers often equated such books with the iconoclastic, "debunking" mood that supposedly prevailed in American biographical writing in general during the twenties. In reality what Brooks and the others were doing was to perpetuate the idealistic concerns of prewar romantic nationalism. Their books were actually less biography than a "type of cultural martyrology for their own times."[65]

## IX

Many years after the storms of the twenties had passed, Mumford remarked that he, Brooks, Bourne, Frank, and Rosenfeld had been "fellow workers in the task of reclaiming our American literary heritage." Meanwhile "the disillusioned expatriates of the 'lost generation' . . . were traveling in the opposite direction."[66] Brooks as well later came to distinguish between the prewar and postwar generations of American intellectuals and artists. The younger men and women of the twenties, Brooks felt, had been too much influenced by the debunking spirit, by the gloomy forecasts for Western civilization offered in such books as Oswald Spengler's widely read *The Decline of the West* and Henry Adams's posthumously published memoirs,[67] and by a general sense of betrayal in the war's aftermath. To Europeans, America had still represented the hopeful future, but to "its most sensitive minds it was darker than the old world and filled with nothing but defeat, degeneration and failure."[68]

Brooks wrote that description twenty-five to thirty years after the fact, out of his own disappointment with the course of American imaginative literature since the twenties. But his recollections, as well as Mumford's, point up the ironic fact that two men who had worked hard and successfully to carry forward the idea of a national culture should later, at least by implication, minimize their own efforts and those of quite a substantial number of like-minded people in all the American arts. In short, Brooks and Mumford ended up buying the legend of the Lost Generation—and fitting that legend into their own jaundiced view of the twenties.

One of their principal objections—both at the time and later on— was to the self-conscious expatriation undertaken so fashionably by so many of the younger generation in the years after the First World War. Except for Harold Stearns and a few others, those who had been active in the prewar Insurgency stayed at home during the twenties or

left the country only for brief periods. Yet contrary to what Randolph Bourne had prophesied, younger intellectuals and artists commonly went to live for protracted periods in London, Berlin, Rome, or, most of all, Paris. Besides the extremely favorable exchange rates their dollars commanded in the postwar years, Americans were drawn to Europe for a variety of reasons. Some yearned to resume the encounter with the Old World begun during their wartime service. Others sought firsthand exposure to the antiformalist influences in literature and the other arts. Still others just wanted to be able to drink good liquor freely at a time when their homeland had gone legally dry. The austere T. S. Eliot in England, the cantankerous Ezra Pound in France and later Italy, and the matronly Gertrude Stein in France provided models of creative individuals who for all practical purposes had cut their ties to America, yet seemed untroubled by the kind of regrets Henry James had voiced late in his life.

The expatriate Americans of the twenties were hardly interested in ideological controversy or political activity, but then neither were most of their counterparts in ideas and the arts back in the States. Waldo Frank is a useful example of what happened to the somewhat older prewar generation. Nominally a socialist during his *Seven Arts* days, Frank had been exhilarated by the Russian Revolution and by the native political radicalism he had found in the western United States right after the war. For a short time he had worked as an organizer in Kansas for the Non-Partisan League. Soon afterward, however, Frank was deep into the study of Judaism, psychoanalysis, and Spanish history and culture. For the remainder of the decade, despite his affiliation with the *New Republic* in 1925 as a contributing editor, Frank's concerns were only marginally political.[69]

While neither expatriates nor stay-at-homes acted especially "lost" in the twenties, it was hard for most of the younger critics and artists to take themselves as seriously as Van Wyck Brooks, for example, had always taken himself. Thus Edmund Wilson could imagine a dialog between Brooks and F. Scott Fitzgerald, Wilson's Princeton classmate, on the joylessness and lack of vitality in American life. "It just struck me as ironic," Wilson wrote H. L. Mencken in 1922, "that while Fitz and [his wife] Zelda were reveling nude in the orgies of Westport (summer before last) Brooks in the same town, probably without ever knowing they were there, should have been grinding out his sober plaint against the sterile sobriety of the country."[70]

Fitzgerald, for all his revelings and lavish living on both sides of the Atlantic, did work at his craft with the utmost seriousness and determination. So did the other new artistic talents of the postwar period—Ernest Hemingway, John Dos Passos, William Faulkner among

the fiction writers; Hart Crane, Wallace Stevens, Marianne Moore among the poets; composers like Aaron Copland and Roy Harris; painters like Charles Burchfield, Edward Hopper, Stuart Davis, Thomas Hart Benton. Their dedication was at least as great as any previous generation's, and if they lacked compelling issues and causes to inspire them, they found sufficient inspiration in their own struggles for personal fulfillment—for the full realization of their potential as creative artists.[71]

The similarities and continuities between the somewhat older and somewhat younger groups of critics and creators are at least as important as their differences. The twenty-five-year-old Edmund Wilson sounded remarkably Brooksian when he complained in 1920 about "the gulf in American literature." Wilson saw a great division in American life and thus in American art between refinement and vulgarity, the educated elite and the masses. Could the gulf be closed? At first Wilson was doubtful; maybe both genteel elitists like Henry James and Henry Adams and "the born poets and prophets with no background save the soil," like Twain and Dreiser, would be submerged in the rising tide of mass vulgarity. Yet again, there were hopeful signs. There did seem to be a new demand for ideas and beauty, as evidenced by the poetry renaissance, the little-theater movement, and other stirrings in recent years. For all of America's crassness and repressive morality, "one cannot help feeling that both art and intelligence have more life in them to-day than they had in the unleavened half century which drove Henry James to England and Henry Adams to France."[72]

Like the prewar insurgents, the younger malcontents complained but also exhorted, wished but also hoped. Walt Whitman remained a hero to both groups, and Whitman's vision of a whole America, its people liberated in body as well as in spirit, had if anything a stronger appeal in the twenties than in the prewar period. Powerful reinforcement for the Whitmanian creed came from the controversial British novelist D. H. Lawrence, who wrote part of the time in Europe but also spent a good deal of the decade in the United States. Preaching an organic, sexually centered philosophy and arguing the need for man's repudiation of machine civilization and his reunion with nature, Lawrence was widely read, damned, and praised on both sides of the Atlantic.[73]

Many prewar and postwar malcontents shared Lawrence's quarrel with machine-age civilization, as well as his contempt for Puritan and pioneer influences and the ethic of practicality. They saw the nationwide effort to ban liquor as the ultimate folly of a repressed and repressive land, of an emotionally splintered people for whom personal fulfillment usually translated into money and power. Like their critical

predecessors, twenties critics and artists often damned the Middle West as the heartland of American self-righteousness and spiritual stuntedness.[74] The "revolt from the village"—from the kind of place typified by Sherwood Anderson's Winesburg, Ohio, and Sinclair Lewis's Gopher Prairie, Minnesota—became one of the reigning intellectual clichés, even though, as before the war, relatively few of those in revolt had actually come from the village.

George Bernard Shaw might announce in the twenties that at last America was "producing an art of its own instead of merely boring Europe by returning its exports with all their charm rubbed off." Shaw's fellow Irishman St. John Irvine, a lesser but still highly respected playwright, might surprise his readers with the observation that "the average mind in America is better than the average mind in England, so far as the appreciation of literature is concerned."[75] Such assurances meant little to men and women affecting the posture of alienation from their country and seeking the perspective of self-exile. From that wholly different perspective, it might be easier to understand why America was as spiritually backward as it was. By fulfilling one's own potential, one might, in some small way, open up the prospects for an American renaissance.

Ezra Pound, as Warren Susman has shown, pioneered in this "functional" role for the expatriate. In Pound's view, the expatriate should act as an overseas agent for American culture, editing little magazines, encouraging young talent, transmitting ideas and formal innovations, generally serving as a liaison between Europe and America. In the absence of a single American cultural capital on the traditional European model, Pound came to see Paris as the potential focus of the American Risorgimento. Thus Pound's move in 1920 from London to Paris signaled and symbolized the ascendancy of Paris as the West's cultural capital, the main place Americans might go to achieve the most effective angle of vision on oneself and one's country.[76] Or as Malcolm Cowley expressed it in 1922, "The last century of American literature might be diagrammed as a progression away from London. . . . intellectually no city is as far from London as is Paris."[77]

Yet, as Brooks wrote much later of the expatriates, "They were as full of their country as the Spaniards were of Spain or the Poles of the 'Polish question', while their great aim was to escape from the 'moral obligation to be optimistic' and from 'Protestant morality' and 'success' in American terms." Cowley, an ambulance corps veteran at twenty who went to France to become a poet and critic, summarized his generation's Eurocentrism, its belief that "Art and ideas were products manufactured under a European patent; all we could furnish toward them was raw talent. . . ." In everything, Cowley remembered, "in every

department of cultural life, Europe offered the models to imitate—
in painting, composing, philosophy, folk music, folk drinking, the
drama, sex, politics, national consciousness. . . ." Even so, Cowley has
also described the mingling of nostalgia with estrangement in the
expatriates' outlook. "In Paris or Pamplona, writing, drinking, watch-
ing bullfights or making love," as Cowley recalled, "they continued to
desire a Kentucky hill cabin, a farmhouse in Iowa or Wisconsin, the
Michigan woods, the blue Juniata. . . . They were deeply attached to
[America], no matter what pretense they made of being indifferent
and cosmopolitan, but they felt it had rejected them."[78]

Harold Loeb, founder of the expatriate monthly *Broom* (and the
inspiration for the sad Robert Cohn in Hemingway's novel *The Sun
Also Rises*), wrote in the memoirs of his expatriate period that all
along he had "questioned the desirability of universality. Perhaps in
caveman days culture approached universality, but ever since, diversi-
fication had enriched human life." Loeb saw his objective as being "to
help Americans find out what they themselves meant. The more differ-
ent cultures on the earth's surface, the richer human life would be, or
so I felt." Alfred Kreymborg, Loeb's associate on *Broom,* thought his
expatriate's angle of vision enabled him and his friends to see America
more clearly. "A number of crude, powerful forces had emerged from
the soil across the Atlantic," Kreymborg realized. He now saw them
"as so many skyscrapers trying to brush the heavens and lifting the
consciousness of the race, however slow, timid or sceptical, to a forth-
right future in which love, life, and beauty might at last have room
for something to resound."[79]

# X

Starting up little magazines in foreign lands for the benefit of
American readers occupied a substantial number of the American
seekers who lived abroad during the twenties. Nothing they did,
though, equaled the overall quality of the New York–based *Dial,* whose
life as spokesman for cultural avant-gardism almost exactly spanned
the decade. At the end of 1919 the course of the *Dial*'s development
had again changed dramatically when Martyn Johnson sold out his
interests in the magazine. Scofield Thayer and John Sibley Watson,
the new publishers, abandoned the liberal-radical political orienta-
tion and the explicit cultural nationalism of Johnson's *Dial,* several
of whose contributors now joined the *Freeman.* Appearing monthly
in an overhauled format, the new *Dial* listed Thayer and Watson as
coeditors, although Watson actually stayed in the background and left

the running of the magazine to Thayer and Marianne Moore. A remarkable number of exceptionally talented young people—Kenneth Burke, E. E. Cummings, Malcolm Cowley, Hart Crane, Jean Toomer, to name a few—gravitated to the *Dial*. The monthly also featured such leading avant-gardists as Pound, Lawrence, and Eliot (whose "The Wasteland" the *Dial* published in full in November 1922), as well as established men like George Santayana, Thomas Mann, and Bertrand Russell. Criticism occupied about three-fourths of each monthly issue; the remainder went to fiction, poetry, and reproductions of experimentalist line drawings, paintings, and sculptures by both American and European artists.[80]

The *Dial*'s interests and sympathies were clearly with artistic modernism both at home and abroad. Sherwood Anderson, an innovator in subject matter, perhaps, but hardly in form, as well as Van Wyck Brooks and Waldo Frank occasionally published in the *Dial*. Paul Rosenfeld, always more attuned to the currents of modernism than his friends from the *Seven Arts* period, was a regular contributor to the magazine. In general, though, the *Dial* had little use for the kind of historically and socially grounded criticism identified with the early *New Republic,* the *Seven Arts,* the 1917–20 *Dial,* and then the *Freeman.* In 1924 the *Dial*'s annual literary award of $2,000 went to Brooks, who had published some chapters of his impending James biography in the magazine. Yet in its announcement of the award the *Dial* acknowledged that "it fails to accept the whole body of his doctrine." In truth, the immediate group around the *Dial*, developing theories of art that held matters like personality and social context to be extraneous to the analysis of formal expression, doubted that Brooks was a literary critic at all. In turn Brooks despised the kind of pure estheticism he feared the *Dial* had embraced.[81]

To be sure, the *Dial*'s tastes and tolerances were considerably broader than those of other avant-garde magazines in the teens and twenties. Nonetheless, the *Dial* became the most influential, the most admired, and certainly the most elegant American voice for artistic modernism. Its death in 1929, more a result of fatigue on the part of its editorial staff than of declining finances, symbolically closed a decade that had been more hospitable to many aspects of modernism than the 1930s would be.

Neither the *Dial*'s dominant modernism nor artistic modernism in general precluded strong emotional involvement with America. Charles Ives's music and the architecture of Louis Sullivan and Frank Lloyd Wright proved the compatibility of modernist techniques and romantic nationalist ideals. So did Hart Crane's self-conscious, Whitmanesque strugglings to refute Eliot's morbid vision of modern existence and to

affirm what Crane believed were the life-giving qualities in America's urban, mechanized civilization. And so did the poetry and essays of William Carlos Williams.

Like Ives and the poet-businessman Wallace Stevens, Williams, a practicing physician at Rutherford, New Jersey, had to work at his art in his spare time. Still another apostle of Whitman, Williams was convinced like Whitman and H. L. Mencken that American speech was so radically different from English, not only in vocabulary but in rhythms, as to constitute a wholly separate language. Reviewing the fourth edition of Mencken's *The American Language* in 1936, Williams wrote that "the worst thing of all is to imagine, as we still do, that we speak English. And be proud of it!" The great mistake the St. Louis–born Eliot had made, he contended a few years later, was to abandon "the imperatives of his native language—if he ever knew it!—for English." And as late as 1955 Williams referred to his longtime "concern with a language which had not been taught to us in our schools, a language which has a rhythmical structure thoroughly separate from English."[82]

In his lean, exact poetry Williams tried to capture that rhythmical structure and, by focusing on the history, folklore, and people of his New Jersey locales, to reveal something about both country and cosmos. Though a technical experimentalist—a central figure in the modernist movement in American poetry—Williams believed as much as Van Wyck Brooks that the artist could never cut himself off from his native environment without risking the loss of his creative powers. For Williams culture was not a thing but an act, not "something left over" but the arrangement of all the facts of a people's existence into "an ordered and utilized whole. . . ."[83]

Also as much as Brooks, Williams was out to find a usable past, a past that would serve as "our greatest well of inspiration. . . ." In 1925, in a book called *In the American Grain*, Williams dealt with nearly a score of men out of American history, only one of whom had been primarily a writer. Whereas Brooks studied American writers to learn the lessons of failure, Williams studied people as diverse as Columbus, Cortez, Cotton Mather, and Aaron Burr, Franklin, Washington, Lincoln, and Daniel Boone—not as real historical personages but as mythopoeic figures.[84] As anti-Puritan as anybody, striving always for the kind of organic wholeness of body and mind, individual and collective experience that Whitman had idealized, Williams nonetheless refused either to mourn over his country's shortcomings or to campaign for an American renaissance. Much in the manner of Ives, Williams found the native materials at hand to be plentiful and was content to exploit them on his own terms.

## XI

The broad-based excellence of the *Dial* was one testimony to the changes that had taken place in American cultural life during the span of two decades or so. Henry May has written that by the post–World War I years "it was hard to find a convincing or intellectually respectable spokesman for the prewar faith."[85] Yet while the Genteel Tradition remained at bay in the postwar period, there were still plenty of active defenders of the older idealism and positivism of the traditional culture. How "convincing or intellectually respectable" genteel spokesmen may or may not have been is of course a matter for personal judgment. The fact remains that the decibel level of exchanges between cultural conservatives and insurgents seemed higher than ever after the war, as the romantic nationalists persisted in their attack on genteel values and as modernism and the modernist ethic gained wider currency in American life.

All along, of course, one of the loudest castigators of genteel moralism and artistic sensibility had been H. L. Mencken. In the postwar years Mencken continued to relish his role as aging *enfant terrible,* the scourge of latter-day Puritans and genteel uplifters, not to mention prohibitionists, religious fundamentalists, Ku Klux Klansmen, and the business-minded middle class—Mencken's "booboisie." In 1924 Mencken and his colleague from the *Smart Set* George Jean Nathan gained an even more effective vehicle for their blasts at benighted America when they established the monthly *American Mercury*.

For all his broad tolerance of anything that ran contrary to the old order, Mencken was never very close to the avant-garde, even in literature, his main interest. As a critic he continued to work in the line of Saint-Beuve and Taine; like both genteel traditionalists and romantic nationalists, Mencken was interested less in the creative object itself than in its historical, social, and psychological context. Thus his long sponsorship of the fiction of Theodore Dreiser had to do largely with Mencken's liking for Dreiser's gloomy, deterministic view of human nature and his frank treatment of sexual motivation. Those qualities in Dreiser's work, together with the shocked reactions to his novels in genteel critical circles, were to Mencken more than sufficient compensation for Dreiser's ponderous prose and frequently shallow characterizations.

Dreiser was also a German-American, and he endeared himself to Mencken even more by joining him in opposition to American involvement in the war in 1917. With considerable courage, Mencken refused to moderate his Anglophobia and continued to boast of the

glories of German culture at a time when German speech, philosophy, music, and even cuisine were under attack throughout the country. Not surprisingly, Anglophilic genteel critics denounced Mencken as a traitor and a subversive. For the younger postwar insurgents, however, Mencken seemed even more lovable—or at least admirable—for the enemies he had made.

Of those enemies, the most vociferous and the one with whom Mencken carried on the sharpest quarrel was Stuart Pratt Sherman. Although he was born in 1881 in rural Iowa and was raised in that state and in Los Angeles, Sherman had strong ancestral ties to New England. It was there that he sought his education, earning his undergraduate degree at Williams College and his Ph.D. in literature in 1906 at Harvard, where he came under the astringent influence of Irving Babbitt. After a year at Northwestern University, Sherman joined the English Department at the University of Illinois. In basic sympathy with Babbitt's and Paul Elmer More's antiromanticism and their growing aversion to modernism, Sherman became a frequent contributor to the *Nation* in the years of More's editorship.[86]

On the title page of a collection of his *Nation* essays, dedicated to More, Sherman quoted Matthew Arnold's caveat against romanticism: "Man must begin, know this, where nature ends." "The great revolutionary task of nineteenth-century thinkers," Sherman added, "was to put man into nature. The great task of twentieth-century thinkers is to get him out again. . . ." Too many of their contemporaries, he lamented to Brander Matthews, were bent on "tossing and goring the poor old 'moral law' . . . ."[87]

Usually affable and easy-going in his personal relationships, Sherman let his affection for Great Britain and British letters get out of hand when the United States finally went to war on Britain's side. More than ever, Sherman saw the Anglo-Saxon tradition coming down through New England Puritanism—the tradition that taught duty, sobriety, and self-discipline—as the essence of true Americanism. Mencken, in his fondness for Nietzschean amoralism and his contempt for traditional American values, and Dreiser, in his portrayal of man as caught in the web of his primal, bestial instincts, were both dangerous influences, inhibitors of the kind of single-minded dedication the cause of democracy demanded. Sherman attributed Dreiser's "barbaric naturalism" and all other deterministic ways of thinking to modern German philosophy and art. Both Mencken and Dreiser were examples of the "spiritually alien strain in our recent literature," a consequence of "the later importations of European blood and culture."[88]

Through the war years Sherman served as the most militant spokesman for those who despised both the older romanticism and estheticism

and the newer influences of naturalism and modernism. After the war, though, Sherman cooled down considerably; by 1922 he could describe Harold Stearns's *America and the Young Intellectual* as "fun" and suggest that such books "can be treated as effectively with banter as with bludgeon."[89] Gradually he began to come to terms with the new literary currents, even offering qualified praise for Dreiser. Sherman came to believe it might be possible, in the interest of marshalling American talent behind the cause of a great national literature, to achieve some kind of accommodation between the warring literary factions. With the conscious intent of serving that cause and working for that accommodation, he left academe in 1924 to assume the editorship of the New York *Herald-Tribune*'s literary supplement. He wanted, he wrote his friend William Crary Brownell, "to get the Emersons and the Jacksons together, and their offspring to intermarry." By the time Sherman died of a heart attack while swimming in Lake Michigan in the summer of 1926, he was frankly at odds with Babbitt and More, whom he now regarded as out of touch with the best American writing.[90]

Even so, Sherman remained to the end basically a humanist. Along with Babbitt and More, he believed in moderation as the central rule of life, in man as a rational being whose reason and innate moral sense set him above and apart from other organisms, and in the need for human spiritual regeneration. Sherman softened his rhetoric and his judgments in the 1920s, but Babbitt and More, his earlier mentors, set themselves more determinedly than ever against contemporary trends in ideas and the arts. With the passing years these men had kept a small but devoted following. Now they and those who shared their views undertook to state their case in a systematic, unified fashion. The New Humanism was the name they took for what had become, by the end of the twenties, a formidable and coherent intellectual movement.[91]

Despite their disdain for the shallowness and sentimentalism they found in American literature around the turn of the century and their efforts to enrich and dignify the country's criticism, More and Babbitt never abandoned their essentially moralistic approach to art. Like Brooks, Bourne, Mumford, or Mencken, More and Babbitt had been preeminently concerned with broad issues of value and conduct, issues expressed in but not confined to art. Just as the romantic nationalists and their uneasy modernist allies persisted in their offensive against the Genteel Tradition, so the New Humanists were unrelenting in their condemnation of romanticism, estheticism, and, most of all by the twenties, the deterministic bases of literary naturalism. Ironically, some of the country's most thorough malcontents were some of the

same people Randolph Bourne had regarded as the smug and satisfied enemy.

The quarterly *Hound and Horn* and the monthly *Bookman* were especially hospitable to New Humanist writings. In those magazines and elsewhere, critics like Norman Foerster of the University of North Carolina, Robert Shafer of the University of Cincinnati, and Frank Jewett Mather of Princeton University joined More and Babbitt to inveigh against what More called "the all-invading currents of irresponsible half-thinking. . . ." More likened John Dos Passos's novel *Manhattan Transfer* to "an explosion in a cesspool" and hissed at "brawling vulgarians like H. L. Mencken. . . ."[92]

The New Humanist movement reached its apex early in 1930 with the publication of the symposium *Humanism and America*. Edited by Foerster, the collection consisted of fourteen essays by Babbitt, More, Mather, Shafer, and an interesting assortment of others, including the former little-magazine insurgent Gorham B. Munson and T. S. Eliot, who by this time had managed to accommodate his technical avant-gardism to a fervent Anglo-Catholic traditionalism. *Humanism and America* was the supreme systematic statement of New Humanist social philosophy and esthetics. In his introduction Foerster succinctly defined humanism as "a working philosophy seeking to make a resolute distinction between man and nature and between man and the divine." In its formative phase in the period of the Renaissance, Foerster said, humanism's great foe had been medieval otherworldliness. In the twentieth century humanism confronted "this-worldliness, obsession with physical things and the instincts that bind us to the animal order. . . ." And inasmuch as the United States now tended to set the pattern for other nations in thought and practice, humanism's most powerful challenge had come in America.[93]

Widely reviewed and heatedly discussed, *Humanism and America* occasioned a hastily put-together collection of rebuttal essays by both socially oriented critics like Edmund Wilson, Lewis Mumford, and Malcolm Cowley and estheticians like Kenneth Burke and Yvor Winters.[94] In May 1930 New Humanist spokesmen and their adversaries even staged a debate in Carnegie Hall.

But the New Humanist dispute belonged essentially to the 1920s. The excitement it stirred up passed quickly, leaving little evidence of the long and ofttimes bitter quarrel that had flared after 1900 and finally came to a head in 1930. Babbitt died in 1933 and More followed him four years later. With them died much of the intellectual prowess behind the once generally accepted belief that art should uplift and ennoble, should express and inspire the best in human nature. Meanwhile the Great Depression—the central, transforming event of the 1930s—

had closed in on the country. Singly or in small groups, most of the no longer young expatriates had made their way back to an America stricken by an intractable and ravaging economic malaise.

The twenties was an extraordinarily dynamic period in the history of American criticism and artistic creativity. Much of that dynamic had to do with the two- and sometimes three-sided battles between surviving but still-vocal traditionalists, still-strident romantic nationalists, and increasingly confident modernists. The controversy over the New Humanism was only one manifestation of the remarkably diversified character of American cultural thought in the twenties. Similar clashes of critical opinion also enlivened the course of American music, drama, visual art, architecture, and the increasingly pervasive and talked-about popular entertainments. Those encounters, swirling around the central issue of a national culture, help illumine the complex history of ideas and art in the American 1920s considerably more than does the notion of a sour and cynical Lost Generation.

# This Hot Chaos
# of America

ALFRED STIEGLITZ SOMETIMES REMINISCED THAT DURING HIS STUDENT days in Europe in the 1880s, he had seen many wagon-hitched stallions standing in the city streets, their half-erect, swaying penises in full view for anyone who happened to look. "In New York," Stieglitz liked to point out, "such a thing would not be permitted. All the horses in the city are geldings." And in 1923, as a way of typifying his country's overweening prudery, Stieglitz photographed the underside of a harnessed gelding on a Manhattan street. He called the picture "Spiritual America."[1]

Sentiments such as Stieglitz's abounded in American intellectual and artistic circles in the 1920s. Verbally and visually, images of spiritual emasculation and starvation were in common usage to describe the state of thinking in a country where the sensitive, creative individual supposedly had always had to struggle against the stifling influences of Puritan, pioneer, and profiteer. The twenties may not actually have spawned a rootless, alienated Lost Generation; nonetheless, the decade brought intensifying intellectual protest against the governing attitudes and values in American society. More prosperous than ever, the masses of Americans, so the complaint went, were only grubbier and greedier than ever, more philistine and less appreciative of nonmaterial considerations. "Americans are still a very well satisfied (smug) overfed people—A people disliking direct thought," sighed Stieglitz in 1928. Or as George Jean Nathan put it, with characteristic hyperbole, "The American landscape presents currently the spectacle of a slaughter-house of taste. . . . The view is of an unbroken succession of abattoirs, each bursting with the profits of its depravity."[2]

# I

There was, though, another side to the complaint about America's suffusive materialism. Above all, the twenties was a period of material abundance for the United States. Economists and economic historians have long debated how deep and inclusive the prosperity of the period really was. The fact remains that especially in the years 1923–29, the American people as a whole were materially better off than they or any other people had ever been. Americans were able to afford more of just about everything, including culture. They spent more money on what elitist critics considered idle diversion—popular magazines and phonograph recordings, cheap fiction, sporting events, motion pictures—than they spent on "high culture." A vast surplus, though, remained for the support of the traditional arts. In retrospect, it is apparent that for all the constraints—legal, moral, and otherwise—under which the American creative artist still worked, his situation in the 1920s was generally advantageous. By 1925, four years before his death, Robert Henri had come to believe that "today, there is a greater chance in this country to work, . . . a greater general appreciation of the student of art and of life than perhaps ever existed in the world's history."[3]

Despite F. Scott Fitzgerald's dead gods, despite Gertrude Stein's Lost Generation, despite Frederick Lewis Allen's well-turned portrait of a "highbrow" class gone sour on all forms of idealism, renewed inquiry into the history of American thought and culture in the twenties highlights the potent workings of a hopeful, often buoyantly confident cultural nationalism. Even Allen, after noting the remarkable achievements in the arts coming out of the decade, had to acknowledge that "the idea was gaining ground that this fresh and independent work might . . . be genuinely native, that the time had come when the most powerful nation in the world might rid itself of its cultural subjection to Europe." Back in 1913 Randolph Bourne had admonished his countrymen to put aside their inherited, Europeanized notions of taste and develop their own self-sustaining "inner taste" out of the amorphous present—out of "this hot chaos of America."[4] In the twenties, as never before, the American arts focused on the American spectacle in an effort to give form and meaning to that hot chaos.

The task was "to attempt a realistic presentation of the whole gaudy, gorgeous American scene."[5] That was the way H. L. Mencken and George Jean Nathan stated the intent of the *American Mercury,* the new monthly magazine they inaugurated at the beginning of 1924. One

of the many paradoxes in the cultural history of the twenties is that two generations of scholars, taking their cue from Frederick Lewis Allen, have tended to see that magazine as the principal embodiment of the decade's purported intellectual cynicism. The fact is that the *Mercury* continuously exhibited a zestful, nearly all-encompassing fascination with American life. Ambivalent but ultimately cheerful, the *Mercury*'s posture toward America mainly reflected the thinking of Mencken, who delighted in the amazing diversity of his countrymen and their unpredictable, frequently irrational behavior. As Ernest Boyd observed in the *Freeman* in 1921, "no European can read Mr. Mencken without feeling how absolutely and unmistakably American he is."[6]

To be sure, the *Mercury*'s wide range of contributors and Mencken and Nathan in their regular columns fired away at a crowded gallery of foes. Politicians and real estate promoters, fundamentalists and medical faddists, superpatriots and small-town literary societies all came in for their share of ridicule. The magazine's famous "Americana" section, an array of local news notes sent in from around the country, poked fun at midwestern insularity, genteel morality, and other American traits. One way of looking at that feature, however, was that it, like much of the rest of the *Mercury,* amounted to a monthly celebration of national eccentricity.

The *Mercury* also published a number of forthright cultural nationalist declarations. Charles Henry Meltzer, for example, pleaded for an end to foreign domination in America opera. Lewis Mumford advocated a natively and functionally expressive American architecture. Thomas Craven demanded an American school of painting and sculpture.[7] Mencken was sympathetic to almost anyone who had something to say against artistic gentility, which he loosely identified with the alien and enervating influence of Anglo-Saxonism.

Even more closely involved with the hot chaos of America was the urbane, handsomely illustrated *Vanity Fair.* Founded in 1913, *Vanity Fair* had never abandoned its disdainful attitude toward reformers. It had, though, abandoned the disdain for popular taste that had prompted its declaration in 1917 that "of course, 'democratic' is an absurd adjective to apply to any art. Art is aristocratic and arrogant. . . ."[8] By the twenties the big and expensive monthly was covering everything from the booming spectator sports to Hollywood movie personalities, from jazz bands and blues singers to auto design, from avant-garde sculpture to comic strips.[9] What distinguished *Vanity Fair* —aside from its expensive format and the absence of fiction—was the quality of its contributors and the fact that its tastes encompassed both popular culture and avant-gardism. *Vanity Fair* both reflected

and promoted a developing intellectual awareness of the powerful hold the mass entertainments had on the American consciousness, and at the same time aided the further downgrading of the older genteel culture.

Akin to *Vanity Fair,* at least in outlook, was the *American Parade: A Magazine in Book Form.* Appearing for only four quarterly issues in 1926, each separately hardbound, the *American Parade* published mostly fiction and verse. Yet the magazine's credo, as stated by Editor Walter Adolphe Roberts, could have served quite well for either *Vanity Fair* or the *American Mercury:* "There is a circus going by the door. This magazine is vastly interested in the circus, but has no scheme for reforming it. We shall cheer whatever is beautiful, or strong, or amusing in the big show, and leave the rest to the dullards." The *American Parade* offered a good deal of commentary on popular culture, particularly in Walter Haviland's "Forays in the Seven Arts" column. Haviland argued that skyscrapers, the movies, jazz, vaudeville, comic strips, and modern mass advertising were all genuine art forms, "motivated by a cult of energy, which replaces the spirituality to be found in European art." Far from bemoaning the American preoccupation with money and possessions, the *American Parade,* Roberts said, "perceives a hard, clear beauty growing out of our materialism, because, no matter how blunt the manifestation, there is to be discerned an imperial quality unmatched since Ancient Rome." And in his magazine's final issue (October 1926), Roberts advised current American expatriates to remember the early Romans who had gone to Athens in search of art and life. Americans should plunder Paris for ideas, love her and then leave her, not emulate those Romans who had tried to make themselves over into Athenians.[10]

The short-lived *American Parade* would be of scant significance if it did not represent an important but generally overlooked strain in twenties cultural criticism: an all-embracing, exultant romantic materialism. Harold Loeb's *Broom,* published abroad for three years and then in New York for part of another, expressed such sentiments even more vividly. Unlike those on both sides of the Atlantic who were either hostile or ambivalent toward modern technology, the group around *Broom*—Loeb, Alfred Kreymborg, Matthew Josephson, Malcolm Cowley, and to a lesser extent Hart Crane and William Carlos Williams—passionately embraced both the machine as the chief symbol of American civilization and the commercialized mass culture made possible by machine production. Fascinated with movies, advertising, detective fiction, and black blues, Loeb declared that the machine was "indigenous to America and reflective of the nation's emerging identity.

. . ." With Kreymborg, Loeb believed that the expatriates had to come to Europe to comprehend the vibrance and dynamism of America's machine-made civilization.[11]

When *Broom* moved from Rome to Berlin in 1922, Josephson announced that the monthly would combine a "militant modernism" with a vision that would be even "more American." The time had come "to recognize a national art as profoundly American as Baseball, The Jazz Band, The Cinema, and the Dizzy Skyscraper." America would never have an indigenous culture by imitating established European methods of doing art. Here—in their insistence on measuring American achievements by traditional European standards—was where the thirty contributors to *Civilization in the United States* had gone wrong. "It is time to examine our home products sympathetically," said Josephson, "to judge if they are not sprouting with an authentic beauty that justifies their outlandish departures from the past or from previous European traditions."[12]

*Broom* was at least as concerned with promoting artistic experimentation by both Europeans and Americans as it was in promoting the idea of a national culture. Yet its equation of technological prowess with America and its belief that the creative artist would find in machine civilization "an amazing store of fresh artistic material" made it briefly a major voice for a new, expansive kind of cultural nationalism. Big, bright, brutal America, with all your sins we embrace you as an exciting creative source—so might be summed up the credo of the Broomists. Malcolm Cowley put it more elaborately when he said that America was "a conception which must be renewed each morning with the papers. It is not one conception but a million which change daily, which melt daily into one another."[13]

Inaugurating the final, New York phase of *Broom*'s career in the August 1923 issue, Loeb acknowledged that the *Broom* group was "dubious whether a reformed Main Street, with a Little Theatre, Community Pageants, Modern Book Shop and Birth Control Club would be more attractive and happier." Loeb agreed with Van Wyck Brooks that vulgarity and excess abounded in America. Still, there was "a great deal to be said for the American system of going the limit if you are going to go it at all." Josephson added in the same issue that "The large, imaginative, daring, formidable people in America are mostly to be found on the vaudeville stage, in the movies, the advertising business, prizefighting, railroads, Wall Street."[14]

Unfortunately, nobody in the federal government was sufficiently large, imaginative, daring, or formidable to intervene when the postal inspector for New York City banned the January 1924 *Broom* on the

grounds that it included obscene material. The specific offense seems to have been a story by Kenneth Burke that contained a reference to a "plural breasted woman."[15] *Broom* thus went the way of *Camera Work,* the *Craftsman,* the *Seven Arts,* the *Masses,* the *Freeman,* and various other products of the continuing cultural Insurgency.

Matthew Josephson went on to write a book that closed with a plea for an American art appropriate to a machine civilization—something that would organize and give meaning to "the dispersed and scattered beauty" of sleek automobiles, tall office buildings, and gleaming modern kitchens. Oliver M. Sayler, a tireless promoter of artistic modernism in the twenties, similarly urged artists to become "Great Interpreters of a machine culture." Nineteenth-century America had ignored its artists, given them "no life which art could interpret significantly. Machine Age America, on the contrary, is an age rich in opportunity for interpretation, an age pleading for interpretation." Paul Rosenfeld and Waldo Frank were also fascinated by machine culture, at the same time that they reaffirmed their faith in a coming national awakening. "It is not Paris we want," Rosenfeld proclaimed; "it is more New York, more Chicago, more Kalamazoo, Omaha, Kenosha, more loop, more gumbo and gravel, more armature spiders." For Frank, writing in the late twenties, the machine had become the central fact of American life, the key to the "savage worship of cruel forms" in the "American jungle." With Europe a dying continent, more than ever the future lay with America. For all its intellectual and spiritual malnutrition, the country was still "capturable."[16]

During this period in his career, Frank, like Rosenfeld, Josephson, and American intellectuals and artists in general, was basically apolitical. Frank went out of his way to dismiss the assumptions of Herbert Croly, Walter Lippmann, and the rest of the prewar political progressives and radicals as having had little to do with America's real ills, which had always been spiritual. The present political apathy across the country was a good sign, Frank thought, because it meant that American potential could not be diverted into "conventional adjustments. . . ." Robert L. Duffus, surveying the state of the American arts about the same time, agreed that "Politics has lost its importance for us. . . . The channels into which our violent energies can be turned are fewer. . . . Is it incredible that we should turn to the arts, and there write in our scrawling masculine characters the name of America beside the names of Italy and Greece?"[17] Whatever one might say about the coarseness and crassness of contemporary American life, it was hard to deny that the American capitalist system seemed well on its way toward making irrelevant the historic economic bases of political conflict.

## II

In the absence of a consciously formulated esthetic of the machine, the country's industrial designers and craftsmen were already creating a brilliant "applied art." So argued those who acclaimed the "masterpieces" on display at the Metropolitan Museum's sixth annual exhibition of industrial artifacts in New York early in 1922. Later that year a contributor to the *Forum* suggested that a truly American art, if ever realized, would be an art for the masses, derived from and expressive of industrial design. "It is in the factories," he wrote, "that the national ideal is being hammered into shape, not in eerie studios with lights." Albert Sterner, a fashionable New York portraitist, apparently saw no irony in his claim that industrial designers were really "the purposeful art workers in the land and rise in a great many instances to the level at least of the so-called artist. . . ." Applied art—defined as "art which makes something which we need about us beautiful"—was the man in the street's alternative to an increasingly esoteric modernism, maintained Warren E. Cox in the *American Mercury* just before the end of the decade. Better for art "to live to be a wanton than die a pure and lonely maid."[18]

Such thinking paralleled the emergence of a new group of visual modernists, painters who broke away from both the nonrepresentational style of the "291" group and the tradition of Robert Henri and the city realists. Variously called cubist realists, precisionists, or immaculates, such painters as Charles Demuth, Joseph Stella, Charles Sheeler, and Niles Spencer saw an austere beauty in clean, spare machine forms. Their work thus was technically much closer to prewar cubism than it was to either the romantic expressionism of the "291" modernists or the often outlandish experiments of the emigré Dadaists. The cubist realists deliberately chose themes that were familiar, even banal. Stella did several cubistic renderings of the Brooklyn Bridge, and Demuth used a smiliar method to paint such objects as grain elevators, assortments of valves and pipes, and the numbering on a fire truck. Sterile, geometrically arranged industrial landscapes were Spencer's specialty. Sheeler's minutely detailed paintings of ships' decks, Pennsylvania Shaker barns, railroad tracks, and Henry Ford's River Rouge auto plant featured a surface realism that almost matched the photographs of the American landscape for which Sheeler was also gaining notoriety. His paintings and those of the other cubist realists—devoid of living beings and preoccupied with shape, line, and angle—were as much abstract as realistic.[19] Such work was the principal manifestation in the visual arts of a common dis-

position in the twenties to understand American civilization as, for better or worse, preeminently a machine civilization.

Meanwhile, Alfred Stieglitz and the painters associated with the defunct "291" gallery and Robert Henri and the romantic realists were still around in the twenties. Neither group retained much cohesive identity. John Marin, Marsden Hartley, Max Weber, and Georgia O'Keeffe now painted in a more nearly representational way, while Arthur Dove and Alfred Maurer often did abstract collages. The prewar realists were even more disparate by the twenties. In the few years before his death in 1925, George Bellows concentrated on refining the formal values in his pictures as he sought what he called "dynamic symmetry." William Glackens continued to emulate Renoir; John Sloan did nudes and landscapes, experimenting with cross-hatching effects. The postwar work of Henri, George Luks, and Everett Shinn was undistinguished, although in 1923, six years before his death, Henri belatedly published an extended statement of his democratic nationalist ideas.[20]

Stieglitz was more solicitous and protective than ever of the artists he had sponsored over the years. In turn they remained close to him and his activities in New York. O'Keeffe and Stieglitz were married in 1924. Reporting to Waldo Frank in 1920 that "my 'babies' are all producing good work," Stieglitz acknowledged that "that is all I live for. —To help them do that." As Frank prepared to leave for Europe the next year, Stieglitz wrote that "I know the fascination of Europe— but the fight here is the one that is mine." Despite his continuing pontifications on America's shortcomings, Stieglitz mellowed appreciably in his sixties. He even maintained a warm friendship and long correspondence with Royal Cortissoz, perhaps the dean of the surviving genteel art critics. Cortissoz always wished Stieglitz well in his various ventures and penned a glowing appreciation of the modernist patriarch in one of his books.[21] "You know how I feel about some of your men," he wrote Stieglitz in 1928, "but as for the sincerity and valor of your fight for them I can't tell you how sympathetically I cheer you on."[22]

By the late twenties both the genteel elitism of Cortissoz and the modernist elitism of Stieglitz were quite clearly in retreat. The most remarkable development in American painting after 1925 was the appearance of a revived, confident, sometimes clangorous native realism, firmly rooted in the precepts of democratic cultural nationalism. Its leading practitioners were Charles Burchfield of Ohio, Edward Hopper of New York State, Thomas Hart Benton of Missouri, John Steuart Curry of Kansas, and Grant Wood of Iowa. The home-state designations are important. Even though all of them (except for

Burchfield) had studied in France and had spent portions of their careers in Manhattan, they still maintained strong ties to the American hinterland. Benton, Curry, and Wood, in fact, would become the core of a militant midwestern regionalism in the 1930s.

Burchfield, Hopper, Benton, Curry, Wood—these painters, together with a new group of Manhattan realists loosely called the Fourteenth Street School, made up a very general style and a rather distinct outlook, which came to be designated American Scene.[23] Like Henri and the earlier city realists, and unlike most visual modernists, the American Scene painters generally had pronounced views not only on the technical aspects of their art but also on the relationship between the artist and American society. As Martha Candler Cheney pointed out in the waning days of the movement in the late thirties, the American Sceners believed in the unbroken evolution of the art of painting in the Western world. They valued the masterworks of the past and thought established techniques generally adequate for contemporary purposes, as opposed to the modernists, who tended to view stylistic and technical precedents as irrelevant to the demands of a new age.[24] At the same time, the American Scene painters were all strong nationalists, at least interested in, often dedicated to, the realization of a genuinely and distinctively American visual expression. Coming along during a period of growing national artistic maturity, they could afford to be insistent on representational style and native subject matter. The earlier realists around Henri, on the other hand, for all their romanticized renderings of American life, had had to concern themselves mainly with the struggle to win recognition for American artists.[25]

Charles Burchfield, born in 1893 in northeastern Ohio, had won a prestigious scholarship to the National Academy of Design when he was in his late twenties. He spent only a year in New York, however, before returning to his home base at the Cleveland School of Art. Following his discharge from the Army in 1919, Burchfield experimented with modernist technique for a few months, a period he later described as one of "degeneracy in my art that I have never been able to explain." Then he happened to read Sherwood Anderson's fictional sketches of the thwarted, repressed people of *Winesburg, Ohio*. Anderson's book "made me realize," Burchfield testified, "that I was forsaking my birthright." Coming to share Anderson's vision of an America ugly, unjust, and spiritually stunted yet yearning for beauty and expressiveness, Burchfield "began to feel the great epic poetry of midwest American life, and my own life in connection with it." Watercolor was Burchfield's principal medium, the small town his main subject matter. Sometimes satirically, sometimes gloomily, almost al-

ways with rich colors and decorative lines, Burchfield depicted the people and places of the Great Lakes region. "It is simply part of my mental makeup," he said, "that I am satisfied to express my own surroundings as nearly as possible in my own way."[26]

If Burchfield's watercolors suggested a variety of moods, Edward Hopper's oils offered lonely, bleak landscapes and cityscapes and a characteristic preoccupation with stark contrasts of light and shadow. Eleven years older than Burchfield, Hopper was a native of Nyack, a small town upriver from New York City. He had studied in Manhattan at the New York School of Art with Robert Henri and also with Kenneth Hayes Miller, later identified with the Fourteenth Street School of realists. After several years in France and Spain, Hopper returned to the United States and saw some of his work displayed at the 1913 Armory Show. It was not until the late twenties, though, that he really came into his own. By then this sometime expatriate had become thoroughly disenchanted with "international" art. Striving for an intense, highly personal, yet commonly recognizable reality, an art "firmly rooted in our land," as he said of Burchfield's work, Hopper nonetheless remained a ruggedly independent man. The country's foremost painters—George Inness, Thomas Eakins, Winslow Homer, John Sloan, George Bellows—had all been "race-conscious," he said, but "the main thing is the natural development of a personality; racial character takes care of itself to a great extent, if there is honesty behind it."[27]

Of the three men who came to make up the famous midwestern regionalist triumvirate of the thirties, only Thomas Hart Benton had gained much notoriety before 1930. The variegated background of this small, wiry native of Neosho, Missouri, included stints as a teenage newspaper illustrator in Joplin, a Navy draftsman in the war, a night school instructor, a gallery director, a movie set designer, and a student at the Chicago Art Institute and in Paris. In Paris Benton came under the influence of visual abstractionism; some of his abstract paintings appeared in the 1916 *Forum* exhibition. By 1926, when the thirty-seven-year-old Benton became an instructor at the Art Students League in New York, he had left behind his abstractionist phase and was thinking more and more about what he called "My American Epic in Paint." Soon he was at work on a series of murals for the New School for Social Research in Manhattan. Completed in 1930, the New School frescoes put Benton at the forefront of a new generation of American muralists. Featuring bright, even garish coloring and scenes of city life filled with active, seemingly hard-pressed people, Benton's New School murals suggested nothing so much, perhaps, as the kind of revelling in the spectacle of modern America that was such a familiar part of twenties cultural criticism.

Neither John Steuart Curry nor Grant Wood won much critical recognition in the twenties, even though each had done some of his most characteristic work before the decade was out. Stocky, farm-bred, pipe-smoking Curry, born in 1897, was the youngest of the resurgent visual realists. Curry also had gone through the Chicago Art Institute and studied in Paris, with an intervening several years as an illustrator for various popular magazines. By 1930, when Curry had his first one-man show—at the Whitney Studio Club in New York—he had already done the evocative *Baptism in Kansas* (1928), maybe his best-known single canvas. His favorite theme in those years was the clash between rugged agricultural civilization in the wheat belt and the forces of a capricious and often violent nature.

The Cedar Rapids, Iowa, family into which Grant Wood was born in 1892 was chronically poverty stricken. Wood got his first training from a series of art lessons running in the *Craftsman* magazine. Somehow he managed to come up with enough money to pay for periods of study in Minneapolis, at the state university in Iowa City, and at the Chicago Art Institute. After trying his hand at business and at high-school teaching, Wood finally made it to the Académie Julien in Paris, where he was exposed to latter-day French impressionism. In 1928, while he was teaching art in Cedar Rapids, he received a commission to do a stained-glass window for the local American Legion post. Ignorant about stained-glass art, he went to Munich to learn what he could. There he was struck by the hard, sharp clarity and glazed finishes of the late-medieval Flemish and German primitive painters, whose techniques seemed especially promising for the homely, simple subjects he wanted to paint. Wood's window, finally installed in the Cedar Rapids Veterans Memorial, was not noteworthy in itself. Refining the techniques he had learned in Germany, however, Wood began to produce an increasingly acclaimed body of vivid character studies and landscapes. Often working in oil on composition board, Wood both satirized the American past and idealized the present in the American heartland.

Thomas Craven, art critic for William Randolph Hearst's loudly patriotic New York *American,* took it upon himself to publicize and promote the American Scene realists at every turn. For more than a decade Craven crusaded for native realism and against nonrepresentational modernism. Modernists might agree with Henri Matisse that realism was obsolete because "with the advent of photography disappeared the necessity for exact reproduction in art."[28] Craven equated nonrepresentational painting and sculpture with decadence and sterility. Such art, he insisted, could never communicate the feeling of belonging to one country, one place, one people. The whole French-dominated modernist movement after Cézanne was an alien, subversive

influence in American life. Alfred Stieglitz became for Craven "a Hoboken Jew without knowledge of, or interest in, the historical American background. . . ."[29]

Craven was himself a rather recent convert to artistic nativism. Born in the same year as Benton and the same state as Curry, Craven had taken his B.A. at Kansas Wesleyan University, then gone to Paris to study painting and write poetry. "I embarked seriously onto the business of transforming myself into a Frenchman," he later said of his Paris years. When he returned to the United States, he roomed with Benton in Greenwich Village and then enlisted with him in the Navy. After the war he published a novel called *Paint,* about a hard-boiled, rugged individualist painter, doubtless modeled on Benton. In addition to his work on the New York *American* beginning in the early twenties, he contributed frequently to the *Dial* and other magazines.[30]

Craven's *Dial* pieces were general explorations of contemporary European and American art tendencies. He wrote approvingly of Matisse, John Marin, and the cubists, of modernism's "diversity of forms" and concern with "creative thought as opposed to imitation of nature. . . ."[31] Craven was especially enthusiastic about the work of his friend Benton, then still in his modernist phase. By 1925, however, with Benton in the process of repudiating his earlier experiments, Craven began to champion an aggressive realism and nationalism. Now he became a frequent contributor to the *American Mercury.*

Probably the turning point for both Benton and Craven was the early 1925 exhibition at the Daniel Gallery in Manhattan of Benton's series of canvases depicting life in his native Missouri. Craven hailed the paintings as being "of the same texture as American life, which contains beneath its harshness an undercurrent of sadness and idealism." Now he blasted Matisse and his "Negromaniacs and would-be Persians" for their "infantile draughtsmanship" and for worshipping "Congo sculpture, the descriptive scratches of the Bushmen, Peruvian pottery, and everything else that was savage and undisciplined." Craven described Benton, who had not yet actually executed any murals, as "the only mural painter alive. . . ." There was nothing wrong with American visual art, Craven thought, that could not be cured by "a return to the native soil and an honest, concentrated, pictorial exposition of our character and manners."[32]

At the end of the twenties Craven had not yet discovered Curry and Wood, had not linked them to Benton, and had not begun to sound his trumpet in behalf of a whole new school of native visual art. For the moment he was content to praise Benton among present-day painters and, oddly enough, not the hardy realists Homer and

Eakins but their mystical, reclusive contemporary, Albert Pinkham Ryder, among the country's earlier artists.[33] Craven's greatest notoriety would come in the next decade, when his continuing crusade for Americanism in art and his intemperate attacks on modernism would earn him a reputation as the critic who "probably has more enemies among artists than any other living man."[34]

### III

While the term American Scene was not in use among architectural writers in the twenties, if it had been it might well have described the jagged, ever-changing silhouette of the big American city. For a diverse array of American observers—from poets and painters to politicians and professors—the towering office building, more conspicuous in the United States than anywhere else, came to symbolize the authority and majesty of the world's most advanced industrial civilization. The "compelling demand" that had produced American skyscraper architecture, said one writer, was the nation's commerce, just as Rome's empire had compelled its architectural grandeur and the universal church had called forth the building achievements of the Middle Ages. "The skyscraper is the most distinctively American thing in the world," wrote the author of a layman's guide to tall-building construction. It was an achievement "essentially and completely American, so far surpassing anything ever before undertaken in its vastness, swiftness, utility, and economy that it epitomizes American life and American civilization and, indeed, has become the cornerstone and abode of our national progress." In the midst of the great urban construction boom of the late twenties, the architectural critic and historian Thomas E. Tallmadge pronounced the skyscraper "far and away the most important architectural achievement of America, her great gift to the art of building. . . ."[35]

There was more to the buoyant architectural outlook of the twenties than pride in the proliferation of skyscrapers. Pointing to other accomplishments like the recently finished Lincoln Memorial in Washington, the Gothic revival in church and collegiate architecture, and the practical planning that went into the best new American houses, Tallmadge was ready to proclaim that the Renaissance had finally come to an end, that a new age had dawned with the Armistice. In store for the United States were feats beyond those of the Greeks in the age of Pericles or the thirteenth-century cathedral builders. Whereas a few decades earlier Americans had not equaled the work of their European contemporaries in any kind of building, "Today there is

hardly a single type of structure in which an excellent claim cannot be advanced for either our supremacy or our equality."[36]

The 1920s was the last period in the history of American building in which eclecticism—every style and every combination of styles—was an esthetically and professionally respectable way to think about formal design. With appropriate modern variations, neoclassicism continued to be the preferred style for banks, museums, and major government buildings. Gothic remained popular for churches and colleges, while house design continued to feature a great multiplicity of historical styles and influences, as well as American stylistic innovations like the California bungalow and the Cape Cod house. As had been true before the war, eclecticism had the support of architects and critics still wedded to European traditions and also convinced that the United States' variations in climate, people, and topography precluded the dominance of one overall style. "The chances of developing a distinctive American style of architecture seem very slim when one considers the size of this country," said the architect Randolph Sexton. In these same years Herbert Croly was reaffirming his long-standing conviction that the proper course for the nation's architects was to work with established, inherited forms, gradually and cautiously adapting them to American circumstances, making modifications as needed, according to "taste born . . . of local conditions and local experience."[37]

There was still a strong dissident element within American architectural thought and practice, a diverse group of people unable to share the prevailing mood of self-satisfaction, ebullience, and eclectic toleration. At the close of the twenties Henry-Russell Hitchcock regretted the romance of the skyscraper that had marked the period. Thrown up with no concern for surroundings, creating such traffic congestion that already in many cities it was quicker to walk than to try to move about by automobile, the skyscraper had become a modern monstrosity, "called into being for its publicity value and as an imitation of New York, but not as a necessary autochthonous development." Insofar as New York was America, Hitchcock grumbled, then the skyscraper was American. But then, "Is all America to be New York?"[38]

If Hitchcock grumbled, then Lewis Mumford cried out against an architecture that, for Mumford, was the most visible symptom of the malaise of American industrial civilization. And if the *Broom* and other intellectuals exulted in the power and beauty of the machine, Mumford was appalled by what he saw as the brutalizing character of the modern technological order. It was technology stripped of its ties to humanity that had produced the ghastly spectacle of the modern American city—"these labyrinths of subways, these audacious towers,

these endless miles of asphalted pavement. . . ." All of this signaled no triumph for intelligent, organized human effort but rather "its comprehensive misapplication."[39]

Mumford was no Luddite, no pastoralist reactionary. What he wanted was a humanized technology functioning in a rationally planned social order, one that had learned how to integrate machine processes into the overall, organic process of living. There was no reason, Mumford thought, to sacrifice the efficiency, convenience, and cleanliness modern technology had made possible; the task was to reverse the preoccupation, since the beginnings of the Industrial Revolution, with production at any cost. Somehow human needs had to be asserted over the demands of profit and the machine.

That meant, among other things, abandoning pointless urban gigantism in favor of planned decentralization. People had to return to their regional roots and recapture some of the sense of community their forbears had enjoyed. Mumford served on the Committee on Community Planning of the American Institute of Architects and in 1923 helped found the Regional Planning Association of America. Both groups vainly sought to interest government and the public in the cause of "regional reconstruction." Mumford's thinking had been influenced by a variety of European sources, most of all the writings of the Scottish biologist and town planner, Patrick Geddes. It was the colonial New England farm village, though, that Mumford took for his model of successful community planning. Part of the heritage of the Middle Ages brought by the early Puritans to the New World, the New England village was the closest Americans had ever come to a cooperative, rationally ordered existence.[40]

Mumford was convinced that good architecture could not be divorced from good social planning. Thus the careful planning of the colonial New Englanders had been indispensable to their evolution of a simple, gracefully functional architecture. As Herman Melville's achievements were part of a vital, usable American literary past, so the tradition of New England building was part of the country's usable architectural past. But to recover that past, Americans also had to recover "the interests, the standards, the institutions that gave to the villages and buildings of early times their appropriate shapes." On the ability of his countrymen to "select and control our heritage from the past," Mumford announced, depended the future of their civilization.[41]

That was what Mumford said in *Sticks and Stones,* the study of American architectural history he published in 1926. Not content to explain changes in American taste and technique, Mumford offered the country's architectural development as a moral object lesson, a study in what happened to a people when they abandoned native

reality for imported artificiality. From the planned settlements, community cohesiveness, and "vernacular" beauty of New England building, Americans had gone on, in the eighteenth and nineteenth centuries, to embrace Renaissance ideals of grandeur and style. Thus, whereas Americans had once practiced the craft of purposeful building, they had come to patronize the generally purposeless art of architecture. Truthfulness in construction had almost disappeared in an architectural scene featuring at the same time neoclassical imitation, romantic irrationality and escapism, and an ugly industrial utilitarianism.

The light of intelligent design had sometimes broken through, most notably in the brilliant execution of the Brooklyn Bridge by John and Washington Roebling, father and son, and the sane, powerful adaptations of Romanesque to churches, government buildings, homes, even warehouses by Henry Hobson Richardson. But the triumph of style over sense came in 1893, when the planners and designers of the Columbian Exposition surrendered to Renaissance grandiosity. Thereafter the disorder of eclecticism, reaching its absurdest form in contemporary Renaissance- and Gothic-embellished office towers, had been dominant. To those who boasted of the skyscraper as the supreme expression of America's mighty civilization, Mumford replied that "Our slums express our civilization, too, and our rubbish heaps tell sermons that our stones conceal. The only expression that really matters in architecture is that which contributes in a direct and positive way to the good life. . . ."[42]

As Mumford subsequently acknowledged, at the time he wrote *Sticks and Stones* he knew almost nothing about the functionally oriented architects who had largely transformed the face of Chicago from the 1880s to the early twentieth century. Thus his treatment had jumped from the Roeblings and Richardson to the Columbian Exposition and its consequences for the further degeneration of architectural values. For Mumford and other American architectural historians in the twenties, "the most creative period in American architecture, that between 1880 and 1900, did not yet exist."[43]

Mumford's *The Brown Decades* in 1931 was an effort to correct that hiatus. His interpretation of the cultural history of the late nineteenth century consciously revised his own earlier estimates as well as those of Van Wyck Brooks, Matthew Josephson, Waldo Frank, and insurgent critics in general. Arguing that in the post–Civil War decades the whole emphasis in American cultural expression had shifted from literature to the industrial and plastic arts, Mumford slighted the period's writing in favor of its painting and architecture. Besides extolling Ryder, Homer, and Eakins, Mumford now gave the Chicago-

area architects their full due and treated Louis Sullivan as the link between the "two great masters" at the beginning and the end of the period, Richardson and Frank Lloyd Wright. With the development of Wright's genius, "modern architecture in America was born."[44]

All along Wright had been Mumford's favorite contemporary architect. Mumford disliked Wright's romantic individualism but acclaimed his "vernacular" emphasis, his efforts to harmonize structure with the circumstances of a particular site and with local and regional factors of climate and culture. While Wright always looked to use native materials, he also took maximum advantage of new materials and techniques made available by modern machine technology. Wright, Mumford observed in 1928, had rejected both the cold, abstract formalism of neoclassical design and the cold, utilitarian formalism of the International Style emerging in Europe over the previous decade. Not a predecessor of extreme functionalists like LeCourbusier in France, J. J. Oud in Holland, or the Bauhaus group in Germany, as some critics claimed, Wright was really their successor, one who had "gone on to an integral architecture which creates its own forms with —not for—the machine." Wright's architecture was a prophecy of "what may generally come to happen when our regional cultures absorb the lesson of the machine without losing their roots or renouncing all those elements which give landscapes and men their individualities."[45]

## IV

For Wright himself the twenties was neither a prosperous nor a happy period. Besides continuing scandal and turmoil in his personal life, Wright saw his career reach its low point in the midst of eclecticism's reigning popularity. Sometimes described by architectural writers as being past his prime, out of touch with contemporary trends, Wright was busy sketching all kinds of imaginative, occasionally bizarre projects. He also carried forward the rebuilding of Taliesin, his home and studio near Spring Green, Wisconsin, partly destroyed in 1914 in a fire set by a crazed employee. Meanwhile, his reputation abroad grew brighter in the postwar decades.

Wright's commissions for actual work, though, came slowly in the twenties. The biggest was for the stunning Imperial Hotel in Tokyo, which withstood the terrible earthquake that struck Japan in 1924. Wright also did several remarkable textile-block houses in southern California. Yet in 1926, seeking unsuccessfully to get the *American Mercury* to publish one of his diatribes against both artistic and moral

prudery, Wright described himself to H. L. Mencken as "only an artist in trouble—and eager to be heard. . . ." He was, he said, " 'fighting back'—and this is in a sense—a hand reaching to you for help."[46]

Even though Mencken never published any of his essays, Wright had no real difficulty getting a hearing. The *Architectural Record,* for example, opened its pages to him for another "In the Cause of Architecture" series, this one published in nine parts in 1927–28.[47] Again Wright pled his case for the architect's creative mastery of the machine; for the evolution of form out of site, materials, purpose, and the architect's personality; and against eclecticism, standardization ("the soul of the machine") , and formal style. Contributing to Oliver Sayler's symposium on American avant-gardism a couple of years later, Wright, with characteristic unconcern for genteel modesty, denied that the United States had any outstanding modern architecture "except as Europe accepted the early work of Sullivan and myself and some few of our architects subsequently learned from Europe to accept their acceptance." Sayler himself might be persuaded that "Machine Age America" had finally arrived at "the broad outlines of a native solution to its native architectural problems." When Wright looked around, though, he saw only a "timely confusion."[48]

That was also the way Louis Sullivan had viewed the contemporary American architectural scene when he died, down on his luck and nearly friendless, in Chicago in the spring of 1924. "We have Tudor for colleges and residences; Roman for banks, and railways stations and libraries,—or Greek if you like—some customers prefer the Ionic to the Doric. We have French, English and Italian Gothic, Classic and Renaissance for churches. In fact we are prepared to satisfy, in any manner of taste." So Sullivan sarcastically described his country's "feudal" architectural preferences in the personal history he finished shortly before his death. *The Autobiography of an Idea* was Sullivan's final reaffirmation of the promise of an architecture expressive of American democracy, which for Sullivan had always been less a system of government than a state of mind, a way of life. A truly democratic and American architecture, Sullivan said for the last time, would achieve the integration of form and function, and thus would fulfill every child's instinct for functional beauty.[49]

While Sullivan's ideas were generally out of favor in the twenties, he was hardly forgotten. The year before he died, he took an active part in the furor surrounding the selection of the winning design in the competition staged by the *Chicago Daily Tribune* to choose the architect for its new tall office building, to be built near Chicago's lakefront. When the *Tribune* prize committee voted for Raymond

Hood's Gothic skyscraper proposal over the unadorned and vertically unbroken design submitted by the Finnish architect Eliel Saarinen, modernist advocates across the country were indignant. Sullivan, writing in the *Architectural Record,* went so far as to demand that the jury repudiate its "act of savagery," which had "deprived the world of a shining mark, denied it a monument to beauty, to faith, to courage and hope."[50]

A later generation, no longer caught up in the traditionalist-modernist quarrels of the century's early decades, might find the actuality of Hood's finished Tribune Tower more visually interesting than Saarinen's monolithic conception. At the time, though, the award of the commission to yet another eclectic, "literary" design seemed the final slap in the face to honest architecture. Someday, wrote the modernist critic H. Harold Kent, "when we are thoroughly 'fed up' with the old method of 'dressing' our steel buildings," then Saarinen's clear vision might influence "a really distinctive, a truly American, architecture."[51]

When Sullivan died, tributes came from people representing a broad range of architectural opinion, again testifying to his continuing fame even after more than a decade of professional quiescence. Wright's tribute to his "beloved master" had to be, he insisted, "an arraignment of the time, the place, the people that needed and hungered for what he had to give, but all but wasted him when he was fit and ready to give." In the neglect of Sullivan's gifts Wright saw "the hideous cruelty of America's blind infatuation with the Expedient. . . ." From a calmer and more detached perspective, Fiske Kimball came closer to the essence of Sullivan's art when he suggested that this "old master" had worked in the tradition of nineteenth-century realism in seeking beauty through truthfulness to nature rather than in abstract form. Although Kimball ignored Sullivan's basic romanticism, he understood that the preferences of Sullivan, Wright, and their followers and supporters clashed not only with the persistent influence of the Genteel Tradition but also with a newly emergent European architectural modernism.[52]

By the late twenties it was increasingly apparent that the International Style was actually a new kind of formalism—abstract, severely geometrical, stripped of individuality to achieve concepts and methods that would be universally applicable. As the Austrian-born architect Richard J. Neutra wrote in 1929 (six years after he emigrated to the United States), the personality and temperament of even the most gifted designer must be secondary to "super personal events" like the mass production of materials and the worldwide knowledge of ad-

vanced building techniques. "National characteristics," according to Neutra, "naturally recede to the background."[53]

In the 1930s the prestige of the International Style's mechanistic modernism would continue to grow in Europe, despite the dominance of Nazi monumentality in Germany and Marxian socialist monumentality in Russia. International modernism would obtain a powerful hold on American design, largely as a consequence of the migration to the United States of a major portion of Europe's architectural talent, in flight from totalitarian repression and war. Yet the thirties would also bring the stunning resurgence of Frank Lloyd Wright.

V

The 1920s was a time of remarkable change in American music. That change was often described in quantitative terms: the sales of phonographs, the amount of "serious" music available on records and people's radio receivers, the multiplication of opera companies and symphony orchestras, the rapid growth in the number of American-born singers performing at the Metropolitan Opera, and the big increases in the ownership of pianos and other instruments and in people taking music lessons. Such indicators were decidedly encouraging for those who continued to advance the genteel proposition that prolonged exposure to good art—meaning the best in the European heritage—was necessary before the United States could have a first-rate musical culture of its own. As the distinguished music educator Oscar Saenger proudly said in 1928, "In truth, this, today, is the real golden age of music in America."[54]

The foremost propagator of genteel musical uplift undoubtedly was Walter Damrosch. For more than four decades, up to the time he joined the National Broadcasting Company in 1928, Damrosch conducted the New York Symphony. The acknowledged dean of American conductors, the German-born Damrosch had unflaggingly sought to educate the people of his adopted country in what he referred to as "music of a higher class"—meaning mainly German romanticism and especially the powerful, ponderous works of Richard Wagner. Brisk, charming, supremely confident, almost totally uninterested in native folk or popular influences, Damrosch did sometimes condescend to the performance of works by American composers. He warmly encouraged the careers of Aaron Copland and George Gershwin and on one occasion, in 1910, even led his orchestra in an effort to play the second movement from Charles Ives's First Symphony during a rehearsal. Having submitted the composition only reluctantly at a

friend's urging, Ives had to listen in pain as the orchestra struggled along until Damrosch, after lecturing Ives on rhythm, finally gave up.[55]

Damrosch brought his messianic attitude, his Germanophilia, and his disdain for most contemporary music to his radio career as conductor for NBC's "Music Appreciation Hour." That program served as Damrosch's personal forum for fourteen years, until he retired in 1942 at the age of eighty. It was one of the most listened-to offerings on radio, mainly because tens of millions of American children and adolescents had to sit through the once-a-week morning broadcasts as part of their regular school day. Damrosch's genial and genteel, Eurocentric influence thus lasted long beyond the time when his own proclivities ceased to accord with the major trends in American composition.

The quantitative improvement in American musical circumstances, often quite effectively exploited by uplifters like Damrosch, failed to satisfy the yearnings of such older romantic nationalists as Arthur Farwell. As late as 1927 Farwell was still protesting that "the existing musical culture has nothing to do with the whole people in America, a people from whom it never sprang, and who certainly, as a whole, want nothing from it, and never will." Even among musical traditionalists there was growing unhappiness over the infrequency with which Damrosch and the other conductors of the country's major symphony orchestras were willing to give a hearing to American composers. In the 1926–27 concert season, a columnist in the magazine *Singing* pointed out, only 4 of the 120 works performed by the New York Philharmonic orchestra were American compositions; Damrosch's New York Symphony played only 5 American works in its 88-work season. The Boston Symphony's total offering of 40 compositions included only 2 pieces that were American written, while the Philadelphia Orchestra played 3 compositions by Americans in its seasonal offering of 39 works.[56]

Daniel Gregory Mason, MacDowell Professor of Music at Columbia University and an ambitious composer himself, was one of those most exercised about such general neglect of American formal music. Mason was incensed when Arturo Toscanini, the fiery and imperious conductor of the New York Philharmonic, turned down one of his symphonies. Even though the composition was later played by Fritz Reiner's Cincinnati Symphony, Mason remained bitter. "It is almost scandalous," he wrote a friend late in 1928, "that our American composers should be subjected to such treatment by the foremost symphony organization in the country." Mason added that the indifference of European-born conductors and musicians to American-written music was exactly what he had had in mind in writing *The Dilemma of American Music,* the book he published earlier that year.[57]

Largely an attack on foreign musical hegemony and the American people's "superstitious reverence for great names and reputations and above all for great prices," Mason's book was the decade's major statement of an increasingly restive genteel musical nationalism. In literature, Mason commented, Americans had continued to cherish their European heritage while they had also come to respect and appreciate their own contemporary authors. In music, by contrast, "it never occurs to us that anything more worth listening to than factory whistles, motor horns, radios and jazz could come out of New York, or Chicago, or Detroit, or Rochester; and we consistently keep our concert halls museums instead of making them grow also into laboratories."[58]

What Mason had in mind by concert halls as laboratories was not the encouragement of radical experimentation but simply a common receptivity among conductors to American work. Like Van Wyck Brooks, who later became Mason's warm correspondent, Mason had no use for avant-gardism. Overintellectualized and faddish, the avant-garde was also a consequence of what Mason denounced as "the Jewish domination of our music." Mason used terms like "Oriental," "garrulous self-confusion," and "the almost indecent stripping of the soul" to describe the work of contemporary Jewish American composers. Like many other genteel critics, he idealized the "Anglo-Saxon qualities" of moderation, sobriety, restraint, and balance. At present, though, "Our public taste . . . is in danger of being permanently debauched, made lastingly insensitive to qualities most subtly and quintessentially our own, by the intoxication of what is, after all, an alien art."[59]

Mason's anti-Semitism had to do mainly with his animus toward artistic modernism as a whole. He remained on the friendliest of terms with many Jews in the arts, as long as they shared his traditional tastes and values. The Genteel Tradition, moreover, was scarcely confined to people of Anglo-Saxon Protestant background. Henrietta Straus and Charles Henry Meltzer, for example, were much like Mason in their attachment to established musical forms, their avid promotion of American achievements within those forms, and their unhappiness with the European hold on American musical preferences. Both were particularly agitated over the situation in opera, where not only foreign music but foreign languages were heard almost exclusively.

"Americans now stand alone," protested Meltzer, "in their devotion to the preposterous superstition that any tongue on earth is better than their own, when it is heard in opera." As music critic for the New York *American*, also Thomas Craven's home base, Meltzer bat-

tled throughout the twenties against the "ring" that "ruled" opera in the United States. Opera speech, he demanded, must be "made plain to us in good, clear, sensible English." Straus was not even content with English translations of established works. Opera written by Americans was what was needed, opera that catered not to the "foreign element" in the cheap seats but to Americans in order to get them into the cheap seats. Until that happened, American audiences would continue to be distinguished by the fact that they actually took offense at hearing their own language in the form of opera libretti.[60]

Over the years several operas by Americans had gotten full exposure at the Metropolitan Opera or elsewhere. The tendency had been for nationalist critics to hail each new native operatic composition as marking, at last, American mastery of the form. The loudest acclaim so far, however, went to *The King's Henchman,* produced at the Met early in 1927. With a score composed by Deems Taylor and a libretto written by Edna St. Vincent Millay, the opera was indeed a notable event, a work that received fourteen performances in three seasons. A common response was that of the New York *Evening Post*'s critic, who praised it for having "killed forever the oft-repeated question, 'Is opera in English possible?' "[61] Yet Taylor's opera, set in tenth-century Saxon England, failed to convince those for whom true American opera meant somehow capturing the American character and the spectacle of American life. The Great American Opera, wrote the author of the first study of American operatic composers in 1927, would feature "a distinctly American technique, and this set to music which is the natural expression of the methods of thought of a composer who has been developed in an American environment."[62]

The notion of *the* great American opera or symphony or whatever seemed old fashioned and even a bit silly for the postwar generation of musical modernists. Yet the modernism of the twenties was still generally compatible with the ideal of a strong native musical expression, an ideal that the composer Roger Sessions remembered as being the principal concern of the decade among American composers and critics.[63] Certainly that was the case with the Brooklynite Aaron Copland, still in his teens when the war ended. One of the first Americans to study with Nadia Boulanger, Copland became part of the colony of American intellectuals and artists living in postwar Paris. There he had the experience of discovering America in Europe—an experience that was common for both hard-working students like Copland and expatriate drifters like Harold Loeb. "Gradually," Copland recalled decades later, "the idea that my personal expression in music ought somehow to be related to my own back-home environment took hold

of me. The conviction grew inside me that the two things that seemed always to have been so separate in America—music and the life about me—must be made to touch."[64]

Not content like their musical elders to reiterate Europe's traditional formulas, young composers like Copland, Roy Harris, George Antheil, and Virgil Thomson were also little interested in the efforts of older nationalists to derive an American music from native folklore and Indian materials. "Our concern was not with the quotable hymn or spiritual," said Copland, but with "a music that would speak of universal things in a vernacular of American speech rhythms." Like Charles Ives, they wanted to write music "with a largeness of utterance wholly representative of the country that Whitman had envisaged." Yet they did not know the work of Ives, the man who had already come closest to that ideal. Thus they had to seek out the rich sources of contemporary European music, having abandoned the search for usable musical ancestors "because we became convinced that there were none—that we had none."[65]

Paul Rosenfeld, the portly, good-natured veteran of the prewar *New Republic* and *Seven Arts,* was the foremost critic trying to accommodate the vision of an American renaissance to the new influences at work in postwar American music. As a critic Rosenfeld may have been, as Roger Sessions has said, only a "passionate amateur," a transitional figure between an older criticism content to give information about composers and explain the basic elements of their music, and a later criticism fully conversant with modernist innovation, occupied with formal questions, and committed to music as a self-contained expressive mode.[66] Even as a passionate amateur, Rosenfeld was considerably ahead of prevailing attitudes in American music criticism. He encouraged not only nationalistically inclined modernists like Copland but also the other modernists who in 1923 established the quarterly *Modern Music* as an international forum. The war, Rosenfeld believed, had brought such a shift of power and resources from Europe to the United States that it was no longer possible for music or any other art to survive without the crucial participation of creative Americans. Only "pioneering and puritanism and the republic of business" would frustrate the American potential in such men as Sessions and Copland, young creators who offered "gigantic proof of the rebirth of feeling in America."[67]

Even though their individual works seldom had more than one performance, most of the younger American composers were considerably more successful than Ives had been in getting at least an initial hearing. The responses of critics and audiences were usually wary and sometimes downright hostile, as in the case of Antheil's *Ballet méch-*

*anique,* performed at Carnegie Hall in the spring of 1927. Copland, often experimenting with jazz and other popular music idioms, was far and away the most visible new composer. For example, he obtained performances of his Symphony for Organ and Orchestra with Damrosch's New York Symphony in 1925 and his Concerto for Piano and Orchestra with Serge Koussevitsky's Boston Symphony two years later. Throughout this early period in his career, Copland's conscious aim continued to be, as he later described it, "to write a work that would immediately be recognized as American in character."[68]

Yet the main kind of postromantic American composition heard in the postwar decade was that of an older group of men working in the line of the French impressionist composers. Often overtly nationalistic, postwar American impressionism included works like Frederick Converse's tone poem *California* and his orchestral suite *American Sketches,* Samuel Gardner's suite *Broadway* and Louis Gruenberg's *Jazz Suite,* and John Alden Carpenter's *Adventures in a Perambulator* suite and his two ballets, *Krazy Kat* and *Skyscrapers.* Aiming to evoke places, events, moods, common experiences, and commonly held symbols, such music was perhaps best exemplified in Converse's *Flivver Ten Million,* a tone poem performed by the Boston Symphony in 1927. A celebration of the automobile, the work was a succession of musical episodes with titles like "Dawn in Detroit," "May Night by the Roadside," and "The Collision."

Meanwhile, the influence of Indian sources and black folksong—present in various degrees in the work of Edward MacDowell, Arthur Farwell, Henry F. B. Gilbert, and a number of other composers in the prewar period—faded as the twenties moved along. Folk-song scholarship, by contrast, went forward rapidly. By 1928 the Library of Congress had established an embryonic Archive of American Folk Song, prompted by the decade's steady flow of folk-song studies and collections. Undoubtedly the most famous of the collections was Carl Sandburg's *The American Songbag* (1927). Gathered from all over the United States and drawn in part from Sandburg's own experiences as an itinerant laborer, the large assortment was, the poet hoped, "precisely the sort of material out of which there may come the great native American grand opera."[69]

Students of black folk song continued to add documentation to both sides of the controversy over the African versus American origins of early black chants, field hollers, and spirituals. Fifty-nine books on black folk song appeared between 1914, when Henry F. Krehbiel's pioneering *Afro-American Folk Song* was published, and 1926, when Newman White was able to proclaim that "The white man's interest was now for the first time predominantly objective and scientific, no

longer patronizing or purely sentimental. The Negro song had gained enormously in dignity among the white people."[70]

## VI

It was not the older black folk music that mainly interested white critics, composers, and musicians in the twenties. Nor was it the ragtime that had thrived in the first decade of the century but was now moribund. Rather, it was a kind of music only recently discovered by white listeners, a volatile, sometimes lyrical, sometimes raucous expression, which in one way or another influenced most American popular music in the postwar period, as had ragtime in the years before the war. Ultimately the new music gave the twenties its most familiar sobriquet—the Jazz Age.

Like ragtime, jazz was preeminently an instrumental form, although it was often vocalized to break or punctuate instrumental passages. Emerging a little later than ragtime from the black musical underground of such cities as Mobile, Memphis, Kansas City, and most of all New Orleans, jazz, like ragtime, derived from a variety of sources— in the case of jazz particularly the brass-band and blues traditions. And, like ragtime, jazz emphasized rhythm and syncopation at the expense of smooth melodic line. Unlike ragtime, though, jazz was not formally composed and scored, not written down to be performed in a particular manner. The essence of jazz, in fact, was a musician's distinctive yet disciplined, wholly improvised variations on a piece of music that otherwise was apt to be hackneyed and banal. Scott Joplin and most of the other leading figures in ragtime had had some formal music training. They spent at least as much of their time writing rags as playing them. In the early history of jazz, however, there were no composers as such, only mostly self-taught musicians who "composed" their music in the act of playing it. Thus whereas ragtime's development had been progressive and reasonably coherent up until it was submerged into the mass of prewar popular music, jazz evolved discontinuously, not by composition but by idiosyncratic playing style.[71]

Just before the war, white musicians, chiefly from New Orleans, brought jazz to the northern cities. The kind of jazz played by whites in the style of the early New Orleans black musicians quickly came to be called "Dixieland." Chicago became the home of several bands consisting of white musicians determined to master the new music. In 1917 one such group, the Original Dixieland Jazz Band, played a highly publicized stand at Reisenweber's Restaurant in New York and also made the first Dixieland phonograph recordings. Thereafter

New York and the other big eastern cities came alive to the "hot" sounds of neophyte "jazzmen." Europe's fascination with jazz dates largely from 1919, when the Original Dixieland Jazz Band made a celebrated English tour.

By the early twenties jazz had spread across the country and had become a characteristic part of the Bohemian atmosphere of Greenwich Village. Chicago, however, remained the focus of white musicians' growing involvement with the form. Within a few years observers of the jazz scene were talking about a distinctive "Chicago style" being played by young musicians like the cornetist Jimmy Mc-Partland, the clarinetist and saxophonist Frank Teschemacher, and the legendary Leon "Bix" Beiderbecke. A brilliant cornetist, Beiderbecke had won the admiration of both white and black peers by the time he died in 1931 at the age of twenty-eight.

Beiderbecke and many other white players freely acknowledged their debt to black musicians like Joseph "King" Oliver, Ferdinand "Jelly Roll" Morton, Edward "Kid" Ory, and a remarkable young trumpeter coming along in the twenties, Louis "Satchmo" Armstrong. Immediate contacts between black and white jazz performers increased steadily as they and other gifted black players migrated to Chicago and then to New York. Yet despite such contacts, despite growing critical interest in the origins and development of the jazz form, and despite the recordings made by a few black bands, what jazz historians would later call the "classic" jazz of Armstrong and the others was little known to most whites in the twenties. Even when they played to white audiences, black jazz artists nearly always had to perform in smoke-filled speakeasies and dance halls, where their music had to be loud enough to surmount the din and clatter. Their recordings were usually not marketed as part of general popular-music offerings, as were white jazz discs, but rather as "race records" aimed at a small (though fast-growing) black market in the northern cities.

What happened to jazz was basically what had happened earlier to ragtime. As a musical form, jazz was subject to a process of denaturing and homogenization to make it suit the taste and values of the white musical public. As a musical designation, jazz, like ragtime, came to mean almost anything featuring strong rhythm and syncopation. That would actually include most of the dance music of the period as well as a good deal of what was broadcast by the quickly multiplying local radio stations. As Barry Ulanov has disapprovingly observed, "jazz was not jazz in the twenties; it was everything else."[72] Whereas a few years earlier, popular music enthusiasts had hailed Irving Berlin as a "ragtime" composer, so now they hailed him for his tuneful "jazz" creations. Finally, a substantial number of critics and composers sought

to make jazz into something more than it had been. Willing to overlook jazz's unsavory origins and associations, they proclaimed jazz as America's unique contribution to world music and as the likely basis for a "serious" music that the American people and people everywhere would at last have to recognize as indubitably American. No form of artistic expression seemed to have more potential for capturing the hot chaos of America than a powerful symphonic utterance inspired by jazz, assimilating it, and bringing it to its highest fulfillment.[73]

Jazz, Samuel Chotzinoff wrote in *Vanity Fair* in 1923, was the long-awaited answer to America's lack of a comprehensive body of native folk music. "The negro genius has been chiefly responsible for whatever musical development America can boast," Chotzinoff insisted. "It is that genius which has produced the American jazz, the only distinct and original idiom we have." Alfred Frankenstein, a clarinetist with the Chicago Civic Orchestra who also played what he called jazz in nightclubs, declared that "If America contributes nothing more to the progress of the arts [than jazz], she will have given enough." Jazz was the music of the American city, of "hot-dog wagons and elevated trains," "morning papers published at nine in the evening," "the quick lunch and the signboard and the express elevator." Jazz, as Frankenstein understood it, included the music of Berlin, Jerome Kern, George Gershwin, and other popular songwriters—any music, in short, that featured "syncopating saxophones." Similarly, for the critic and musical historian Henry Osborne Osgood, "jazz" meant the music of those who had "extended" the crude music of black musicians. Thus white popular dance-band leaders like Ted Lewis and Vincent Lopez, the novelty pianist Zez Confrey, and songwriters like Berlin and especially Gershwin were all "jazzists." It remained to be seen whether jazz would evolve into "a school in serious music, an acknowledged influence in the music of the world." Might some gifted American composer come along to carry jazz "far, far away from its faults?"[74]

Even Aaron Copland, who should have known better, viewed jazz mainly in terms of what it could be, not what it really was. Copland's 1927 article in *Modern Music* was probably the most sophisticated technical analysis of jazz published up to that time. The key to jazz, Copland believed, was polyrhythm, a quality that would be "traceable more and more frequently in symphonies and concerts." Copland himself in a number of his early compositions worked not only with jazzlike polyrhythms but also with syncopation and blues melodies. Yet he ignored the essential polyrhythmic character of the earlier ragtime and showed no real awareness of the central factor in the early development of jazz—improvisation.[75]

Jazz or pseudojazz had plenty of detractors and an abundance of outright enemies. People like Daniel Gregory Mason thought no more of jazz than they had of prewar ragtime. It was lamentable, Mason wrote in *The Dilemma of American Music*, that instead of being educated to the complexities, profundities, and nobilities of great music, the nation's children had been caught up in "the crude nerve-stimulant of 'jazz'." At the other extreme were modernist exponents like Paul Rosenfeld. Rosenfeld described worthwhile music as "what jazz from the beginning is not: the product of a sympathetic treatment of the sonorous medium." Jazz was "mere beat," "an extraordinarily popular drug-like use of the materials of sound. . . ." Pandering to cheap, illusory desires, jazz could never be anything besides entertainment— "something which temporarily removes people from contact with the realities."[76]

For all of Rosenfeld's sympathy with artistic modernists in the twenties, his stern judgment on jazz again points up the frequent parallelisms in the thinking of cultural conservatives and romantic nationalists. Yet the hope for jazz as the potential foundation of a great national music also extended across the intellectual spectrum, from traditionalists like Osgood all the way over to devout modernists like Carl Van Vechten, one of the most fashionable and influential people on the New York cultural scene in the postwar decade.

Van Vechten was born in 1880 in Cedar Rapids, Iowa, the prairie town that also produced Grant Wood twelve years later. A graduate of the University of Chicago, Van Vechten was tall and blond with large, protruding teeth that ruined his chances to be handsome. An apostle of estheticism in his own art, Van Vechten was also something of a sybarite in his style of living. He thus came to epitomize much of what has often seemed most characteristic in the intellectual life of the twenties. The six novels he published from 1922 to 1930 dealt with such matters as the milieu of artists and would-be artists, the corruption of young innocents by worldly sophisticates, and the triumph of sensual pleasures over genteel commitments to doing good. Van Vechten was a friend and sponsor of avant-gardists in all the arts and an especial enthusiast for experimental photography. He became a skilled photographer himself, one whose portraits of figures in the arts, entertainment, and sports are some of the finest done in the twenties and thirties.[77]

Van Vechten's major significance for the cultural history of the postwar period has to do wih his diligent efforts in transmitting to his white associates and readers an awareness of the rich and varied achievements in contemporary black culture. Along with his interests in Stravinsky's music and Gertrude Stein's poetry, in motion pictures,

vaudeville, Broadway musical revues, modern dance, and avant-garde photography, Van Vechten cultivated friendships with black intellectuals and artists and spent a good deal of his time in Harlem. There he developed a real fondness for the blues renditions of Bessie Smith and Ethel Waters and the black jazz being played in Harlem's cabarets. More than any other white intellectual of his time, Van Vechten tried to get underneath the surface features of American black society. "Ain't it hell," he jokingly wrote H. L. Mencken in 1925, "to be a Nordic when you're struggling with Ethiopian psychology?" And despite its melodramatic plot inventions and frequently florid prose, *Nigger Heaven,* the novel Van Vechten published the next year, was a vivid and generally convincing depiction of the lives of black Americans in a complex urban setting.[78]

Van Vechten was closer than any other white observer to the remarkable outpouring of creativity centered in Harlem in the twenties. As much as anyone, he was responsible for the vogue among chic and well-to-do whites of "going up to Harlem." Yet for Van Vechten the dynamics of Harlem's intellectual and artistic life were more than a fashionable curiosity. He grasped the basic fact that what was commonly called either the Harlem Renaissance or the Negro Renaissance was a reenactment in microcosm of the insurgent movement within white thought and culture in the prewar period. Young black creators had launched a similar revolt against the ideals and assumptions of the black custodians of culture, a genteel elite that in most respects was a mirror image of white cultural gentility.

The black intellectual who played a role in the Harlem Renaissance roughly equivalent to that of Van Wyck Brooks in the prewar Rebellion was Alain Locke. After taking his A.B. in the Harvard class of 1907 along with Brooks, Locke had also gone to Europe (as a Rhodes Scholar) and had then returned to America with his nationalist emotions running high. In Locke's case, though, national fulfillment meant both the realization of a brilliant general civilization for America and the realization of the cultural aspirations of black people in America. Like Brooks, Locke protested against the mundane, materialistic forces thwarting American creative genius, against "the psychology of the herd," as he phrased it, "the tyranny of the average and mediocre; in other words, the limitations upon cultural personality."[79]

By the twenties, now holding a Ph.D. from Harvard, Locke was a professor of philosophy at Howard University in Washington, D.C., the nation's biggest all-black institution of higher learning. In the face of rising enthusiasm among the urban black masses for the pan-Africanism promoted by the flamboyant Marcus Garvey, Locke continued to think in terms of a type of "new Negro" who would spearhead the movement for black cultural identity within the United States.

Along with black intellectual leaders like W. E. B. DuBois and James Weldon Johnson, Locke was convinced that gifted black Americans had much to contribute to the overall regeneration of American life. As Johnson told an audience at Howard, "the richest contribution the Aframerican poet can make to American literature will be the fusion into it of his own racial genius. Extreme rhythm, color, warmth, abandon, and movement."[80]

Locke, DuBois, and Johnson accepted the conventional wisdom carried over from the nineteenth century to the effect that "high culture" or the "fine arts" depended on a long and rich legacy of folk culture. The absence of such a fund of folk art in America had long been a source of complaint among both genteel and romantic nationalists. White composers and critics had often viewed black spirituals, field songs, and dances from slave times as authentic and usable folk materials. But whereas DuBois continued to favor the older forms of black music, Locke and Johnson as well as younger figures in the Harlem Renaissance—the novelists Wallace Thurman, Jean Toomer, Zora Neale Hurston, the poets Countee Cullen and Claude McKay—increasingly talked about jazz as a genuine, accessible, and fruitful folk-music source. Yet for such people, as for most white commentators in the twenties, jazz had little value in itself. It was rather a means to a greater end—the assertion of black genius in traditional, more "serious" forms. In his novel *The Autobiography of an Ex-Coloured Man*, Johnson had his hero dream of symphonies based on jazz. "It is very ironic," Nathan Irvin Huggins has written, "that a generation that was searching for a new Negro and his distinctive cultural expression would have passed up the only really creative thing that was going on."[81]

For Van Vechten as well, jazz was a means, not an end. Whereas he had earlier enthused over the pseudoragtime of popular dance music as worthy material for the Great American Composer, so now he enthused over jazz and blues.[82] Jazz, he wrote in 1925, was "not the last hope of American music, nor yet the best hope, at present . . . it's the only hope."[83] As a major part of his campaign to encourage the acceptance of jazz among white people and the development of a jazz-based higher musical expression, Van Vechten assiduously promoted the career of George Gershwin, whose potential he claimed to have been the first to appreciate.

## VII

Van Vechten had first met Gershwin in 1919, when Gershwin was twenty-one years old. Gershwin had been born in Brooklyn, the son

of fairly prosperous Russian Jews who had come to the United States several years earlier in the first wave of the massive "new immigration" from the southern and eastern regions of Europe. In his early teens Gershwin gave up the piano lessons he had been taking with an established teacher and went to work "plugging" (demonstrating) songs for the sheet-music publishers concentrated in the area of Manhattan called Tin Pan Alley. When Van Vechten made his acquaintance, Gershwin's songs, often with lyrics by his older brother Ira, had already made him one of the three or four most sought-after popular composers in America. In 1923 Van Vechten helped arrange a concert at Aeolian Hall in New York for the noted singer Eva Gauthier. Between songs by Arnold Schoenberg, Paul Hindemith, Béla Bartók, and other modernists, Gauthier sang a medley of popular numbers, accompanied by Gershwin at the piano and including his "Swanee" and "I'll Build a Stairway to Paradise."[84]

By that time Gershwin was studying musical structure and technique with the composer Rubin Goldmark, who had himself studied with Dvořák in the 1890s. Soon Gershwin was at work on an extended formal composition based on the familiar elements of jazz and intended to capture its essential spirit. The work had been commissioned by Paul Whiteman, the roly-poly and ebullient leader of a highly successful "semiclassical" orchestra, for an "Experiment in Modern Music" program Whiteman was putting together. Orchestrated by Ferde Grofé, Gershwin's composition was barely ready for Whiteman's concert on Sunday, February 12, 1924, at Aeolian Hall.

That afternoon turned out to be one of the most memorable in American musical history. With Gershwin at the piano, Whiteman's orchestra performed what Gershwin had entitled *Rhapsody in Blue*. Opened with a long clarinet blues wail, the composition proceeded unevenly but powerfully, offering an assortment of blueslike melodic sequences and jazzlike rhythmic and syncopated effects.

*Rhapsody in Blue* was an immediate sensation. It brought the young composer widespread acclaim as the man who had finally taken jazz and given it an unquestionably American expression within larger musical forms. Van Vechten was no more carried away than many others when he proclaimed *Rhapsody in Blue* "the most effective concerto for piano that anybody had written since Tschaikovsky's B flat minor." He wrote Gershwin that his work was "the foremost serious effort by an American composer. Go straight on and you will knock all Europe silly." A few might agree with the modernist composer and critic Virgil Thomson that the *Rhapsody* was "just some scraps of bully jazz served together with oratory and cadenzas out of Liszt." But even those like Samuel Chotzinoff, who thought it "diffuse and blundering," also gave Gershwin credit for doing something vital and

refreshing, for pioneering in the extension of jazz. Walter Damrosch believed that Gershwin might be the "genius" who would "tame" jazz and "pour into this very low form of art some real emotion."[85]

Dark-featured, not really handsome, but well-dressed and engaging, Gershwin seemed supremely confident that he could go on to even bigger feats in "serious" composition. A natural melodist, he wisely kept writing popular music, doing the scores for several big musical revues and producing some of his most enduring songs in the late twenties and early thirties. Yet to a greater extent than any other American composer, Gershwin pursued a parallel course in formal music. In 1925 Damrosch commissioned him to write a work for the New York Symphony. The result was the Concerto in F, performed by Damrosch's orchestra late that year. Orchestrated by Gershwin, who had continued his technical studies since his *Rhapsody* triumph, the concerto was a conventional three-movement work for piano and orchestra. More formally correct than the *Rhapsody,* maybe less inspired, and certainly less provocative, it nonetheless still incorporated substantial elements of popular jazz and other popular music. Three years later, again under commission to Damrosch, Gershwin composed *An American in Paris,* a tone poem for orchestra (including taxi horns) . Performed by the merged New York Symphony–Philharmonic with Damrosch as conductor, it featured a delightful blues section and was generally Gershwin's most melodic formal work. *An American in Paris* completed Gershwin's arrival as a major contemporary composer, known and admired in Europe as well as in his own country.

One of the major beneficiaries of Gershwin's determined efforts to fashion a great American symphonic music from popular jazz was Paul Whiteman. A man with a strong sense of social purpose, Whiteman was bothered by black jazz's ancestry and its appeal to raw emotion, yet he was also convinced that jazz was "the true folk music of America," "a racy, idiomatic, flexible language all our own," an expression of the Machine Age and the American soul. What had to be done was to make jazz "sweeter" and smoother, less raucous and more refined, more acceptable to broad public (meaning white) tastes. So on one hand Whiteman and his orchestra did arrangements that toned down original jazz numbers; on the other, they offered syncopated and otherwise enlivened renderings of familiar "serious" compositions. By supposedly dignifying jazz and by "jazzing the classics," Whiteman built a huge following for his music both at home and in Europe, especially after the publicity surrounding the premiere of *Rhapsody in Blue.*[86]

Neither exponents of authentic jazz nor musical modernists had much use for Whiteman's dressed-up adaptations. Some traditionalists applauded Whiteman for using jazz to give the masses a taste of "seri-

ous" music; for others, Whiteman's jazz—any jazz—remained a product of an age of disorder, hedonism, and revolt against convention, of a "dance-youth-sex-burlesque-commercially urgent milieu. . . ." If anything, Whiteman's music just added to the general confusion about what jazz was and was not. The trouble, wrote Abbe Niles, one of the more astute early students of the music, was that "writers and speakers on jazz, friendly and unfriendly, don't know their subject, and the people who know it best can't write."[87]

At the end of the decade jazz was still being described as nearly everything. It was America's only genuine folk music, or a collection of aphrodisiacal sounds emanating from the netherworld, or the most vital raw material yet to come along for a great American symphonic expression. Waldo Frank came closer to the truth than most twenties commentators when he characterized jazz as "not so much folk music—like the spirituals—as a folk accent in music." As a folk accent, the jazz played by Armstrong, Beiderbecke, and the other purveyors of the genuine article survived the twenties in reasonably good shape, despite the smothering embraces of its friends and the sneers and smears of its enemies. In its own time, though, "classic" jazz was never well known to the white public.[88]

## VIII

Jazz was one of the "lively arts" Gilbert Seldes wrote about in his pioneering study of American popular culture, published in 1924.[89] Like most other people writing on jazz during the postwar decade, Seldes was unable to distinguish between original jazz and the ragtime- and jazz-influenced popular music of the period. At the same time, Seldes was entranced by the efforts of Stravinsky in Europe and Gershwin in the United States to use jazz in symphonic forms. Thus he could both admire "jazz" for its "roaring and stamping and vulgar" traits and Paul Whiteman for elevating the music into something finer and better.[90] But if Seldes's thinking about jazz was as muddled as practically everybody else's, his book was the principal manifestation of one of the most significant intellectual phenomena of the twenties: the growing critical discovery of the variegated forms of popular culture. Seldes was among the first to recognize the magnitude and portent of the creative outpouring that had taken place in the mass-consumption arts over the past several years.

*The Seven Lively Arts* was the work of a thirty-two-year-old journalist and critic who had been born in Alliance, New Jersey, where his visionary immigrant father was trying unsuccessfully to keep going

a communal farm. A graduate of Harvard in the class of 1914, Seldes, like a number of other figures in the prewar and postwar Insurgency, started out as a poorly paid newspaper arts critic. Later on he served as the Washington correspondent for a Paris daily and as an associate editor of *Collier's* magazine. Beginning in 1923 he was managing editor and dramatic critic for Scofield Thayer's overhauled *Dial*.[91] Unlike most of his *Dial* colleagues, Seldes wanted to know what moved the masses, and he believed that to make contact with the "real America" it was necessary to understand the way most people sought entertainment. In this respect he was closer to the *Broom* intellectuals, the group around *Vanity Fair* (which first published most of the material in Seldes's book), and to a lesser extent those connected with the *American Mercury* and the short-lived *American Parade*.

By definition, Seldes admitted, popular culture did not seek to express either the sublime or the truly tragic. Its purpose was to amuse and divert. Yet the lively arts—such sheer entertainments as vaudeville, the motion pictures of Charlie Chaplin and Mack Sennett's Keystone Cops, popular songs and "jazz," the musical extravaganzas of Florenz Ziegfeld, the stage comedy of Al Jolson, Fanny Brice, or Eddie Cantor, the dancing of Irene Castle and Fred and Adele Astaire, the circus and burlesque, the comic strips and the humor of the newspaper "colyumists"—were frequently as imaginative and creative as "high culture." Except when the formal arts were exceptionally vigorous, the lively arts were "likely to be the most intelligent phenomena of their day."[92]

In their precision, their straightforwardness, their democratic spirit, the lively arts were the most fruitfully and characteristically American cultural expression the country had. The danger, said Seldes, was not in the corruption of high culture by the mass entertainments—not, for example, in the fact that the piquantly anarchic characters in George Herriman's "Krazy Kat" comic strip had inspired John Alden Carpenter's "jazz pantomime" ballet in 1921. The danger was rather in the corruption of both major and minor arts by "the great god bogus." Standardized, middle-brow pretentiousness was the real enemy, exemplified in the pseudosophisticated fiction of James Branch Cabell and Joseph Hergesheimer (two favorites of H. L. Mencken), the theatrical productions of David Belasco, the saccharine "art songs" of Ethelbert Nevin and Charles Wakefield Cadman, civic masques and pageants, "the high-toned moving picture," and grand opera in general. The source of the trouble was the Genteel Tradition, which had taught "that what is worth while must be dull; and as often as not we invert the maxim and pretend that what is dull is higher in quality, more serious, 'greater art' in short than whatever is light and easy

and gay." Seldes put his faith for the salvation of the lively arts in their "simple practitioners and simple admirers," who preserved "a sure instinct for what is artistic in America" and thus had "created the American art."[93]

Seldes, like the great majority of his intellectual contemporaries, had little use for most of what came from the American motion-picture industry. Seldes was ecstatic over the brilliant comedy of Charlie Chaplin, an almost universally admired figure throughout the Western world in the postwar period. Besides the Keystone Cops and the daredevil serialized adventures of Pearl White, Seldes also praised the prewar cinematic achievements of David Wark Griffith, especially Griffith's epochal *The Birth of a Nation* in 1915. The problem with the steadily declining Griffith, though, was the problem with movies in general. On one hand, genteel reformers constantly labored to uplift and refine movie content; on the other, "high-brow" intellectuals kept trying to make the movies into great art. "The moving picture," Seldes grumbled, "when it became pretentious, when it went upstage and said, 'dear God, make me artistic' at the end of its prayers, killed its imagination and foreswore its popularity." By the end of the decade Seldes was close to despair over the state of a medium that, particularly since the advent of talking pictures in 1928 and the virtual immobilization of cameras inside padded boxes to keep their whirring off the sound track, had lost most of its essential motion. Now his feeling was that "the majority of [films] are so stupid, tasteless, and wearisome that no man of average intelligence could bear to look at them twice."[94]

Plenty of people complained about the plodding character of the early "talkies." However inane in content most silent films may have been, they had seemed close to perfection in such technical aspects as editing, camera work, lighting, and set design. A whole generation of actors had grown up skilled in the pantomime that was the essence of presound acting. Yet despite rapid progress in cinematic technique since the prewar period, cultural critics had always deplored the intellectual shallowness of a medium described as early as 1910 as "probably the greatest single force in shaping the American character." Randolph Bourne had been troubled that, for all the country spent on schools, libraries, and museums, the movies still marked "the norm of what happy and hearty America is attending to." In 1915 the vociferous Illinois poet Vachel Lindsay, in the first American-written book of real motion-picture criticism, called on film writers to make "Whitmanesque scenarios" and to transform the movies into a kind of great democratic art gallery. By the time he revised his book in 1922, however, Lindsay was fed up with the film industry's obsessive profit-seeking. Only public subsidy for adventurous young filmmakers

centered in the colleges and universities, he thought, might rekindle the democratic promise motion pictures had held in their early years.[95]

The novelty of sound lifted total weekly movie admissions to around 100 million in 1929, the last year of interwar prosperity. Jack L. Warner, whose studios had been the first to produce feature-length sound movies, pessimistically predicted that motion pictures were through as "a truly international form of expression. . . ." The talking picture, Warner said, had "become a national art, due to the introduction of language with thought and theme implications. . . . it means the loss of world wide supremacy—of American-made motion pictures."[96] Warner's prophecy proved to be wildly off the mark. The sound era would see the United States take an even stronger position in the world movie trade; almost everywhere "Hollywood" would be virtually synonymous with filmmaking.

## IX

If most critics found the aggregate of Hollywood's picture production to be cheap and meretricious, essentially irrelevant to the issue of an American renaissance, then they could scarcely contain their enthusiasm over the turn of events in legitimate theater. More suddenly and manifestly than in any other art, a true awakening took place in the American drama in the period after 1918. While the hopes of Percy MacKaye and others that community pageants would become the drama of democracy faded in the postwar years, the little-theater movement continued to grow and prosper in cities and towns across the country. But it was New York, the nation's theatrical epicenter, that experienced the most remarkable outburst of creative energy, mainly, though by no means entirely, in the plays of Eugene O'Neill. In 1919, at the conclusion of his compendious two-volume chronicle of drama in America, Arthur Hornblow remarked that "The American theatre awaits a modern Moses to lead the way out of captivity."[97] The very next year, with the Provincetown Players' productions of O'Neill's *Beyond the Horizon* and the *The Emperor Jones,* the complex, troubled O'Neill found himself widely hailed as just such a deliverer.

From the retrospect of fifty to sixty years, it is hard to grasp the enormous impact O'Neill had on American drama in the span of less than one decade. From 1920 to 1929 O'Neill wrote and had produced, mostly by the Provincetown Players, twelve major dramatic works and several lesser plays. By 1928 even so sardonic and severe a judge as George Jean Nathan was ready to praise O'Neill for giving

American drama the independence and courage it had always lacked. O'Neill had demonstrated "that there is a place here for a whole-hearted integrity in dramatic writing, and that there is a public here that is generous in its response to it." The many manuscripts he had read in recent years had convinced Nathan that young American play-wrights were working more seriously, trying harder if still most of the time not succeeding. And thanks mainly to O'Neill's willingness to deal frankly with the actualities of human relationships, they could now write adult plays for adult audiences. Overall, European drama was still far ahead, Nathan thought. But "the wind is stirring in the cities and on the prairies. In time, maybe, in time. . . ."[98]

From 1920 on, dramatic critics hailed almost every New York sea-son as being better than the previous one. Reviewing the 1919–20 season, which had brought O'Neill's *Beyond the Horizon* and several fine productions of the newly organized Theatre Guild, Kenneth Mac-gowan was moved to quote Shelley's "Heaven smiles, and faiths and empires gleam / Like wrecks of a dissolving dream." Oliver M. Say-ler called the next season, highlighted by O'Neill's powerful *The Emperor Jones* with a predominantly black cast, "the most encourag-ing season our stage has even known." After the 1921–22 season Ludwig Lewisohn wondered "whether any previous theatrical season in Amer-ica has a comparable record of native dramatic activity." Of the next year's output, Arthur Hobson Quinn said simply, "It has been a great season in the theatre."[99]

And so it went for most of the twenties. Admittedly much of the best on Broadway and in the productions of the Provincetown Players and the Theatre Guild consisted of new stagings of the classics of Western dramatic literature, the works of well-established contem-porary Europeans, or the initial American productions of plays by new foreign dramatists. Like Sheldon Cheney before the war, Oliver Sayler was inclined to think that the awakening in the American the-ater had more to do with achievements in scenic design and a growing receptivity to new talent and influences from abroad than with the germination of native playwrights. "America emerges more and more surely," wrote Sayler, "as the refuge, clearing-house, testing ground, for the theatre of the world." Such a secondary function was still enough to make present American drama "the most provocative of the arts."[100]

For others there was reason for pride that in 1926, for the first time in its six-year history, Burns Mantle's annual compilation of the ten best plays produced in New York consisted entirely of works by na-tive authors.[101] For still others there was a growing realization that while O'Neill was the most prolific and potent American playwright

to come on the scene since the war, he was by no means the only talented one. The expressionist innovator Elmer Rice, the strong realist Sidney Howard, the clever satirist Philip Barry, the versatile Maxwell Anderson, and the foremost product of the Carolina Playmakers, Paul Green, were among at least a dozen new native playwrights who together had altered the course of American dramatic development. By the late twenties, at least in dramatic art, America's long-awaited renaissance seemed at hand.

There were still plenty of people dissatisfied with the current situation in drama. At the beginning of the decade Walter Prichard Eaton had complained that actual life in America and the content of the commercial theater were so divergent that there was nothing to be learned from drama about the national character—except that the people apparently had a penchant for frivolous and escapist fare. The American theater, in Eaton's judgment, "reveals fewer national characteristics and more knees than were dreamt of in Mr. Taine's philosophy." Three years later Percy Hammond of the New York *Tribune* similarly protested that "the Broadway drama is not teaching us much this season about American life and character." Eaton was particularly unhappy that the Theatre Guild, America's leading producing company, had not done more to promote native playwriting.[102]

By 1929, moreover, there was a growing sense of alarm at the slump that had hit theater in New York. The 1928–29 season was financially the worst in a decade and maybe the worst ever, reported a *New Republic* columnist. Ninety percent of the productions starting the season had failed; twenty plays had gone under in the space of one week. One-fifth of the theaters in Manhattan had closed by the beginning of 1929. Like the economy as a whole, the economy of New York's theatrical establishment had started to fall off well before the stock market collapse in the fall of 1929. Although the slump was chiefly a consequence of the surge in motion-picture attendance following the advent of talkies, some saw a decline in dramatic quality as well. The American theater was experiencing "a fundamental dearth of real dramatic authorship," said Clayton Hamilton, one of the period's better critics. "Apparently," Hamilton sighed, "the glorious efflorescence of modern drama . . . has suddenly become—while we were looking elsewhere—a matter of the past. . . ."[103]

Whatever was wrong with American theater in the twenties—overcommercialization and overcentralization in New York, persistent Eurocentrism, the reluctance of producers to gamble on new American playwrights—still seemed curable through the little-theater movement. "Out of the little-theatre circuits, the university courses, and the rest of the groping amateur effort," Eaton hoped in the early twenties,

"will one day rise, perhaps, a true American theatre instead of our present pitiable aggregation of itinerant showmen who occasionally scuttle out from New York." In 1929, in his study of the country's little theaters based on a 14,000-mile tour funded by the Carnegie Corporation, Kenneth Macgowan similarly hoped that the loose and far-flung network of amateur theater groups that had burgeoned over the past fifteen years might develop into an American version of a national theater. In a small, homogenous country the concentration of theatrical resources around a sophisticated elite might meet national artistic needs perfectly well. "But the United States is not homogeneous," Macgowan admonished his readers; "more than that, it is rich in life far removed from sophistication." American dramatists should study the life closest to themselves and then write plays that were "an expression of local characters and local conditions—easily understood by their own people, easily attractive to them." When it arrived, a national theater for America would not be found "on feverish Broadway or in that synthetic capital, Washington. . . . It will live nationally as American life lives nationally through its local and characteristic institutions."[104]

Macgowan figured that around 28,500 dramatic performances were mounted each year in the United States, of which some 3,000 were given by colleges and universities and by about 200 fairly well-established local theaters. Perhaps as many as 335,000 Americans appeared in some kind of dramatic offering each year before audiences Macgowan thought might total 12,500,000. Such figures failed to impress critics like John Anderson. In his sustained attack on the dominance of Broadway and the power of the dollar, Anderson argued that the little theaters, including even the college-university groups, were generally unwilling to do a play until it had first won success in New York. Thus, instead of feeding Broadway, they tended to feed on it. As far as Anderson was concerned, "whatever is new and vital and promising in the American theatre at this moment—as little as it is—lies completely within the commercial theatre." And from Maurice Browne, the Britisher who had instigated and led the defunct Little Theatre in Chicago, came the confession that the great shortcoming of both his venture and the little theater movement overall was "the fact that it took and is taking its values from Europe instead of creating its own theatric forms and dramatic literature."[105]

Yet if American drama still fell short of the ideal of an indigenous, independent expression, it was obvious that a basic transformation had taken place in the nation's dramatic culture in the postwar decade. The size and extent of the little-theater movement, the spectacu-

lar rise of O'Neill and the emergence of various other new American playwrights, the healthy condition of theater in New York (at least until the 1928–29 season), and, not least of all, the development of a more mature brand of criticism all testified to that transformation. "Twenty years ago," Joseph Wood Krutch remarked at the close of the period, "the drama was hardly a department of contemporary American literature; today it emphatically is."[106]

## X

What had happened in drama was only one factor in the overall American literary resurgence that had begun about 1910 and was still going strong. In 1927, in its thirteenth edition, the *Encyclopaedia Britannica* finally abandoned its "reminiscent" attitude toward the country's literature and included articles on modern American writing by Carl Van Doren, Louis Untermeyer, and H. L. Mencken, among others. In his important history of American letters since 1890, published in 1930, Fred Lewis Pattee began with the premise that the period had "produced the greater bulk of those writings that we may call distinctively our own work, work peculiarly to be called *American* literature."[107] Meanwhile, the Modern Language Association, the country's largest organization of literary scholars, had finally responded to urgings from its small but vocal American Literature Group and sanctioned a journal to be devoted exclusively to American literary scholarship. Under the sponsorship of Duke University and under the editorship of Jay B. Hubbell, the quarterly *American Literature* made its appearance in March 1929. "Within the last five years," Hubbell noted in his editorial statement, "American scholars have awakened to the fact that our literary history supplies a rich and comparatively unworked field."[108]

The next year the Nobel Prize Committee for the first time gave its award for literature to an American. It was widely suggested at the time that the choice of Sinclair Lewis was perhaps less a matter of honoring the accomplishments of a particular writer than of acknowledging the world stature of modern American literature as a whole. That was also the way Lewis treated the honor in his Nobel Laureate address in Stockholm in December 1930. Lewis spoke in praise of the "great men and women in American literary life today," mentioning, among others, Theodore Dreiser, Eugene O'Neill, Sherwood Anderson, Carl Sandburg, Edna St. Vincent Millay, as well as H. L. Mencken and Van Wyck Brooks. He even lauded the early Hamlin Garland,

whose harsh prairie realism had shown Lewis that "I could write of life as living life." Although Garland had later "gone to Boston and become cultured and Howellsized," the succeeding generation had challenged and done fierce battle with "Victorian and Howellsian timidity and gentility. . . ." In Lewis's view the battle still had to go on until the liberation of America was complete.[109]

As Malcolm Cowley noted, Lewis was "vastly overestimating the strength of his surviving enemies." By 1930 the insurgent intellectuals and artists, in Cowley's words, "were mopping up territory already conquered."[110] While a variety of official and unofficial censorship continued to prevent some kinds of explicitness, in thematic terms, literary and other kinds of artists had to contend with few remaining restrictions. The New Humanism represented the last unified, philosophically coherent effort to shore up the moralistic foundations of the American arts. After that the cultural gentility's twenty-year retreat became a rout.

In 1929 Joseph Wood Krutch, in a book often taken as the Lost Generation's belated manifesto, bemoaned what he assumed to be the moral and spiritual emptiness of the "modern temper." Modern man, according to Krutch, was unable really to believe in either the discredited older humanistic values or the ruthless, amoral prowess of triumphant science and technology. Heroism, love, tragedy—the historic subject matter of great art—all became impossible in the modern context. Art, Krutch suggested, could be neither restorative and inspirational as in the Great Tradition, reformist and regenerative as in romantic nationalism, nor even meaningfully self-expressive as in cultural modernism. Living in a pointless universe, man was thrown back on "the animal's unquestioning allegiance to the scheme of nature. . . ."[111]

An implicit rebuttal to Krutch came a year later in the first significant essay published by a young critic named Lionel Trilling. Literature as well as art in general were still possible, Trilling said. "The material of art has always been the relation of man to himself, of man to fellow-man, of man to universe." That material still existed, "and in America it is being made both more subtle and more momentous." America had been hot chaos to Randolph Bourne; Trilling saw it as "disorder under a superficial regimentation." Whatever was wrong with the arts in America was not the fault of the artist's environment but of the artist himself, who had to quit yearning for acceptance by society and understand that his proper role was to be a rebel, a radical questioner. For the salvation of art in America was not to be found in "a great rapprochement with the environment, but in its becoming subversive and dangerous to the social order."[112]

Trilling's essay was perhaps the most concise statement of the creed of radical modernism thus far published by an American. Just as radical modernism—with its version of the lonely artist living by necessity in perpetual estrangement from the larger society—had repudiated the moralistic presuppositions of the Genteel Tradition, so also had it repudiated the socially regenerative purposes of romantic nationalism. In fact, romantic nationalists had always strived to achieve just that rapprochement with the social environment which Trilling warned against. Over the long run modernism would win out over romantic nationalism in defining the artist's relationship to himself and to American society. Over the next decade, however, American cultural nationalism—still dedicated to the regeneration of society through art, still wedded to the democratic ethos, yet now also strongly affected by ideological controversy—would be ascendant. Paradoxically, the economic catastrophe of the 1930s would provide the context for the most determined efforts so far to realize an authentic, indigenous culture for America and a viable and purposeful role for the creative artist in American society.

CHAPTER **5**

# The Decade of Convictions

ONE OF THE LASTING INTELLECTUAL ACHIEVEMENTS OF THE 1930s was the creation of a powerful set of myths about the period between the Armistice in the fall of 1918 and the collapse of the stock market in the fall of 1929. According to that mythology, the twenties had been a decade of escapism and self-indulgence, a frivolous, hedonistic time when the American people were content to enjoy the illusion of prosperity and the American political leadership was content to watch the country speed toward the abyss of the Great Depression. Ignoring the extremes of wealth and poverty, the fragile position of the wage-earning class, the steady decline of the agricultural economy and rural life, and a host of other signs of basic social sickness, Americans had trusted the claims of big business that the country had entered a New Era of enlightened capitalism and left behind the old cycle of boom and bust.

Then came the Crash and an ever-deepening depression, shattering the New Era and exposing the business system of the twenties for the sham it had been from the outset. As most commentators in the early thirties readily understood, the years ahead would be profoundly different from those just ended. Concluding his best-selling instant history of the twenties, Frederick Lewis Allen said that "the United States of 1931 was a different place from the United States of the Post-war Decade; there was no denying that. An old order was giving place to new." In his review of Allen's book, John Chamberlain added that "Psychologically, we are closer to 1896 or 1904 than to 1928." Whereas the twenties had been tired of social causes, "the '30s will be forced to go crusading."[1]

# I

Allen's *Only Yesterday*, a beautifully conceived collection of impressions and insights, was the most persuasive single contribution to the twenties mythology.[2] One of Allen's major themes was that while the rest of the population had pursued pleasure and possessions, intellectuals and artists had wallowed in self-pity, cynicism, and an irresponsible estheticism. Convinced that the country was lost to the Puritans and philistines, disillusioned by the war and disgusted by America's spiritual squalor, "the highbrows," as Allen called them, had either fled to Europe or sulked at home.

Of course the reality had been something quite different. In retrospect what seems most striking about the intellectual-artistic life of the twenties is not a general disinterest in politics and ideology but an enormous diversity and fecundity, an intense occupation with the full realization of the creative potential of both individuals and the whole society. The post–World War I decade, it now becomes clear, featured a continuing ardent quest for a rich and recognizably American culture.

From the perspective of the immediate post-Crash years, however, there seemed little to be learned from the culture of the twenties besides the lesson of its irrelevance to the disguised realities of that period and the raw, inescapable realities of the present. Malcolm Cowley's exaggerated version of the creed of the avant-garde was an indictment of himself and those who had shared his artistic views in the twenties: *"Art is separate from life; the artist is independent of the world and superior to the lifelings."* That decade's concentration on the circumstances of the creative individual was a luxury no longer affordable in Depression America. As the narrator suggested in Budd Schulberg's novel *What Makes Sammy Run?*, individualism had become "the most frightening ism of all."[3]

One of the earliest and also most characteristic of such assessments came from V. F. Calverton, the most astute of several avowedly Marxist literary critics gaining prominence in the thirties. In 1923, at the age of twenty-two, Calverton (born George Goetz) had founded the *Modern Quarterly* in his native Baltimore. Remaining wholly independent of the newly emergent Communist Party of the United States and the *New Masses*, the party's monthly literary magazine, Calverton's journal became the most sophisticated left-wing periodical published in America.[4]

In the late summer of 1930, with industrial production sagging and with farm prices seemingly in pursuit of stock values in their down-

ward spiral, Calverton predicted that whereas the years 1914–20 had been an "age of revolt" and the twenties a time of cynicism, the thirties would be "the decade of convictions." Apparently fooled by the present commotion the New Humanism was causing, Calverton thought the choice for intellectuals in the years ahead would be either humanism or social radicalism. In any case, it would be hard to stay neutral, to try to go back to the cynical twenties, when "the stress was not upon values but upon the folly of them." That decade, Calverton announced, "represented the debacle of individualism—as at its last debauch."[5]

Calverton proved less than half right on the matter of choices. On one hand, the New Humanism soon fizzled; on the other, only a small minority of intellectuals and artists became full converts to Marxist radicalism. Even so, the atmosphere of crisis produced by the economic tailspin promoted a heightened political and social consciousness throughout American cultural life. More than at any time since before the war, political causes became intellectually respectable. No longer subsisting on the fringe of ideas and art, the "Left movement," Harold Clurman has remembered, was now "the main movement of the American consciousness in the process of its growth." In the twenties cultural dissidents had usually perceived the ills of America as spiritual or psychological; for the thirties the common tendency was to begin with the overarching fact of material privation. As Frederick J. Hoffman has phrased it, "Repression gave way to oppression as the critical war cry."[6]

Paralleling the rediscovery of politics, ideology, and social causes was a phenomenon often described as "the rediscovery of America." In the twenties, expatriation as a way of escaping America's spiritual poverty had often been the fashionable course. Now repatriation—an equally self-conscious act of coming home to America's tangible poverty—became equally fashionable. Plenty of people who in the twenties had been actively involved in the task of building an American culture now described themselves as having really seen America for the first time, as having found new purpose and hope in a country that seemed on the verge of economic collapse. "They rediscovered America, in one book after another," Malcolm Cowley said of himself and the other returned exiles, "and it was a different America from the country they had deserted in the 1920's." For the intellectual generation of the twenties, Maxwell Geismar wrote in 1941, the Depression "came as a sort of salvation. . . . Rather like the insulin treatment of modern therapy, the shock of the depression brought our artists back from the shadows of apathy or hostility to a more fruitful share in our common heritage."[7]

However exaggerated and ahistorical such claims may have been, they represented a fundamental intellectual premise for the thirties. In 1932 Harold Stearns, who had tried to speak for the "young intellectuals" in the postwar years, returned to the United States after more than a decade of residence in France, the last few years of which he had spent in poor health and financial straits. Soon Stearns was at work on *Rediscovering America,* a book that expressed his wonder at the changes in his native country. He found that the American arts had come to flower and were now "our own at last, without apology, without shame, without distrust." Now it was possible to speak of a separate American language and a strong national literature in which that language found expression. America's growing pains, Stearns decided, were finally over.[8]

Ludwig Lewisohn, an American pioneer in the application of psychoanalysis to literary criticism, had also left the United States for Europe in the twenties. Back home by 1934, Lewisohn acknowledged that he had once been unhappy in "Puritan" America. Now, though, he marveled at the nation's "completeness," at its orderly freedom even in the depths of hard times. "In so many things in which Europe is supposed to excel (and did so, historically speaking, till the other day) it is now America that excels." The common run of Americans were a people "less driven and hardened, less cruel and rapacious, far less either flunkies or snobs, kindlier, better spirited, freer and more naturally conscious of freedom and, therefore, more tolerant than the people of other Western lands."[9]

Such extravagant praise for America and Americans—the common people, the masses who in their suffering took on a hitherto unrecognized nobility—was a characteristic feature of American social and cultural commentary in the period after 1930. Up to now, the midwestern novelist Ruth Suckow scolded, the American intellectual class had cut itself off from the country's "plain folks." The time had come for intellectuals to lay a foundation for their work in America and its people, to realize that "here the country lies—huge, half formed, fundamentally various under the hasty superficialities of standardization, and fundamentally one country."[10]

Of course not everyone shared the new mood of rediscovery and reconciliation and the feeling that the gap between the creative individual and general society had to be closed, presumably on society's terms. An undercurrent of discontent with mass values and the ethos of American democracy persisted throughout the thirties.[11] Older cultural elitists like H. L. Mencken and Albert Jay Nock were disgusted by the sudden change of heart so many onetime dissenters had experienced. The country was as bad as it had always been, Nock insisted,

only now its intelligentsia "regard its imperfections with a gladstone hope, and a faith amounting to certainty." Mencken finally admitted that he would have been better off in the eighteenth century, "when human existence, according to my notion, was pleasanter and more spacious than ever before or since."[12] Late in 1933 Mencken gave up the editorship of the *American Mercury*. Never again would he operate at the center of American cultural criticism as he had in the teens and twenties.

Meanwhile, Alfred Stieglitz, who had sought nothing less than a revolutionary alteration of critical perceptions and standards, remained determinedly apolitical. Such a stance put him out of touch with prevailing attitudes in the arts throughout the thirties. When his old friend Waldo Frank expressed disappointment that Stieglitz had not become involved in the Left movement, the seventy-two-year-old Stieglitz replied, "In reality I am much more active in a revolutionary sense than most of the so-called Communists I have met. I have always been a revolutionist if I have ever been anything at all."[13]

In the Depression years, though, there was little place for Stieglitz's kind of radicalism—a radicalism having to do mainly with formal experimentation and the liberation of the creative individual. "Realism" now seemed to define the only meaningful way to think about the function of art and the role of the artist. "We are becoming increasingly conscious of the fact that we have always been essentially realists at heart," wrote one commentator, speaking specifically about visual art but also generalizing about common American attitudes. "As a nation we are not attuned to play with abstraction," said another. "Our efforts are more flat-footed." In practicing a technical realism, so the argument went, artists should focus on the social realities of the here and now in stricken America. By 1933 Montrose Moses had become convinced that the "American note" was thoroughly assimilated into drama across the country. "On every side," Moses enthused, "we hear: Write of the life around you, protest against the condition that attempts to engulf you, dramatize America. We have never had such incentive as we have now to 'go native.' "[14]

## II

The substantial reinvolvement of intellectuals and artists with social issues meant that biographically and socially based criticism in the arts reached a high point. The tradition of Saint-Beuve and Taine dominated literary studies. Early in the decade Russell Blankenship, author of a highly successful American literature text, stated the pre-

vailing view among literary scholars and critics: "The student who wishes to know how fully our literature speaks for its age and how an age is re-created by its literature will find a knowledge of American social history is probably the most valuable portion of his intellectual equipment." Surveying American writing "as an expression of the national mind," Blankenship repeatedly insisted that the question was not whether literature spoke for its age but how it spoke.[15]

A readily apparent corollary was the long-running search for a usable past, a creative heritage from which present-day writers could draw inspiration for their own efforts to further a viable culture. A year after the Great Crash the uncompleted third volume of Vernon Louis Parrington's *Main Currents in American Thought,* the most comprehensive attempt anybody had made so far to lay out that usable past, was published posthumously. Born in 1871 in Illinois and raised in Kansas, where his father was a lawyer and judge, Parrington had grown up in the rancorous political environment of the farmers' protest movement of the eighties and nineties. After getting his A.B. from Harvard, he came right back to Kansas to teach English literature and French at the College of Emporia. Subsequently, he spent nine years at the University of Oklahoma before his outspoken political views got him fired. He taught the rest of his life at the University of Washington, where he wrote his massive study of American letters. Parrington died two years after the first two volumes appeared.[16]

Parrington hated early New England Puritanism and what he saw as the constricting Puritan legacy, hated big business and the cities, hated the East's dominance of American economic and cultural life. He started with a conception of literature that was virtually all-inclusive, more concerned with "forces that are anterior to literary schools and movements" than with "the narrower belletristic. . . ."[17] Thus his approach was like that of Mencken, Van Wyck Brooks, Lewis Mumford, the New Humanists, and indeed the great majority of students of literature in his time. Through the country's literary development—the writings of people as different as Jonathan Edwards and Benjamin Franklin, Edgar Allan Poe and Walt Whitman—Parrington wove a dialectical pattern of conflict between the forces of "democracy" and those of "aristocracy" and "plutocracy." After ending his first volume with the triumphant presidential inauguration of Thomas Jefferson and his second with the New England Transcendentalists, Parrington was only able to finish a broad outline and a number of disparate essays for a third volume that would bring the full story up to his own day.

Parrington's work was shot through with superficial and sometimes shoddy judgments, generally disregardful of intrinsic esthetic problems,

and set in a simplistic, even Manichean framework. It was nonetheless a heroic attempt to offer a past that would be usable both artistically and ideologically, a grand liberal tradition in American thought and literary art. In his sustained protest against the passing of the independent agricultural producer and small entrepreneur and the rise of a powerful business elite, Parrington went farther than anyone in America ever had toward a synthesis of literature and ideology, art and politics. Parrington's work presaged the Left criticism that would become one of the most vivid—and also most ephemeral—cultural manifestations of the Depression era.

For Parrington the measure of both a healthy society and a healthy literature was whether they promoted the fulfillment of democracy and individual liberty. For the Marxist critics it was whether literature and society had come to terms with the historical inevitability of social conflict and the imperative of building a revolutionary consciousness in the working class. Yet while native Marxists took their premises and theoretical framework from European thought, most of them also sought to formulate a distinctively American Marxist cultural heritage—still another version of the usable past. The result was a rather strong nationalistic element in much of the Marxist cultural commentary of the thirties.

That concern was most evident in the period 1935–39, years in which Communists in the United States and other Western countries abandoned doctrinaire Marxism in favor of accommodation with "progressive" non-Marxists. Yet even under the "Third Period" policy of irreconcilable opposition to capitalism and "bourgeois democracy," Marxist critics argued the need for a proletarian art rooted in the American experience and relevant to American prospects. As early as 1921 Michael Gold, later to emerge as the central figure on the *New Masses* magazine, had written that a real American literature must be founded on the struggles of the American working class. To anybody who might object that a workers' art would lack subtlety and refinement, Gold had a ready answer: "Yes, we may be crude, but at least, thank God, we are American." Gold's famous blast nine years later at Thornton Wilder's "parlor Christianity" and his refusal to face contemporary realities had to do largely with the fact that, according to Gold, Wilder was unable to "write a book about modern America."[18]

What Gold wanted, Richard Pells has observed, was a new literature, one emphasizing "a distinctive *national* style and outlook—an ideal which, ironically, sounded closer to Emerson or Brooks than to Marx." Or, as James B. Gilbert has said, the radical literary movement held out the prospect of both "a renaissance and a political revolution. . . . The search for a new America during the 1930s ended in the vision of a society transformed by the proletariat and the intellectuals." As

the romantic nationalists had wanted to end the isolation of the artist in society, the Marxist critics wanted to end the isolation of American culture from the influence of the "progressive" forces at work in history. It all amounted to an updated, Marxianized version of the old idea of an American renaissance. Taking a role similar to the one Van Wyck Brooks had envisioned for them, intellectuals and artists would act as social prophets—except that in the Marxist scheme they would serve as adjuncts to the Communist Party and a proletariat stirred to revolutionary consciousness.[19]

Unlike the diverse aggregation gathered around the prewar *Masses,* the Left intellectuals of the Depression period generally wanted nothing to do with personal rebellion and Bohemian styles in living. The style of the thirties Left was determined, earnest, and above all logical and systematic. The times were too deadly, they believed, for the kind of fun-poking and fun-seeking that had characterized the efforts of earlier radicals to blend politics, life, and art. Politics and art could and commonly did blend in the thirties, but life was supposed to be a matter of disciplined thinking and hard work.[20]

Both independent Marxists like V. F. Calverton and faithful Party-liners like Granville Hicks shared that sober outlook. Calverton's *The Liberation of American Literature,* published in 1932 in the trough of the Depression, was the first book of its kind, a full-blown American literary history from a consistently Marxist point of view. Artistic criticism, Calverton declared at the outset, took on real significance only when based on the correct social philosophy. He also freely acknowledged that he had neglected technical analysis and evaluation because it was first necessary to show how literature had developed in relation to its class content. Up to now, he maintained, the nation's letters had expressed a tenaciously optimistic belief in boundless economic opportunity. That was the bourgeois delusion from which American literature had to be liberated.[21]

For all his ardent Marxism, Calverton shared the romantic nationalists' yearning for a rich and powerful native literature. He quoted approvingly Brooks's plaint from his *Freeman* days that American writers "cannot feel they are voicing anything but their individual sentiments, and for this reason they lack confidence in themselves." The trouble, Calverton said in what served as his personal manifesto, was that despite all the inquiry over the past two decades, American writers still lacked a viable tradition. Literary generations in America were dishearteningly short, as Brooks had said. But how could it have been otherwise, Calverton asked, in such an unstable, bourgeois-dominated society? Only a proletarian tradition could give American writers the confidence they needed. In the American working class was "the foundation for the beginning of a new lasting literary school

dedicated to the defense of a growing proletarian tradition." The task of Left writers, therefore, was "to bring literature back to the masses."[22]

While Calverton wanted to liberate American literature from its bourgeois outlook, Granville Hicks looked for radical tendencies or at least a spark of social consciousness in virtually every significant writer the country had produced over the past seventy years. Literary editor of the New Masses in 1933–34, Hicks was a native New Englander and Harvard graduate and a former ministerial student and Christian Socialist. His reputation as the Communist Party's outstanding literary figure rested mainly on his book The Great Tradition, a retelling of American literary history since the Civil War within a devoutly Marxist framework. While Hicks roundly condemned pessimism and estheticism wherever he found it, he also found a great deal of writing that was socially useful, infused with "the spirit that moves the noblest creations of all American writers." That spirit made up Hicks's "great tradition" in the national letters.[23]

The American intellectual-artistic class was particularly hard hit by the Great Depression. That fact alone goes a long way to account for the widespread attraction of Marxism and the Communist Party —what Malcolm Cowley called the thirties' "Red Romance." As the economic crisis in the capitalist countries deepened, the image of Soviet Russia, seemingly transforming itself at an incredible rate under the Stalin regime's Five-Year Plan, was an enormously appealing one. While they might disapprove of the suppression of political dissent in the USSR, non-Communists on the Left generally applauded the Soviet commitment to a collectivist, rationally planned economic order and staunch opposition to the spread of international fascism.[24]

Yet for most the Red Romance was nothing more than that—never a marriage or even an engagement. Edmund Wilson spoke for many others in 1931 when he urged non-Communist "progressives" to "take Communism away from the Communists" and "prove that the Marxian Communists are wrong and that there is still some virtue in American democracy. . . ." Wilson, in other words, wanted a thoroughgoing native American radicalism, one that would overhaul the economic system without overturning American traditions of popular government and civil liberties. As for the arts, Wilson argued that American society—with its nearly universal literacy, its nonfeudal, pioneering, individualistic past, its much greater class complexity—was so fundamentally unlike that of Russia that one country could not possibly take its cultural models from the other. In short, "the country which has produced Leaves of Grass and Huckleberry Finn has certainly nothing to learn from Russia."[25]

If Wilson and non-Marxists in general were little interested in searching for a usable proletarian past in America, the criticism most

of them wrote remained socially and historically grounded. The creative artist, as they saw him, was still a product of his social environment, and what he did as an artist was still intimately related to his national identity. In 1934 Joseph Wood Krutch remarked in wonder on the variety of usable pasts floating in the intellectual atmosphere. As he wisely noted, both the earlier anti-Puritan critics and the current Marxists found largely the same American heroes, people who had supposedly stood against intolerance, superstition, greed, and constraints on personal expression. "The past we believe in," Krutch concluded, "is the past which justifies today. . . ."[26]

## III

Meanwhile, the man who had coined the phrase "usable past" and struggled harder than anybody to awaken the American creative consciousness abandoned his accusatory attitude and embraced America—or at least practically everything he came across in its cultural history. In 1932, having finally overcome the mental illness that had stricken him in the previous decade, Van Wyck Brooks published his long-delayed biography of Ralph Waldo Emerson. A loving, imaginative (some said too imaginative) re-creation of the man, his family, his circle of friends, his New England, *The Life of Emerson* set Brooks resolutely on the path of reconciliation and reaffirmation down which he had started in 1927 with his *Emerson and Others* essays.[27]

Brooks had finally achieved his intellectual and emotional synthesis. In the process he had made his own separate peace with America and most of all with the Puritan heartland. That fact became even more evident in 1936, when Brooks published his imposing history of New England intellectual life in the pre–Civil War decades. Working on a much bigger canvas than had Lewis Mumford in the twenties, Brooks rediscovered the "golden day" in all its richness and vitality. Chatty, incessantly anecdotal, heavy with nostalgia for an age of creative community Brooks yearned for in his own time, abundant with kindness and affection toward people like Longfellow and Lowell, whom Brooks had once derided, *The Flowering of New England* was a singular achievement and a deserved best seller. Almost identical in its biographical method and almost equally celebrational was the sequel, *New England: Indian Summer* (1940). Here Brooks largely rehabilitated the late nineteenth century, which he and his contemporaries had earlier despised. Brooks could even write fondly of such previous villains and victims as William Dean Howells, Henry James, and Henry Adams.[28]

In his ripe middle age Brooks had become the elder statesman of American criticism, at last made famous and moderately wealthy by his writing. The popularity of his histories was one evidence of the thirties' strong receptivity to the glorification of the American past; Brooks's reconciliation with America turned out to be extraordinarily opportune. Yet in other ways Brooks was out of joint with the times. Waldo Frank, his comrade from the *Seven Arts,* zealously went Left in the Depression years, as did many of Brooks's other friends. Like most Left intellectuals, Frank stopped short of actual membership in the Communist Party. He did, though, take a leading role in the Communist-controlled League of American Writers, which brought together a considerable diversity of literary people for its biennial congresses beginning in 1935. When Frank urged Brooks to sign the call for the first Congress of American Writers, Brooks refused, chiefly because of a reference in the call to the fight against "bourgeois ideas in American literature." What the league considered bourgeois, Brooks pointed out, "is to me sacred and real; and to say anything else would be for me to deny my conception of the ends of life." Later he did allow his election to the league's national council, as did the equally skeptical Mumford.[29]

Still vaguely a socialist and apparently still seeking some kind of brotherhood of artists, Brooks continued reservedly to support the League in the Popular Front years of the late thirties. Yet he was never really comfortable with the insistent political mindedness of the period. As he had been impatient with self-conscious expatriation and mannered cynicism in the twenties, so he also had little use for Left posturing in the thirties. The problem with America had always been spiritual. At one time Brooks had admonished Americans to understand their spiritual poverty; in the thirties he undertook to educate his fellow intellectuals in America's spiritual riches.

## IV

All the arts in the Depression period were affected to some extent by an attraction to Marxism. Theoretically, cultural nationalism was inconsistent with the ideal of an international workers' culture. Yet if anything, the Left mood of the thirties had the effect of intensifying the longings of many who had sought to promote native creative expression in the pre-Crash years.

That was certainly the case with the playwright Paul Green, who had gone from the Carolina Playmakers to win a Pulitzer Prize for *In Abraham's Bosom,* his tragedy of a black sharecropper family staged by the Provincetown Players in 1926–27. Despite the awakening in

drama to which he had himself contributed, at the start of the thirties Green could still describe the American theatrical situation as "singularly barren and confused," unable to express American life in the vital way railroads, industry, skyscrapers, and movies did. More than ever, the playwright was convinced that socially conscious art was both an imperative of the times and the most efficacious way to articulate the national character.[30]

Green's plays in the thirties suggest a pattern of development common to American cultural life as a whole in that decade. Green exhibited his strongest Left inclinations in the early and mid-thirties in *The House of Connelly,* a play about class tensions in the twentieth-century South, and in the antiwar drama *Johnny Johnson,* both produced by the Group Theatre. Beginning in the late thirties, though, Green increasingly sought his materials in early American history. Ultimately he wrote a series of historical pageants, of which the first was *The Lost Colony.* Depicting the vanished late-sixteenth-century settlement on Roanoke Island off the Carolina coast, the pageant was presented on the site in 1938 with the participation of North Carolina's division of the Federal Theatre Project.[31]

Even before the Crash there had been signs of a growing Left spirit in American theater, especially in the work of the New Playwrights, a short-lived company formed by John Howard Lawson, John Dos Passos, and Em Jo Basshe. Lawson's *Processional,* produced by the illustrious Theatre Guild in 1925, was the first Marxist-inspired play given a major performance in the United States. Aside from its ideological slant, the most notable feature of Lawson's early dramaturgy was a plentiful use of the materials and modes of popular culture. In effect *Processional* was a comedy revue with a class-struggle theme. The play featured a veritable "processional" of popular caricatures, such as an exploitative capitalist boss and his henchman, the sheriff, vicious Ku Klux Klansmen, a Negro minstrel, and a dynamite-wielding proletarian hero. Lawson said that he wanted to "express the American scene in native idiom," "a development, a moulding to my own uses, of the rich vitality of the two-a-day and the musical extravaganza." Only in the popular theater could one find the "native craftsmanship" on which "to lay the foundations of some sort of native technique, to reflect to some extent the color and excitement of the American processional as it streams about us."[32]

In many ways Lawson's *Processional* suggested the America-as-spectacle attitudes of *Broom, Vanity Fair,* the *American Mercury,* and the *American Parade.* Lawson's and Dos Passos's fondness for the popular arts was also reminiscent of what Matthew Josephson, Harold Loeb, and most of all Gilbert Seldes wrote in the twenties. The only thing really alive in the American theater, Dos Passos declared as

late as 1931, was the "jazz"-filled musical revue. But whereas the popular theater of the twenties had voiced "the imperialist prosperity myth," now there was a chance to have "a theatre of depression, a theatre that perhaps would be able to mold the audience a little instead of everlastingly flattering it."[33]

Although Lawson abandoned experimental drama and Dos Passos gave up playwriting altogether, the influence of vaudeville and other forms of popular theater was still much in evidence throughout the thirties. Major examples of that influence included Robert Peters and George Sklar's *Parade,* a spritely musical revue presented by the Theatre Guild in 1935; the long-running late-thirties revue *Pins and Needles,* produced and performed by members of the International Ladies Garment Workers Union; Marc Blitzstein's "play with music," *The Cradle Will Rock* (1937) ; and to some extent the crude "agitprop" performances of the radical Workers' Laboratory Theatre.[34]

The prevalent mode in American drama after 1930, however, was realism. Often didactic and even lecturish, thirties plays usually emphasized message at the expense of method. Eugene O'Neill might feel that "when an artist starts saving the world, he starts losing himself."[35] Many other dramatists, though, willingly yielded to the strong pull of the times' sociopolitical agitations.

The high tide of Left expression in American theater came in the period 1932–36. Besides the Workers Laboratory Theatre, the Theatre Union was also decidedly Left, as was, to a lesser extent, the Group Theatre. The Theatre Guild staged James Wexley's *They Shall Not Die* (1934) , a dramatization of the sensational case of the eight black "Scottsboro boys" on trial for raping two white women in Alabama, and Robert E. Sherwood's sardonic antiwar drama, *Idiot's Delight* (1936) —besides Peters and Sklar's *Parade.* Such highly successful Broadway productions as Sherwood's *The Petrified Forest* (1935) , Sidney Kingsley's *Dead End* (1936) , and Maxwell Anderson's *Winterset* (1935) also reflected the period's strong social consciousness. One enthusiast on the Left was convinced that the Depression had finally given America a "red-blooded and robust" drama for the people.[36] Certainly it seemed that Dos Passos's call for a "theatre of depression" had been amply heeded.

One study, however, had found that of fifteen hundred independently produced plays on Broadway between 1929 and 1941, only seventy-four had "socially significant" themes or dealt directly with public issues and controversies.[37] Box-office receipts in New York continued the decline that had set in a year before the Crash; the annual number of Broadway productions, more than two hundred fifty in the late twenties, had dwindled to around eighty a decade later. Little-

theater groups across the country were hit even harder. In the straitened circumstances of the thirties, there was more than ever a tendency to play it safe and produce innocuous light plays and "musical comedy." Regardless of the intended audience, the people who actually saw the "socially significant" plays of the thirties consisted mostly of the same bourgeois class that was supposed to be the enemy. For the proletarian masses at whom such consistently radical companies as the Theatre Union and the Workers' Laboratory Theatre aimed their offerings, the less expensive "escapism" of the movies was a more compelling attraction.

The most important new dramatic company to appear in the Depression years was Group Theatre. Group Theatre's principal instigator was Harold Clurman, the son of an East Side New York physician and a former bit player with the Provincetown Players and the Theatre Guild. As early as 1927–28 Clurman was excitedly talking about "an organic theatre," a repertory company with "a certain homogeneity in all its parts: directors, actors, plays."[38] A trip to Russia in 1930 converted him to the "Stanislavsky method," a directorial and acting technique pioneered in the Moscow Art Theatre and involving an intense identification of actor with character.[39]

Clurman later described the close, often abrasive interaction of the members of the Group as "an experiment in living," an effort to achieve a spiritual unity among the members of the company, which would somehow carry over into the relationship between performers and audience. Waldo Frank, speaking before a fund-raising meeting for the Group early in 1932, called for "a new alliance in place of the alliance of the intellectuals with the money class, an alliance of the men of mind, of vision, the artists, with the People. . . ." Yet by Clurman's account, the Group was less interested in politics than it was in achieving what Clurman termed "a truly representative American theatre." The Group should become, Clurman told its members in 1935 when he returned from his second visit to the USSR, "the recognized and honored first theatre of America." That meant developing not only technical excellence but also a repertory "that will truly represent all the creative aspects of our country, that will make use of the widest and deepest traditions to which as an American theatre we are heir."[40]

In the first three years after its founding in 1931, the Group offered, besides Paul Green's *The House of Connelly,* such socially conscious plays as Clare and Paul Sifton's *1931–* (1931) and John Howard Lawson's *Success Story* (1932). Its social protest phase reached a peak at the beginning of 1935 with *Waiting for Lefty,* a sensational one-act play that vaulted into playwriting prominence Clifford Odets, hitherto

a minor actor in the company. Inspired by a New York taxi drivers' strike the previous year, the play ended with the militant unionist "Agate" putting the fateful choice to the audience and with members of the Group leaping from seats around the theater to lead the people out front in a roaring "Strike! Strike!"

When he hurriedly wrote *Waiting for Lefty* late in 1934, Odets, only twenty-four years old, was in the midst of about six months of active membership in the Communist Party. Yet his longer plays showed clearly that his real interest was not the drama of agitation and protest but the subtler, more complex drama of social criticism. Odets had the good sense to go to his own background—a close Bronx Jewish family with solid middle-class values—for the inspiration and materials for his more substantial works. "The source of much of Odets' strength as a 'proletarian' playwright," Gerald Rabkin has written, "lay precisely in the fact that he did not force himself to write about the proletariat." In *Awake and Sing!*, generally regarded as his best play, and *Paradise Lost*, both produced in 1935, then in *Golden Boy* (1937) and *Rocket to the Moon* (1939), Odets was preoccupied in one way or another with the disintegration of bourgeois hopes, family life, and moral values—within a distinctly American context. Insofar as such plays were anticapitalist, they had to do mainly with capitalism's moral and spiritual rather than economic depredations. The malaise Odets described was not greatly different from the indictment of America the romantic nationalists had made in the prewar and postwar decades.[41]

In terms of the overall development of American drama in the twentieth century, the Left movement of the thirties seems more and more only an interlude. The radical-revolutionary surge in the theater actually lasted little more than half a decade. After that, under the sway of the New Deal, the Popular Front, and then the spread of war in Europe and Asia, the main ideological orientation in theater and American cultural life as a whole shifted from radicalism to a celebration of national virtues and values.

## V

The Great Depression was at least as much of a financial blow for American music as it was for theater. Across the country, symphony orchestras and opera companies either had to shorten their seasons, close down temporarily, or, in a few cases, fold permanently. Even the previously prosperous Metropolitan Opera had to appeal to its millions of radio listeners for contributions and cut its 1933–34 season

from twenty-four to fourteen weeks. The repeal of national prohibition at the end of 1933 and the reopening of nightclubs improved circumstances for popular dance bands, but the economic crisis continued to take its toll on professional musicians. Moreover, the advent of sound in motion pictures ended the practice, common in the biggest movie "palaces" in the twenties, of hiring small orchestras to accompany major silent productions. By 1934, according to one estimate, about sixty percent of the musicians in the country were out of work.[42]

At the same time, the situation for composers was alleviated by growing opportunities in other directions and in some areas where jobs were shrinking for performing musicians. As Aaron Copland pointed out decades later, in the thirties American composers could feel for the first time that there was a real practical need for their services. If sound pictures threw some performing musicians out of work, the talkies also created an unceasing demand for original soundtrack compositions. With an annual production of five hundred to seven hundred feature-length pictures, of which maybe half involved at least some original scoring, the Hollywood studios provided lucrative employment for substantial numbers of composers (as well as for novelists and playwrights lured to Hollywood for occasional or long-term work as scriptwriters). To a lesser extent, composers also found themselves sought after to provide music for radio dramatic productions, for legitimate theater, and for the increasingly ambitious efforts of native ballet and modern dance companies.[43]

Variously called "role music," "program music," or by the German designation *Gebrauchmusik,* scores for films, radio, and theater had to be simpler, more direct, more thematically recognizable than other kinds of formal music. Often involving highly self-conscious efforts to evoke the American scene, program music had obvious similarities to the impressionism that had thrived in the twenties. Copland's *Music for Radio* (1937) exemplified the best of the period's program music, as did Virgil Thomson's stirring scores for the documentary films Pare Lorentz made for the New Deal's Farm Security Administration—*The Plough That Broke the Plains* (1936) and *The River* (1938).

Radio not only broadened opportunities for composers but also seemed to be a medium with enormous potential for educating and uplifting mass musical taste and appreciation. By 1940, twenty-eight million homes, accounting for 82 percent of the national population, had radios. About one-third of total broadcasting time went to some kind of music. According to one enthusiastic account, "it became as difficult to avoid hearing good music as it had been in past years to get the opportunity to hear it." In 1939 the Metropolitan Opera broadcasts and the concerts of the NBC Symphony, New York Phil-

harmonic, and Detroit Symphony had a combined weekly listening audience estimated at well over ten million.[44]

Moreover, despite the economic squeeze on most Americans, sales of phonograph recordings climbed steadily throughout the thirties. The RCA Victor Company, the biggest record producer, reported that most of the increase in its sales had come in its symphonic, opera, and chamber-music lines. By the end of the thirties, sixteen symphony orchestras in the United States were classed as "major" musical aggregations; scattered across the country were an estimated two hundred fifty full-fledged but supposedly "lesser" symphonies. What was especially remarkable was that even in the period since the Crash, something like one hundred cities had somehow managed to establish their own new symphonies.[45]

"The struggle for a deep-seated, wide-spread musical culture is likely to be a long one." That was still the skeptical conclusion in 1933 of the authors of the report on the arts for President Hoover's Committee on Recent Social Trends. While the American composer was getting more of a hearing, the American people still worshipped performers—conductors and virtuosi musicians—and tended to be little concerned with composition itself. Until they also became "composer worshippers," contended the music critic W. J. Henderson, they would still lack a true musical consciousness. If the United States produced its own great composers, added Howard Hanson, director of the Eastman School of Music, then it was musically a great country. Otherwise, "we are a musical failure, regardless of whether we may or may not have a hundred orchestras, every one of which may be better than the best orchestra abroad." America had all the outward signs of musical maturity, Copland said at the end of the decade. "But . . . first-rate orchestras, brilliant conductors, imported opera singers, child prodigies, and the like cannot by themselves constitute an important musical culture. . . . Actually the crux of a mature musical situation is the composer—for it is he who must create the music on which the entire superstructure of the musical world is founded."[46]

The campaign for the recognition of American composers—a campaign supported as enthusiastically by traditionalists like Daniel Gregory Mason as by modernists like Copland—was still going strong in the thirties. If anything, the complaints were louder than ever about foreign-born conductors and what Copland described as "this continual preoccupation with the embalmed masterwork" at the expense of contemporary American compositions. "Being alive," snapped Copland, "seems to relegate the composer automatically to the position of an 'also ran.'" Roy Harris was equally upset over the attitude of audiences and the musical establishment toward American work. Arturo

Toscanini's tour of Europe with the merged New York Philharmonic-Symphony in 1930 exemplified the problem American composers faced. Toscanini offered not a single American composition but always made room for some music by composers native to the countries on the tour. "When foreign conductors and soloists refuse to perform our works," Harris exploded, "they are denying American creative musicians the right to speak to American people. When they surround us with the idioms of eighteenth and nineteenth century European masters, and thus directly insist that these idioms must be our ultimate musical values, they are subtly and circumspectly curtailing our musical liberty and our pursuit of musical happiness." Down with the European yardstick, declared Randall Thompson, another unhappy native composer. "We ourselves must be the supreme judges of our own music. The value that a given work has for us is the important thing, and that value is only to be estimated by its relation to other works of our own."[47]

To the standard claim that Toscanini and other leading conductors were only giving concert audiences what they wanted, Hanson emphatically replied that it was the duty of every chamber, orchestral, or operatic organization performing in the United States and supported by American money to play the best American-written works obtainable. Hanson bluntly called for a "benevolent chauvinism" in American music, inasmuch as "The foreigner believes in internationalism for Americans and belligerent nationalism for his own country." At least, Mason commented, there was more receptivity to American-written music the farther one got from New York. Especially in Chicago there was "a steady provincial population of intelligent people . . . guided, educated, and inspired by conductors of broad sympathies, living ideals, and proportionate musical skill." And despite his animus toward Toscanini, Mason had nothing but praise for "the really intelligent and sympathetic type of foreign conductor, who plays our works often under trying conditions and against considerable dumb protest from our own people."[48]

## VI

Roger Sessions is doubtless accurate in his recollection that in the thirties the right to be heard rather than what was to be heard was the most urgent issue for American composers.[49] That had really been the main issue all along, ever since the young Edward MacDowell began to attract attention late in the previous century. Only somewhat less urgent, however, was the issue of what kind of music the country's

composers should produce. Except for the work of the black composer William Grant Still, older black folk elements had about disappeared from American formal composition, as had Indianisms. Jazz and pseudojazz were also less evident in formal composition than had been the case in the twenties, even in the scores of Copland and Gershwin. On the other hand, white folk-music sources like old hymns, cowboy and mountain ballads, and fiddler's tunes figured more prominently than ever in American composition. Copland's music for the ballet *Billy the Kid* (1938), for example, repeatedly quoted the cowboy song "Bury Me Not on the Lone Prairie." Thomson used the hymn "How Firm a Foundation" as a leitmotif in his score for *The River*. Practically everything written by the Virginia traditionalist John Powell featured quotations and derivations from southern mountain music.

The efficacy of exploiting native materials and the need to keep in close contact with the country's musical heritage was one of the few areas of common agreement among traditionalists, modernists, and eclecticists. Traditionalists like Mason still talked about the realization of a great national music, presumably the end result of a long, patient developmental process. Mason was convinced that just as Great Britain had finally, in the late nineteenth and early twentieth centuries, asserted its musical nationality in the work of C. H. H. Parry, Edward Elgar, and Ralph Vaughan Williams, so America was now on the verge of its own independent expression.[50]

Mason admitted that the United States might never have an actual "school" of composers because American life was "many-sided, nowhere nucleated, and, as a subject for art, chaotic." It was nonetheless possible to identify some "distinctive temperamental attitudes," which should gain expression in a genuinely indigenous music. One such attitude, the Massachusetts native and Harvard graduate devoutly felt, was New England moderation—a quality expressed by MacDowell as well as by Emerson, Thoreau, and Robert Frost, but often obscured by Jewish exaggeration and excess. Besides moderation, distinctive American attitudes had to do with hustle, inventiveness, a preference for action over thought, and a certain childlike naïveté. Thus to "a young, vigorous, and idealistic people like ourselves," the European and especially the Jewish sense of "ugliness, disorder, disillusion" must be irrelevant. When America finally had its own music, insisted Mason, "it will not be disillusioned or cynical or sophisticated or ugly" but based on native tradition and native folk song and therefore "simpler than European styles, more childlike in feeling, yet contented in its childlikeness—in short more naked and unashamed."[51]

By the 1930s Mason's musical contemporaries were usually less interested in talking about the composer's obligation to convey some

mystical quality called national temperament or character than in mining American source materials for musical ideas. One of the few younger American composers who shared the assumptions of older genteel nationalists like Mason was Roy Harris. Born in a log cabin in Lincoln County, Oklahoma, on Lincoln's birthday in 1898, Harris had grown up in California. After a brief period of study with Arthur Farwell, he had gone to France, where he learned and came to use much that was technically new in the postwar period. Yet Harris remained a fervent nationalist, convinced that there was an American uniqueness that could be captured musically. American music, he wrote in the early thirties, was just entering its third, culminating phase. Having first accepted and then disseminated the older musical culture of Europe, America was now prepared to move toward a new music, one developed "from the intensities of a specific place and time, embodying new idioms which identify and record the emotions of the people who produced it." The American temperament—marked by humor and gaiety yet also a certain stark dignity—was more direct, less pompous than the European. And whereas European musicians learned to think of rhythm in broad, symmetrical meters, Americans were "born with a feeling for its smallest specific units and their possible juxtaposition." Clearly the music Americans wrote had to have a fundamentally different character.[52]

Whether Harris's own compositions met his criteria is of course debatable. A generation later Thomson's judgment was that Harris's Third Symphony "remains to this day America's most convincing product in that form." Contemporaneously, Paul Rosenfeld thought that Harris's music eloquently bespoke a basic Americanism, especially the sweep and loneliness of the composer's native Plains. Harris, according to Rosenfeld, was "probably the greatest natural talent in American music" next to Charles Ives, whose work, finally being performed with some degree of regularity, Rosenfeld had only recently discovered. Like Ives, Harris was "nothing if not a nationalistic American composer," said Rosenfeld. The music of both men was "deeply, typically American," expressing "an almost national experience." Both Ives and Harris typified the individual artist whose consciousness of his own "essence" blended with national consciousness and ideals.[53]

The least explicit of the arts, music was predictably the least affected by the Left movement. The early thirties saw the formation in New York of a Composers' Collective, whose members included such fairly well-established figures as Henry Cowell, George Antheil, Charles Seeger and Wallingford Riegger, with Copland on its periphery. Although discussions within the Composers' Collective often had to do with

the possibility of developing a new type of music aimed toward the proletariat, actually the group produced nothing resembling a coherent body of musical thought.[54] Most of its attention centered on the same problem—getting a hearing for one's music—that was the persistent concern of nearly all American composers. Above all, the members of the collective shunned what they presumed to be the prevailing estheticism of the twenties. When Copland, at the time of his closest association with the Composers' Collective, called for "a school of composers who can speak directly to the American public in a musical language which expresses fully the deepest reactions of the American consciousness to the American scene," he was saying fundamentally the same thing Arthur Farwell had said a quarter-century earlier.[55]

## VII

Most of the political content in Depression-era music was to be found not in "serious" composition but in what was increasingly called "musical comedy" or simply "musicals." After 1927, under the influence of Jerome Kern's long-running *Showboat,* the loosely formed revues of the teens and twenties steadily gave way to rather carefully plotted musical plays integrating words, music, and story line into a coherent dramatic whole. American musical comedy proved to be a clever instrument for political and social criticism. Besides Peters and Sklar's *Parade* and the ILGWU production *Pins and Needles* (both more in the mold of earlier revues), the decade brought the sharp satire of such full-blown musical comedies as George and Ira Gershwin's *Of Thee I Sing* (1931) and *Let 'Em Eat Cake* (1933), Richard Rodgers and Lorenz Hart's *I'd Rather Be Right* (1937), and Marc Blitzstein's *The Cradle Will Rock* (1937).

For devotees of traditional opera, the prospects for the emergence at last of a strong native school of composers in that form seemed to brighten quickly after 1930. Deems Taylor scored a second operatic success in 1931 with *Peter Ibbetson,* which received sixteen performances in four seasons at the Metropolitan Opera and thereby established a long-standing record for an American work given at the Met. Other notable American efforts in opera were George Antheil's *Helen Retires* (1934), Louis Gruenberg's operatic version of O'Neill's *The Emperor Jones* (1933), and Virgil Thomson's *Four Saints in Three Acts,* with libretto by Gertrude Stein and originally with an all-black cast. Howard Hanson's *Merry Mount* (1934), based on the story of Thomas Morton's carefree colony, which had flouted Puritan mores in seventeenth-century New England, had nine Met performances and

pleased many commentators by taking its inspiration directly from American tradition. That also seemed to be the main virtue of Douglas Moore's one-act *The Devil and Daniel Webster,* produced in New York in 1939. Based on a story by Stephen Vincent Benét, Moore's little opera recounted a mythical court battle between Satan and the great New England statesman for the soul of a simple New Hampshire farmer. The fact that on one night, February 28, 1934, *Merry Mount, Helen Retires,* and *Four Saints in Three Acts* were all three being performed in New York seemed incontestable proof that American opera and American music in general were finally coming of age.[56]

Yet complaints continued that native composers tried too hard to emulate the style of European "grand opera," that what they wrote was usually pretentious, stilted, artificial. Although Taylor's *The King's Henchman* and *Peter Ibbetson* were both solid successes at the Met, they also were frequently cited as the worst kind of America opera, in that they took foreign themes and settings, used European musical idioms, and consequently failed to speak to and for America and its people. American opera, one commentator suggested, was "most satisfying as an artistic production when it is entirely American, when libretto and music are both intimately allied with nationwide American experience."[57]

By the end of the thirties the firm consensus was that the man who so far had come closest to writing that kind of opera was George Gershwin. As a composer of popular songs, musical comedies, and also film scores, Gershwin thrived more than ever in the Depression years. At the same time, he continued to work to build his reputation as a "serious" composer. Given his repeated success in musical comedy, Gershwin was bound sooner or later to try his hand at opera. As early as 1922 he had written a one-act "Negro Opera" called *Blue Monday,* which was incorporated into the annual Broadway revue *George White's Scandals.* Some years later he read DuBose Heyward's novel *Porgy.* When the novel was dramatized on Broadway in 1927, Gershwin was quick to see its operatic potential. Eventually he undertook to write an opera based on the story of the crippled Porgy's tribulations with the good-hearted trollop Bess, the dope-pusher Sportin' Life, and the menacing Crown on Catfish Row, a black tenement section near the Charleston, South Carolina, waterfront.

With libretto by Heyward and Ira Gershwin, George Gershwin's *Porgy and Bess,* an opera in three acts and nine scenes, was produced by the Theatre Guild and first performed in Boston and New York in the fall of 1935. Gershwin's extraordinary melodic gifts were evident throughout the score. Despite the "folk opera" label frequently given to his work, Gershwin drew heavily on popular-song idioms and very

little from folk tunes. *Porgy and Bess* was widely acclaimed as the first American opera combining both effective music and an effective native setting. It initially ran for four mouths at the Alvin Theatre before going on tour under Theatre Guild auspices. Successfully revived in New York three years later, then again in 1942, and again in 1953, the opera also had a sensational European tour in the fifties. Whatever its original shortcomings in orchestration, recitative, or otherwise, *Porgy and Bess* has become an enduring part of the nation's musical literature. If not the Great American Opera, it nonetheless continues to be the most familiar and favored extended composition by an American.[58]

## VIII

When Gershwin died of a stroke in Hollywood on July 11, 1937, two months short of his thirty-ninth birthday, music publications still sometimes referred to him as a composer of "jazz songs." As Otis Ferguson commented, Gershwin had "made the idea of jazz—as opposed to jazz itself, of course—acceptable to those who must get their music over a shirtfront. . . ."[59] Exploiting basic elements of jazz and the blues more consistently and successfully than anybody else, Gershwin had been largely responsible for the most dynamic period in the history of American popular music up to that time. Singable tunes and dance music by Americans could be heard nearly anywhere one traveled in the Western world. Carl Van Vechten's discovery in Vienna in 1932 was a typical one: "They don't play Johann [Strauss] here any more; it's all Gershwin and Berlin."[60] And by the thirties more and more critics were willing to take popular music seriously, if not as art then at least as a guide to mass attitudes and values. One observer went so far as to predict that popular music "will tell as much to future students of current civilization as any histories, biographies, or newspapers of the time."[61]

Early in the thirties the terms "popular music" and "jazz" were still pretty much interchangeable in the thinking of white listeners and critics. Confused with everything from sticky sentimental ballads to the booming finales in musical comedy, jazz had virtually lost its real meaning except to the black and white musicians who still played it and a handful of purist critics in the United States and abroad. One of those foreign jazz enthusiasts was the Frenchman Hugues Panassié, who published in 1934 the first knowledgeable book-length critical analysis of the music. Translated and brought out in the United States two years later as *Hot Jazz,* Panassié's book helped considerably to re-

establish the distinction between general popular music and the unique combination of polyrhythms, syncopation, and improvisation that defined authentic jazz.[62]

By the mid- and late thirties many commentators on American music had developed a decided aversion to efforts at incorporating and amalgamating jazz elements into symphonic works. If one had to have an authoritative word on the issue, there was Ralph Vaughan Williams's opinion that while jazz had little potential for profound development, it was undeniable evidence of America's musical vitality, a "purely indigenous" music played most effectively only by Americans. Or as Winthrop Sargeant put it, jazz was a music of the "peasant proletariat." Lacking sufficient poetic or intellectual content to rival "classical music," it was nonetheless unmistakably American like the skyscraper, the comic strip, tap dancing, or the happy-ending movie. Jazz was a lowbrow art—formless, without tradition, instinctual, participatory not spectatorial. And lowbrow art, said Sargeant, echoing what Gilbert Seldes had suggested in the twenties, was the most characteristically American kind of art.[63]

About the time that critics and composers began to disentangle jazz from the broad body of commercial popular music, the jazz form underwent something of a revival and entered still another phase in its disorderly development. Suddenly, it seemed, jazz had become "swing." The translation of Panassié's book on jazz came out in 1936 with the subtitle *The Guide to Swing Music,* and in the same year the great jazz trumpeter Louis Armstrong published an autobiographical fragment called *Swing That Music!* Jazz musicians, said Armstrong, had gotten tired of "the stale brand of jazz" that had come out of the twenties, music "all tangled up in 'Tin Pan Alley,'" music that "made fortunes for men who couldn't swing a jew's harp." Jazz "began to go soft with too much success coming too early. . . . I saw it start travelling in flashy company and pretty much go bad for a good many years."[64] What Armstrong was talking about was the near-eclipse of real jazz in the early post-Crash period. As jazz groups broke up, skilled jazz practitioners (or at least the white ones) drifted into big dance bands like those of Rudy Vallee, Fred Waring, or Guy Lombardo— bands that specialized in "sweet," eminently danceable music.

By the mid-thirties, though, *le jazz hot,* as the French called it, was making a strong comeback under the swing rubric. Actually just another name for jazz, "swing" seems to have been coined by the British Broadcasting Company, which shied from references to "hot jazz" on its programs and substituted "swing music." Within a short time the new name caught on almost everywhere, suggesting that "jazz," with its vaguely sexual connotations, had never been an agreeable usage

for many people. At any rate, as Barry Ulanov has noted, " 'Swing' . . . was a singularly good descriptive term for the beat that lies at the center of jazz."[65]

Not a new kind of music, as its commercial promoters claimed, swing was really a consolidation of basic New Orleans–style jazz with the movement toward bigger popular-music aggregations. In the twenties several black dance bands in New York, particularly those of Fletcher Henderson and Edward "Duke" Ellington, had begun to play rather precise arrangements, subordinating improvisation and heavy rhythm in the interest of closer teamwork and a smoother melodic line.[66] White musicians and band leaders, however, generally dominated the emergence of swing after 1935. Artie Shaw, Glenn Miller, the Dorsey brothers, and Woody Herman had some of the major swing bands of the late thirties and early forties, but it was Benny Goodman, a splendid clarinetist, who came to be known as the "number one swing man." Goodman's music, often arranged by Fletcher Henderson, featured precision, traditional harmony, and some "hot" solo improvisation, especially from drummer Gene Krupa and Goodman himself.[67]

Swing was ascendant for roughly a decade, from mid-Depression to the end of the Second World War. Arranged, harmonized, and smoothed out for the big bands of the era, played at college and high school dances, in fashionable night clubs, almost incessantly on radio, and occasionally even in concert halls, swing became nearly coextensive with American popular music. Whereas in the twenties both popular and formal music had borrowed heavily from jazz, in the next decade jazz as swing reached out to encompass other kinds of music. Yet for all its innovations, authentic swing remained authentic jazz. Thus for the only time in its history, authentic jazz had a broadly popular audience.[68]

The jazz-as-swing revival of the late thirties had little significance for American cultural nationalists. Armstrong might argue that swing was "America's second big bid to bring forth a worthwhile music of its own,"the first having been the early jazz Armstrong had learned to play as an orphan boy in New Orleans. "We won't have many excuses," Armstrong thought, "if we let today's swing music go the same way."[69] But in fact the time was past when cultural nationalists looked to jazz as the long-sought folk-music inspiration for a great American symphonic expression. After the Second World War, jazz, popular, and formal music would pretty much go their separate ways. Jazz itself would begin to divide into "classic" or traditional, modern, and eclectic styles, while formal composition would pursue an increasingly experimental and esoteric line of development. The nationalist vision of a great American music would fade rapidly.

## IX

More than in any other area of American culture, nationalistic attitudes dominated American visual art in the 1930s. As was true of the fiction and drama of the Depression period, such sentiments often mingled with a spirit of social consciousness.[70] The thirties was probably the last decade in which a majority of America's painters and sculptors struggled to communicate with a broad, unsophisticated public. The times seemed to demand a great "social art"—an art the American masses could understand out of their own experience. Presumably that meant that painting and sculpture should be strongly representational. More than at any time since the Armory Show, Americans painted and sculpted in readily recognizable images and symbols.[71]

Insofar as the main tradition in American visual art had been realism, the Whitney Museum of American Art, opening in 1931 on Eighth Street in Manhattan, served to further that tradition. When the Whitney Museum opened its doors, Curator Hermon Moore announced that the institution would not try to define "the American spirit" or sponsor any particular school of native artists. Rather, the Whitney would concern itself with "the individual artist who is working out his destiny in this country, believing that if he is truly expressing himself, his art will inevitably reflect the character of his environment."[72] Such a credo was broad enough to include almost everybody, but in fact the Whitney showed little interest in native avant-gardists during its first half-decade. Much of its effort went into bringing together the national artistic heritage, as in its exhibition on American genre painting and sculpture in 1935 and its survey of a century of American landscape painting three years later. Among contemporaries, the Whitney's favorites were realists like John Sloan, Alexander Brook, Eugene Speicher, and Edward Hopper.[73]

Meanwhile the Museum of Modern Art, ostensibly intended by its seven wealthy founders in 1929 to foster international modernism, also joined in the rediscovering-America spirit of the times. In 1932 the MOMA staged an exhibition of American folk art, and throughout the thirties it sponsored untaught American "primitive" artists. Near the end of the decade, moreover, the conservative Metropolitan Museum of Art had a huge, panoramic *Life in America* show.[74]

If the Whitney Museum had wanted to acknowledge the preeminence of one school or tendency, it would doubtless have been American Scene. A resurgent realism was already the strongest influence in American painting at the end of the twenties. Peaking in the middle

of the next decade, the American Scene movement became one of the reigning sensations in the nation's cultural life. Artists like Hopper, Charles Burchfield, Reginald Marsh, and particularly Thomas Hart Benton, John Steuart Curry, and Grant Wood experienced a notoriety such as few painters anywhere had known in their own lifetimes.

For its enthusiasts, American Scene meant more than just a concentration on native subject matter. As Alfred Frankenstein pointed out in 1938, artists had been painting the landscape and people of America for generations. "What distinguishes the American scene group," said Frankenstein, "is a highly complex attitude toward the subject, an attitude compounded of romantic emotion and realistic delineation, of a desire to expose the plain, unvarnished facts of American life plus a strong, even sentimental love for the facts that finally emerge. . . . It is an art of people, and what they do and the places they live, not an art of mountains, clouds, or the sea."[75] American painting in the thirties was often literally crammed with people. Above all, the artists of the American Scene school dealt with what they thought ordinary Americans could recognize and easily relate to. As Reginald Marsh quipped, "Well-bred people are no fun to paint."[76]

To charges that the realist revival had taken American visual art backward, supporters like Martha Candler Cheney answered that contemporary representational artists had produced a body of work "that is sufficiently original and distinctive to be called *American* and that is sufficiently informed with a contemporary esthetic content to be called *modern*." American artists were no longer trying to illustrate a theory, wrote Forbes Watson, whose *American Magazine of Art,* together with Peyton Boswell's *Art Digest,* provided the main support among the art journals for the American Scene movement. The current realist vogue meant "a return to the great tradition when the painter's first duty might be said to have been to set down the facts, and as it were, throw the art in free." "In the art world," exulted Ruth Pickering in 1935, "the balance of power is shifted from dead painters to live ones and from abroad to home. . . . American art is for the moment triumphant."[77]

The American Scene movement was anything but monolithic. It was both rural and urban, both agrarian and industrial, even both proletarian and bourgeois. One of the major elements in American Scene was the Fourteenth Street School, a loosely associated group of Manhattan painters who had studied at the Art Students League and especially with Kenneth Hayes Miller. The Fourteenth Street artists were frequently compared to the city realists of the years before the First World War. Some of their work—particularly that of Miller him-

self and the robust, ribald pictures of Reginald Marsh—was strongly suggestive of George Luks and the early John Sloan and George Bellows. At the same time, the paintings of shopgirls, subway riders, and people waiting in unemployment offices by Isabel Bishop and the brothers Moses, Isaac, and Raphael Soyer evoked a mood of weariness and resignation.

Meanwhile Edward Hopper and Charles Burchfield each continued to depict his country in his own stubbornly independent way. Younger artists like Paul Sample, Lamar Dodd, and Peter Hurd painted grimy seaports, the drab panorama of a southern Piedmont town, and the raw landscape of the Southwest. Even though Left critics often dismissed American Scene art as sentimental and escapist, the social realism of William Gropper, Ben Shahn, and Jack Levine was also part of the decade's paint-America compulsion. "With the complex society of our times," Gropper said, "with science, electricity, radio, capitalism, fascism, wars, and the Big Apple, the artist cannot sit in his ivory tower any longer painting still-life pictures."[78]

Above all, the designation American Scene meant midwestern regionalism. That in turn almost invariably called to mind the "Triumvirate": Benton, Curry, and Wood. The reputations of these men and the prices and commissions they could command soared in the thirties. The enthusiasm among critics and collectors for their work and that of other regional painters was part of a frequently expressed disenchantment in the Depression years with the long-term trend toward industrial development and urban growth. Such New Deal programs as the Tennessee Valley Authority, the Division of Subsistence Homesteads, and the Resettlement Administration manifested the beliefs of President Roosevelt and many others inside and outside government that Americans should either return to or stay on the land, keep their roots in their region and their ties to home and family.[79] When Thomas Hart Benton announced that big cities "offer nothing but coffins for living and thinking," he was only carrying to an extreme the common antiurbanism of the thirties. By 1936 Forbes Watson was complaining about "cornfield press agents" who had "dinned into the ears of the inhabitants of saddened Manhattan Island the theory that art, if it is to have any vitality, by Gosh! must keep away from the city."[80]

New York City was at the bottom of what was wrong with the arts in America, Benton and his associates were convinced. New York intellectual life, Benton declared, consisted mostly of conservative academicians, humorless Marxists, and "aesthetic-minded homosexuals" who got into positions of power by "ingratiation or subtle connivance." For such "dependent-minded" people, "imported ideas are

the only ones cherished." Sure that the city was "a highly provincial place," Benton moved back to Missouri in the spring of 1935 after contracting for a mural for the state capitol in Jefferson City.[81] By that time his mural paintings for the New School for Social Research, the Whitney Museum, and the Indiana State Building at the 1933 Century of Progress exposition in Chicago had made him the best-known muralist in the country.

Benton had also become one of the leading propagandists for representational art and national expression, qualities that were interchangeable in his thinking. There was no such thing as a common humanity, he insisted before the left-wing John Reed Club in New York early in 1934. There were only different "humanities," each formed by environment, by "a conglomerate of racial factors," and by "the pressure of those psychological attitudes which have their origin in the historic development and intermixture of the other two." Thus there was no such thing as universal art. To suppose as much was to succumb to either the decadence of classicism or the decadence of abstractionism. Nationalism, on the other hand, was "inseparable from a great art," a "living art." If America were to have a truly national artistic expression, he said in 1936, "we'll have to yield to the pressure of the locality."[82]

If Benton thought that he had to flee New York to "get more closely acquainted with the actual temper of the common people of America," all along Wood and Curry had kept their home bases in the nation's midwestern heartland.[83] There the "real America" supposedly still existed in its most nearly undefiled form. All three prospered despite the protracted slump in the art market. Wood's *American Gothic* (1930), his tongue-in-cheek study of his grim-visaged sister and her pitchfork-clutching neighbor, soon became one of the most familiar American paintings. Besides their technical perfection, Wood's sometimes idyllic, sometimes satirical pictures won admirers with their "Americanism." By 1935, according to Watson, American collectors "who yesterday pursued the great trio, Picasso, Matisse, and Derain," were "in equally eager pursuit of Grant Wood." Despite his new affluence and despite the failure of his art colony at Stone City, Iowa, Wood continued to spend most of his time in his native state, convinced that "a true art expression must grow up from the soil itself." In the mid-thirties he accepted a faculty appointment at the State University of Iowa.[84]

At home in Kansas, Curry continued to depict the violent drama of nature in the Plains country and the folksy simplicity of its people. The least talented of the regionalist Triumvirate, an artist whose

painterly qualities seldom rose above the mediocre, Curry nonetheless won over his share of critics and collectors. In 1937 he also got an academic appointment—as artist-in-residence at the University of Wisconsin. Even that had a bucolic aspect; Curry's position was under the administrative jurisdiction of the university's college of agriculture, whose dean reported that Curry "makes sketches of football players, and hangs around the stock farms talking to the boys about the beauty of a sow's profile."[85]

The midwestern regionalists and American Scene art as a whole received extensive coverage in the popular periodical press, especially Henry Luce's monthly *Fortune* and weekly *Time* and *Life* and the monthly *Scribner's Magazine*. From 1935 until it ceased publication in 1939, *Scribner's* operated under a declared "formula of examining life in the United States." Besides regularly publishing Thomas Craven's essays, *Scribner's* also reproduced pictures by Raphael Soyer, Alexander Brock, Peter Hurd, and other American Sceners for its covers. Luce's magazines carried a number of lavish color layouts on the work of American Scene artists; *Time* had Benton on its cover late in 1934.

The loudest and most persistent advocate of American Scene was still Thomas Craven. Craven's favor continued to fall mainly on Benton, Curry, and Wood, but he also admired Marsh and other eastern realists. Craven was generally carried away by what he saw as a national artistic coming-of-age in the Depression years. Art, he argued, was born not of peace and plenty but of turmoil and violence, of uncertainty and a spirit of restless striving. Craven exhorted painters to seize on the country's endlessly variegated subject matter: ". . . the immensity of New York; . . . the Renaissance banditry and racketeering of Chicago; . . . the cotton belt and the hill billies of the South; . . . the tractors in the Kansas wheat fields; the cow gentlemen of the Southwest; the Rockies; and the proud breed of Californians—an epic in itself!"[86]

Craven's militance in behalf of artistic independence, representational painting, and native subject matter made him the main target of those who thought American art had to move into the stream of international modernism. When his critics insisted that art should always be open minded, tolerant of new ideas and influences whatever their source, Craven pronounced "A curse upon their tolerance!" All along America had been "so gullibly tolerant of imported cultural fetishes that she has remained in colonial bondage to moldering European abstractions." A "robust nationalism"—democratic, flexible, accessible, relevant—had been responsible for Mark Twain and Walt Whitman, for Theodore Dreiser and Sinclair Lewis, for the full realiza-

tion of an independent American literature. Now conditions were right for a similar assertion in visual art, inspired by the "rough-and-tumble originality" of the midwestern regionalists.[87]

Craven always insisted that he was no dogmatist, that it was really the genteel academicians and the art-for-art's sake people who were bound by dogma and absolutes. The same was true for the doctrinaire Marxists, whose proletarian internationalism was as off-base as Bohemian internationalism. Communist art betrayed a basic ignorance of the American background and the American spirit, which was "overwhelmingly pragmatic," with an "all-absorbing interest in tangible matters. . . ." Thus, for all their differences, the painters of the American Scene concentrated on "definite properties," on "the particular and the characteristic." Their leaders naturally came out of the Middle West, where "American particularism is at its highest and the frontier heritage of thought and conduct lives on in stark realities, spreading distrust for all absolutes and preserving the hope and temper of democracy."[88]

## X

In 1932 Craven wrote that the future of American visual art lay in murals. In turn, the future of mural art was in the hands of the nation's architects, who should work closely with muralists to integrate building design and decoration into organically realized structures.[89] At that bottom point of the Depression, Benton and a few others were still obtaining good mural commissions. But most American muralists, obviously dependent on the amount of large-scale commercial, institutional, and governmental construction going on, were in a bad way.

That began to change in the fall of 1933, when the Public Works of Art Project, organized under the New Deal's Civil Works Administration, gave jobs to about three thousand artists in a nationwide effort to decorate federally owned buildings. After CWA disbanded in the spring of 1934, many of the PWAP artists, as well as several thousand other unemployed painters, sculptors, and craftsmen, found jobs with the Treasury Department's newly organized Relief Art Project and the Federal Art Project under the Works Progress Administration. All of these programs included much mural work, most typically in schools, small post offices, and New Deal public housing projects.[90]

The major government undertaking in mural art had nothing to do with work relief. In October 1934 Secretary of the Treasury Henry Morgenthau ordered the establishment of a Section of Painting and Sculpture under Edward Bruce, who had also headed PWAP. Besides

overseeing the government's whole building-decoration function, the Section of Painting and Sculpture (subsequently renamed Section of Fine Arts) was to execute the biggest jobs itself. It was to choose muralists by competition and not by need. Over the next several years the section commissioned murals by some of the country's leading painters, including Boardman Robinson, Henry Varnum Poor, George Biddle, Reginald Marsh, John Steuart Curry, and William Gropper. By 1940 the Fine Arts Section had decorated 821 buildings in 777 cities with 951 murals, and had employed about 600 painters under commission. WPA relief funds spent by the Federal Art Project and Treasury's Relief Art Project supported artists doing 2,550 other murals across the country.[91]

The federal mural program of the thirties, whether executed under commission or for relief wages, was unprecedented in its size and cost. It largely transformed American mural painting, hitherto a rather minor art dominated by academic neoclassicism. Boardman Robinson summed up one of the guiding assumptions behind the program: "Our own environment, and preferably our native environment, being the source and stage of our experience, furnishes the most vital material for the artist's use." More than any other kind of activity, enthusiasts claimed, murals promoted the democratization of the arts. By literally bringing art to the people, murals could do much to end both the estrangement of the artist from society and the "state of prostitution" to a wealthy elite, in which, according to George Biddle, the artist had lived since the fifteenth century. What the contemporary Mexican muralists Diego Rivera, José Orozco, and David Siqueiros had achieved in their country, American mural painters could also achieve—a great public art founded on the common democratic faith of artist and people. The murals of the Mexicans and of Americans like Benton and Robinson, Craven said in 1934, presaged a whole new art, an art "not devoted to the whims of rich collectors nor to the scholastic attention of specialists, but to the needs of large groups of people who, for a long time, have taken no interest in art because art has taken no interest in them."[92]

Thinking mainly of the federal mural program, Forbes Watson declared near the end of the thirties that "the Depression was the greatest blessing that has come to American art." For people like Watson and Craven, the current upsurge in mural work, mostly done under government sponsorship, had finally turned the tide in favor of a democratic and national art and against elitist and internationalist influences. Yet the lasting effects of thirties mural work were not momentous. Although the Section of Fine Arts supposedly gained permanent status in the Treasury Department in 1938, less than a

year later it was transferred to the Public Building Administration, where it remained until its official termination on June 30, 1943. The mural activities of the Treasury Relief Art Project, brought to an end in 1938, and the Federal Art Project, which lasted until 1943, suffered from the same vagaries of staffing and funding that plagued all the government's relief efforts in the arts. A generation later the murals of the thirties had largely disappeared, victims of the renovation or destruction of a great number of the buildings in which they were done.

## XI

One of the basic shortcomings of Depression-era mural painting was a lack of integration with architectural surroundings. Craven may have envisioned the blending of mural painting and architectural design as the key to an artistic renaissance for America, but in fact thirties murals usually had little relationship to the structures whose walls they covered. "It was not a program of painters, sculptors, and architects with homogenous ideas," one critic commented in retrospect, "nor did it possess self-sustaining elements over other decades."[93] As it turned out, the architect had little to offer the painter and sculptor, and they generally worked with scant regard for his conceptions.

That was one explanation for the mostly undistinguished character of American architecture in the thirties. A more obvious factor, though, was the economic slump. Despite some improvement from 1933 to 1937 and then again in 1939–40, the slump persisted through the whole decade. Within a year after the stock market crash it was clear that the spectacular building boom of the twenties was over. By 1932 outlays for new construction in the United States were 40 percent below what they had been in 1928; contracts let under the supervision of architects had declined from more than $3.5 billion to less than half a billion. Total income earned from architectural practice was less than one fifth that of 1928. The number of architectural firms in the country had dropped from about 9,000 to about 5,000. "Behind these figures," observed the critic and historian Talbot Hamlin in 1933, "lie the smashed hopes of a great part of the architectural profession."[94]

Despite the hardships and disappointments the Depression visited on architectural practice, the thirties turned out to be an exciting and pivotal period in architectural thought. Whereas the twenties had been an age of eclecticism, a period that exalted individual choice and expression, the thirties was a time when individualism, either in eco-

nomics or in the arts, was in widespread intellectual disfavor. The guiding ideal was no longer an architecture of choice; administering to the one-third of a nation President Roosevelt described as ill housed meant that choice must give way to necessity. The present need, Editor Michael Mikklesen of the *Architectural Record* said in 1931, was not houses but housing.[95]

The thirties brought growing acceptance of the complex of ideas and methods still called the International Style early in the decade, but more commonly referred to as "modern architecture" a few years later. The evolution in terminology suggests what happened during the period: the rapid absorption of European architectural theory and its adaptation to a set of values—democracy, practicality, inventiveness—presumed to be traditionally American but given more meaning and urgency in the present social crisis. Paradoxically, it now seemed that the International Style—with its subordination of individual personality, its austerity and disdain for ornamental effects, its obsession with function and use, its widely if not universally adaptable forms—could become the foundation for an American national style, or at least for an architecture responsive to American needs. American architecture had to rid itself of "belief in a type of superarchitectural genius," said Richard Neutra, the brilliant Austrian-born designer now in his second decade of American practice. "The great improvising individualist is an anachronism in the modern world."[96]

James Marston Fitch recalled that on the staffs of the architectural magazines he worked for in the thirties, "none of us doubted for a moment that there *was* a national movement, that its future was assured and that technology was the means whereby it would be accomplished."[97] In the pre-Crash years architectural thinking, like much of the rest of American cultural analysis, had often been ambivalent about the transforming effects of the machine. In the thirties, though, there was no longer much room for doubt: Mass production, standardization, simplification, and the other consequences of machine processes had become indispensable to the task of rehabilitating the impoverished masses. And as Robert L. Duffus said in 1936, voicing the decade's familiar democratic collectivism, "there is no higher right in our society than the right of decent, fit and eventually beautiful housing for . . . all the people."[98]

Meanwhile the romance of the skyscraper, so much a part of the cultural history of the twenties, faded quickly. Many writers on architecture, caught up in the Left trend of American social thought in the post-Crash years, came to equate towering office buildings with the unchecked, ultimately destructive concentration of wealth and power under capitalism. As "a product of human greed," wrote Claude Brag-

don in 1932, the skyscraper had stood "in ideal symbolic relation to the country and to the times."[99] Even the period's most dramatic achievements in skyscraper design and construction—Manhattan's Empire State Building and the immense commercial complex called Rockefeller Center—failed to win the approval of architects and critics who insisted that architecture must promote social reconstruction.

Two events in particular aided the spread of modernist ideas after 1930. One was the Museum of Modern Art's much-talked-about 1932 exhibition of photographs and models depicting the accomplishments of the foremost European modernists—LeCourbusier, Ludwig Mies van der Rohe, J. J. Oud, and Walter Gropius and others associated with the Bauhaus in Germany. The major effect of the exhibition and of the book by Henry-Russell Hitchcock and Philip Johnson that grew out of it was to publicize the spare, impersonal functionalism of the International Style. The next year Chicago plowed ahead through the Depression to celebrate its Century of Progress with a glorification of technological might. Featuring a prevalent functionalism, the buildings at the Chicago fair amounted to the American layman's introduction to the new architecture.[100]

An outpouring of books and essays on modern architecture followed the Museum of Modern Art exhibition and the Chicago fair. Modernism, proclaimed its advocates, offered an architecture of simplicity, purity, function, and truth—an architecture of equality and democracy rather than unrestricted freedom and individualism. As the Soviet Union was the chief inspiration for the American champions of systematic economic planning, so the International Style inspired those who sought systematic social planning around an architecture based on disciplined technology.[101]

No one combined advocacy of modernist architectural design with a zeal for radical social redesign better than Lewis Mumford. Although Mumford never entirely abandoned his romantic artistic values and thus his fondness for Frank Lloyd Wright's conceptions, he moved farther than ever from Wright's combative individualism. Architecture, Mumford wrote in 1931 in *The Brown Decades,* "as a social art cannot depend upon the existence of men of genius." The role of the architect was not to usurp that of the carpenter, builder, engineer, and manufacturer but to organize their work into an orderly composition. Thus Mumford made International-Style functionalism a central element in his arguments for low-cost public housing. In turn those arguments were part of Mumford's plea for a "new domestic environment" for Americans. Such an environment would be created by accepting the cultural region as the basic unit for social reconstruction and decentralizing urban populations into carefully planned, largely self-

sufficient communities. The United States and all Western society, Mumford maintained, must realize that a new historical era was opening, the "biotechnic." By dissociating capitalism from technology and then giving priority to the "biological and social arts"—medicine, agriculture, education—over technology, modern man could reclaim his destiny.[102]

Mumford's views in the thirties were really anti-architectural. He vehemently rejected the presumption that architectural achievements were independent creative acts to be admired in and of themselves. But then Mumford's judgments typified much thirties architectural thinking. To an unprecedented degree, concepts of beauty, grace, and elegance gave way to considerations of purpose and efficient use. By 1941 the Museum of Modern Art was running an exhibition on the architecture of the Tennessee Valley Authority—"the greatest that America has yet produced," according to the museum's director. In their "blocky big simplicity" and careful attention to scale and placement, said the *Nation*'s architectural columnist, the designs for TVA's dams represented "architecture in its oldest and most basic sense." What was equally praiseworthy was that TVA was a collaborative achievement by teams of anonymous designers, engineers, and builders.[103]

TVA was undoubtedly the most impressive result of the greatly expanded, nationwide program of public works inaugurated in 1933 under the New Deal. At that time many people, like the Swiss-born architect William Lescaze, hoped that the New Deal might be "laying down the foundation for an American architecture, of modern architecture for a modern nation." It was not enough to survey, plan, and coordinate carefully, Lescaze warned. "The choice of a definite architectural theory must be made, a clear-cut position must be taken."[104]

The designs for the many schools, courthouses, post offices, airport terminals, bridges, and housing projects built by the Public Works Administration, the Works Progress Administration, and other New Deal agencies followed no definite theory and amounted to no clear-cut architectural position. Nor, except for TVA, was there any clear verdict on the quality of federal construction efforts. The authors of an officially sponsored study of public building concluded that architects working on government projects had proceeded logically and systematically, borrowing from contemporary theory but also frequently making their own contributions. In the more successful buildings designed according to modernistic precepts, they cautiously suggested, "a style has emerged that may perhaps be the seed of the long sought 'school of American design.'" Frederick A. Gutheim, however, was probably closer to the critical consensus when he surveyed seven years of public building and blasted PWA for doing nothing to show

"how we can work our way out of the architectural jungle and into something a little better." Instead PWA had served "as a sounding board for any and every school of architecture heretofore invented, and . . . several that had never received public recognition and encouragement until the PWA came along." Thus PWA's record was a matter of "pure eclecticism in action as well as in style, a pandering to every pressure, every taste, every dictate. Architecturally it has stood for nothing."[105]

## XII

Frank Lloyd Wright doubtless agreed, though for different reasons. Amid the prevailing excitement over New Deal patronage of the arts and widely expressed hopes that government works programs opened up possibilities for new architectural ventures, Wright remained convinced that "what we call 'art' is best left to take care of itself, *if only we will get the artificial lets and hindrances like education and Government out of the way.* . . . Now, lots of things can be done by way of Government. But you cannot do much that way in what we call creative art."[106]

Sixty-one years old in 1930, Wright had taken on the look if not the outlook of a patriarch, with his unfashionably long gray hair, his turn-of-the-century Bohemian's clothes, and his pontifical manner. There are two major ironies about the course of Wright's career in the thirties. One is that in a period more and more influenced by the mechanistic impersonality of the International Style, Wright, as much of a romantic individualist as ever, made a strong comeback from the difficult times of the twenties. The other is that whereas in the years of prosperity Wright had been without commissions much of the time, in the Depression-ridden thirties a succession of well-paying clients, willing to go along with his free-ranging and often far-fetched conceptions, kept him busy.

Although his earlier designs had strongly affected the development of European modernism, Wright had no use for the cool steel-and-glass formalism of the International Style. Wright also still detested cities, which were as much "coffins" for him as they were for Thomas Hart Benton. Thus Wright continued to work on rural and suburban sites, using native materials as much as possible, integrating site and structure logically and "organically," opening up interior spaces so that they seemed to flow naturally into each other. His two greatest achievements in the thirties were polar opposites: "Falling Water," the incredible cantilevered house built over a waterfall at Bear Run,

Pennsylvania, for the Pittsburgh department store magnate Edgar Kaufmann, and the Administration Building for the Johnson Wax Company at Racine, Wisconsin, a structure whose many remarkable features include ceilings formed by bundles of glass rods and supported by graceful mushrooming pillars.[107]

Regardless of Wright's fundamental differences with the current wave of modernism, its growing prestige boosted to new highs his own prestige as an architectural trailblazer. His Kahn Lectures at Princeton University at the beginning of the decade were well received, as was his long, epigrammatic autobiography, published two years later. In the spirit of the thirties, he even seemed to be moving Left. An early admirer of Roosevelt and the New Deal, Wright also had abundant praise for the Soviet Union, which he visited in 1937 as the American delegate to the first All-Union Congress of Architects. While he regretted that the USSR had followed Western urbanism and architectural "grandomania," he talked about the atmosphere of freedom in the country, the spirit of its people, "the unconsciously proud way they carry themselves." If Stalin was betraying the Revolution, as the Trotskyists claimed, "then, in the light of what I have seen in Moscow, I say he is betraying it into the hands of the Russian people."[108]

In 1935 Wright disclosed Broadacre City, his scheme for a comprehensively planned suburban community. Designed at Taliesin West in Arizona, the winter home for Wright and his colony of student architects, Broadacre City was Wright's major contribution to the enthusiasm for social planning. His scheme took maximum advantage of the natural surroundings and featured a combination of socialism and private ownership. A careful pattern of farms, residences, places of worship, and schools ringed—but did not cluster around—industrial, governmental, and transportation facilities. Wright's ideal community would presumably require an ideal population as well—one lacking the intractable differences of class, race, politics, values, and assumptions dividing Wright's real countrymen. Broadacre City, as his chief biographer has said, was "a most naive, romantic view of modern America."[109]

So Wright's view of modern America and its social and cultural potential remained for the rest of his long life. Wright actually loved the older America, the freehold society that Thomas Jefferson, Wright's greatest hero among the nation's public men, had wanted to preserve. Essentially an antistatist Jeffersonian in his politics, Wright, like many of his fellow midwesterners, broke with Roosevelt when the president's foreign policy began to move the country toward war after 1939. The eastern seaboard's support for interventionism seemed to Wright further proof of the East's unshakable attachment to Europe and Europe's ways.[110] Wright's cultural regionalism, like that of the

midwestern American Scene painters, functioned as a preemptive cultural nationalism that took for granted the synonymity of Middle West and America.

## XIII

Wright's admiration for Jefferson was much in keeping with a resurgent interest in the writer of the Declaration of Independence. Quoted by liberal New Dealers, anti–New Dealers on the political Right, and even by Communist Party spokesmen in an effort to link the Party to an American "progressive" tradition, Jefferson served as a useful symbol of almost anything to almost anybody.[111] In 1937, with Jefferson's historical reputation reaching its peak, the Congress finally commissioned a memorial to the third president for the national capital. When the commission went to the neoclassicist John Russell Pope, also the chief architect for the new National Art Gallery, architectural modernists stirred up a controversy that was even louder than the one surrounding the Tribune Tower competition in the twenties.

Opponents first denounced the absence of a national design competition as "an incredible proceeding for a public monument of such importance." Then when Pope's design was made public, they were beside themselves. Wright called Pope's Greek and Italian conception "an arrogant insult," and went on to blast public architecture in the capital city as "the sacrifice of the living spirit to the dead letter." William Lescaze was also generally dismayed by Washington's official architecture—"a long series of dreary, costly, pretentious, inefficient, and dishonest buildings"—and particularly upset by Pope's design. Americans, Lescaze declared, needed "architecture which makes them aware that it's good to be alive today in the twentieth century, it's grand to be alive today in a democracy—in America!" Meanwhile the faculty of the Columbia University School of Architecture termed the Jefferson Memorial design "a lamentable misfit both in time and place." Joseph Hudnut, head of the Harvard Department of Art, described as "surely one of the most fantastic in the history of architecture" a project to "assist the immortality of Thomas Jefferson by the reconstruction of a temple once dedicated to the seven gods of Rome. . . ."[112]

Pope's defenders pointed out that Jefferson himself had favored the classical style for his home at Monticello and for the University of Virginia. He would heartily approve of what Pope had proposed, they maintained.[113] For modernist adherents that was hardly the point, which was simply that such vestiges from an age of aristocratic privi-

lege and indulgent wealth, of idealized beauty abstracted from social realities, had no place in a country that had rededicated itself to the extension of democracy and equal opportunity for all.

The completed Jefferson Memorial was a structure of simple white elegance attractively situated near the tidal basin south of the Mall. It turned out to be the most admired public monument in America next to the Lincoln Memorial, completed a decade earlier in neo-Grecian mode. By the late thirties big crowds of tourists were also descending on Colonial Williamsburg, the scene of Jefferson's early public career. There they viewed the portions of the Virginia colonial capital that had been re-created since 1927, when work had begun under funding supplied by the Rockefeller family. Colonial Williamsburg, James Marston Fitch complained, had "done more to stultify and corrupt American taste than any single event in our history, the Columbian Exposition possibly excepted."[114] Despite the most strenuous efforts of modernist advocates like Fitch, the influence of older notions of architectural form and esthetic value remained considerable, if not in architectural theory then in public taste.

The crisis of the Great Depression prompted large numbers of the country's creative minority to strive to understand and communicate with the collective experience of the American people. That was true as much in architecture, where modernists linked adaptable, utilitarian design to the task of social reconstruction, as it was in music, where composers were often willing to exploit native folk and popular resources, or in the literary and visual arts, where the social and artistic values of realism prevailed. Both figuratively and literally, intellectuals and artists came home to America and sought to reestablish their relevance to the larger society. Not only did they rediscover the American present; as the decade progressed they more and more explored the national past, seeking enduring values, precedents for action, even meaningful legends with which to fashion the most elaborate version thus far of a usable past. Thus what happened in the years 1935–41, a period of persistent economic slump followed by the outbreak of global warfare, was a remarkable celebration in American thought and culture of the goodness and glory of the nation and its people. The decade of convictions ended up as less a matter of working for radical change than of reaffirming almost everything about America and Americans.

# CHAPTER 6

# This Question of the National Tradition

THE LONG AND REMARKABLY VARIEGATED HISTORY OF AMERICAN CULtural nationalism finally reached a climax in the late 1930s and early 1940s. The ideological radicalism that had flared across the intellectual and cultural spectrum early in the thirties largely subsided after 1935. Under the new policy of the Popular Front, the Communist Party reached out to unite with liberals, non-Communist radicals, and all other "progressive forces" in common opposition to fascism at home and abroad. Meanwhile, the New Deal's innovative, multifarious attack on the Great Depression prompted renewed confidence in the country's economic and political institutions and undercut whatever broad popular appeal the Communist and Socialist parties might eventually have been able to generate. By 1935 President Roosevelt and the New Deal had won over substantial numbers of people who had sought more radical alternatives in the early Depression years.[1]

Of course the widely shared impulse among intellectuals and artists to rediscover and become reconciled with America well antedated both the Popular Front and the New Deal. Strong nationalistic currents had moved in the cultural life of the 1920s. Even under the Third-Period policy of intransigence toward capitalism and bourgeois democracy in the early thirties, Communist cultural spokesmen like Michael Gold and Granville Hicks as well as independent Marxists like V. F. Calverton had sought within American history and tradition the bases for a revolutionary art of the proletariat. Affirmations of the American people and the American experience—or at least large portions of both—had become much the intellectual fashion in the post-Crash years.

More than anything else, though, it was the Popular Front that promoted a spirit of democratic nationalism in the American arts. If the Great Depression was the central fact of the 1930s for American life as a whole, then from 1935 to 1939 the Popular Front was the central influence at work in American cultural life.

# I

The Popular Front—or United or Peoples' Front as it was also called —was an invention and always an instrument of Soviet foreign policy. Fearing the Soviet Union's isolation in case of war with Nazi Germany, the Stalin regime shifted its official line from open hostility toward the Western capitalist democracies to accommodation and conciliation. According to the new policy, domestic Communist parties were to moderate if not abandon their revolutionary line and activities, and cooperate closely with antifascists of every kind in the interest of stopping the spread of fascist and profascist influence in Europe and presumably in the Western Hemisphere as well.[2]

In the United States the formation of the Popular Front meant that for all practical purposes the Communist Party gave its support to the New Deal. Under the slogan "Communism is twentieth-century Americanism," the Party nominally ran its own presidential candidate in 1936 but praised Roosevelt at the same time and acknowledged that his reelection was the desired outcome. Now the Party talked very little about awakening revolutionary consciousness in the proletariat. Instead, its focus was on common efforts among "progressives" to aid the struggle of organized labor—especially the new mass-production unions affiliated with the Congress of Industrial Organizations—for "social justice" within the framework of a capitalist system throttled by the Depression and tamed by the New Deal.

The existence of the Front also meant that Party and fellow-traveling intellectuals and artists could warmly endorse an American culture founded not on militant proletarianism but on an ambiguous, nearly all-inclusive democratic liberalism. At the same time, numerous people who had tended Left but had disdained the Party's sectarian politics and esthetics early in the thirties now could find a common ground with Communists in support of democracy and against fascism at home and abroad.

In October 1935 Michael Gold provided the watchword for the cultural Popular Front. "The chief battleground in the defense of culture against fascist barbarism," Gold proclaimed in the *Daily Worker*, "is in this question of the national tradition." Thereafter

Party spokesmen fervently embraced many of the same figures in the nation's past and present and at least implicitly endorsed the same bourgeois standards for judgment they had only recently scorned. As Gold later proudly recalled, "to help build the People's Front against fascism, the Communists drew upon all the libertarian treasures of the American past. Everything most typical of the American past was restudied and brought into the contemporary arena." The Communists, Gold claimed, "first demonstrated that the spirit of American history was a democratic muse, and was bitterly opposed at every point to fascism."[3]

Subsequently Gold proposed that before the year 1935 was out the American Left formally celebrate the centennial of Mark Twain's birth. Communist spokesmen also began regularly to invoke figures out of the nation's past as different as Thomas Jefferson and John Brown, Walt Whitman and Thomas Paine, in support of such causes as labor unions, civil liberties, and antimilitarism. Gold and Michael Blankfort collaborated on a play about John Brown produced by the Federal Theatre Project; in keeping with the ethos of the Front, the authors made Brown a hero for his zealous abolitionism but condemned his recourse to revolutionary violence.[4]

The favorite American historical personage in the Front years was Abraham Lincoln. The cresting Lincoln vogue dated from the twenties, when John Drinkwater's successful Broadway dramatization of Lincoln's life, Stephen Vincent Benét's epic poem John Brown's Body, and Carl Sandburg's two volumes on Lincoln through his election to the presidency had all made the Civil War leader the personification of the innate, democratic goodness of America. Lincoln, according to his hagiographers, shared with the masses of his countrymen a basic honesty and steadfastness in duty, a homely simplicity, a practical-minded idealism, an instinctive folk wisdom. Daniel Gregory Mason tried to capture those qualities in 1936 in his Lincoln Symphony, performed by both the New York Philharmonic and the Los Angeles Philharmonic over the next two years. So did Robert E. Sherwood in his 1938 Broadway hit Abe Lincoln in Illinois. The following year Sandburg concluded his hymnic biography with the publication of Lincoln: The War Years, in four volumes. Marking the high tide of Lincoln worship, Sandburg's work portrayed Lincoln as an extraordinary yet common American who emerged from the toiling millions to save the nation in its greatest trial.[5]

President Roosevelt, hardly a commoner himself, also exploited the Lincoln revival, often quoting the sixteenth president and suggesting parallels between present circumstances and those in Lincoln's time. By the end of the thirties, Benét, Sandburg, and Sherwood had all

three become unofficial propagandists for the Roosevelt administration; Sherwood would go on to serve as one of the president's main speechwriters.[6]

Along with nearly everybody else, the Communists joined in the apotheosis of Lincoln as well as other national heroes. At the Party's 1936 national convention, huge likenesses of Jefferson and Lincoln hung behind the speaker's rostrum. The Red Romance of the early thirties had turned into a romance with America—"a blend," Oliver Larkin has said, "of rhapsody, ridicule, and nostalgia, of hopeful self-glorification, sober pride, and sheer curiosity." Less charitably, Barbara Rose has referred to the "genuine need for a comfortable collective fantasy of a God-fearing, white-picket-fence America, which in retrospect took on the nostalgic appeal of a lost Golden Age."[7]

Even documentary reportage, intent earlier in the decade on uncovering the grimmest Depression realities, shifted during the Front years to a kind of presentation that was still superficially factual but actually celebrated the resilient qualities in American society. Gilbert Seldes's mordant *The Years of the Locust* or Edmund Wilson's foreboding *The American Jitters* would be suitable examples of the documentary genre from the early thirties; Louis Adamic's *My America* or the photo-essay volumes of Erskine Caldwell and Margaret Bourke-White exemplified the less critical reportage of the Front years.[8] Documentary literature after 1935 or so, William Stott has observed, "was fundamentally conservative in the same way the New Deal was," inasmuch as "its emphasis was on particular experience and the little man, its tone was sentimental (though it pretended to toughness), its principal theme was diversity as strength."[9]

Unity and strength through diversity might be taken as the essential Popular Front credo. Such a confident attitude, not greatly at variance with what Randolph Bourne had had in mind when he talked about transnational America, tended to gloss over class differences and to emphasize and frequently sentimentalize geographical, religious, linguistic, and even racial differences. In his enduringly popular play *The Time of Your Life*, first produced in 1939, William Saroyan captured the basic Front mood with his gallery of American types and his characterization of the simple folk as more "real" than the rich and well born. Saroyan's message was that goodwill and cooperative effort would ultimately triumph over the power of evil. That was also what came across in the series of popular movie comedies directed by Frank Capra, in the prodigious, closely autobiographical novels of Thomas Wolfe, and, for all its formal eccentricity, in James Agee's stunning book about his encounter with three impoverished sharecropper families in Alabama. Not radical political

and economic schemes but the nobility and stubborn endurance of the American people, such spokesmen suggested, would finally deliver the nation from its present predicament and bring about, in Wolfe's words, "the true fulfillment of our spirit, of our people, of our mighty and immortal land. . . ."[10]

The appropriate Marxist-influenced analysis in the early thirties had arrayed a bourgeois ruling class in control of government against the downtrodden, powerless masses. That analysis now gave way to a fuzzier view of "the people," often aided by their government, struggling against the minority of "economic royalists," as Roosevelt called them, who stood in the way of social justice. It seemed that the intellectual and cultural Left had advanced—or maybe retreated—to the position the New Deal had held all along. For example, *The Cradle Will Rock,* Marc Blitzstein's musical play, offered not revolution but unionization—a right protected by the federal Wagner Act after 1935 —as the workers' answer to the ruthless steel baron "Mister Mister." Meanwhile, Sandburg blended history and folklore with democratic mysticism in a pounding poetic tribute to *The People, Yes* (1936). Maybe the quintessential Front-period novel was John Steinbeck's *The Grapes of Wrath,* both a best seller and a critical triumph in 1939 and subsequently an acclaimed motion picture. In his agonizing odyssey of a dispossessed Oklahoma farm family lured to California and then brutalized by ruthless fruit growers, Steinbeck provided only one period of real respite—an all-too-brief stopover in a clean, modern, democratically governed rest camp run by the Farm Security Administration. Despite their many trials, the family survives because, in Ma Joad's words, "Why, we're the people—we go on."[11]

The all-embracing Americanism of the Popular Front years manifested itself in numerous other ways. For example, Farrar and Rinehart's beautifully written *Rivers of America* volumes were intended, said Editor Constance Lindsay Skinner, "to reveal American Folk to one another" and thus, while reaffirming their regional diversity, to demonstrate their common democratic traditions. Another example was the growing fascination with the country's architectural heritage, evidenced not just by the re-creation of Colonial Williamsburg but by less-publicized activities like the National Park Service's Survey of Historic American Buildings as well as the increased emphasis on early architecture in tourist literature. Still another was a large proportion of thirties mural work—in fact the whole American Scene movement in visual art, a phenomenon that antedated the Front by nearly a decade but nonetheless gained powerful reinforcement after 1935 from the prevalent artistic nationalism. By 1939 Thomas Craven,

a self-described "historian and participant" in the "astonishing efflo-
rescence" of native painting, could congratulate himself and his
fellow nationalists that at last the despised "fancy cults" of Paris were
dead. "A battle has been waged and won," Craven exulted, "a decisive
victory over provincial ignorance, anemic imitation, cheap interna-
tionalism, and the postwar hang-over of esthetic snobbery."[12]

One of the major indications of the changes in American cultural
opinion was the symposium *America Now*. In 1938 Harold Stearns
edited another weighty volume of essays in a conscious effort to pro-
vide the kind of summary statement for the thirties that *Civilization
in the United States* had supposedly been for the postwar years. Yet,
whereas *Civilization in the United States* had amounted to a sustained
protest against the emotional and artistic shortcomings in American
life, Stearns described the present volume as "a tolerant book," one
that "reflects our day and our time. . . . Indeed, the tones of mockery
or of bitterness are singularly lacking in contemporary social criticism.
. . ."[13] The contrast in moods was most obvious in the way Stearns
put the 1938 book together. He allotted as much space to politics as
to the arts and included essays on topics like racism, religious faiths,
labor, and Communism, which the earlier collection had ignored. The
malcontents of the twenties were all missing, even though some of
them, like Van Wyck Brooks, had mellowed a great deal in the inter-
vening years. H. L. Mencken, who had changed little while the times
had changed much, turned down Stearns's request for a contribution
to the new volume: ". . . some of the men you have lined up [are]
propagandists of obvious nonsense, and I'd certainly hesitate to appear
side by side with them."[14]

The 1922 essayists had been idealistic and generally unhappy,
elitist and often estranged. The *America Now* contributors were char-
acteristically sober, realistic, and overall pretty confident about the
future, despite the stubborn hold of the Depression and mounting
international strife. The essayists on the arts seemed to take for
granted that the United States had already reached a fairly high level
of cultural maturity, and that the critic's responsibility was no longer
to exhort but to understand. Douglas Haskell, for example, applauded
the "defeat" of the skyscraper and the advent of a more socially con-
scious and socially purposeful architecture geared to "the new work
of devising a continuously improving, continent-wide, shelter service."
Sheldon Cheney, though rejecting the "blinders decreed by the Ameri-
can-scene people," warmly appreciated "the existence of a rich and re-
warding body of American work" in painting and the fact that "among
the component parts or forces of American civilization, art is at last

well up as an accomplishment." According to Deems Taylor (the only contributor on the arts who also had written for the 1922 volume), music suffered not from the American public's failure to appreciate the composer but from the unwillingness of the typical composer to get in touch with his public. It was up to the composer to "find an idiom that is intelligible to the people around him. . . ." The composer needed to "worry more about what a Kansas masonry contractor thinks of him . . . and worry less about whether or not Béla Bartók would approve."[15]

## II

By the late thirties the American intellectual and artistic minority appeared to feel more at home in American society than it had ever been. Earlier in the decade there had been a great deal of talk about the obligations of that minority to commit itself to radical social and economic change. Now it seemed even more urgent to stand up against fascist totalitarianism and for the nation's democratic and civil libertarian traditions. As Van Wyck Brooks wrote later, this reconciliation with America and what it stood for "was characteristic of many a censorious mind of earlier days, for, with all its abuses, our prosaic republic seemed curiously inculpable beside Mussolini's Italy or Germany or Spain." Never had there been so much involvement of people in the arts in so much political and quasi-political activity. "The intellectual and artistic life of N.Y.," Harold Clurman reported, "is . . . undergoing a kind of momentary eclipse or merging into a state where for the moment it is indistinguishable from the political life. People are so busy signing petitions . . . they have no time to write anything else."[16]

A host of "Front organizations," their key positions usually occupied by Communist Party members, held rallies and solicited funds for a variety of "progressive" causes—most of all for the beleaguered Spanish Republic. Helped some by Soviet Russia, the republican government fought a losing struggle against the rightist insurgent forces of General Francisco Franco. While the Western democracies kept out of the Spanish conflict, Franco received massive quantities of matériel and sizable numbers of combat forces from Germany and Italy. No cause stirred emotions on the Left so profoundly as the Spanish Civil War, which Frontists regarded as a rehearsal for the bigger war that sooner or later would have to be fought between fascism and democracy. People as disparate as Van Wyck Brooks and Malcolm Cowley, Waldo

Frank and Ernest Hemingway, could come together on the issue of Spain.[17]

It seemed, in fact, that the kind of artistic fellowship or community Brooks and many others had talked about over the years was about to become a reality under the aegis of the Popular Front. In the Front's cultural organizations, especially the League of American Writers and the Congress of American Artists, creative people from various backgrounds, with various artistic interests and objectives, could rally around what they proudly if ambiguously called the American tradition. That tradition was elastic enough to include the courage of the signers of the Declaration of Independence, the wisdom of the framers of the Constitution, the democratizing influences of Jefferson and Andrew Jackson, the zeal of the antebellum abolitionists and the early twentieth-century reformers, even the resoluteness of the Puritan dissenters in coming to America to secure their freedom to worship. People in ideas and the arts, Popular Front advocates exhorted, had to relate their own work to the intensifying crisis of democracy. As Lewis Mumford told the first Artists' Congress in February 1936, "The time has come for the people who love life and culture to form a united front. . . , to be ready to protect, and guard, and if necessary, fight for the human heritage which we, as artists, embody."[18]

## III

A substantial minority on the Left would have nothing to do with the Popular Front, convinced that over the long run it was futile to try to carry on any kind of cooperative relationship with the Communists. Opponents of the Front included Norman Thomas and his followers in the fast-fading Socialist Party and old-line independents like John Dewey, the well-known historian Charles A. Beard, and Oswald Garrison Villard, former publisher of the *Nation* magazine. One of the most vocal anti-Front contingents on the Left consisted of the group of critics associated with the bimonthly *Partisan Review*.

Originally *Partisan Review* was the organ of the John Reed Club of New York, the Communist Party's main Manhattan literary affiliate. The magazine suspended publication in the fall of 1936 after its editorial staff split over various matters, especially the insistence of Party-line Stalin supporters on condemning the exiled revolutionary Leon Trotsky. A year later William Phillips, Philip Rahv, Dwight Macdonald, F. W. Dupee, and several other admirers of Trotsky revived *Partisan Review* as an independent radical magazine, prepared

to do battle with "Stalinism" on both political and cultural issues. While their bimonthly would continue to be "revolutionary in tendency," they disclaimed "obligation to any . . . organized political expressions. . . ."[19]

By that time the Popular Front was in full swing. The people who edited and wrote for *Partisan Review* perceived a desperate need to restore the kind of skeptical, adventurous, ironic mood in American intellectual and cultural affairs that Randolph Bourne had called for during the First World War. The influence of the Front, they contended, was stifling critical detachment and speculative thought in favor of a comfortable ancestor worship, a smug provincialism that in its own way was as enervating as the Genteel Tradition. John Dos Passos, disgusted with Communist cultural politics and outraged by the Spanish Communists' liquidation of the anarchists in Barcelona, congratulated Rahv on his efforts to "keep a little life in the Left, which is rapidly merging with the American Legion." Before long, said Dos Passos, leftists would be "selling Liberty Bonds and pinning the white feather on anybody who doesn't enlist in the next war for democracy."[20]

In place of the overarching Americanism of the Front, the *Partisan Review* group sought to reestablish a connection between ideological radicalism and artistic radicalism, such as the old *Masses* had stood for in the prewar years. The intense, usually humorless *Partisan Review* radicals lacked the *joie de vivre* of Max Eastman, Floyd Dell, John Reed, and the others on the old *Masses,* but they wanted just as much to radicalize both American politics and American tastes and values. Yet they anticipated no sudden revolutionary transformation. The task of building culture in America was actually a matter of rebuilding an avant-garde that had fallen into sad repair under the influence of Party-line Stalinism and the esthetic doctrine of "socialist realism." As Lionel Trilling (who would become one of *Partisan Review*'s leading contributors) had said back in 1930, American intellectuals and artists had to realize that their role was to subvert prevailing values and norms, not reinforce them.[21]

Much in the manner of Alfred Stieglitz in the heyday of the "291" gallery, the people associated with *Partisan Review* looked toward the emergence of a self-conscious elite that would fully reinvolve American culture with the main international tendencies. Whatever prospect there might be for realizing something called a national culture in America depended, first, on the "Europeanization" of American literature and presumably the other arts as well. By reestablishing contact with the most advanced forms of thought and expression in Europe, American creative artists and critics could speak more cogently both

as Americans and as members of a trans-Atlantic "intelligentsia." Unlike such uncompromising individualists as Frank Lloyd Wright or William Carlos Williams or young James Agee, Rahv, Phillips, and the rest of the *Partisan Review* group were much concerned with their collective identity—as a unique contingent whose primary responsibilities were not to society but to each other. For them, as Richard Pells has commented, "the dream of a finding a place in an organic community gave way to a celebration of the homeless intellectual, forever alienated and uprooted, the eternal exile without hope of return."[22]

Others in the arts were equally dissatisfied with the effects of the Popular Front on American expression—and indeed with the whole trend in the thirties to mix art and ideology. Max Eastman, still professedly a Marxist but wanting nothing to do with either the sectarian Communism of the early thirties or the ecumenical Communism of the late thirties, wrote two forceful books attacking the concept of literature as an instrument for political ends. Although James T. Farrell's *Studs Lonigan* trilogy (1932–35) was hailed as the period's finest "proletarian" fiction, Farrell nonetheless argued that "living literature" could never be "merely synonymous with formal ideology, generalized themes, and the explicitly stated ideas of its writers." Farrell stubbornly kept aloof from what he termed the "pseudo-populism" of the Popular Front. Critics like Christopher Lazare decried the American-Scene vogue and particularly what Lazare called the "wet nurse relationship to the American artist" of the Whitney Museum of American Art. "Art in this country," sighed Lazare, "is apparently no longer a method for universalizing experience, but for constricting it. . . . Qualitative values have disappeared from the critical vocabulary and have been supplanted by geographical symbols and place names."[23]

Meanwhile, a strikingly new critical influence was germinating. Already by the end of the thirties, essayists and columnists were making reference to the "New Criticism," a mode of analysis in literature and more particularly poetry that was at odds with the whole social and biographical orientation which up to then had dominated American critical thought. The New Critics insisted on the primacy of the creative act in and of itself, without regard to social, historical, or other environmental circumstances. Structure, texture, inner logic, symbolic meaning—these should be the principal concerns of criticism, according to such spokesmen as Kenneth Burke, Cleanth Brooks, R. P. Blackmur, John Crowe Ransom, and Allen Tate. The New Critics undertook to reinvigorate the critical function by treating criticism itself as a creative act. Their determinedly apolitical and ahistorical stance placed them well beyond the *Partisan Review* group. Within a decade or so the New Criticism—or "formalist criticism" as it later came

to be called—was well on its way to becoming the authoritative voice in American literary studies.[24]

<div align="center">IV</div>

In the summer of 1939, however, the Popular Front was still a powerful factor in American ideas and art. The League of American Writers and the other Front cultural organizations were at the peak of their membership and prestige, and so was the "progressive"-patriotic-nationalistic outlook in the American arts. Some people had already abandoned the Front, unable to digest the cynical behavior of the Spanish Communists (the dominant element in the republican government by the time it fell early in 1939) or the bloody purges carried out in Russia by Stalin against his comrades in the Bolshevik Revolution and everybody else he suspected of disloyalty.

Yet most managed to continue to believe in the broad Left coalition until August 23, 1939. On that day the governments of Adolf Hitler's Germany and Stalin's Russia signed a treaty of trade and nonaggression. Within twenty-four hours Communist Party publications stopped exhorting "progressives" to take common action against the menace of fascism and started calling for strict American neutrality if war should break out in Europe. That war came eight days later, when, with Russian acquiescence assured, Hitler's modern air and ground forces launched a long-planned invasion of Poland, thereby triggering British and French declarations of war against Germany. The Popular Front was left a shambles; for many the autumn of 1939 was a time for painful reevaluation and recantation, for searching the wreckage for some kind of coherent position.[25]

The collapse of the Popular Front did not mean the evaporation of the moods, premises, and tastes in the arts the Front had done so much to reinforce. If anything, the nationalistic attitude was more pronounced in the period from the outbreak of war in Europe to the Japanese attack at Pearl Harbor than it had been up to 1939. With Europe steadily falling under Nazi domination and with Imperial Japan aiming to control China and much of the rest of Asia, the United States seemed more than ever the luminous homeland of democratic liberty.

Even within the American Communist movement there was no return to the revolutionary Marxism of the early thirties. Communist critics like Michael Gold joined the Party's political leadership in denouncing the Roosevelt administration's pro-Allied foreign policy and the buildup of American armed forces. Yet such arguments often

involved appeals to the country's alleged traditions of antimilitarism and noninvolvement in Europe's quarrels. Communist cultural criticism was still flavored with Americanist allusions. Gold, while attacking the "renegades" and "hollow men" who had deserted the Left, could still proclaim that "You cannot go wrong in the politics you follow if you keep your eye always fixed on this true Nation of the majority." Communism was still equatable with the "democratic tradition" and Americanism.[26] And when Germany attacked the USSR on June 22, 1941, American Communists quickly moved to reconstruct the Popular Front. Reciprocally, many non-Communists were willing once again to regard the Soviet Union as one of the "progressive" nations fighting against the global menace of fascism.

## V

The period of the Popular Front happened to coincide almost exactly with the healthiest years of the four federal arts projects established as part of the Works Progress Administration's huge work-relief program in the summer of 1935. Thus Communist critics as well as cultural commentators in general could applaud the federal government's unprecedentedly extensive and diverse entry into the sponsorship and dissemination of culture. Without the Great Depression, Washington's role in the arts would doubtless have continued to consist mostly of commissioning painters and sculptors to decorate federal buildings. Between 1933 and 1935 the Public Works of Art Project, the Treasury Department's Relief Arts Project, and to a lesser extent the Federal Emergency Relief Administration had already put to work a considerable number of unemployed people in the arts. But what happened under Federal One (the WPA designation for the Federal Writers', Music, Art, and Theatre Projects) was a much bigger, more expensive, and more variegated enterprise, one that many contemporaries saw as the salvation of the creative arts in America. Besides saving thousands of writers, actors, teachers, directors, stagehands, musicians, composers, painters, sculptors, and craftsmen from poverty and professional humiliation, Federal One seemed to have rejuvenated the country's whole cultural situation.[27]

Reviewing the work of the Federal Writers' Project up to 1937, Lewis Mumford was certain that "more public good has come out of the bankruptcy of the economic order than ever came regularly out of its flatulent prosperity." Suzanne LaFollette came away from the Museum of Modern Art's show on the Federal Art Project "with the feeling that the depression of 1929–? may prove to have been the

best thing that ever happened to American art." Federal One, said its admirers, had given culture to the masses on a scale unknown anywhere at any time. "What the figures . . . dramatically signify," wrote the young journalist James Wechsler, "is the dissolution of those barriers between the artist and the people which have caused American artists to stagnate in poverty and despair. . . . WPA endowed the artist with a sense of belonging to his own country."[28]

For the Congress, for President Roosevelt, and for WPA Administrator Harry Hopkins, the arts projects were relief efforts first and last. Hired from the relief rolls like the millions of other WPA workers, people from the arts were supposed to remain on the federal payroll only until they could get steady work elsewhere. Beginning in 1937, moreover, WPA as a whole suffered regular budget cuts, with the arts projects, under fire inside and outside the Congress from their inception, taking the sharpest reductions. Finally, in 1939, the Congress refused the entire appropriation for the Federal Theatre Project, concentrated the administration of the remaining arts projects in the states, stipulated that at least one-fourth of their funding must come from local sources, and set an eighteen-month limit for continuous WPA employment. The reorganized and reduced Writers', Music, and Art projects carried on for a few more years until, like the Treasury Section of Fine Arts, they quietly expired in the midst of the Second World War.

The administrators of WPA's cultural projects never managed to resolve an inherent contradiction in their programs. WPA cultural projects were supposed to do work of lasting value, but also do it with people who were usually not first-raters to begin with and, in any case, were to draw WPA wages for the shortest time possible. As late as the fall of 1941, at a conference on WPA arts at the Library of Congress, John Steinbeck (himself once an employee of the Writers' Project) succinctly posed the issue: "Are we feeding needy artists or creating artistic expression?" After two days of discussion, also attended by such prominent people as Van Wyck Brooks, Roy Harris, Malcolm Cowley, and Howard Hanson and presided over by Librarian of Congress Archibald MacLeish, the conference still had not given a satisfactory answer to Steinbeck's question. Nor had it shed much light on another major issue: whether WPA arts were to aim for the highest possible level of professional accomplishment with the talent at hand or to concern themselves mainly with serving the cultural needs of local communities. Usually phrased as professionalism versus service, the issue was also one of creation versus dissemination.[29]

Despite their unresolved contradictions, their budgetary uncertainties, their administrative complications as federally financed and di-

rected but state-organized ventures, and their transitory work forces,
WPA's arts projects compiled a most remarkable record. For example,
the Federal Writers' Project, while doing relatively little to encourage
the production of fiction and poetry, put its average complement of
about five thousand writers and would-be writers to work on a wide
range of activities. FWP workers inventoried the extant archival ma-
terial of state and local governments and about twenty thousand
churches, collected the reminiscences of former slaves, produced sev-
eral photographic essays in the this-is-America vein of the period, and
compiled a number of volumes on American ethnic groups. FWP was
also much involved in studying folk origins, as were all the WPA
arts projects under the overall supervision of WPA's Joint Committee
on Folk Arts. FWP's Folklore Studies division, headed by B. A. Bot-
kin, sent researchers into remote areas all over the country to hear
and set down specimens of American humor and oral tradition. As
had long been true in American folk researches, the Folklore Studies
division proceeded under the assumption that folklore was a continu-
ing, evolving popular expression, the study of which was directly
pertinent to contemporary society. WPA considered folklore, said Bot-
kin, as part of "a living culture," information useful not just in a
local-regional context but "in progressive and democratic society as
a whole."[30]

The Writers' Project's most celebrated achievement was the Amer-
ican Guide Series, a vast, never-finished array of city, state, regional,
and territorial guidebooks. The guidebooks offered a staggering com-
pendium of generally accurate information about the history, geogra-
phy, economy, customs, traditions, and even the superstitions and
prejudices of Americans. The guides were anything but Chamber of
Commerce promotional tracts. A close student of the guidebooks has
recently commented on their "critical approach to America," their de-
tailed honesty about American failures as well as successes. All in all
they presented an extraordinarily balanced portrait of a diverse people
and a diverse land.[31]

## VI

The Federal Music Project employed more people than any other
WPA cultural venture (nearly sixteen thousand at its peak in 1936)
and could also claim to have reached directly the most Americans.
To a greater extent than the other projects, moreover, FMP brought
to a head the conceptual conflict over professionalism versus service.
National Director Nikolai Sokoloff, on leave from the conductorship

of the Cleveland Symphony, was convinced that FMP's ensembles must perform at the highest possible level of musicianship. Insofar as FMP had a duty to the larger society, it was to expose the masses to "good music" and elevate their level of taste and appreciation. Others in FMP, typified by Assistant Director for Folk Art Charles Seeger, believed that the project should give music to the people but also take their contributions, thereby narrowing the distance between formal composition and folk sources, between the cultural elite and the masses, between high culture and folk culture. The educational activities of FMP community music centers and touring groups would be the foci for such a grass-roots program.[32]

Sokoloff's main concern throughout the years he was national director, 1935–39, was to sustain the quality of the major FMP ensembles concentrated in New York, Chicago, Los Angeles, and other big cities. Because of Sokoloff's insistence on the highest standards of performance, the major organizations played less often than they might have and reached fewer people with the message of cultural uplift. Yet by 1940 FMP estimated that almost 160 million people had attended about a quarter of a million performances by its orchestras, bands, and chamber, choral, and operatic groups. About 17,700,000 children and adults had received some amount of music instruction under FMP.

FMP also invited American composers to submit manuscripts to a national audition board, which judged those suitable for performance by FMP ensembles. In March 1940 FMP reported that its musicians had played works by 3,258 American composers, of whom nearly 1,300 were living and nearly 300 had worked for the Music Project at some time. FMP's Composers' Forum Laboratories, started first in New York in the fall of 1935 and subsequently instituted in eleven other cities, played scores and then invited comments from professional critics on hand as well as questions from the general audience.[33]

Both aspiring and established composers were able to get excited about what FMP was doing. Daniel Gregory Mason was buoyed by having his music performed by a WPA symphony in New York early in 1936—"a great experience for me," as he described it to Van Wyck Brooks, "disheartened as I was by the snobbery and journalistic commercialism of the [New York] Philharmonic." "To think that one is speaking and others—plain people—are hearing, makes the whole artistic process live," declared Mason, who added that he now had "a new hope for our musical vitality." Across the continent in San Francisco, Ernst Bacon was similarly enthusiastic about his work as conductor of that city's WPA symphony, even though his organization consisted mainly of ex-theater musicians.[34]

By 1941 FMP workers had indexed some 7,300 compositions by 2,558 native Americans. FMP's documentation included not only available program notes and reviews but also notations on the "Americana" derivations—folk tunes, legends, landscapes, and the like—for different compositions. Each year from 1938 to 1940, moreover, FMP organized three-day national music festivals that were given over entirely to native music. The Music Project also staged special programs in 1938 to mark the seventy-fifth anniversary of Edward MacDowell's birth.[35]

According to one scholar, the Federal Music Project's openness to American work, not war-inspired patriotism, was the chief reason for the fact that from the 1939–40 concert season to that of 1942–43, the amount of American-written music played by the country's leading symphonic organizations increased from 9.7 percent to 20.8 percent. In other words, American entry into the war only reinforced a shift that had already begun under the influence of the Music Project. "What has become of the famous old musical game that used to be called 'Neglecting the American Composer'?" asked Robert Simon of the *New Yorker* magazine in 1940. Apropos of the amount of American music he had recently heard in concerts at Carnegie Hall, Town Hall, and elsewhere around New York, Simon suggested that "our performers are taking our composers for granted and are playing and singing their output simply because they think it's good stuff."[36]

Sokoloff and most of his associates in Washington were not much interested in folk music because it did not fit their ideal of professionalism. Music Project personnel recorded and notated Spanish folk songs in New Mexico, black work songs in Mississippi, Indian music in Oklahoma, and the ballads of Kentucky mountaineers. Most work of that kind, however, took place under the administrative aegis of WPA's Joint Committee on Folk Arts, which drew on all the federal-relief arts projects for money and staff.[37]

The Joint Committee on Folk Arts also sponsored the well-known fieldwork of John A. Lomax and his son Alan for the rapidly growing Archive of American Folk Song in the Library of Congress. Established in 1928 under the library's Music Division, the Archive subsisted on private contributions until it got its first small congressional appropriation in 1937. In the early thirties the Lomaxes made a famous tour of southern prison camps, and in succeeding years they and other researchers continued to roam the South and also did recordings in the Middle West and New England. By 1940 the Archive of American Folk Song had built a collection of approximately four thousand folk-music discs; within another five years, under B. A. Botkin's determined direction, the Archive had doubled its holdings.[38]

As a freshman at the University of Texas in 1895, John Lomax had shown one of his English professors some manuscripts of cowboy songs he had heard when he was growing up on the west Texas frontier. "Worthless," the professor commented. "Just another example of the crudity of America. If it is ballads you like, my boy, stick to the English ballads."[39] Lomax, though, simply could not bring himself to follow the English ballad tradition associated with the great nineteenth-century collector Francis Child. According to the Child tradition, one began with the original English and Scottish ballads and then studied their preservation elsewhere. Lomax and his son and others like Botkin, Seeger, George Pullen Jackson, and Dorothy Scarborough focused not on the preservation but on the modification and evolution of folk materials, which became vital ingredients in what Botkin called "the people's culture, a democratic diversity of occupations and nationalities." Nothing that came from the people was excludable as far as the egalitarian folk enthusiasts were concerned. Their interests ranged from mountain ballads and fiddle tunes, field hollers and spirituals, to the songs of fishermen, turpentine workers, coal miners, and lumberjacks, to the music of Poles, Italians, Jews, Louisiana Cajuns, and the great multiplicity of other ethnic groups in America.[40]

Both as scholarly and as popular phenomena, collecting, playing, singing, and listening to folk music reached new highs in the Popular Front and immediate post-Front years. In 1930 Jean Thomas, a self-styled "traipsin' woman" who had first gotten interested in folk music in the late twenties when she went into the Kentucky mountains as a circuit court stenographer, had organized the American Folk Song Society. With a national committee that included such luminaries as Carl Sandburg, Stephen Vincent Benét, and Paul Green, the society staged annual National Folk Festivals, beginning at St. Louis in 1934. By the time the fifth festival was held in the national capital, folk music—or at least what passed for folk music—had won enthusiastic acclaim as the most natural means of "weaving into one great national pattern the distinctive rhythms of the various racial groups whose rich culture has poured into our country from many lands."[41]

Bill C. Malone has pointed out that when the Lomaxes and other researchers went in avid pursuit of authentic folk songs, many times they actually heard versions of commercial "hillbilly" recordings, which in turn rural southerners had heard on radio or phonographs. What Malone has designated "commercial country music"—usually called hillbilly from the twenties through the forties—had already become the favorite music for great numbers of white people throughout the South. Hillbilly was also a fast-growing part of the popular music business, especially in the releases of Okeh Records, the Columbia

Record Company's hillbilly and "race" music subsidiary. Meanwhile, starting with the bitter textile workers' strike at Gastonia, North Carolina, in 1929, Socialist and Communist labor organizers moved into the generally nonunionized southern states. One consequence was that northern radicals became acquainted with southern ballads, some of which either they or radicalized native southerners adapted into songs of social protest. Thus by the mid-thirties the American Left had begun to use "folk music" as an instrument for radical propaganda. Left critics distinguished between "folk music"—supposedly anonymous and communal, sprung from the hearts of the people, the product of a slowly changing oral tradition—and obviously commercial hillbilly music. As Malone has suggested, hillbilly "did not conform to the scholars' esthetic standards or to the standards that the folk were 'supposed' to have."[42]

With the advent of the Popular Front, the Communist Party and its allies sought to transcend cultural proletarianism. The Front also coincided with the flowering of popular and scholarly interest in America's folklore—folk-song traditions. The Party-controlled American Music League—pledged "to collect, study, and popularize American folk music and its traditions"—succeeded the Third-Period Workers' Music League. And besides folk and pseudofolk ballads from the rural South, the cultural program of the Front-period Left also encompassed black spirituals, blues, work songs, even jazz—anything that seemed to come from the depths of the American folk consciousness. In 1936 Lawrence Gellert published a volume of *Negro Songs of Protest* under American Music League auspices. The *New Masses* regularly published columns of jazz criticism, and in 1938 and 1939 the Party sponsored "Spirituals to Swing" concerts at Carnegie Hall. Meanwhile, largely as a result of Alan Lomax's promotional activities, an informal group of "folk" singers became a familiar feature at Front-inspired political rallies. Frequently called the "Lomax singers," the group consisted of such people as Charles Seeger's son Pete; Woody Guthrie, a hillbilly singer from Oklahoma by way of California; Will Geer, an actor and singer from the Federal Theatre Project; the professional balladeer Burl Ives; and the black bluesmen Josh White and Huddie Ledbetter.[43]

The "Lomax singers" provided the nucleus for the better-organized and better-publicized Almanac Singers, the major musical contingent associated with the Communist Party in the post-Front years. Even though the Party had changed its official line from collective security to strict neutrality and now denounced Roosevelt's pro-British foreign policy, the strongly Americanist flavor in its cultural program remained essentially unchanged. Folk-style musical renditions—preaching peace, brotherhood, and the righteous cause of labor—were more than

ever a feature of Party functions. However little appeal such music may have had for the urban working class, the "hootenanny" became a central element in American Communist cultural life. After the German invasion of Russia, when the Communist line shifted back to universal antifascism and calls for collective security, the Party gave "people's music" a prominent role in the neo-Popular Front. By that time singers in New York and elsewhere were commonly composing their own "folksongs," of which the best known was probably Woody Guthrie's ballad of the *Reuben James,* a U.S. destroyer sunk by a German submarine in the Atlantic. The link between folk music and social protest and commentary, originating in southern labor struggles and strengthened in the Popular Front and post-Front years, was firmly established by the 1940s. What Malone and others have designated "urban folk music" became the province of Left intellectuals, who at the same time downgraded commercial hillbilly, the kind of music the "folk" really liked.[44]

## VII

If the Federal Music Project's contribution to the folk-arts enthusiasm of the late thirties was usually peripheral, that of the Federal Art Project was central and well publicized. In fact FAP was the most heavily engaged of all the WPA cultural projects in the investigation, promotion, and dissemination of an American folk tradition. Holger Cahill, FAP's national director, was one of the country's leading authorities on the folk content in American visual art. In the fall of 1930 Cahill had organized a sizable exhibition of American primitivist painting for the Newark Museum of Art, and two years later he had assembled Mrs. John D. Rockefeller's big American folk-art collection for a show on "the art of the common man" at the Museum of Modern Art. Meanwhile he published in the *American Mercury* an important essay on American folk art, "the first mention of the subject," he later pointed out, "in a major magazine."[45]

Cahill excluded self-consciously produced commercial craftsmanship —furniture, pottery, textiles, glassware, and silverware—from his definition of folk art. His interests centered on "art which is produced by people who have little book learning in art techniques and no academic training, whose work is not related to established schools, and is, in most instances, anonymous." Such art might come from carpenters, blacksmiths, house and sign painters, "girls in boarding schools, old maids, lonely bachelors. . . ." Cahill especially admired the work of the itinerant colonial-era limners, whose portraits were "of

far more importance, as art, than the work of many a *petit maître*." He called attention especially to the sculptural qualities in such objects as duck decoys, toys, bootjacks, and ships' heads. A full appreciation of American folk art, Cahill contended, would lead toward a new interpretation of the country's art history and toward greater respect for the American artistic tradition.[46]

Of Scottish ancestry, a native of Iceland, and a Columbia University graduate, Cahill was a round-faced, peppery little man who sported a small brush moustache. A passionate egalitarian, Cahill loved both art and democracy and was convinced that the gap between the two must be bridged. "Art should belong to the whole people. In the great periods of art it *has* belonged to the people." That had been the case in America from the mid-seventeenth to the second quarter of the nineteenth century—American art's "happiest time." But with the rise of mass-production industry and the advent of museums endowed by the rich and dedicated to "archeological" rather than living art, the people had lost contact with creative expression. The notion had taken hold that creativity was a matter of solitary genius, "of rare, occasional masterpieces." "The crucial circumstance," said Cahill, paraphrasing a New Deal economic cliché, "is not overproduction in art, rather it is underconsumption." The task of all the federal arts projects was to prove "that we can give art back to the people—that we can produce a genuine, democratic people's art."[47]

For Cahill himself, there never was any conflict in FAP's mission between professionalism and service. FAP's overriding responsibilities were to put unemployed artists and craftsmen to work, and to reinvolve the American people with art. Certainly FAP's national director had no objection to painterly excellence. Moreover, unlike the Public Works of Art Project and the Treasury Department's Section of Fine Arts and Relief Arts Project, Cahill's operation showed no prejudice against nonrepresentational artists. FAP employed various painters—like Jackson Pollock, Mark Rothko, Willem de Kooning, and Arshille Gorky—whose work would later be central to the revival of abstractionist painting in America. Older nonrepresentationalists like Marsden Hartley and Stuart Davis also worked for FAP at one time or another. Altogether, some 10,000 artists under FAP employment did approximately 128,000 separate murals, easel paintings, and sculptures, plus about 240,000 prints.[48]

As Cahill saw it, the overall quality of that vast amount of work was not the main issue. Of greater moment was the fact that while New York City predictably had the biggest and most talented roll of artists, FAP work was on display in hundreds of other towns and cities across America. One key element in Cahill's democratization scheme

was the establishment of community art centers, through which FAP
was supposed to curb the Northeast's domination of the visual arts
and put Americans everywhere in touch with creative activity. At one
point FAP operated 103 community centers. At such places local artists
could get a start instead of migrating to New York or Europe; pre-
viously jobless art teachers could teach the rudiments of painting,
sculpture, even interior decorating; handicraft enthusiasts could seek
to revive local interest in pottery, wood carving, leatherwork, quilting,
and a variety of other declining skills. The art centers also served as
bases for FAP's national mural program, whose painters decorated
hundreds of buildings, usually concentrating on familiar scenes.[49]

The other element in FAP's effort to democratize art was the much-
praised Index of American Design. Perhaps nothing better epitomized
the decade's nationalistic, democratic, and folkish temper than the
index. Though operating out of FAP's national offices in Washington,
the index depended heavily on research and artwork by people in
the community art centers. Intended to rediscover and record an
American vernacular tradition, the index was a compendium of plates
(about 20,000 in all) illustrating the history of the decorative arts in
America up through the nineteenth century. The index proved, as
Oliver Larkin observed in retrospect, "that thousands of nameless
Yankees had wrought superbly in wood and iron, silver and wool: the
gaudy crispness of carved circus wagons and cigar-store Indians, the
reticence of samplers, the slim perfection of Shaker cupboards, the
prancing silhouette of the farmer's weather vane, and the florid tulips
of the Pennsylvania potter." In effect the index had revived the original
meaning of art, said a contemporary eulogist, by "adopting the defini-
tion that came down to us from Ancient Greece where art meant
fitting, joining, and constructing as well as forming, depicting, and
representing, and where there was no distinction between the so-called
fine arts and the industrial arts."[50]

Closely related to the folk-art and handicrafts revivals and the over-
all democratic nationalism of the thirties was the popularity of primi-
tivist painting. The spare-time, avocational work of thorough amateurs
—the untrained and unlettered "common people"—was the most basic,
revealing expression of "a sturdy pioneering people who had colonized
a wilderness through fresh, vigorous enterprise and robust vitality—
qualities with which their native art was necessarily endowed." So
went the claims of the romantic nationalist promoters of primitivism.
The fact that gifted amateurs were usually unable to judge the good
from the bad in their work and thus failed to progress much beyond
their first pictures was what gave them "an untouched quality, a spiri-
tual innocence" and thus a great deal of their appeal. At the same

time, modernists found much to like in primitivist painting because in its flat planes, distortions, and strong coloring it demonstrated—albeit unintentionally—some of the characteristic features of twentieth-century expressionism and abstractionism.[51]

So at one end of the decade Cahill staged his *American Primitives* show in Newark; near the other end the Museum of Modern Art held a *Contemporary Unknown American Painters* exhibition, which introduced the work of sixteen new amateur artists. In between, the American art market, having first boomed in the twenties for eighteenth- and nineteenth-century primitivist art, also began to bring handsome prices for contemporary primitivists such as John Kane, an ex–coal miner from Pittsburgh; the black artist Horace Pippin from Philadelphia; and Anna Mary Robertson "Grandma" Moses, a hearty little woman in upstate New York who, when she turned eighty in 1940, was just coming into her own as an American art legend. Three of her many homely rural scenes appeared in the 1939 Museum of Modern Art exhibition; the next year her pictures charmed critics and buyers at a one-woman show in Manhattan. Over the next generation both her fame and the value of her paintings would continue to soar.[52]

## VIII

More than anybody else, Constance Rourke tried to provide a coherent theory not only for folk painting and sculpture but also for the whole range of American vernacular expression. Rourke grew up in Grand Rapids, Michigan, in a solid, middle-class family environment. She had most of the social advantages, including an elite education at Vassar College, where she took her B.A. in 1907. After two years in Europe on a traveling fellowship, Rourke came back to Vassar to teach for six years. She resigned her teaching job in 1915 and eventually reestablished her home at Grand Rapids, although she traveled all over the country as a free-lance writer. At Cahill's urging she came to Washington to head up the Index of American Design under FAP, but after one year she had had enough of bureaucratic Washington. Early in 1941, in Grand Rapids, she broke her back in a fall; a week later, at the age of fifty-five, she died of a thrombosis.[53]

Constance Rourke was not content to defend the American arts according to the usual Eurocentric qualitative standards; she was not even really interested in the traditional concept of "culture." Her long-range purpose was to show the fallacy in the historic lament about the lack of deeply grounded folk traditions on which to base the fine

arts in America. She was also much concerned with another old issue in American cultural controversy: the split between the artist and society. Rourke saw that split as the consequence of the fine arts–folk arts dichotomy. To resolve the dichotomy, she argued, it was necessary to understand creative expression in America as an indigenous process taking place among people of European background, to be sure, but operating in a wholly new setting in the New World.[54]

Frederick Jackson Turner's historical particularism—his emphasis on the advancing western frontier and the critical role of geographical sections in American history—was one major influence affecting Rourke's thinking. Another was the esthetics of Johann Gottfried von Herder, who had argued in the eighteenth century that a healthy national artistic life depended on the possession of a fund of communally developed "folk forms." Still a third influence was the developing scholarly discipline of cultural anthropology, particularly the work of Jane Ellen Harrison, Sir James G. Frazer, and Gilbert Murray in England, and Franz Boas and Ruth Benedict in the United States. From such scholars Rourke learned to think of culture not as the best that had been thought and expressed but as a "whole configuration." The arts thus became not the achievements of a talented minority but the manifold, functional, adaptive ways in which an entire people expressed itself. Artistic judgments became relative, a matter of determining how a people devised modes of expression adequate to its own peculiar needs and aspirations. And studying how the efforts to satisfy those needs and aspirations manifested themselves in social, political, economic, and artistic forms would make it possible to comprehend the essential national character.[55]

Rourke's debts to Turner, Herder, and the cultural anthropologists were clearly evident in the five books she wrote after 1930. Her *American Humor* (1931), subtitled *A Study of the National Character*, endeavored to reveal "the patternings of the grain" of American life by sketching the evolution of three stock comic types—the frontiersman, the New England Yankee, and the Negro. More than sympathy and promotion, she maintained, the American creative artist needed "an unstudied association with his natural inheritance," because "few have worked without a rich traditional store from which consciously or unconsciously they have drawn." Twenty years earlier Van Wyck Brooks had described the task of criticism as to illumine the American record of artistic failure and thus inspire creators to overcome their lack of a usable past. For Rourke, criticism should be a matter of "discovering and diffusing the materials of the American tradition"; the artist, meanwhile, must "steep himself in the gathered light."[56]

In Rourke's usage the term "popular arts" encompassed both traditional folk art as well as modern commercialized mass entertainment—

both the Herderian substratum of folk consciousness and Gilbert Seldes's consciously contrived seven lively arts. Inasmuch as culture was a continuum, a whole, it was no more necessary to distinguish folk from commercialized expression than it was to distinguish those two from the fine arts. Thus the legendary frontiersman Davy Crockett figured in both folk tale and commercial popular literature; in fact the real Crockett had carefully nourished and skillfully manipulated his own status as a living legend. The painter and photographer Charles Sheeler, Rourke said in a 1938 study, had drawn on and instilled in his own work the sparse, "classic" tradition of American craftsmanship, best expressed in the angular Pennsylvania barns and farmhouses Sheeler had discovered in the twenties. Sheeler's pictures were thus "a composite of qualities which could belong only to ourselves"—an affirmation of the characteristically American traits of understatement, economy, order, clarity, directness.[57]

Rourke's magnum opus was to have been a three-volume study of American culture, synthesizing history, anthropology, and esthetics in a grand reinterpretation of the nation's creative experience. At her death she had completed only fragments of her intended book. A year later Van Wyck Brooks, who had taken some of Rourke's early pieces for the *Freeman* and then had helped her get financial support for her researches in the thirties, assembled those fragments together with some of her previously published essays in a volume entitled *The Roots of American Culture*. Brooks's sensitive preface was a significant document in itself, because it indicated how far Brooks had modified his own conceptions of art and culture, partly under Rourke's influence, partly as a consequence of his own persistent efforts to come to terms with the American cultural past. In a succession of questions Brooks summarized Rourke's major conclusions and also implicitly revealed his widened personal perspective: "Was it not . . . the case that we had a long folk-life behind us which had found inevitable expression in forms of its own? Had not the critics ignored the creative forms that have always existed in this country? And could these not be shown to constitute an esthetic tradition?" In his own writings, moreover, especially in his chapters on popular literature and western humor and Mark Twain as a humorist in *The World of Washington Irving* (1944) and *The Times of Melville and Whitman* (1947), Brooks continued along the lines Rourke had suggested to further his own rediscovery of America.[58]

Rourke's basic theme, stated in the title essay of *Roots* and reiterated one way or another throughout the remainder of the book, was a denial that "the peaks of achievement, . . . the masterpiece, the influence of genius and the fine arts" were "a final index quality of a culture." It was rather the "special tenacities, currents of thought,

contagions of feeling," the "dominant arts, whether these are polite or impolite, practical or impractical," that actually determined national culture. "The original use of the word culture," Rourke reminded her readers, "contains its most far-reaching idea: culture is tillage, a fertile medium, a base or groundwork inducing germination or growth in terms of expression." Ultimately, a "sensitive historical criticism" would make possible "fresh reconstructions of our notion as to what constitutes a culture, with a removal of ancient snobberies and with inclusions."[59]

## IX

The kind of expansive historical criticism Rourke had in mind would become less and less fashionable during the decades after her death. Her work nonetheless did much to broaden the contemporary cultural consciousness, most of all where the study of American humor was concerned. In the considerable literature appearing in the thirties on the nature and development of the native humor, the usual disposition was to see Americans as either unique possessors or possessors in unique quantity of "the primitive vigor of imagination and the mature enjoyment of nonsense," as Max Eastman put it. The characteristic elements in American humor supposedly were exaggeration, homely bluntness and directness, and the archetypal sucker or dupe.[60] A few might stubbornly protest that humor, like art, was universal, that "the study of literature in general, and of humor in particular, needs a moratorium on generalizations about national and racial characteristics."[61] The more common feeling, however, was that a distinctively American comic strain was part of a distinctive national culture whose lineaments were becoming increasingly apparent.

One part of that American comic strain that critics and scholars had only recently begun to investigate was graphic humor. The Whitney Museum published a two-volume history of two centuries of American caricature, a weighty compilation premised on the belief that "The graphic humor of a people is in essence a vernacular record of the social and political history of that people," and that "each *people* . . . has its own peculiar graphic vernacular and accent. . . ."[62] By 1935 a contributor to the *New Outlook* was hailing comic strips as "the closest possible approach to a common denominator for the people of the United States," something that offered "a more important key to an understanding of the American mind than many other better studied evidences of our national culture." "The funnies are the doodles of a nation," enthused another essayist, a form of visual art

that was deceptively crude, like Grant Wood's paintings, and filled with the kind of activism and heroism found in Thomas Hart Benton's murals. Thomas Craven thought the comics featured a "quality of irreverence" that, while not confined to America, "flourishes here, as flower and weed, as in no other land or clime."[63]

That quality of irreverence also marked the most acclaimed graphic humor of the period, the motion-picture animations of Walt Disney and his organization in California. After finishing his training as a commercial artist, the midwestern-bred Disney had begun drawing and producing animated cartoons in New York in the early twenties. In 1926, at the age of twenty-four, Disney migrated to Hollywood, where he soon proved to be not only a gifted animator in his own right but also an absolute genius at organizing and directing a growing staff of artists and illustrators. Following two years with Universal Studios, Disney founded Walt Disney Productions and introduced the insouciant Mickey Mouse in a series of one-reel pictures. By the mid-thirties Disney and his associates had expanded into short feature-length color animations and had made international celebrities not only of Mickey Mouse but of Donald Duck, the Three Little Pigs, and a growing assortment of other anthropomorphic creations.[64]

The Disney team's elaborate and sophisticated artwork, its imaginative use of musical and other aural effects, and the persistent charm and plain funniness of Disney movies won both huge popular followings and praise from intellectuals. Plenty of critics were ready to proclaim the animated film, brought to its finest expression by Disney, as a stunning new art form. Gilbert Seldes described Disney's "Silly Symphonies," which synchronized the antics of a cartoon menagerie with excerpts from well-known formal-music compositions, as "the perfection of the movie." The next year the *American Magazine of Art* featured a big layout on film animation as "America's youngest art." Animation, said Dorothy Grafly in the accompanying text, had restored to art "the magic carpet of escape." Disney's movies had given people of all ages a common, identifiable reality, "probably the first genuinely American art since that of the indigenous Indian." Not a substitute for painting but an art in itself of which America could be proud, animation, especially that of Disney, was "doing more today to keep art alive in the hearts of men, women, and children than all the exhibitions attended throughout the season by a little coterie of the intelligentsia." "An art-for-all . . . great murals that move," rhapsodized the French critic and art historian Jean Charlot when he lectured at the Disney studios in 1939.[65]

Despite such accolades, Disneymania had begun to wane by the early forties, at least in intellectual circles. *Snow White and the Seven Dwarfs*

(1939), Disney's first full-length picture and probably his finest over-all, incurred considerable stricture in the liberal magazines for its sylvan sentimentalism and unregenerate cuteness.[66] In fact, Disney's own social views were solidly conservative. And because he was never willing to risk outrunning his audiences' tastes, he could never manage to transcend the representationalism of his commercial artist's background.[67] After the costly and pretentious *Fantasia* (1940), Disney's pictures became steadily less innovative and painstaking. By the mid-1940s his studios were moving away from the increasingly expensive full-animation process and toward partially animated or regular feature films.

## X

In the May Day parade of 1938 in Manhattan, the delegation from the left-wing New Theatre League sang a paraphrase of the seven dwarfs' work song in *Snow White:* "It's not so hard / Get a union card / And whistle while you work!" Such an amalgam of Disneyian fantasy and the cause of organized labor suggests much about the tenor and ethos of the Popular Front. Standing for "a mass development of the American theatre to its highest artistic and social level" and for "a theatre dedicated to the struggle against war, fascism, and censorship," the New Theatre League was very much a part of the cultural Popular Front. So, in varying degrees, were organizations like Group Theatre, Theatre Union, the Mercury Theatre, the Actors Repertory Company, and the fund-raising Theatre Arts Committee.[68] They all contributed to the Left-tinged Americanist mood that characterized the theater as much as the other arts in the years 1935–39. Even more than they, however, the Federal Theatre Project brought together and gave expression to prevailing cultural sentiments in the Front period.

The Federal Theatre Project was the single most controversial WPA cultural undertaking—and it was the first to go. More than the other WPA arts projects, FTP was plagued throughout its brief history by accusations that it wasted tax money dealing in Communist propaganda. National Director Hallie Flanagan and lots of other people involved in FTP did share the vaguely Left inclinations prevalent in American ideas and art during the 1930s. There should have been no great mystery in the fact that substantial numbers of the previously jobless playwrights, directors, and actors who found work with FTP felt personally victimized by the sagging capitalist system. Some of FTP's offerings—such as *The Revolt of the Beavers,* a WPA Children's

Theatre production, and Marc Blitzstein's nearly aborted *The Cradle Will Rock*—were hardly the kind of plays that would allay the suspicions of Congressmen.[69]

Yet the thinking behind the Theatre Project had less to do with Left propaganda than with cultural nationalism. Flanagan and her associates wanted to seize the unique opportunity afforded by the Depression-spawned federal work-relief program to build a nationwide theatrical enterprise, one that would carry the dramatic art to people everywhere in the country. FTP drew on and fostered the same democratic, decentralist, largely antiurban attitudes that operated in the Writers', Music, and Art projects. In FTP, though, the decentralist motive was probably even stronger, because historically America's highest concentration of theatrical money and talent resided in Manhattan.

For decades cultural nationalists had bemoaned that concentration and had called for a revolt against New York's theatrical dominance.[70] The little-theater movement, full of such promise in the years around the First World War, had actually delivered not much at all. So said discontented commentators like the stage critic John Anderson. Taken as a group, little theaters had been satisfied to borrow rather than to create, to stage amateurish versions of plays that had first been successful in New York and thus to produce almost no new playwrights. As he had in the twenties, Anderson dismissed the ordinary provincial theater as "a frank imitation of the Broadway theatre, following it slavishly and waiting for its cue." The "tributary theatre," wrote the director of the University of California Theatre in 1937, had rarely "succeed[ed] in flowing into the mainstream of American theatre to the enrichment of that stream."[71]

All of American theater's historic shortcomings—not only centralization but also commercialization, elitism, and a lack of contact with the everyday existence of the American people—the Federal Theatre Project would try to remedy. That was the goal of Hallie Flanagan, the attractive, effervescent, forty-five-year-old woman who left the Vassar College Experimental Theatre in the summer of 1935 to become FTP's national director. Flanagan had graduated from Grinnell College in Iowa in 1911, a year ahead of Harry Hopkins, the man who would put her in charge of FTP a quarter-century later. Left a widow with two children in 1918, she taught a year at Grinnell, wrote a prize-winning play, and then came east to Radcliffe College to serve as George Pierce Baker's assistant in his 47 Workshop. Subsequently she gained national recognition with the Grinnell Experimental Theatre, and in 1926 she came back east to organize a similar project at Vassar. A Guggenheim traveling fellowship made it possible for her to study firsthand

what Konstantin Stanislavsky and his contemporaries were doing in revolutionary Russia.[72]

That influence as well as what Flanagan had learned on her own in experimental theater was evident in *Can You Hear Their Voices?*, produced at Vassar in 1931. The play consisted of a series of vignettes in silhouette, dramatizing a report by the Communist journalist Whittaker Chambers on the plight of drouth-stricken farmers in Arkansas. Similar to but developed independently of Communist agitprop theater, *Can You Hear Their Voices?* was the obvious precursor of Federal Theatre's "Living Newspaper" dramatizations of current public issues like slum housing, the Tennessee Valley Authority, and the anti–New Deal Supreme Court. The widely and enthusiastically reviewed Vassar production made Flanagan one of the best-known people in American noncommercial theater.[73]

Flanagan's basic conception of the Federal Theatre Project, as she said in 1938, was that it should be "a carefully planned program, national in scope, regional in emphasis and American in democratic attitude." Not a centralized national theater on the European model, FTP should be literally a federated theater, presenting plays that "should bear increasing relationship to the actual variations of geography, physical and spiritual," to the diversity of the people, to their history and present problems. Flanagan looked toward the "dramatic development of each state and region in a nation-wide pattern. . . . Only a theatre which springs from or penetrates into city, town, village and farm can be called an American theatre." As Flanagan said in her memoirs, FTP never sought the approval of the mythical "first ten rows," where sat the elite who supposedly determined the fate of plays. She and her colleagues were out to capture the biggest possible public.[74]

FTP had a peak work force of about ten thousand people, ranging from janitors to stagehands to electricians to cue girls, and including both fledgling and established actors, playwrights, directors, and producers. It had producing companies in forty states, and its troupes performed in every part of the nation, doing everything from puppet shows and children's plays to Shakespeare and Shaw. FTP's Harlem unit, brilliantly led by Orson Welles and John Houseman, did *Macbeth* with an all-black cast and a Haitian locale; a Chicago production of Gilbert and Sullivan's *The Mikado* in an updated "swing" version was such a hit that it was brought to New York; other local units performed plays in Yiddish and Spanish. FTP units also put on plays about Davy Crockett in Dallas; about Dunkard settlers in Reading, Pennsylvania; about Hoosier life in Indianapolis and mountaineers in Asheville, North Carolina. Actors and workers from WPA had a

big hand in the presentation of Paul Green's pageant *The Lost Colony* on Roanoke Island, North Carolina, during the summer months of 1938. V. F. Calverton was moved to write that "the Federal Theatre is making a definite attempt to excavate historical remains which can be converted into gripping drama."[75]

FTP was only in its second season when it reached what was probably the pinnacle of its career. On the night of October 27, 1936, the FTP stage version of Sinclair Lewis's novel *It Can't Happen Here,* depicting the rise of a fascist dictatorship in America, opened simultaneously in seventeen different cities. In the major New York production, Lewis himself played Doremus Jessup, the folksy liberal newspaperman who finally acts to rally democratic resistance. Another high point was FTP's New York production early in 1938 of *Prologue to Glory,* a play by E. P. Conkle about Abraham Lincoln's entry into public life. FTP's main contribution to the Lincoln worship of the Popular Front years, *Prologue to Glory* was good enough to become the only Federal Theatre drama ever included in Burns Mantle's annual *Best Plays* compilation.[76]

It was an impressive record, all the more so in view of the numerous handicaps FTP faced. Besides the chronically unstable character of FTP's work force, congressional hostility and budget-slicing, and the cumbersome, overlapping administrative arrangements that hampered all the arts projects, FTP's local operations, particularly in New York City, were wracked by much bickering and backbiting.

With all its glittering achievements, FTP never fully realized the mission Flanagan and her associates had outlined when they began their work in Washington. The envisioned network of regional and local theaters, organically related to different constituencies from which they would receive their nourishment and inspiration, just did not materialize. New York and, to a lesser extent, Chicago and Los Angeles dominated the Theatre Project—in publicity, money spent, number of employees, quantity and quality of productions, and the amount of attention received at national headquarters. The main evidence of the fulfillment of Flanagan's grand design was North Carolina, where, building on the regional-theater foundation laid by Howard Koch and the Carolina Playmakers, FTP gave direction to eighteen different amateur theater groups. Otherwise, though, FTP's efforts to spark dramatic activity at the local-regional level were generally disappointing. Beginning in the spring of 1938, Flanagan and her subordinates in Washington tried to give their program a broader national base, striving among other things for more productions outside the big cities and local sponsorship arrangements that could evolve into a national subscription audience.

A combination of factors, not the least of which was the waning support of WPA Administrator Hopkins as his own presidential ambitions waxed, kept Flanagan's efforts to extend and rejuvenate FTP from getting off the ground. By the summer of 1938, as Jane Mathews has written, "the time for launching a bold program that would thrust the Federal Theatre into communities across the nation, winning for that institution an expanded audience and new constituents, had passed."[77] The next year, despite a strong drive to save the Theatre Project by a diverse array of people and organizations in the arts, the Congress eliminated its whole allocation from WPA's fiscal 1940 budget. At the end of June 1939 FTP simply ceased to be. Of the many epitaphs its passing prompted, Malcolm Cowley's might be taken as representative: "It was for a time the center of almost everything that was fresh and experimental in the American theatre. More than that, it came closer than anything else we have had—perhaps closer than anything we shall get in the future—to being an American national theatre."[78]

## XI

Broadway commercial theater was also substantially affected by the persistent social consciousness coupled with ideological expansiveness that gave the Popular Front its distinctive character. "Anger at the manifest failure of capitalism gave way to the apprehension of war," Gerald Rabkin has written, "and the mood at the end of the thirties was unquestionably less socially aggressive than at the mid-decade."[79] Two plays by Elmer Rice, an early experimentalist who had subsequently turned to more realistic drama, typified the shift in moods on Broadway from early-thirties anger to late-thirties affirmation. As he had first done in *Street Scene* (1929), Rice presented a diversity of American types in *We the People* (1933), this time to show how the Great Depression affected every aspect of society. Rice's message, delivered in the closing scene by an idealistic college professor who has resigned to protest restrictions on his freedom to teach about social injustice, was that "It is our house: this America. Let us cleanse it and put it in order and make it a decent place for decent people to live in!" Five years later, Rice's message in *American Landscape,* frankly described as "an affirmation of the American tradition of liberty and of the American way of life," was that America was already a pretty decent place to live in. Now the issue was whether Americans would safeguard their common inheritance of freedom and respect for human rights. Rice dramatized that issue in the life of

Captain Frank Dale, an old New Englander about to close his factory because he doesn't like unions and to sell his homestead to a band of native fascists.[80]

Malcolm Goldstein has even used the expression "cult of nostalgia" to describe much of what got produced on Broadway in the late thirties. Certainly American playwrights had never sung so often or so loudly of America and particularly of the nation's past. *American Landscape,* for example, featured a ghostly parade of Captain Dale's worthy New England forbears to admonish the old man to live up to his country's historic principles. The same year brought Robert E. Sherwood's long-running *Abe Lincoln in Illinois,* whose success quickly overshadowed the Federal Theatre Project's *Prologue to Glory.* Other hymns to America included E. B. Ginty's *Missouri Legend,* on the career of Jesse James, and dramatizations of the stories of Johnny Appleseed by Arnold Sundgaard and Marc Connelly, Casey Jones by Robert Ardrey, and John Henry by Roark Bradford.[81]

Meanwhile, Thornton Wilder scored a huge Broadway success with *Our Town* (and incidentally refuted Michael Gold's charge that he could not write about America). Intended as a metaphysical speculation on the universal themes of love, death, and the resilience of the human spirit, the play gave a tender view of small-town America that also fitted neatly with the sentimental tendency so frequently evident in Front-period culture. The same holds true for George S. Kaufman and Moss Hart's *The American Way* (1939), which combined small-town folksiness with a warning against the fascist threat. Kaufman and Hart told the tale of a German immigrant cabinetmaker who settles in Ohio in the nineties, becomes wealthy, loses his fortune trying to help a friend in the Crash, and ends up being murdered by a mob of local Nazis.[82]

Despite the breakup of the Popular Front in the aftermath of the Nazi-Soviet Pact, the liberal-democratic-patriotic ethos persisted as powerfully as ever on Broadway. In fact, the Nazi victories on the European continent, the single-handed resistance of the British from the summer of 1940 until the German invasion of Russia the next summer, and the Roosevelt administration's insistence that the security of the United States depended on the defeat of Germany, prompted a steady stream of plays linking the struggle against fascism abroad to the cause of freedom at home. Several such plays came from Sherwood, Rice, and Maxwell Anderson, who, together with S. N. Behrman and Sidney Howard, formed the Playwrights Producing Company to finance and stage their own plays. Sherwood's *Abe Lincoln in Illinois* got the company off to a rousing start; Rice's *American Landscape* was its fourth production. In the twenty-seven months from Poland to

Pearl Harbor, Anderson's *Key Largo* (1939) and *Candle in the Wind* (1941) , Rice's *Flight to the West* (1940) , and Sherwood's *There Shall Be No Night* (1940) all spoke out passionately against totalitarianism and for American-style democracy and freedom. The only major anti-Nazi play not offered by the Playwrights Producing Company in the pre–Pearl Harbor period was Lillian Hellman's suspenseful *Watch on the Rhine,* which won the Drama Critics' Award for the 1940–41 season.[83]

Such plays, however dated and melodramatically forced they might seem to a later generation, testified to the strong flavor of social consciousness mixed with democratic nationalism in all the arts in the pre–World War II period. Those were years in which the most active and generally the best-received playwrights presupposed that great public events and issues impinged directly on the subject matter of art and the responsibilities of the creative artist. Already, however, the "drama of commitment" played out on the "political stage" was in decline. By the end of 1940 Group Theatre had disbanded, as had Theatre Union, the Actors Repertory Company, and Mercury Theatre. The Frontist Theatre Arts Committee was also gone, while in 1941 the New Theatre League federated into five autonomous regional-center theaters and lost a good deal of its socially conscious orientation. By 1943 the Playwrights Producing Company dramatists were also running out of steam. Actual American participation in the war did little to spur the sagging concern with collective causes and issues in the theater.[84]

## XII

In 1922 Harold Stearns had ignored motion pictures and the embryonic medium radio in putting together *Civilization in the United States.* For *America Now* in 1938, however, Stearns made "Amusement: Radio and Movies," by the seasoned Hearst-syndicate journalist Louis Reid, the lead essay in his book. "Upon these inexpensive, easily-accessible and closely-related amusements," wrote Reid, "the public is so dependent that vast commercial, sociologic, technological and—not the least—artistic forces have been given new and powerful play in the nation."[85]

Ever since the mid-twenties, when radio's potential as a mass communications medium became apparent, there had been regular prophecies that radio would promote not only greater national solidarity among Americans but also a cohesive, recognizable national culture. "Rich, powerful and dominating," as a *Vanity Fair* contributor de-

scribed radio in 1931, "it is a stupendous instrument, serving the hopes
and needs, the dim, imperceived aspirations, of a hundred million
American people."[86] By that time American radio programming had
settled down to a durable and predictable pattern of news, weather,
sports, recorded music, serialized "soap opera" and adventure, and
variety and comedy offerings. Yet exponents of radio as an artistic
medium kept their hopes high. Certainly there was reason to be
impressed by the steady growth in network-originated "live" broad-
casts of symphonic and operatic music, a trend climaxed by NBC's or-
ganization of its own symphony orchestra in 1937.

It was in dramatic art that radio seemed to have the greatest poten-
tial for transcending both traditional cultural forms and the mediocrity
of mass entertainment. Radio theater, its enthusiasts claimed, could
do what neither the little-theater movement nor the Federal Theatre
Project could do: instantly create a free, decentralized, and accessible
theater for Everyman, a dramatic art whose audience was theoretically
the whole American people. Moreover, as a "blind" medium, one that
depended solely on communication through the auditory sense and
thus on the ability of the auditor to create his own visual images, radio
raised the prospect of a unique kind of theater that could hold its
own against the motion picture or stage drama. Far from being a
handicap, radio's blindness could become its greatest dramatic asset.
With comparative ease and economy, radio could stimulate a range
of images limited only by the range of the individual imagination.[87]

Dependent on the power of language, radio obviously required
plays written expressly for the medium. In radio plays, speech, care-
fully supplemented by sound effects, would have to substitute for
visual action. An early advocate of a drama fashioned to the peculiar
limitations and capabilities of radio had observed that "In the final
analysis it's the words, words, words that count." As yet, wrote the
dramatic critic R. Dickson Skinner in 1931, there had been no general
realization that radio was "a special and distinct form of make-
believe which must . . . have its own ideas and its own rules." Skinner
anticipated that radio drama would evolve into a form rather like
that of the wandering storytellers of the Middle Ages—a narrated tale
interspersed with bits of dialog.[88]

Such a preoccupation with the magic powers of language led natu-
rally to the belief that poetic drama—a mode only Maxwell Anderson
among the major American playwrights seemed interested in keeping
alive—was especially suited to radio. "The wide social function of
poetry could be restored through radio," argued a *Theatre Arts* col-
umnist, "if poets would only prepare themselves to use it." And if
they were willing to use it, added John Erskine, critic, poet, and

Columbia University professor, "poetry can once again come out of the boudoir and the study and match itself against the world."[89]

By the mid-thirties a number of ambitious poets and playwrights as well as imaginative people already working in radio were ready to use the medium in just such a fashion. Up to then the three radio networks had shown little interest in original radio drama. During 1935–36, however, CBS began supplying free time to its affiliates in slots were NBC already had exceptionally popular shows. Willing to test public taste with inexpensively produced experimental offerings, CBS in July 1936 established as a "sustaining" (nonsponsored) program the "Columbia Workshop." Under the direction of Irving Reis and Norman Corwin, the workshop created a critically acclaimed series of innovatively conceived and written half-hour dramatic broadcasts—and inaugurated a period that would come to be remembered as the golden age of radio theater.[90]

What many people regarded as the best thing ever to originate in the workshop—or in radio theater as a whole—was one of its first-season dramatizations. In April 1937 CBS broadcast the workshop's production of *The Fall of the City,* a drama in verse by Archibald MacLeish, with musical score by Aaron Copland and narration by Orson Welles. A live broadcast like all the other workshop presentations, the play was performed in an old armory in Manhattan to accommodate the scores of people necessary for the crowd noises. *The Fall of the City* was a powerful antifascist allegory written by one of the most socially conscious artists of the period. MacLeish's personal evolution from estheticism and expatriation in the twenties to collectivism and activism in the thirties typified the course a great many people in the arts had taken. His play depicted a terrified city trying to decide whether to resist or to come to terms with an approaching invader. At last the invader, nothing more than an empty suit of armor, clanks triumphantly between rows of kneeling citizens afraid even to look up.[91]

A remarkable blending of sound effects, music, and the magnificent orotundity of the twenty-one-year-old Welles, *The Fall of the City* seemed true radio theater, the kind of creative act that would open up a whole new genre in dramatic art. Certainly that was MacLeish's conviction. "Over the radio," he pointed out in the preface to the published text of *The Fall of the City,* "verse has no visual presence to compete with. Only the ear is the poet's perfect audience—his only true audience. And it is radio and only radio which can give him public access to this perfect friend."[92]

The Columbia Workshop originated about a year after the formation of the Popular Front. The workshop's career as well as the whole

golden age of radio drama had much to do with the tendencies and moods of the Front years and then the period of the Second World War. The workshop specialized in dramatic presentations that voiced the times' intellectually and culturally prevalent democratic nationalism: the mystique of the people, the worship of the heritage of freedom, the insistence that good men everywhere must form ranks against the fascist peril. Such attitudes were evident in workshop offerings like MacLeish's *Air Raid* (1938), *America Was Promises* (1940), and "The States Talking" (1941); in Corwin's *They Fly through the Air with the Greatest of Ease* (1939), "The Oracle of Philadelphi" (1940), and "Between Americans" (1941); and in Maxwell Anderson's "Magna Carta" (1940) and Bernard C. Schoenfeld's "Little Johnny Appleseed" (1940) and "What We Defend" (1940).

Meanwhile, NBC and the Mutual Broadcasting System joined in with such broadcasts as Anderson's "The Feast of Ortolans" (1937), which used a dinner conversation among aristocrats and literati on the eve of the French Revolution as a way of admonishing Americans not to be complacent in the face of organized evil. Like Corwin's *They Fly*, Stephen Vincent Benét's *Nightmare at Noon* (1940) was a narrative poem about a fascist bombing and a warning that the predators might also attack the United States. Among other notable presentations in a similar vein were John LaTouche's "The Statue of Liberty," which assured a refugee from defeated France that the lamp of freedom still shone bright in America, and Robert Tallman's "I Sing a New World," which raised Walt Whitman to extol modern America's energy and achievement.[93]

After the United States formally went into the war, patriotic and democratic emotions reached their peak in radio drama. By that time Corwin, the dominant figure in the Columbia Workshop since Reis's departure for Hollywood early in 1938, was being hailed as the first of radio's "men of letters whose reputations will be as sure as those of novelists, historians, or biographers, poets or playwrights."[94] Still only thirty at the time of Pearl Harbor, the dapper, wavy-haired, Boston-bred Corwin had never gone to college but had already become a veteran newspaperman by the time he joined CBS in 1936.

Corwin's name became almost synonymous with poetic and patriotic radio theater. Between 1938 and 1948, Corwin later estimated, he wrote about one hundred fifty original radio dramatizations. A week after Pearl Harbor was bombed, all the networks carried his celebration of the Bill of Rights, *We Hold These Truths*. Broadcast to an audience estimated to be the largest up to then for a program "using regular radio technique," the script prompted Carl Van Doren to announce that Corwin "is to American radio what Marlowe was to

the Elizabethan stage."[95] Four more times during the war, Corwin's lyrical renderings of American democratic idealism got all-networks exposure. His mission, he frankly told a conference on educational radio in the spring of 1942, was to "indoctrinate the people" on why they were at war. Subsequently he also labored to indoctrinate them in the goals of peace, especially in his *On a Note of Triumph,* commemorating victory in Europe in May 1945, and his "14 August," broadcast within hours of the Japanese surrender.[96]

Corwin regretted that poetry had become "the almost exclusive property and interest of poets themselves" and indicated that he would try to restore poetry to "its once high position as a national art —a poetry of the people. . . ." Radio, he suggested, would eventually develop a literature equal to that of stage drama—"as soon as adequate facilities are placed in the hands of writers sincerely interested in the medium."[97] For several reasons the hopes shared by Corwin, MacLeish, and many others for radio theater were never wholly realized. Unsold air time had been the seedbed for radio experimentalists all along; after the war the amount of such time available on the networks decreased by a third. Programs like the Columbia Workshop or the Mercury Theatre of the Air had never consistently attracted large listening audiences; as Gilbert Seldes said of Corwin's style of dramaturgy, "it remained a rather special taste." After 1945 the kind of inspirational lift that the Popular Front and then the coming of war had provided was hard to find in radio or anywhere else. Most of all, of course, television finally destroyed whatever promise network radio may have had of spawning a new art form. On the eve of television's ascendancy, in 1949, Corwin quarreled with CBS over the subsidiary rights to his radio plays and left commercial radio to work for the United Nations.[98]

## XIII

"Unchallenged is Hollywood's technical supremacy. In such details as photography, sound recording, set and costume designing, the California producers lead the world." So Louis Reid described the state of American motion pictures in the 1938 *America Now* symposium. Yet for all their formal excellence, the movies still suffered from "the seemingly inescapable necessity of making their dominant appeal to childish intelligence."[99] Reid's view was a typical one. Walt Disney's accomplishments in animated film cheered Reid as they did numerous other people in ideas and the arts. There remained, though, a great deal of critical disappointment that the kind of hopes Vachel Lindsay

had once expressed for the motion picture to become the great democratic visual art still seemed far from fulfillment.[100]

The fact remained that in the 1930s, more than ever, the movies came from America. Though handicapped by various technical difficulties for several years, sound pictures cushioned the Depression's impact on the movie industry. Weekly attendance did dip sharply in the early thirties; maybe as many as a third of the movie houses in the country shut down. In the last half of the decade, though, average weekly movie attendance in the United States had climbed back to around 85 million. And despite Hollywood's full conversion to sound production, American dominance of the world film market persisted until 1940-41, when the Germans overran most of Europe and effectively closed the Continent to American film imports. In fact, one of the reasons frequently cited for the frivolousness of most Hollywood output was the industry's sensitivity to foreign political opinion.[101]

Although film historians have offered varying interpretations of American movie content in the Depression era, they have agreed that then, for better or worse, the movies "really counted." Motion pictures probably meant more to more Americans during the thirties than at any time before or after that decade. The question is what they meant. The retrospective consensus seems to be that overall the Hollywood studios either went along as if nothing much had changed, or they produced pictures with a tendency to reassure moviegoers that American government, economy, and society were basically sound. That reassurance, moreover, seems to have come most frequently in the late thirties and early forties. Like the other arts and entertainment media, movies were strongly affected by the antifascist, Americanist, and New Dealish influences at work in the Popular Front period and the years just prior to the Pearl Harbor attack.[102]

Such an interpretation of movie content and intent excludes Orson Welles and Herman Mankiewicz's stunning and ambiguous *Citizen Kane* (1941), the finest American film of the period. Yet it would obviously include numerous other movies that were popular with both the public and the critics. Among such pictures were *The Great Dictator* (1940), a sharp satire on Hitler that was Charles Chaplin's first-all-sound film; John Ford's celebrations of the Old West in *Stagecoach* (1939) and of the toughness and valor of the common people in the beautiful movie version of *The Grapes of Wrath* (1940); and nearly all the movies directed by Frank Capra. From the comedies *It Happened One Night* (1934), *Mr. Deeds Goes to Town* (1936), and *You Can't Take It with You* (1938), to the more sober *Mr. Smith Goes to Washington* (1939), to the deadly serious *Meet John Doe* (1941),

Capra, a stoutly pro–New Deal son of Italian immigrants, eulogized the innate goodness, simple heroism, and commonsensical wisdom of the great masses of Americans.[103]

It was all very much within the broad "progressive" consensus of the period. Beginning in 1939, Hollywood's Americanism may have become even more intense and self-conscious. Early that year the Committee on Un-American Activities of the U.S. House of Representatives conducted hearings on alleged Communist influence in the movie industry, the first in a series of such inquiries the committee would make over the next decade and a half. It appeared that American filmmakers were trying hard to answer the kind of question Louis Reid posed: "Where . . . is the picture which would show the inherent substantiality of the American character, the fundamental soundness of the American system amid the noisy storms of totalitarianism?"[104]

Accompanying the upsurge in movies venerating the American people and American democracy was a growing disposition on the part of critics to view not just occasional pictures but the overall content of Hollywood films with greater tolerance, fascination, and enthusiasm. Ruth Suckow had to acknowledge that American movies constituted "an unconscious social document" from which historians could learn much about contemporary America. For those who decried the movies' crassness and artificiality as opposed to the genuineness of folk art, Mark Van Doren had a ready answer. It might be better if Americans sat around on earthen floors and occupied themselves with folk dancing, ballad singing, and storytelling, Van Doren facetiously suggested. Still, he would rather live in American society as it was, a society with "its own notions as to the way it prefers to be entertained." For Clifford Odets, just back late in 1937 from a well-paying stint as a Hollywood scriptwriter, the movies were already "the folk theatre of America." Their treatment of American types and themes might be "puerile in every respect," but they had "explored the common man in all his manifestations" and thus finally "spoken to the people," as Walt Whitman had called on the nation's poets to do.[105]

Actually, according to V. F. Calverton, the movies had given back to the masses the popular theater they had lacked since the eighteenth century. Calverton maintained that Hollywood self-censorship as well as the array of state and local censors at work in the thirties were still preferable to the official censorship in the totalitarian countries, including the Soviet Union. Otis Ferguson of the *New Republic*, one of the few regular, serious American film critics of the period, was convinced that the best Hollywood pictures were the best being made

anywhere. Their lightness, movement, and technical flair made American movies what Ferguson called "immediate experience." Movies, wrote a *North American Review* essayist, were quintessentially American, "the first-born art child of the young and vital American spirit. . . ." True, the movies were rarely serious, but then "We are a young, a laughter-loving nation. We have no stomach for the heavy tragedies of older, more sophisticated races." What was most significant was that American motion pictures were "the index to our temperament: an amalgam of extravagance, generosity, prodigality, love of excitement and change, quickness to laughter, passion for self-improvement, and the odd combination of the mechanistic and idealistic attitude toward life."[106]

However sound such judgments may or may not have been, they were indicative of a rather considerable shift in intellectual attitudes toward motion pictures. Even the Communist *New Masses* and the leftist *New Theatre,* organ of the New Theatre League, adopted a more patient and indulgent outlook toward Hollywood "escapism," applauded "progressive" films that condemned social evils like secret nativist societies and southern lynching, and were generally sympathetic toward Capra's tributes to the little people. By the time the United States entered the war, there was already a lot of talk about the need for films to bolster national morale and prepare the people for patriotic sacrifices. "We need a primer of democracy: clear, confident, inspiring," declared the well-known director Walter Wanger in tones reminiscent of early thirties Marxist calls for making art a revolutionary weapon. "We must communicate to the citizens a simple but rock-bound conception . . . of the noble aims and certain triumphs of the democratic order." When movies did that, then they would "function as instruments of democratic communication."[107] A deluge of simplistic "war movies" was in the offing.

## XIV

In 1936 a columnist for the *Christian Science Monitor* remarked on the national popularity of "dancing, teaching, studying, discussing and reading books about dancing—all kinds of dancing." The country had room for it all, "because we are all kinds of people. And it is our natural heritage to love dancing."[108] Such an ebullient statement would have been almost inconceivable twenty years earlier, at the height of the pre–World War I cultural Insurgency. When the critics of that day had speculated whether music or drama was America's

"most belated art," they had unconsciously acknowledged the even
more backward state of the art of dance. That backwardness, when
discussed at all, was most commonly ascribed to the repressiveness of
the Puritan heritage and the stubbornness of the country's cultural
elite in perpetuating the dominance of imported European classical
ballet.[109]

Yet the two elements of the most revolutionary phase in the history
of dance since the emergence of ballet in eighteenth-century Italy and
France both dated from the years of the Insurgency. On one hand the
tours of the Imperial Russian Ballet introduced Americans to a new,
more dynamic style within the conventional ballet form. On the
other Isadora Duncan and Ruth St. Denis introduced Americans to
a whole new conception of dancing, one that asserted the primacy of
personal expression over adherence to conventionalized movement.

Isadora Duncan is one of the legendary figures in the history of
the American arts, even though she spent relatively little of her adult
life in the United States. In fact, the California-bred Duncan was in
most ways the personification of the expatriate Bohemian—a woman
whose personal life was as much a calculated revolt against social
convention as her dancing was a revolt against artistic convention.
The mistress of a succession of men of widely varying ages, Duncan had
three children out of wedlock and generally scandalized genteel so-
ciety on both sides of the Atlantic. Meanwhile, performing almost ex-
clusively in solo concerts or with the girls of her school, she developed
an exuberant, lyrical, largely improvised way of dancing that made
her a sensation in Europe and also won her a considerable following
in America.[110] Never really beautiful, a bit plump even in her young
womanhood, and downright fat in middle age, Duncan nonetheless
projected a vibrance and grace that captivated her audiences. That
was true whether she danced to Beethoven in a clump of woods in
Germany or to the French national anthem on a bare stage in New
York.[111]

In September 1927, at the age of forty-nine, Duncan died in France
when her long scarf caught in the wheel of an automobile in which
she was riding, and snapped her neck. Not long before that she had
finished her autobiography, which closed with a plea for Americans
to liberate their bodies and express "the vibration of the American
soul striving upward, through labour to harmonious life." Paraphras-
ing Whitman's "I hear America singing," Duncan proclaimed "I
see America dancing"—but not to the Charleston or foxtrot and not
to "the inane coquetry of the ballet." The ballet was not for Americans;
their legs were too long, their bodies too supple, their spirits too free.

"A tall, finely made woman could never dance the ballet." Instead, America's youth should "come forth with great strides, leaps and bounds, with lifted forehead and far-spread arms to dance the language of our Pioneers, the Fortitude of our heroes, the Justice, Kindness, Purity of our statesmen, and all the inspired love and tenderness of our Mothers." Dancing that way would "make of them beautiful beings, worthy of the name of the Greatest Democracy."[112]

For all her ardent Americanism and all the notoriety that surrounded her career, Duncan had little direct influence on dance technique in her native country. More immediately significant was New Jersey's Ruth St. Denis (née Ruth Dennis). Beginning in 1909, St. Denis attracted quite a lot of attention in New York and other cities with her demonstration of Egyptian, East Indian, Siamese, and other forms of "exotic" dancing. In 1915 she moved to Los Angeles and with her new husband, a young dancer out of Kansas City and Denver named Ted Shawn, established the Denishawn School of Dance. Relocated in New York six years later, Denishawn taught a free-form dance style variously termed "expressionist," "impressionist," and "interpretive." The school became the training ground for a group of young men and women who over the next few decades would transform the art of dance in America.[113]

What Denishawn aimed for, Ted Shawn wrote in the mid-twenties, was to make dance in America "as seemingly formless as the poetry of Walt Whitman, and yet like *Leaves of Grass* it will be so big that it will encompass all forms." Organized democratically, based on the principles of freedom and progress, such an indigenous dance would manifest itself "through rhythmic, beautiful bodily movement, broader and more elastic than has yet been known." Like Duncan, Shawn showed his and Denishawn's vestigial gentility in repeated contemptuous references to "jazz," which he identified with New York City and thus with foreign influences. "We need never borrow material from any nation," he maintained, "for we are full to abundance with undeveloped ideas and themes." Shawn himself had already drawn on nineteenth-century New England "folk" dances for a series of arrangements called *Boston Fancy, 1854*. He pointed to mountaineer and Creole dances, polkas, even Hawaiian hulas as other "folk" sources, as well as themes from Whitman, Robert Frost, Bret Harte, from cowboy life, American folklore, modern American commerce, sport, technology. From all that and more, American dance innovators could fashion a wholly new, natively American expression. For his part, Shawn would not rest until "my own consciousness [has] expanded to the point that I may be a Whitman of the dance."[114]

Neither Shawn's nor St. Denis's career as a dancer reached those exalted heights. Even after they closed Denishawn in the early thirties, however, they continued both in their own concerts and as teachers to spread the gospel of dance as "the translation of subjective experience into overt movement. . . ."[115] As teachers they sent forth what amounted to the second generation of American dance modernists.

In the winter of 1929–30 Martha Graham, Doris Humphrey, and Charles Weidman, all Denishawn alumni, plus Helen Tamiris and a few other dancers, formed the Dance Repertory Theatre in New York. They usually had to give concerts on Sunday evenings because that was about the only time theaters were available. "America," Graham wrote a few months later in Oliver Sayler's volume on native avant-gardism, "is cradling an art that is destined to be a ruler, in that its urge is masculine and creative rather than imitative." Graham urged Americans to shun not only "the imperialism of the ballet" but "the weakling exoticism" of oriental and other "transplanted" dance styles as well. By denying such prior influences, Graham and her colleagues had been able to "arrive at the starting point for the American expression, the American gesture." To go beyond that, it was necessary to " 'Know the land' "—its exciting contrasts, its vast distances, its machinery, its people. From such knowledge "will come the great mass drama that is the American Dance."[116]

In the early thirties the Dance Repertory Theatre and other groups worked to lay a foundation for modern expressive dance in America. Coinciding with the onset of the Great Depression, their efforts often demonstrated the common disposition of those years to fuse art and ideological radicalism. After 1935, however, the modern dance movement—at least the biggest portion of it, that concentrated in New York—also was caught up in the spirit of the Popular Front. The New Dance League abandoned Left stridency and staged dance concerts that reflected, in Malcolm Goldstein's words, "the attitudes comfortable to both the Left and the center of all social classes." In 1937, claiming a membership of two thousand, the League held a Dance Congress paralleling the Front-inspired Writers' and Artists' Congresses. Helen Tamiris took over leadership of the Federal Theatre Project's New York–centered Dance Project, where in 1937 she produced probably her best-known single work, a dramatization of black protest songs called *How Long Brethren*.[117]

Meanwhile, much of what the Dance Repertory Theatre did was intended to express the American scene and the American past. In line with what Ted Shawn had urged in the twenties, Graham had already (1934–35) gone to the country's history and folklore for the materials

that went into her *American Provincials* and *Frontier*—to which she added *American Lyric* in 1937. Humphrey's *American Holiday,* a trio of short dances, concluded with an interpretation called "Fourth of July"; Weidman took his theme in *American Saga* from the Paul Bunyan legend. At the end of the summer 1938 session of the Bennington College School of Dance (with which Graham and her colleagues had been associated since the college's founding in the early thirties), Graham's *American Document* had its first performance. Lincoln Kirstein, previously critical of Graham's innovations and a partisan for ballet, nonetheless called *American Document* "the most important extended dance creation by a living American. . . ." The work, according to Kirstein's description, "employed a male voice as oracle, comment, and interlocutor declaiming statements from classic American papers." Introduced with a rather abstract duet called "Declaration," it moved to "an Indians' lament for the spirit of the land they had lost, then a statement of Puritan fury and tenderness, an elegy of the emancipated Negro slaves, and a finale of contemporary self-accusation, a praise of our rights, and a challenge to our own powers to persist as democracy." Two months later Graham and her students danced *American Document* at a *New Masses* benefit in New York, thereby providing one of the memorable moments in Popular Front history.[118]

The most avid promoter of modern dance in the thirties was John Martin, who in 1927 had joined the New York *Times* as the country's first full-time dance critic. Born in 1893 and raised in Louisville, Martin had never attended college but had gone directly into the acting profession from high school. After twelve years on the boards (including a two-year stay with the Chicago Little Theatre), Martin had edited a drama weekly, helped manage an experimental theater group, and done some directing on his own before coming to the *Times*.[119]

Martin's relationship to dance was strikingly similar to Thomas Craven's to painting. The obvious difference is that whereas Craven fought against most modernist trends in visual art, Martin tirelessly campaigned to win acceptance for the formal radicalism of modern dance at the expense of traditional ballet. Both men were vigorous, often bellicose cultural nationalists, who shared the conviction that, as Martin said in 1936, "We can no more create in terms of somebody else's experience than we can digest his dinner." In fact, Martin went out of his way to applaud Craven's "salubrious rampages among the painters" and to commend Charles Burchfield, Thomas Hart Benton, and John Steuart Curry for their intrinsic Americanism. Because it

was "impossible for men of different cultures to respond to each other's arts in equal measure," America must have its own art—not a national art in the sense of an official orthodoxy such as now prevailed in Russia and Germany but an art that would be, to use Whitman's old word, autochthonous.[120]

For Martin ballet represented narrow academic values, genteel prudishness, European cultural dominance. Ballet belonged to the kind of aristocratic, authoritarian system of belief Americans had overthrown in winning their independence and then in smashing southern slavery. The modern dance movement, Martin argued, was one expression of a continuing American revolt against hierarchies and superimposed authorities and for toleration and experimentation. And no matter whether a dance's form were closely representational or totally abstract, if its creator had "a mind and spirit shaped and colored by the background of American life, it will be an American work of art that results. . . ." Dancing before pre-Raphaelite draperies in a Greek-style tunic to European romantic music, Isadora Duncan had nonetheless remained essentially American.[121]

Dance, Martin was happy to announce, "has refused to be a class art any longer and has made up its mind to be a mass art." In the work of Tamiris, Humphrey, Graham, and the other American leaders in modern expression, "the accent has shifted completely away from the safely remote and romantic realm of flora and fauna to the immediate world of men and women." Such innovators performed recognizably American dance, the dance of affirmation, as opposed to the dance of acquiescence done by the German-born Mary Wigman or Hanya Holm. The American dancer "does not accept life, but undertakes to shape it to its own ends." Less interested in states of being than in the process of becoming, the American "is not by nature healthily introspective; he looks not into himself but rather out from himself." The central factor in American dance—what gave it its form, its power, its dynamism—was the American concept of man as the master of his own fate, of man conquering the wilderness, shaping the environment to his own design, man as possessed of a "desire to change the world." American dance was therefore brisk, sparse, direct, "with no time for sensuous dallyings and ornamentation," no stomach for wasted motion and self-indulgence.[122]

So in 1939 America's best-known dance critic analyzed an art that had come into its own during little more than a decade. A *Nation* columnist eagerly agreed with Martin that modern dance was about to move out of its "Sunday-evening cultism and [be] brought into relationship with the arts and the modern world." The usually re-

served George Beiswanger of *Theatre Arts Magazine* enthused that the Dance Repertory–Bennington group had "succeeded in reaching its most important objective, the creation of an American theatre dance." When Graham, Weidman, and Humphrey had abandoned Denishawn's "venture in exoticism," they had made "in effect a decision to return to America." Acclaiming the pervasive Americanism of Graham's *American Document* and finding strong suggestions of Americanism even in abstract pieces like Weidman's *Opus 51* or Humphrey's *Passacaglia,* Beiswanger saw a concentrated effort "to find a dance which would communicate American meanings and values to an American audience." By 1941 another critic could salute Graham's *Letter to the World,* drawn from the life and writings of Emily Dickinson and first performed that summer at Bennington, as "surely the apex of that American dance which began with Isadora Duncan."[123]

## XV

Duncan thought that young Americans were both temperamentally and physically unsuited to dance classical ballet; John Martin equated ballet with European decadence and dominance in the arts. In 1930, in the same book in which Graham exhorted practitioners of interpretive dance to know and express the American land, the scenic designer Robert Edmond Jones speculated that ballet might be "as irrelevant to our time as archery."[124] Yet the same decade that saw the emergence of modern dance in the United States also saw the appearance of an American-originated and largely American-oriented ballet, something the country had never had.

That achievement was attributable mainly to a young department-store heir named Lincoln Kirstein, a native of Rochester, New York, and a Harvard graduate (class of 1930). As a twenty-year-old sophomore in 1927, Kirstein and his classmate Varian Fry had founded the *Hound and Horn,* a stylish literary quarterly that became an outlet for several of the New Humanists and, toward the end of its life, for literary theoreticians laying the groundwork for what became the New Criticism. By 1934 Kirstein and Fry had tired of the magazine, and Kirstein was already occupied with a new project, the creation of the American Ballet Company. With some of his own money but mostly with generous backing from Edward M. M. Warburg, another wealthy classmate, Kirstein brought over from Paris George Balanchine, the brilliant Russian emigré director, and hired the choreographer Vladimir Dmitriev away from the Ballet Russe de Monte Carlo. At the same

time, Kirstein ruled that all performers employed by the company as well as all teachers on the staff of the adjunct School of American Ballet had to be American citizens.[125]

What Kirstein wanted was an American extension of the line reaching back from contemporary ballet in the Soviet Union and the Ballet Russe de Monte Carlo, through the Imperial Russian Ballet, and then to classical ballet in France and Italy as it had developed in the eighteenth century. Dance, Kirstein believed, must always return to that line, must always remain a spectacular art. Modern dance, in shunning spectacle and the big audience, had made itself a transitory phenomenon, "already a period." At the same time, Kirstein had no patience with those who still acted as if *"Russianballet* is a single word." Because audiences and critics had been "drugged into believing there is only one pattern, the Slav," they had refused to take American creators in the ballet form on their own terms. By contrast, American popular dancers—entertainers like Fred Astaire, Ray Bolger, and Eleanor Powell—were enormous favorites with a public who recognized that each had a "unique, indigenous, and creative style." Both modern dance and the aloof, impersonal Russian-style ballet must give way to an American ballet, one that utilized appealing music taken from popular sources like "ragtime jazz [sic] or swing," retained the basic conventions of traditional ballet, yet transcended arid classicism. It might take three or four generations, but ultimately, Kirstein was certain, "there will be an American ballet as truly national as the Russian. . . ."[126]

The School of American Ballet opened in New York in January 1934 with a prospectus announcing its intention "to preserve and further the tradition of classic theatrical dancing in order to provide adequate material for the growth of a new national art in America."[127] The American Ballet Company got under way the following December with a performance in Hartford, Connecticut, of *Alma Mater,* a satire on American college life written by Warburg. A few months later the company had a two-week season in Kansas City; then in the fall of 1935 it became the official ballet of the Metropolitan Opera. The next summer Kirstein organized a touring company called the Ballet Caravan, initially made up of twelve young dancers from the School of American Ballet. With a repertory consisting of dances created by its own members, the Ballet Caravan annually toured the United States, performed in Canada and South America as well, and in 1940 had a long engagement at the New York World's Fair.[128]

By that time the American Ballet Company, its connection with the Metropolitan Opera broken since 1938, had practically ceased to exist. Balanchine, like so many other people in the arts during the

thirties, had long since left to partake of the largesse of Hollywood. In the two and a half years it was at the Met, the company had performed almost nothing but well-known European ballets or occasional contemporary works by Stravinsky and other Europeans.

The promotion of American-written ballet became the purview of the Ballet Caravan. Under Kirstein's personal direction, the Caravan zealously joined the Americanist boom advanced by the Popular Front and then kept going by the approach of war. Choreographed by either Lew Christiansen or Eugene Loring and with libretti often written by Kirstein himself, the Caravan's distinctly Americanist repertory came to include such works as *Pocahontas* (1936), *Yankee Clipper* (1937), *Filling Station* (1938), and *Billy the Kid* (1939), with scores written by Elliott Carter, Paul Bowles, Virgil Thomson, and Aaron Copland respectively. At the beginning of 1940, as the Caravan returned from a tour of one-night stands in fifty cities to open an engagement on Broadway, *Time* magazine remarked that "Kirstein's home-made ballet, like Finland's home-made army, appeared to hold its own against the Russian product."[129]

Even the lordly Ballet Russe de Monte Carlo showed a taste for Americana. As early as its 1934 tour the troupe had performed *Union Pacific*, a dramatization in dance of the history of the first transcontinental railroad, with music by Nicholas Nabakov and libretto by the ubiquitous Archibald MacLeish. Five years later the Ballet Russe did a ballet on the Old West called *Ghost Town*, for which Richard Rodgers did both score and libretto. The height of the Ballet Russe's involvement with American scenes and themes was *Rodeo*, first performed in New York in the fall of 1942. Aaron Copland's music and Agnes De Mille's choreography combined to produce a work of exceptional charm and vitality, perhaps the most successful and certainly the best-known American effort in the ballet form.[130]

Early in 1939 George Beiswanger rhetorically pondered the significance of the remarkable efflorescence in American dance—both ballet and modern—that had taken place in the past few years. "It means," he answered himself, "when taken in conjunction with our new architecture, our reborn mural art, our Federal Theatre projects, our multiplying orchestras, our vigorous regional schools of painting, our industrial arts, our Thomas Wolfe and even our Hollywood, that . . . we are actually in the midst of the renascence for the signs of which our prophets still anxiously scan the horizon."[131]

In reality there seemed to be few people still scanning the horizon in search of a truly and fully realized American culture. Most seemed ready to acknowledge, along with the architectural historian Roger

Hale Newton, that Americans had finally overcome their "deeply rooted inferiority complex" and that *"quite unconsciously,* we native and benighted Americans [have] meanwhile produced an *indigenous* culture quite unbeknownst to the little gilt gods of snobbish pedantry!" The editorial director of the *Architectural Record* said in 1940 that the nation's writers, dramatists, painters, composers, and designers all "speak today in a truly American idiom free from subservience to Europe or to the past." Despite the death of the Federal Theatre Project and the financial struggle that continued to be the lot of most creative artists, that same year the influential muralist George Biddle described the American cultural situation as generally favorable. Biddle judged the prevailing trend in the American arts to be democratic, "toward a more extroverted, human interest, American-scene expression" and away from estheticism and abstractionism.[132]

On every hand the search for a usable past seemed to have led to the discovery of abundant cultural riches. "It is a strange yet understandable paradox," observed Turpin C. Bannister of the newly founded American Society of Architectural Historians in 1941, "that American men and women, increasingly confronted by catastrophic world events, have experienced a resurgent interest in the origin, development, and present character of their own cultural tradition." In the shadow of Pearl Harbor, this question of the national tradition, to use Michael Gold's phraseology, still seemed highly pertinent to American cultural circumstances. A nationwide folk-dance boom was under way. In addition to a considerable increase in symphonic and choral works celebrating America, the popular-music industry was rushing to produce songs with patriotic lyrics in the aftermath of the phenomenal success of Kate Smith's rendition of "God Bless America." "The U.S. was singing," commented *Time* in the summer of 1940, "as it had not done in years, of pride in its past, of hope in its future."[133]

"Never before has art seemed so solidly integrated with the social needs of the community," announced Biddle in 1940.[134] The major consideration here is not whether Biddle's confident assessment was accurate, but that he and what appeared to be a sizable majority of his intellectual and artistic contemporaries assumed such a circumstance was good for themselves and good for America. That had been the prevailing notion in American cultural criticism since at least the time of Emerson. First Whistler and a few other esthetes before 1900, and then a larger and more vocal but still outnumbered contingent of radical modernists in the twentieth century, had questioned whether the artist and society had any common interests at all, whether in fact the mission of art did not dictate continuous tension between the creative individual and most other people. Up through the 1930s,

though, the commonly accepted view continued to be that the artist, if not directly obligated to work to change his society, at least should somehow relate his work to past and present circumstances in his particular social environment. The corollary was that understanding creative expression was largely or mostly a matter of relating it to those same circumstances of environment.

Such thinking would hold up less and less in the postwar decades, as American creative artists and cultural critics increasingly turned inward and away from collective concerns, and as the issue of a national culture came to seem at best marginally germane to the true concerns of art.

# Renaissance Not Regeneration

OBVIOUSLY A GREAT PATRIOTIC EVENT IN ITSELF, THE SECOND WORLD War nonetheless signaled the incipient decline of the nationalistic impulse in the American arts. The long-run effect of the war experience was to internationalize American tastes and critical attitudes, and at the same time to undercut the historic intellectual occupation with the social meaning and purpose of art. By the late 1940s the question of when and how the United States would arrive at its own recognizable, preeminently national culture no longer seemed to have much bearing on the leading issues in American intellectual and artistic life. The whole concept of a national art—an art supposedly grounded in the collective emotions of a historically identifiable people—came to appear as at best a nineteenth-century eccentricity, at worst a wrongheaded notion that obscured the difficult esthetic problems confronting both creator and critic. The closely related proposition, that what intellectuals and artists did should contribute directly to social change, also fell into critical disrepute. Both the idea of a national culture and the idea of socially purposeful art, according to the postwar critical consensus, expressed an inherent fallacy about a necessarily idiosyncratic creative process.

I

Of course such a transformation in critical attitudes was not immediately evident. The German invasion of the Soviet Union the

242

summer before Pearl Harbor made possible the partial reconstruction of the Popular Front. As the American Communist Party again clamored for all-out aid to the "progressive" nations fighting the fascist aggressors, much of the Left managed to reunite in a loose liberal-radical coalition. Although public opinion polls showed that a majority of the general population favored curbs on the civil liberties of Communists, on the whole the image of the Soviet Union, America's formal ally after Pearl Harbor, was a positive one throughout the war years. The Soviets' fiercely heroic stand against the German invaders served to obscure such bothersome matters as the Moscow purge trials, the Nazi-Soviet Pact, and the USSR's aggressive war against Finland in 1939–40. Boosted by Roosevelt administration spokesmen like Vice President Henry Wallace and former Ambassador to the USSR Joseph E. Davies and glowingly depicted in most of the press and in several Hollywood productions, the Soviet Union seemed not only a vital wartime ally but a nation whose friendship would provide the keystone for a new, peaceful international order.[1]

Yet despite the neo–Popular Front and an unprecedented degree of national unity, the immediate consequences of the war for the American arts were not momentous. A few established composers— Aaron Copland, Roy Harris, Morton Gould, Ernst Bacon—addressed their music directly to the crisis of wartime.[2] Popular culture, moreover, rushed to the colors after Pearl Harbor. Grossly oversimplifying the complex issues of the period, America's filmmakers adhered pretty closely to Office of War Information directives on film content. The stylized action-combat and espionage-adventure movies turned out in profusion by the Hollywood studios usually voiced the sentimental Americanism of the first Popular Front, with the added quality of sentimental internationalism as propagated by the neo–Popular Front. The wartime dramatizations of Norman Corwin and his fellow radio playwrights carried basically the same message—instruction on the blessings of American liberty, exhortation for Americans to join forces with freedom-loving peoples everywhere to smash the fascist enemy and then build a lasting peace.[3]

Otherwise the country's foremost creative talents made little conscious effort to relate their work to the great events taking place around them. The collective anger and collective idealism that had infused much of the fiction, poetry, and stage drama of the thirties was hard to find in the writing of the war period. American Scene painting was clearly on the wane by the early forties. The deaths of Grant Wood in 1942 and John Steuart Curry four years later took the heart out of midwestern regionalism, while Edward Hopper and Charles Burchfield were well past their peak creativity. Tired of nearly

two decades of prevalent realism, many critics were ready to welcome the abstractionist revival gathering momentum since the late thirties.[4]

In ballet and modern dance as well, the Americanist vogue was in sharp decline after 1941. *Appalachian Spring,* a happy commingling of the talents of Martha Graham and Aaron Copland, first performed in 1944, in effect brought to a close the nationalist phase in Graham's career and in American modern dance as a whole. Agnes De Mille's robust, well-integrated sequences in the smash-hit musical *Oklahoma!* (1943), together with Jerome Robbins's exuberant *Fancy-Free,* first given by the Ballet Theatre in 1944, marked the main expressions in ballet of the kind of Americanism popularized by Lincoln Kirstein before Pearl Harbor. Kirstein himself was in the Army most of the war, and his Ballet Caravan was under wraps because of wartime travel restrictions. In the postwar years Kirstein would no longer insist on American-born dancers, no longer promote the use of native themes and materials.[5]

Architectural modernists were generally even more unhappy with the results of the federal government's hurried wartime construction programs than they had been with the public works efforts of the New Deal.[6] At the same time, invocations of the cause of a distinctly American architecture were considerably less common in architectural discussions during the war years than had been true in the thirties. Much of the explanation for that was the migration of some of Europe's foremost architects from the wartorn Continent to the United States. The presence of men like Ludwig Mies van der Rohe, Laszlo Moholy-Nagy, Walter Gropius, and Marcel Breuer not only vastly enriched architectural practice in America but also did much to internationalize architectural taste and theory. In fact the war accelerated the trend toward the emergence of an international architectural profession that operated on the assumption that human needs should be met by architectural strategies having little if anything to do with national, "racial," or ideological distinctions.

The refugee intellectuals, as the learned immigrants were popularly called, also included people in virtually every other area of the arts as well as in science and scholarship. Arnold Schoenberg, Paul Hindemith, Igor Stravinsky, Kurt Weill in music; George Grosz, Piet Mondrian, Fernand Léger, Wassily Kandinsky, Paul Klee, Marc Chagall in painting; Jean Renoir in filmmaking; Thomas Mann in literature —these were but a few of the internationally renowned artists who fled either Germany after the rise of Hitler or other parts of Europe after the outbreak of war. Since the beginning of the century American enthusiasts for the European avant-garde had urged their countrymen to follow the new currents in international culture; now much of the Continent's living avant-garde had made its way to the United States.

A major effect of the intellectual-artistic migration was to break down
what remained of America's prewar cultural insularity. While many
of the refugee artists would contribute brilliantly to postwar artistic
achievements in their adopted land, their contributions would work
to make American culture increasingly cosmopolitan.[7]

## II

"To the United States," wrote the emigré Italian man of letters
Paolo Milano not long after Pearl Harbor, "falls the immense task
of making European culture something above and beyond all national
boundaries, with meaning for all, something definitely and gloriously
pan-human." Such sentiments reinforced a growing disposition among
American commentators to assume that their country had taken cus-
tody of Western culture—maybe permanently, at least for the duration
of the conflict. "The last outpost of free civilization is necessarily also
the last outpost of the free theatre," said John Gassner in 1941. In-
stead of "making an end of all musical gestation," Aaron Copland sug-
gested, the war had "moved the center of creative activity to the
Western Hemisphere." Amid the present chaos, the American mission
must be to make "a special kind of American beauty, which may
serve as beacons in this troubled world." So thought the architectural
historian Roger Hale Newton. "*If* we fail *now* to achieve the maximum
realization of our cultural integrity and fecundity and expression and
progress," Newton was convinced, "we do *indeed* face the Darkest
Ages yet in history."[8]

To talk about art that way—as regenerative, restorative, ultimately
didactic, as having some function beyond the disclosure of the creative
artist's private reality—was to perpetuate long-standing and interre-
lated esthetic and moral assumptions. Such views had been basic to
the Genteel Tradition, had also received powerful expression in the
resurgent romantic nationalism of the pre–World War I period, and
then had informed Left and Popular Front culture in the thirties.
That outlook had served as the basis of Van Wyck Brooks's whole
theory of the creative person, of what Thomas Craven, John Martin,
the Marxist critics, and such otherwise remarkably dissimilar people
as Arthur Farwell and Randolph Bourne had believed. It was what
H. L. Mencken had meant in 1920 when he wrote, "for literature,
after all, is no more than a shadow of the life that it presumes to
deal with, and all the qualities that it shows come out of that life."[9]

Certainly the period after the First World War had brought a
stunning outpouring of creative genius in all the American arts. By
the 1930s and 1940s, though, some of the same critics who had once

rebelled against genteel dominance and pleaded for a rich and vital native culture had come to have second thoughts about current trends, especially in literature. Even though the expatriate fashion of the twenties had mostly passed, the avant-garde poetry and criticism of T. S. Eliot, Ezra Pound, and their followers continued to bother Brooks and Waldo Frank as well as Lewis Mumford, their younger comrade. The pessimistic tone and generous amounts of sex and violence in the fiction of various leading contemporary novelists bothered them just as much. Their quarrel with the currents of experimentalism and literary naturalism again pointed up the parallels that had always existed between romantic nationalists and Genteel Traditionalists.

The trouble with John Dos Passos, William Faulkner, Erskine Caldwell, and a number of other present-day novelists, Frank remarked to Brooks as early as 1934, was that "one and all have accepted . . . a limiting theory of what constitutes reality." By comparison with such writers, the nineteenth-century New Englanders Brooks was then lovingly recapturing "had the scope of Titans. . . ." Mumford sounded remarkably like the lately defunct New Humanists when he wrote Frank that he found James M. Cain's *The Postman Always Rings Twice* and John O'Hara's *Appointment in Samarra* "raw, filthy, meaningless, and in the deepest sense of the word corrupt: brutal and maudlin in their brutality, with the gangster elevated . . . into the sentimentalized and respected hero." Brooks thought the days of such writing were numbered; its spiritless view and exploitation of the ugly side of human nature were "too flat to last much longer." But Brooks reserved his harshest words for "the Elioteers," who were, he said in 1941, "almost as bad as the Germans,—there isn't room on the same planet for them *and* for other human beings."10

Brooks later claimed that he had always distinguished between a writer's caliber and the tendency he represented; he had only objected to certain writers' tendencies, not questioned their abilities.11 Whatever, the fact remains that Brooks and a number of his friends and associates continued to be upset with much of what was going on in American cultural life. Eventually they issued a succession of wideranging indictments of the intellectual-artistic class for allegedly weakening the American people's moral and spiritual foundations and thus leaving them unprepared to confront the challenge of fascism.

Mumford's main concern was to assert what he called "ideal liberalism" over the shallow, materialistic "pragmatic liberalism" he thought prevalent in Western and particularly American society since the eighteenth century. Mumford characterized "pragmatic liberalism" as a blindly optimistic faith in human reason, an insistence on the relativity of values, and a "rather adolescent pride" in the prowess of

modern science. Such beliefs explained why Americans—most of all their intellectual leaders—had refused to face up to the fascist threat. For Frank the enervating malaise was a similar condition he labeled "empirical rationalism"—as opposed to the "Great Tradition" of love and humanitarianism deriving from man's "pre-rational" sense "that his life has purpose and direction and God is in him." Mumford and Frank both looked toward the abandonment of "the atomic and unreal individual," the restoration of family and community life, the realization of "a harmony of the whole of human nature."[12]

Both men were ready to condemn most modern fiction for contributing to the degradation of human values and dignity. Apparently not having read John Steinbeck's paean to the heroism and perseverance of the common people in *The Grapes of Wrath,* Frank announced in 1940 that "like so many of our radicals," Steinbeck "truly possessed the Fascist contempt for man and was wreaking a sadist vengeance, unconsciously, upon his characters." Maybe Frank had in mind Steinbeck's earlier *Of Mice and Men,* a small tragedy about a simpleton who kills a girl and is in turn killed by his friend to keep him from falling into the sheriff's hands. At any rate, Mumford specifically offered that novel as well as Erskine Caldwell's *Tobacco Road,* a ribald rendering of the sharecropper South, as examples of why "the popular mind becomes softly inured to human degeneracy."[13]

Howard Mumford Jones, a Harvard English professor who campaigned throughout the thirties in behalf of a bigger share for American literature in college curricula, also took after an assortment of villains. Jones denounced novelists like Hemingway, Faulkner, and James T. Farrell for succumbing to fatalistic foreign literary fashions; the "samurai class" of academic literary scholars for alienating art from the people; and professional historians for pursuing scientifically verifiable truth so relentlessly that they had almost destroyed the collection of myths and traditions that undergirded American patriotism. "What is the good of getting up meetings to denounce the Fascist conquest of democratic Spain," Jones wanted to know in 1938, "and at the same time writing books to demonstrate that democracy is a failure in the United States?" If democracy survived, "battered and wounded and deserted by those authors who should rally to its standard," it would be only because "there is a vast deal more idealism and good will among ordinary Americans than ever gets pictured in the books that are written about them."[14]

"The Irresponsibles"—that was the epithet the poet Archibald MacLeish hurled at people in scholarship and the arts who had "made no effort to defend either themselves or the world by which they lived." Once a disheartened young expatriate and an admirer of T. S. Eliot,

MacLeish had become the archetypal activist intellectual in the thirties. Taking a leading role in the 1935 and 1937 American Writers' Congresses, MacLeish argued that art must become "public speech," that creative artists must throw themselves into the work of building a better society. By the time the European war began and the Popular Front ended, MacLeish had become librarian of Congress and thus a semiofficial spokesman for the Roosevelt administration. Now he worked harder than ever to convince his countrymen and especially his fellow intellectuals and artists that the present conflict was not just another European war. It was the "American Cause"—"the single man's belief in liberty of mind and spirit"—that was also at stake. Those who insisted that they must maintain objectivity and intellecual purity, that they were obligated to nothing beyond the truth of their own feelings, were guilty of "the perfect type of irresponsibility. . . ."[15]

In light of the high degree of social consciousness and the strongly Americanist flavor in the arts in the years before Pearl Harbor, charges like those of Mumford, Frank, Jones, and MacLeish might seem preposterous—except that they came in a period of prōfound crisis. Among intellectuals, artists, and Americans in general there was mounting anxiety and debate over the nation's relationship to the wars raging in Europe and Asia. Convinced that the United States must intervene to insure the defeat of the fascist powers and the preservation of democracy and liberty, MacLeish and the others sought to understand why many of their contemporaries either failed to share their sense of urgency or flatly opposed any kind of American involvement in the turmoil overseas. Preposterously or not, they found the answers in the principal influences at work in trans-Atlantic culture since the First World War: estheticism, Freudianism, and the naturalistic presuppositions in modern literature. Those influences, they believed, had helped subvert the moral vision that had always informed great art.

Brooks's thinking ran along much the same lines, although he was never able to get as agitated over the world situation as his friends Mumford and Frank. The trouble with the wrecked League of American Writers, he wrote James T. Farrell in the fall of 1939, had been its "over-emphasis on European matters" when it should have been "chiefly concerned with domestic questions on a broadly democratic American basis." He would continue to "believe in a socialized world and socialized country," he told Malcolm Cowley at the same time, but the League simply had not been *in the American grain.* For there is an American grain, and I wish to live with it, and I will not live against it knowingly." A few months later, when the United States had already become Great Britain's ally in everything but name, Brooks still described himself to Mumford as "an incurable isolation-

ist" who did not "welcome rapprochements with England. . . ." While
the United States should arm itself and help Britain if Germany
seemed to be winning, "otherwise I welcome anything that reduces
British prestige in our population." He also disagreed with Mumford's
and Frank's condemnation of eighteenth-century rationalism. To Frank
he wrote, "I don't think the conception of life that lay behind our
Revolution (and in men like Franklin and Jefferson) was as shallow
as you seem to think it. . . ."[16]

Brooks's overriding concern was still culture not politics. Insofar as
he supported the pro-Allied, "interventionist" cause in the pre–Pearl
Harbor period, it was mainly because he shared the interventionist
critics' disappointment and anger at major aspects of the cultural
situation in America. Brooks commended MacLeish, who, "in a
world that has been drugged by fatalism," was "likely to rouse our
thinkers and set our intellectual world in action," but he was endors-
ing the poet's call for unrestricted aid to Britain less than what he
understood to be MacLeish's strong cultural patriotism.[17]

Thus it was Brooks's continuing literary preoccupations that finally
propelled him into the "Irresponsibles" controversy. "I was not
preaching America *über alles* or any such nonsense," Brooks said in
his memoirs. "Cultural identity was all that interested me."[18] Yet
brooks's *The Opinions of Oliver Allston,* published about two months
before Pearl Harbor, seemed to confirm the suspicions of a considerable
number of his contemporaries that he had given up criticism for pa-
trioteering.

Brooks offered his own opinions in the form of journal entries by
an imaginary Oliver Allston. Significantly, Brooks made Allston an
old-line New Englander (which Brooks was not), a man at odds with
much of what was happening around him in ideas and art (which
Brooks indubitably was). Earlier in the century, Brooks acknowledged.
the formation in America of a dissident artistic elite had been neces-
sary as an act of "self-defense, in order to separate from the gross herd."
What had happened was that the creative elite had so separated itself
from the rest of the people that it had itself become the enemy of cul-
ture. The American avant-garde, under the spell of various "decadent
isms" from Europe, had lost touch with primary realities, with the
world as it actually was. Writers like Eliot, Stein, and Pound—as well
as James Joyce and the French Symbolist poets—were "international
mystagogues," "maladjusted persons" possessed of "a morbid will to
power," and above all the propagators of a "coterie literature." In
another category were writers like Hemingway, O'Neill, Faulkner,
Dos Passos, men of great talent who were nonetheless "bent on prov-
ing that life is a dark little pocket," who "seemed to delight in kicking

their world to pieces, as if civilization were all a pretence and every-
thing noble a humbug."[19]

Over and against the literature of despair, degradation, and death,
Brooks put "primary literature"—"a force of regeneration that in some
way conduces to race-survival. . . ." The great themes in art, Brooks
believed, were "those by which the race has risen, courage, justice,
mercy, honour, love." Brooks's gallery of primary writers included
John Milton, Thomas Mann, Emerson, Mumford, Frost, Sandburg—
men in whom "one found a courageous confidence in human nature,
an abounding faith in the will, a sense of the heroic in the human
adventure. . . . All fine things seemed possible as one read these writers.
. . ." And all such writers had understood that "primary things"
could be apprehended best in the national life, in the ties and loyalties
of the group. Citizens of the world all, they had nonetheless first been
citizens of their own country. Citing Henrik Ibsen's pronouncement
that "Culture is unthinkable apart from national life," Brooks added,
"It is better to be a living fact than an optical illusion, better to be
unhappy in Tennessee than a mouthless and meaningless phantom
floating about the Riviera."[20]

At the same time, Brooks had little patience with parvenus of the
late Popular Front who talked about reviving the American tradition.
Insofar as they thought it needed to be revived, they were still out of
touch with it. Communism could never be "in the American grain,"
even though for fifteen years Russia had been "the world's romance
. . . because the search for social justice is the romance of our time."
Paris had long since lost its charm; Moscow was losing its charm, too,
"with our growing sense of what Washington has come to stand for."
The tide was turning toward America, and the future seemed to hold
"a high literary art that will be an expression of the people." The
past quarter-century, though, had produced "few writers who were
both literary artists and voices of the people."[21]

Of course that was the whole point about good writing or any kind
of good art, answered a loud chorus of Brooks's critics. Art should
speak to and even against but never for the lethargic, artistically il-
literate masses. That was the way the group of intellectuals around
*Partisan Review* saw the "Irresponsibles" issue. In a series of snarling
essays they laid into the "Brooks-MacLeish thesis"; in their private
correspondence they were even more candid. "The rubbish that is
being turned out on this theme by Brooks, MacSlush . . . and their ilk
is one of the most sinister and distressing portents of the moment,"
Morton Dauwen Zabel wrote Dwight Macdonald. For Macdonald him-
self it was too much like the *"Kulturbolshewismus"* of the Party-line

Stalinists; Brooks had become "our leading mouth piece for totalitarian cultural values." Farrell, who had attacked Communist artistic dogma in the mid-thirties and then repudiated the Popular Front on the grounds that it had revived the New Humanism in the guise of Marxism, also finally broke with his friend Brooks. He said that Brooks, MacLeish, Mumford, and anybody else who insisted on moralizing about art were nothing more than "ideological policemen" and "frightened Philistines." Literature had its own problems to solve; it could not be made "into the mere handmaiden of politics and into a mere looking-glass of ideologies."[22]

With the Japanese attack at Pearl Harbor and the German and Italian declarations of war on the United States a few days later, the "Great Debate" on American foreign policy, of which the "Irresponsibles" controversy had been only a small part, came abruptly to an end. Yet the bitterness spread by that controversy and many other battles stretching back over the thirties persisted into the war years and long afterward. Never really reconciled to the war and America's alliance with Stalinist Russia, Macdonald became convinced that *Partisan Review* had drifted too far from political issues; in 1944 he left the magazine to found his own monthly, *Politics*. MacLeish wrote speeches for President Roosevelt and, while continuing as librarian of Congress, headed up the government's propaganda efforts in the Office of Facts and Figures in 1941–42. He then served as chief of policy development in the successor Office of War Information and finally as assistant secretary of state for cultural relations in 1944–45. More than ever MacLeish was the intellectual *engagé*. Also more than ever he was open to criticism as an apologist for official policy.[23]

Brooks meanwhile continued to have many admiring readers for what he now intended to be a multivolume "Makers and Finders" history of American literature. *The World of Washington Irving,* published in 1944, continued the labors he had commenced in the thirties with *The Flowering of New England*. Visiting the offices of the *New Republic* in 1942, Brooks reminded young Alfred Kazin of nothing so much as Brooks's own description of William Dean Howells. Brooks, Kazin recalled, "was all white and portly, like the stubby Mr. Howells, that damnably genial man."[24]

If Brooks, once the thorough malcontent, now struck some younger intellectuals as the epitome of the genteel man of letters, in fact he remained at the center of cultural controversy. In the middle of the war the mostly one-sided quarrel Bernard DeVoto had carried on with him for more than a decade finally came to a boil. It all amounted to one of the last open confrontations between defenders and denigrators

of the proposition that art and society were—or should be—mutually reinforcing, and that the health of one determined the health of the other.

<div align="center">III</div>

DeVoto was one of the most active literary figures of the thirties and forties and also one of the most contentious. Dark-featured, quick-tempered, with a bespectacled countenance Sinclair Lewis likened to that of a frog, DeVoto had been born in Ogden, Utah, in 1897, the product of an unlikely union between a Mormon mother and a father of Italian-Catholic ancestry. After two years at the state university, DeVoto had gone to Harvard and then served a year in the Army stateside during the First World War. He finally got his Harvard B.A. in literature in 1920. DeVoto taught English for five years at Northwestern University, then mustered his savings and moved his family to Cambridge, Massachusetts, to live in the Harvard atmosphere and write. He supported himself mainly by writing history and criticism under his own name and lightweight fiction under pseudonyms. For twenty years beginning in 1935, DeVoto wrote the monthly "Easy Chair" column for *Harper's Magazine*. In 1936–38 he lived in New York, doing battle with the Marxists and other critical schools as editor of the influential *Saturday Review of Literature*. After that he moved back to Cambridge and became curator of the Mark Twain Papers, a job he held for the next eight years.[25]

Both DeVoto and Brooks grew up outside New England but chose to settle there, both were Harvard men, both were obsessed with the relationship between literature and the American experience. Otherwise they had little in common. DeVoto really hated romanticism—not on moral grounds like the New Humanists or on clinical grounds like the New Critics but because he despised any kind of abstract, theoretical, or metaphysical thinking, any ideas that did not derive from actual, concrete, experiential reality. Although DeVoto never took the trouble to ground himself in the native philosophical pragmatism of William James and John Dewey, he shared much of the pragmatic outlook. He was also powerfully influenced as a young man by reading the Italian social theorist Vilfredo Pareto. From Pareto, DeVoto came to understand the tenacity with which societies held on to their deep-seated beliefs and values—their "residues," as Pareto called them, as distinguished from "derivations," which were only the surface appearances of social change. Thus DeVoto rejected the notion that intellectuals could ever change society very much or that,

conversely, society was obligated to change to make conditions propitious for intellectuals. Unmoved by the vision of an American renaissance, a glorious welling up of creativity sparked by a generation of prophet-critics, DeVoto had written as early as 1920, "I do not commit the historic folly, from Washington Irving to Van Wyck Brooks, of hearing fiddles tuning up all over America."[26]

Yet DeVoto was as preoccupied with his country as Brooks or anyone else. While he disdained "the Menckian mood toward America," he nonetheless shared the all-encompassing fascination with American life that Mencken's magazine as well as *Broom* and *Vanity Fair* voiced in the 1920s. "Repressions, censorship, cramped, fear-ridden lives"—all these America had in abundance. The task of the artist, though, was not to ask why or how, not to "mourn that these people are not like some other," but to build with the materials at hand. "Make music of the elevated, of the billboards, of the vaudeville, of the baseball games, of the gasoline air, of the river stinks, of the garbage cans, the slums, of every blatant and vulgar monstrosity of this civilization." At least America was alive, "a whole continent stuffed with living things." It was the artist's duty to make art of it.[27]

DeVoto's literary criticism was actually "anticriticism," as one student of his work has described it.[28] "Literary thinking has been my grouch for a long time," DeVoto said in 1936; "I don't like the way the brothers do it and believe in saying so."[29] Most of what he said over the years about literature, the only art he really knew anything about, argued the futility of trying to judge America by what its artists and critics thought or did. In 1932 DeVoto published *Mark Twain's America,* a conscious attempt to refute Brooks's thesis that American society had thwarted Twain's genius. Taken on his own terms, for what he actually accomplished, Twain was a genius, DeVoto contended, an artist who flowered in the circumstances of the America of his times. Brooks, on the other hand, was a metaphysician who insisted on abstracting facts from context and twisting them to fit his own emotions and intuitions, his preconceived idea of America and of art. Like the rest of his literary generation, Brooks believed that intellectuals could direct change when in fact they could only report it. And what they reported had to be more than literary to be truthful.[30]

Brooks never publicly replied to DeVoto's attacks, although he did remark to Mumford (who thought DeVoto "fundamentally, a jackass") that DeVoto had misunderstood his treatment of Twain. His Twain book, said Brooks, was "consistently psychological" and not meant as a literary study.[31] Nor did he once mention DeVoto in his memoirs. Actually Brooks's thinking had already changed a great deal by the time DeVoto took him on; how much DeVoto added to Brooks's al-

tered views on America is impossible to tell. In 1942 Brooks did bring out a revised edition of *The Ordeal of Mark Twain,* which not only corrected some errors of fact DeVoto had pointed out but also considerably watered down the artist-as-victim thesis.

Yet DeVoto kept on the attack—against Brooks and everybody who in his judgment refused to understand real American experience. Only in the meticulous study and re-creation of history—in the narrative of actual events and people—was America truly accessible to the writer. DeVoto's *The Year of Decision: 1846* (1942), a fascinating picture of the crowded happenings across a country in the midst of winning a continental empire, demonstrated that kind of history.[32] Then in March 1943 DeVoto gave six Patten Foundation lectures at Indiana University. The lectures were published the next year as *The Literary Fallacy,* an odd little book that provided the capstone for nearly four decades of literary dispute.

DeVoto's main target in *The Literary Fallacy* consisted of America's most highly regarded imaginative writers in the interwar period, particularly the so-called Lost Generation of the twenties. Those novelists and poets had deliberately cut themselves off from American life as it really was, had denied truths "which had been the commonplace knowledge of every man of sense, the ordinary experience of everyone who had lived in touch with the American realities." Men like Hemingway, Dos Passos, Faulkner, Eliot, even Thomas Wolfe and Sinclair Lewis (both of whom had mercifully escaped the "Irresponsibles" dispute) had simply not understood America. All along the United States had been basically the same country whose intellectuals now, in wartime, were exalting its multifaceted, democratic character. DeVoto digressed into the late nineteenth century to sketch the career of the famous geologist and explorer of western rivers, John Wesley Powell, as a "functional" American in touch with his native environment. He also looked at the medical advances taking place in the twenties at the same time that America's literati were denouncing its cultural barbarism. "Never," DeVoto concluded, "had writers been so completely separated from the experiences that alone give life and validity to literature. And therefore because separation from the sources of life makes despair, never had literature been so despairing, and because false writing makes trivial writing, never had literature been so trivial."[33]

All that was strongly reminiscent of what Brooks, MacLeish, Mumford, Frank, and Jones had been writing a few years earlier. DeVoto went even a step further, suggesting that Adolf Hitler and his Nazi cohorts had been persuaded to commit their aggressions at least partly

by the descriptions of America's alleged decadence and degeneracy its writers had provided in the interwar period.[34] But where DeVoto parted company with Brooks et al. was in denying that such writing had had any effect on the toughness and resolve of the American people or had appreciably touched them any other way. Brooks, MacLeish, and their associates had not understood that the literature of despair that agitated them so much had really been a trivial literature, inconsequential to what DeVoto termed, in a letter to the journalist Dorothy Thompson in 1942, "the vast mass of ordinary citizens who were not in the least vile or tawdry or false or anarchic but only did their best to live decently and bring up their families."[35] Thus the critics, believing that American literature closely reflected and profoundly affected American life, had committed "the literary fallacy."

It was all pretty confusing. Starting out to refute the thesis that there was a necessary connection between literature and the society in which it was produced, DeVoto had gone on to argue that America's creative writers had defaulted on their moral obligation to depict their country faithfully, then had ended up condemning other critics who had said just that in the pre–Pearl Harbor debate over the United States' relation to the war.[36] DeVoto's adversaries, particularly Malcolm Cowley, hammered away at his inconsistencies. Sinclair Lewis's reply took the form of a bitter personal attack.[37] If DeVoto had ever had any secret ambition to gain the respect of his contemporaries as a critic, that was hopeless after *The Literary Fallacy*. Even proponents of the avant-garde like Philip Rahv were willing to acknowledge that "Of course, there is a distinction to be drawn between him [DeVoto] and Brooks (Brooks is so much the better man, and I still think that his early work is valuable)."[38]

## IV

In the years after the war the increasing critical trend was to look askance at the tendency both Brooks and DeVoto represented—"a tendency," as Rahv put it, "utterly irrelevant to literature proper and positively archaic on general grounds." In their "extra-literary pressure and presumption," Rahv said, Brooks and DeVoto had made the same mistake as the "vulgar Marxists," except that instead of worshipping the proletariat they had worshipped " 'America'—an object of adoration and pompous reference which in their sense of it is quite as mythical as the Marxist object." In 1947 Stanley Edgar Hyman spoke as a member of a new generation of critics in dismissing Brooks:

"It has been at least a decade since anyone concerned with literature took him very seriously." Brooks, according to Hyman, had become "a narrow and embittered old gentleman with a white mustache."[39]

That much was nonsense: Brooks's intellectual framework may have seemed narrow and provincial in the postwar years, but he was scarcely embittered. He kept hard at work, publishing no fewer than sixteen books from 1947, when he brought out *The Times of Melville and Whitman,* the penultimate volume in the "Makers and Finders" series, until his death in 1963. His personal reconciliation with America went forward, even if the fashion became dated in the postwar period. "Makers and Finders" concluded in 1952 with *The Confident Years, 1885–1915.* A generally favorable reassessment of the once-despised late nineteenth century and particularly of William Dean Howells's role, the book ended with a lyrical evocation of "the younger generation of 1915." That generation, wrote Brooks, had announced that America was "somehow coming of age." But then in tacked-on chapters surveying American writing from 1915 to 1950, Brooks reiterated his pre–Pearl Harbor charges against literary naturalism, expatriation, experimentalism, and anything else that went against the American tradition—defined as a faith in man's innate goodness and the nobility of the human spirit. Again he censured Pound and Eliot, Faulkner and O'Neill, Hemingway and Dos Passos for their preoccupation with the dark side of human nature. Again, though, Brooks was prepared to admit that avant-garde rebellion originally had been a healthy manifestation, a necessary (albeit temporary) phase that had given young men and women across the country a sense of creative community.[40]

Subsequently Brooks came around to the view that contemporary avant-gardism also had its benefits, mainly in enabling younger writers to keep in touch with literary currents and maintain a feeling of shared purpose. But Brooks never was able to tolerate criticism that denied what Brooks and generations of critics had taken for granted: that the overriding factors in understanding creative expression were biographical and social, which is to say national. The postwar ascendancy of modes of criticism premised on exactly that denial dismayed Brooks, to whom such "grammarians . . . with their categorical tone and esoteric language" seemed actually to be in flight from the true purposes of the critic. Confronted with the abstruse New Criticism and with doctrinaire Freudian or Jungian psychoanalytical criticism only remotely related to what he had done in *The Ordeal of Mark Twain,* Brooks answered that he "scarcely wished any longer to be called a critic when the word assumed these connotations."[41]

At the beginning of 1940 the British poet and essayist W. H. Auden, having recently come to live in the United States, wrote a poem called "New Year Letter." A section in Auden's poem captured about as well as anything ever did the essentials of the formalist critical outlook that would come to prevail in both his adopted and his native country:

> Art is not life and cannot be
> A midwife to society
> For Art is a *fait accompli.*
> What they should do, or how or when
> Life-order comes to living men
> It cannot say, for it presents
> Already lived experience
> Through a convention that creates
> Autonomous completed states.[42]

Fifteen years later one literary scholar described the current mood in criticism as "conservative, restrictive, traditional, if not indeed authoritarian."[43] Literary history, formerly almost inseparable from criticism, was fast losing prestige in English departments, where most criticism was written in the postwar decades. Alfred Kazin's *On Native Grounds,* published in 1942, was one of the last and maybe the best of the broad-ranging, socially grounded American literary histories. Written by a twenty-seven-year-old native New Yorker, the son of Russian Jewish immigrants and a product of the City College and Columbia, *On Native Grounds* surveyed the "modern" age in American prose writing, the period since 1890. Like F. O. Matthiessen in his study of mid-nineteenth-century American writers the previous year, Kazin successfully steered between the tired dogmatism of the fading Marxists and the rarefied esthetics of the rising New Critics. Lucid and tolerant, planted firmly in historical context yet eschewing historical determinism, Kazin's book proved durably popular with general readers—mostly, one suspects, because of its "old-fashioned" method.[44]

The publication in 1948 of the massive *Literary History of the United States,* the result of several years of cooperative scholarly enterprise, failed to stem the tide running strongly against the study of literature within a historical (and usually nationalistic) framework.[45] History had become useful, Warren Susman has noted, only to the extent that it highlighted the mythic quality in American thinking, the historic national tendency to behave as if America were somehow an exception to the tragic fate shared by all humankind. As Howard Mumford Jones disapprovingly observed in 1965, "Once it is granted that the

only parts of a usable past for Americans of the mid-twentieth cen-
tury are those that are precisely like the values and anxieties of the
twentieth century, it seems evident that the cultural purpose of his-
torical studies weakens or vanishes."[46]

The triumph of formalist modes in criticism was both cause and
effect of the postwar decline of nationalistic presuppositions in litera-
ture as well as the other arts. It is no easier task to explain the wan-
ing of American cultural nationalism after World War II than it is
to explain the revolt against the Genteel Tradition and the emergence
of the concept of an American renaissance in the years before the
First World War. Certainly the war itself helped make the idea of
a national culture unfashionable and even, for some commentators,
dangerous. In the aftermath of the war against fascism, the common
inclination was to question whether artistic nationalism could be iso-
lated from the kind of avaricious and destructive political nationalism
that had brought on the war, whether, as Paul Rosenfeld had mused
as early as 1936, "great American nationalistic works of art . . . might
not serve even viler perversions of their ideas than that contrived
by the Nazis with Wagner. . . ."[47]

Besides making the United States the world's foremost military and
economic power, the war worked profound transformations in the
perspectives of many Americans. By carrying several million Americans
to places around the world and exposing them to a dazzling variety of
cultural influences, the war did much to break down American pro-
vincialism and enrich national tastes. Meanwhile, the Roosevelt ad-
ministration, its congressional supporters, and "internationalists" in
general were remarkably successful in converting public thinking to
the view that the United States, through the nascent United Nations
organization, must assume a position of global leadership and thereby
capitalize on its "second chance" to help build a new, cooperative
international order.[48] Thus much of the idealism expressed within a
national context in the decade before Pearl Harbor now took on an
international perspective, even if the "one-world" rhetoric of the war
and early postwar years had much the same sentimental ring as the
Americanist rhetoric of the Popular Front.

The neo–Popular Front came apart in the years 1945–48, a casualty
of the collapse of the wartime Soviet-American alliance and the onset
of the prolonged hostility quickly dubbed the Cold War. The United
States thus became the center of an abstraction known as the "Free
World," and large numbers of its intellectuals and artists now iden-
tified as ardently with the cause of global anti-Communism as they
had in the years before Pearl Harbor with global antifascism. By
1952 editors Rahv and Phillips of *Partisan Review,* having steadily

moved away from the ideological radicalism they had once coupled with avant-garde artistic preferences, were prepared to announce that "American intellectuals now regard America and its institutions in a new way. Until little more than a decade ago, America was commonly thought to be hostile to art and culture. Since then, however, the tide has begun to turn, and many writers and intellectuals now feel closer to their country and its culture." The creative values available in America, Rahv and Phillips were certain, "are necessary conditions for civilization and represent the only immediate alternative as long as Russian totalitarianism threatens world domination."[49]

The *Partisan Review* statement was highly misleading in its implication that a wholesale conversion to belief in the virtues of America had only just happened in the postwar years. In fact, that process of conversion had been the principal theme in the intellectual and cultural history of the thirties, and for that matter had also been a prominent feature of the twenties. What had really happened was that *Partisan Review*'s editors and contributors had embraced a good deal of the cultural patriotism they had abominated in the late thirties and early forties, while many of those who had earlier rallied to the cause of anti-Hitlerism now had come to agree with *Partisan Review*'s unrelenting anti-Stalinism. It was all part of the Cold War consensus, whose limits pretty much determined the range of allowable ideological controversy from the late forties through the 1950s. By the early fifties James T. Farrell, who had earlier blasted the "pseudo-populism" of the Popular Front and the patrioteering of MacLeish, Brooks, and Mumford, was convinced that "today America has become the hope of mankind. For America stands as the biggest and strongest bastion of freedom in a world menaced by totalitarianism."[50]

Farrell's thinking may have been—probably was—representative of a majority of the country's intellectuals, artists, and scholars in the post-1945 decades. While such people turned away from ideological radicalism, accepted the fundamental assumptions behind Cold War foreign policy, and frequently boasted of the amount of freedom they had, they no longer exhibited much interest in the issues of cultural nationalism that had seemed so vital in the century's first four decades. Issues of that kind appeared, as Rahv had suggested about the thinking of DeVoto and Brooks, irrelevant and archaic. Previously, Kazin remarked in a postscript to *On Native Grounds* when it was republished in 1956, fiction (he might have said criticism as well) had "seemed to carry the whole weight of our society." Now novelists were content with "exquisitely studying personal problems alone—by which I mean that the characters in contemporary American novels do not criticize the world they live in and have no thought of changing it;

they merely live in it, as fish live in the sea, and keep their own counsel." "The contemporary sense of the human ordeal is so acute," Granville Hicks said in 1951, "that we are less concerned with institutions than with destiny—with man's fate. . . ."[51]

Man and the human predicament, not the American and his country—so might one briefly state the changed mood Kazin and Hicks were talking about. It was a mood that affected not just literature but the overall content of the American arts. Writers of American fiction, the historian Perry Miller declared when he returned from his Fulbright lectureship in Europe in the early fifties, had the chance "to communicate with free men everywhere," drawing on American experience to portray the universal condition of "the fundamental man."[52] And while several novels produced by Americans in the twentieth century might be called "great," the idea of the Great American Novel had long since become more a subject for humorous fiction in itself than a serious critical issue.[53] Critics could take satisfaction in the fact that "American fiction no longer has to call attention to itself with nationalistic labels."[54]

In 1940 Hicks had been right on target in forecasting that the coming period would be "negative and defensive," a time when the creative artist would seek "modes of retreat" from the social passions that had dominated the thirties. By the fifties both older critics like Maxwell Geismar and a few younger ones like John W. Aldridge were complaining about a social atmosphere that was dense and oppressive and a cultural atmosphere that was thin and abstract. Geismar was discouraged by the current Henry James boom in literary studies. James, Geismar thought, was "the perfect symbol of safety, propriety and gentlemanly behavior" and thus, in the midst of the Cold War and the harassment of domestic radicals, the perfect subject for those who "no longer wished to concern themselves with anything remotely bearing on the social question." Aldridge went "in search of heresy" in current American writing and found very little. What he did find was a "gray new world" inhabited by writers who seemed to lack any purpose beyond "blind survival." More positively, Kazin thought that "The key word in our time is not rebellion but knowledge."[55]

## V

If the quest for a national culture seemed lost in the cosmopolitan intellectual and artistic milieu of the postwar years, on every side there was ready recognition that the United States had become the center of creative activity in the Western world. Writers might seem deaf

to Brooks's call for a literature that would be an expression of the people, but little doubt remained that, as Malcolm Cowley said in 1945, "American literature . . . has become one of the world literatures in its own right, like English and French and German and Russian, instead of being regarded merely as a branch of English literature." In the *Literary History of the United States,* Howard Mumford Jones observed, maybe the unifying element was the negative thesis that by the middle of the twentieth century "it was no longer necessary to worry about nationalism in American literature, which could now be taken for granted."[56]

It was a curious fact that the writers most celebrated in postwar Europe for their "Americanness," like Hemingway, Dos Passos, or Faulkner, were usually the same people prewar nationalist critics had condemned for being false to basic American virtues and values. At any rate, American writing reigned supreme, as commentators on both sides of the Atlantic repeatedly stated. The English editor and critic Cyril Connolly was convinced in 1949 that literary hegemony had permanently shifted to the United States, that "the fort has collapsed and the difficulty now would be to name any major English writers who were not deeply influenced by America." In the shaky aftermath of the war, wrote Stanley T. Williams (another just-returned Fulbrighter), Europeans were ready "to drink deep of this fresher, more abundant life of ours." Continental professors of English were hurriedly converting themselves into "professors of American"; European periodicals were full of American book news; American literature seminars held at Salzburg University drew throngs of bright European students. At home, according to the political journalist Richard Rovere, the literary establishment had grown "huge and prosperous," even though, in relation to the whole population, fewer Americans read books in 1950 than in 1850.[57]

An oft-noted sign of American cultural maturity was the fact that instead of rebelling against the college and university influence and heading for Greenwich Village or Europe, aspiring young artists now sought creative ferment within those former academic bastions of genteel culture. American colleges and universities, the novelist Wallace Stegner recognized as early as 1949, were completing a generation-long process of assuming the lead instead of resisting innovation in the arts. Within a few years Aldridge was protesting against the paradoxical growth of an "established avant-garde" based in university creative writing courses and workshops and in the increasingly specialized scholarship and criticism carried on in university-related quarterlies. The proliferating quarterlies had apparently supplanted the little magazines as the sponsors and beneficiaries of the avant-garde.[58]

That was part of the rather amazing expansion of critical scholarship in the decades after World War II. Jay B. Hubbell, the long-time editor of the quarterly *American Literature,* recalled that at the Modern Language Association's 1923 convention in Ann Arbor, Michigan, a grand total of twenty-five people showed up for the meeting of the American Literature Group. Forty years later the group could expect as many as two thousand to attend some of its sessions at the MLA conventions. Meanwhile American literary scholarship had grown exponentially. It took forty-seven years, from 1891 to 1938, to produce a thousand doctoral dissertations on American subjects but only fourteen years to produce another thousand. Between 1961 and 1966, scholars finished about 260 such dissertations each year, not only in the United States but in Canada and Europe as well. By 1957, according to one report, about half of all current American publications in literary criticism dealt with American writing. Certainly Howard Mumford Jones's fellow academicians had heeded his exhortations to involve themselves more with the national letters, even if the time given to teaching American literature did not yet equal the quantity of scholarship and if the historical method Jones pursued was generally out of favor.[59]

So was the nationalistic attitude out of favor. In 1923, as Hubbell remembered it, most of the American Literature Group's discussion had centered on what then seemed a burning question: whether American writing should be studied primarily as an offshoot of British literature or as an expression of the "national consciousness." "Nowadays," Hubbell remarked in the 1960s, "scholars and teachers are little concerned with literary nationalism and have little interest in literary history." Preoccupied with theory and methodology, with symbolic meanings and other analytical devices, students of American writing focused "not upon the national but the international aspects of American literature." Most teachers in the burgeoning university-based creative-writing programs, commented another observer, "would not think of urging young writers to try to define themselves as Americans in any particular way in their writing, or to act as the evangels of a new spirit."[60]

The story was much the same in the other arts. Social realism was passé in the postwar American theater; neither the limited revolutionary spirit of the early thirties nor the more widespread reaffirmative spirit of the last half of that decade was much in evidence. The leading genre on Broadway was psychological drama, advanced especially in the intense, demanding plays of Tennessee Williams and later of Edward Albee. It was safer to concentrate on inner realities, however outlandish and grotesque they might be, in a period that saw repeated

congressional investigations of Communist influence in the arts and entertainment media and the general acceptance of the practice of blacklisting present or former political radicals. "In the thirties," sourly commented Eric Bentley (another Britisher who had helped reverse the historic pattern of expatriation), "you felt the reassuring presence of the 'real' at the mention of a Worker. Today [1954] you feel it at the mention of a Homosexual." Looking back over the previous twenty years or so in 1965, Harold Clurman noted the irony that in the midst of unprecedented prosperity, the most highly regarded plays had been depressed, whereas the plays of the Depression era had been generally hopeful. Contemporary dramatists had all too often "exiled themselves in the ghettos of their egos."[61] In terms of mood and spirit, the postwar theater had little to offer those who still longed for a drama that would be an expression of the people and their ideals.

Institutionally the long-standing hopes of cultural nationalists also went unfulfilled. Nothing in the postwar period filled the place of the Federal Theatre Project. Outdoor pageants made a considerable comeback and became major tourist attractions during the summer months in various parts of the country. By 1973 it was possible to see eight of Paul Green's pageants—or "symphonic dramas," as Green preferred to call them—in one summer season. The University of North Carolina, with whose drama program Green had long been associated, had even established an Institute for Outdoor Drama in 1963. Yet if historical pageantry thrived in the postwar decades, it did so as a minor dramatic art, unaccompanied by the kind of messianic rhetoric that had sparked the pageant movement in the years before the First World War.[62]

By the 1970s Broadway saw fewer than fifty original productions each season, as opposed to the all-time high of 270 in 1927–28. As prospects grew increasingly bleak for much of anything in New York except musicals and an occasional hit comedy, melodrama, or revival of a classic, the local or "tributary" theaters still appeared as the salvation of American drama. Theatrical activity did become more decentralized in the postwar decades, even though, as Norris Houghton had predicted in 1941, New York remained the mecca for talent and the standard for judging dramatic excellence. Yet as Houghton had also foreseen, there would "spring forth on the way to Mecca a thousand oases." In terms of physical facilities, physical access, funding, and quantity and quality of talent, local and regional theater groups experienced remarkable growth in the fifties and sixties. While university dramatic programs became hotbeds of avant-gardism, many cities seemed to vie with each other in constructing opulent, imaginatively designed and engineered performing-arts centers. Cities like Houston, Dallas, and Minneapolis, once thought of as cultural back-

waters, developed nationally renowned theater companies. By 1966, for the first time since the passing of the old theatrical circuits at the beginning of the century, more professional actors were working in "resident professional theaters" than on Broadway or on tour.[63]

Yet the same complaints critics had made about the shortcomings of the little theaters in the twenties could still be heard forty years later. "To call them collectively the Tributary Theatre is misleading," said Bentley. "They are rather the Parasitic Theatre drawing what little life they have from New York." In 1965–66 Julius Novick surveyed twenty-five local professional theaters scattered across the country and found that Shakespeare, Shaw, Molière, and the German expressionist Bertolt Brecht were substantially favored over the most frequently performed American playwrights: Albee, Williams, O'Neill, and Wilder. Despite the cultural building boom, performing companies often were short of money and thus relied on predictably popular material. Speaking to neither a general local audience nor to the avant-garde, willing "to peddle standard merchandise in which they have no personal stake," the local theater companies were becoming " 'super-marketized.' "[64]

## VI

Almost anywhere one looked on the cultural landscape in the postwar decades, signs were plentiful of rich and diverse creativity. That creativity thrived amid a material prosperity such as the American arts and American artists had never known before. It was equally apparent, however, that the nationalistic concerns that had so agitated creators and critics in the prewar decades had pretty much subsided. In 1956 Roger Sessions characterized the younger generation of American composers as little interested in musical nationalism, "a formula too facile to constitute a definitive solution to our musical problems." Such matters, according to Sessions, had "lost the freshness of a new approach and . . . acquired the character of a provincial manifestation." In the wake of the war and the migration to the United States of much of Europe's musical talent, nationalism had given way to "the occidental spirit, finding in that spirit not only the premises but the basic directives which have given our national development its authentic character." Composers had come to accept the international, Western tradition as the best source for American music. Now the main task of the American composer was the "basically simple" yet immemorial one of "bringing to life the music to which he listens within himself." Sessions quoted an aphorism from Arnold Schoenberg: "A Chinese

philosopher speaks Chinese, of course; but the important thing is: What does he say?"[65]

That seemed to sum up the feelings of most American composers, certainly the younger generation coming along in the postwar era. Some of the older composers still worked in an Americanist vein. Roy Harris continued to write imposing compositions in the symphonic form and to incorporate—critics might say cram—all kinds of popular and folk derivations into them. In the forties and fifties Henry Cowell composed a long series of pieces collectively called *Hymns and Fuguing Tunes,* based on materials from backwoods America. Douglas Moore scored a considerable success at the New York City Opera in 1956 with *The Ballad of Baby Doe* (libretto by John LaTouche), an opera based on the true rags-to-riches-to-rags-again adventures of Baby Doe Tabor in the Colorado gold fields. Aaron Copland set his opera *The Tender Land,* given in its definitive version at the Berkshire Music Center in the summer of 1954, on a farm in the contemporary Middle West.[66]

As early as 1947 Copland had written a friend, "I no longer feel the need of seeking out conscious Americanisms. Because we live here and work here, we can be certain that when our music is mature it will also be American in quality. American individuals will produce an American music, without any help from self-conscious Americanisms."[67] In the 1960s Copland admitted that he had been "downright naive" in supposing that later generations of American composers would want to build on what he and others had done in the twenties and thirties. "Today's gods live elsewhere," Copland mused. The most striking tendency among younger American composers was a close involvement with such European avant-garde innovations as twelve-tone music and electronically produced sounds—a tendency their elders commonly took to be a regression after decades of struggle to escape European musical domination. As Copland saw it, "The young composer of today . . . seems to be fighting hard to stay abreast of the fast-moving post–World War II European musical scene." Even Virgil Thomson, never one to worry much about national distinctiveness, noted with regret in 1970 that, for all America's elaborate musical superstructure of "libraries, historians, pedagogues, and performers," its "population quite expert at listening and terrifyingly addicted to it," and its "excellent composers of all ages and all schools," its music had become largely occupied with "engineering games." Once again Americans were following European leads toward European expressive goals.[68]

An increasingly esoteric modernism had carried the day in American composition. By the time he died in 1954, Charles Ives had supplanted

Edward MacDowell as the man generally recognized to be the country's first really significant composer. That recognition had more to do with Ives's role as a lonely, prophetic innovator in the broad history of twentieth-century Western music than with his romantic-nationalist social and political beliefs and the strongly Americanist orientation of much of his work. American avant-gardists, as well as many of the older native composers, had a considerably easier time getting their music played by first-rate symphony orchestras than they had before the war—in large part because of the steady multiplication of such aggregations under a postwar boom that was both economic and cultural. (With the passing of wartime patriotic fervor, though, there apparently was a *relative* decline in the concert presentation of American music.) [69] For the most outré works, an initial performance was nearly always obtainable through conservatories or college and university schools of music, which were no longer the citadels of musical conservatism they had once been but were now usually in the first rank of the avant-garde.

Jazz had won acceptance and respect from the critics and musicologists, many of whom now hailed it as America's only wholly original contribution to world music. The relationship between jazz and formal music, however, was increasingly tenuous in the postwar decades. At last taken fully on its own terms, jazz no longer seemed to have any potential for inspiring or transforming "serious" music. Jazz continued on its own erratic course, as a form still alternately termed "popular" or "folk" but actually more and more remote from either the popular ambience or its folk origins. From the big bands, careful arrangements, close harmonies, and smooth, danceable rhythms of swing, postwar jazz quickly moved to the more individualized and improvisational, frequently harsh complexities of bebop, then on to the subdued complexities of cool jazz and still other new modes.[70]

Jazz was no longer very danceable, no longer appreciated by a broad public, increasingly the province of a specialized, informed audience. By the sixties it was not unusual to see jazz referred to as a form of "art music." Dixieland or "classic jazz," billed as genuinely American, became a phenomenally successful export in the Department of State's cultural exchange programs. At home, though, jazz was only one part of a highly fragmented musical culture encompassing everything from twelve-tone to tearful ballads, from neo-Baroque to bluegrass country, from a revived ragtime to rock and roll. It all seemed to demonstrate the appropriateness of the question the critic and historian John Tasker Howard had posed back in 1932: "What then is more characteristic of us than that our composers should represent totally different types and produce all kinds of music?"[71]

Maybe more than anything else, the spectacular rise in the mid-fifties of a new kind of popular music, rock and roll, testified to that fragmented culture. Basically a fusion of black blues and white country music, rock and roll quickly dominated the youth music market, which in turn dominated record-buying in the fifties. Rock and roll was decidedly "popular," but really only with a specialized audience consisting almost wholly of teenagers and young adults. Much of the older population, in fact, was appalled by early rock and roll, especially the shouting, hip-swiveling style of Elvis Presley, its most sensational propagator.[72] Much more than jazz ever had, rock and roll won huge followings in Europe and all over the world.

By the early sixties rock and roll had blended with the urban folk music around since the late thirties as well as with a growing variety of other influences to produce "rock." And by then America's youth-oriented popular music had become a vital part of a complex, fast-changing international cultural scene. It was ironic that, having finally completed a long, long process of throwing off European taste in the traditional arts, Americans should then reestablish a flourishing Anglo-American connection in the popular arts, not only in music but in motion pictures and television as well.

## VII

A thoroughgoing avant-gardism ruled American visual art during the late forties and all of the fifties. Actually, well before the war abstractionism had begun to make a comeback in painting and sculpture. Older abstractionists like the painter Stuart Davis and Alexander Calder, famous for his protean sculptural "mobiles," had continued to work productively through the thirties. In 1935 the Whitney Museum of American Art put aside its early bias toward realism long enough to stage a retrospective "Abstract Painting in America" show. By the end of the thirties abstractionism was making a strong surge, especially in the work of a group of younger artists who studied with Hans Hofmann in New York and in 1937 formed the nucleus for the American Abstract Artists. Like the group around *Partisan Review* (which made its reappearance that same year), the American Abstract Artists saw the avant-garde creator, not the proletarian, as the truly revolutionary agent in modern society. They called on artists to repudiate both Left social realism and American Scene in favor of radical nonrepresentationalism. In their preference for severely geometrical compositions, Balcolmb Greene, Harry Holtzman, Ibram Lassaw, and the others in the AAA group did not have much direct influence on

the abstract expressionists who would dominate American visual art in the postwar period. They did, though, reassert the creed of modernism in a period when the question of the social responsibilities of art and artists occupied most critical thinking.[73]

Abstract expressionism pushed the logic of radical modernism toward the outermost reaches of social irresponsibility in art and the innermost reaches of personal statement. With their seemingly random daubings, smears, and slashes of paint and their strange sculptural compositions using welded metal, twisted wire, and pasted glass and wood, the abstract expressionists virtually abandoned not only recognizable form but also any obligation to communicate with general society. Under the sway of wartime idealism, the modernist enthusiast Samuel Koontz might proclaim that "Our revolt against conservatism, against reaction, has made our painters part of a world movement to perpetuate liberal democracy. . . ." Fifteen years later the British art historian Laurence Gowing might find intrinsic Americanisms in the abstract expressionists' fondness for huge canvases, bold and even brutal execution, and unpredictable configurations.[74] Most of the abstractionists themselves, though, were simply not interested in such efforts to link art to the larger concerns of society, to the appreciative capabilities of Everyman, or to the concept of national distinctiveness.

In a letter to the New York *Times* in 1943, Mark Rothko and Adolph Gottlieb acknowledged that their paintings were not meant for people who wanted "pictures for the home; pictures for over the mantel; pictures of the American scene; social pictures; . . . the Corn Belt Academy; buckeyes, trite tripe, and so forth." "The artist's problem is with what to identify himself," wrote the painter Robert Motherwell the next year. "The middle class is decaying, and as a conscious entity the working class does not exist. Hence the tendency of modern painters to paint for each other." Jackson Pollock, soon to become famous for his paint-bucket drippings on long stretches of paper, announced that "The idea of an isolated American painting, so popular in this country during the thirties, seems absurd to me just as the idea of creating a purely American mathematics or physics would seem absurd." A former student of Thomas Hart Benton who now saw that training as "something against which to react strongly, later on," Pollock was convinced that "the basic problems of contemporary painting are independent of any country."[75]

Aided stoutly by the immigration of a number of Europe's leading modernist painters and sculptors in the war period, America's abstractionists left far behind the major presumptions of the thirties, including that decade's characteristic concern for finding a usable past. "Consciously abandoning the past is the essentially American creative

act," said Motherwell. "We painters here remain indifferent to the objects surrounding us. Our emotional interest is not in the external world, but in creating a world of our own." Insofar as the postwar abstractionists shared a common social ethic, it seemed to be, as Oliver Larkin phrased it, "that the deeper art penetrates, the closer it comes not to what makes people different but to what they have in common."[76]

As critics and scholars on both sides of the Atlantic quickly understood, abstract expressionism, the first movement in visual art to originate wholly within the United States, was the major influence in Western painting and sculpture in the mid-twentieth century. Whereas American visual modernism in the decade after the Armory Show had drawn its inspiration and most of its instruction from Europe, the so-called New York School of the 1950s clearly supplanted the long-standing hegemony of the European avant-garde. The Whitney Museum of American Art came fully to terms with modernism in a significant exhibition in 1946, and the Museum of Modern Art and a swelling number of other institutions ardently supported the modernist movement now centered in the United States.[77]

At the height of Cold War tensions in the fifties, anti-Communist militants in Congress, most notably Representative George Dondero, a Michigan Republican, frequently attacked abstract expressionism as decadent, subversive, and Communist inspired. At the same time, curiously enough, they harassed various realists who had been associated with Left activities over the previous two decades. Members of the still-surviving National Academy of Design, the equally conservative National Sculpture Society, and the remnants of the American Scene movement concentrated in the Associated American Artists sometimes lent their support to political denunciations of abstractionism, thereby reducing the historic quarrel between modernists and anti-modernists to its lowest point yet. But after President Eisenhower refused to authorize the censorship of paintings and sculptures to be shown at an American cultural exhibit in Moscow in 1959, even Congressmen began to claim nonrepresentational art as a healthy manifestation of the intellectual and artistic freedom Americans enjoyed, as opposed to the enforced conformity to an official cultural orthodoxy in the Soviet Union.[78]

At any rate, American visual art continued its robust evolution unhindered by further political and ideological controversy through the sixties and into the seventies. That period brought a resurgence of "post-painterly," linear abstractionism and the onset of Pop Art, a mechanistically oriented realism (or pseudorealism) having kinship with earlier Dadaism. American painting also experienced another wave of realism, this one characterized by tightly controlled technique

and a choice of subject matter that was prevailingly somber and sub-
dued. The late twentieth-century art scene featured a remarkable vari-
ety of other styles and approaches, including a still-vital abstract ex-
pressionism.[79] In all this the question of the Americanness in American
art appeared either beside the point or answerable only the way Martha
Candler Cheney had answered it back in 1939: "The paradox of our
American art is its un-Americanness, its mobile, transitory, polyglot
character; and in its lack of any elements of homogeneity and com-
monly prevalent idealism may be the measure of the promise for its
future."[80]

Even the question of whether the creative person should or should
not be alienated—should speak against or in concert with dominant
American attitudes and beliefs—had begun to lose much of its potency.
The concept of the lonely artist struggling against a hostile and philis-
tine public began to seem dated in the affluence the American arts
enjoyed after World War II. At the height of the Cold War Adolph
Gottlieb could observe that at least the contemporary artist was totally
free to be an artist if he would and take his lumps accordingly. And
while Americans could no longer repair to a qualitative standard that
was lesser than the standard for Europe, they no longer had to strug-
gle with a national inferiority complex, either. Therefore, "we are no
longer either chauvinists or expatriates."[81]

One of the striking manifestations of the artistic affluence of the
fifties and sixties consisted of the lavish, sometimes breathtaking mu-
seums and performing arts centers constructed in numerous places
across the country. Probably the most spectacular of the new museums
was the Solomon R. Guggenheim in Manhattan, designed by Frank
Lloyd Wright and finished about six months after Wright died in
the spring of 1959, two months short of his ninety-second birthday.
Responsible for a number of the most remarkable additions to the
postwar architectural landscape, including the Price Tower office build-
ing in Bartlesville, Oklahoma, and the nuclear campus for Florida
Southern College, Wright enjoyed almost universal acclaim in the
period after 1945. Like Charles Ives, Wright lived long enough to see
the general acceptance and widespread use of technical innovations
that most people in his art had found intolerable when he first ad-
vanced them. Maybe the accumulative effect of his ideas was most evi-
dent in the naturally integrated settings, flowing interiors, and generous
use of local materials in the period's best residential architecture.[82]

Even as a very old man, though, Wright still would not moderate his
protests against what he saw as America's moral hypocrisy and material-
istic obsessions. He remained an ardent midwestern nationalist, an
unwavering believer in the proposition that the artist was obliged to

work to fulfill the promise of American democracy. Yet in the cultural climate of his last decade, Wright's romantic views and values had lost much of their edge.

In fact, the preeminent mode in commercial and institutional architecture during that decade was the kind of modernism Wright had always despised—the impersonal, boxlike, European-derived International Style. In the thirties many architects and critics had tried to transmute international modernism into an architecture uniquely suited to the democratic traditions and collective needs of the American people in the crisis of the Great Depression. The triumph of the new architecture after World War II, however, took place at a time of increasing internationalization in architectural thought. As a consequence, the vast building boom of the postwar era was not accompanied by an extension and updating of the historic controversy over how the United States might finally arrive at its own distinctive architectural style.[83] Like the other arts, American architecture turned out to have an amazing range of expressions and variations, especially in the persistent regionalisms that showed up in residential design. Even when a reaction to the glass rectangles of the International Style set in after 1960, those who supported the trend toward richer, more idiosyncratic conceptions, like Eero Saarinen and Edward Durrell Stone, did not bother to revive the issue of a national architecture. Again as in the other arts, in architecture it was possible to take for granted if not a national style then at least substantial national maturity.

## VIII

By the late fifties/early sixties there was much talk about a "culture explosion" in America. In 1964 the journalist Alvin Toffler published a widely discussed book entitled *The Culture Consumers*. Toffler enthusiastically advanced the thesis that "since the end of the last World War a series of astonishing, and on the whole healthy, changes have transformed the social bases of the arts in this country." Rejecting the stereotype of the uncouth American (an image already much faded anyway), Toffler went on to argue that throughout the country—not just in New York and the other major cities but in all kinds of unlikely locations—ordinary Americans were involving themselves with the arts in greater numbers than had ever been the case with any people anytime. "The truth is," Toffler said, "that there has been a historic shift in the place of the arts in American life." As both audience and as participants, Americans consumed culture—and con-

sumed it with remarkable energy, comprehension, and even independence of taste. At last "a maturing nation is beginning to concern itself with the quality of existence."[84]

Toffler's focus was on the boom in the traditional or "fine" arts—in other words, the popular discovery of "high culture" in America. By that time, though, it had become more difficult than ever to make hard and fast distinctions between fine and popular art. There were still those who insisted on trying. Gilbert Seldes, for example, was still arguing in the fifties that at their best the "public arts," as he now called them, at least equaled the average level of creativity in the fine arts. Moreover, because of their powerful hold on the consciousness of Americans of all ages and classes, they were "also media of communication, and bring up social questions so important that at times it is hard to remember their primary function as entertainment." Thus it was incumbent on everybody who wanted to understand American life to come to terms with popular culture and its "great audience."[85]

The attack on "mass culture" as a suffusive, enervating influence came mainly from a group of intellectuals who mostly either had been or still were associated with *Partisan Review*. Some of them, like Philip Rahv, traced the genealogy of the gaudy but empty commercial pseudo-art they called *kitsch* back first to the Communist cult of socialist realism and then on to the indiscriminate Americanism of the Popular Front and neo-Popular Front. Others viewed mass culture as endemic to the breakdown of the older social elites, the destruction of cohesive communities, and the triumph of mass democracy, which had brought an inevitable vulgarization of taste. William Phillips, for example, referred contemptuously to "the populist, egalitarian, anti-intellectual attitudes so deeply rooted in American history." Lionel Trilling remarked more politely that whenever literature was "patently liberal and democratic," it was not of lasting interest, because that kind of art was unable to convey "the sense of being reached in our secret and primitive minds. . . ."[86]

Dwight Macdonald was distressed not only by the pervasiveness of *kitsch* but by what he saw as an even more sinister phenomenon: the emergence of a pretentious, denatured version of high culture he called "midcult." Apparently unaware of what Seldes had said more than thirty years earlier about the corruption of both the traditional and the "lively" arts by the "great god bogus," Macdonald described midcult as a recent development largely related to the rapid growth of a college-trained but essentially uncultured segment of the population. Typified in commercial television's dramatizations of classic plays and its gatherings of intellectuals to discuss complex public issues, by the

social-message movies made by Stanley Kramer and a few other Hollywood producers, and by the kind of fiction, poetry, and criticism published in the *Atlantic* or *Saturday Review,* midcult remained formularized and geared to the standard of popularity, even though it tried to conceal its crassness "with a cultural fig leaf."[87]

Macdonald, the *Partisan Review* editors, and other defenders of high culture believed that at all costs they had to sustain an avant-garde that was imperiled in modern mass society. After the 1950s, though, most commentators seemed to lose interest in the controversy over mass culture.[88] The avant-garde proved quite capable of sustaining itself, even if, particularly in the case of Pop Art painting and sculpture, avant-gardists often went directly to the forms and ambience of commercial popular culture for their subject matter.

Meanwhile, the intellectual discovery of popular culture under way since the 1920s went forward. Discussion no longer centered on whether such expression was worthy of critical and scholarly attention but on conceptual and methodological questions in what amounted to a new scholarly subdiscipline. The formation of the Popular Culture Association and the *Journal of Popular Culture* in the late sixties was only the most obvious sign of the intellectual legitimacy attaching to the study of what entertained the masses.[89] Maybe now the problem was actually overintellectualization. In the intensity and seriousness with which they expounded on everything from the social commentary in rock ballads to the taxonomy of detective fiction, from the mythic content in cowboy movies to the symbolism in souvenir pillows, scholarly specialists in the popular arts sometimes seemed to have forgotten the lighthearted and light-fingered approach Seldes had recommended long ago.

In the last half of the twentieth century an American renaissance was clearly at hand—a quantity, variety, and excellence of artistic expression that, as people as different as Walt Whitman and Edmund Clarence Stedman had hoped, finally matched American commercial and technological genius. The Second World War turned out to be the pivotal event in the history of the American arts. By shifting most of the world's political, economic, and military power to the United States, by ending the Great Depression and laying the basis for the sustained prosperity of the postwar decades, and by prompting the immigration to America of a large number of Europe's most advanced creative artists, the war profoundly altered the material and psychological circumstances in which the arts functioned. The hopes of early twentieth-century nationalists for such European-modeled institutional manifestations as a national symphony orchestra, opera, or theater and

a federal department of the arts never came to realization. In the mid-1960s the Congress did establish and provide funding for a National Endowment for the Arts along with a National Endowment for the Humanities. By 1977 NEA was granting $113.5 million to support the work of both individual artists and a great variety of organizations. Congressional skepticism about the expenditure of public money on certain especially obscure or outlandish projects was persistent, but NEA's leadership remained confident that the basic concept of long-term federal commitment to the arts and scholarship had won acceptance.[90]

Yet neither the people who ran the National Endowment for the Arts nor anybody else seemed interested in trying to promote a national style or even in encouraging artists to say something that would be comprehensible to Americans in general. Mainly as a consequence of the war, America's arts and ideas about art had taken on an international orientation that, except in the thinking of a relatively small number of radical modernists, had been lacking in the prewar period. "Thus Ulysses has come home to preside over the Atlantic Community, an international culture in which the images of Europe and America blend and blur." That was the way a *Partisan Review* contributor summed up the matter in 1958. Despite all the earlier efforts to identify the characteristic features of a distinctively American culture, it was "as if Columbus had never sailed the ocean blue."[91]

For those who had gone in search of that distinctive culture, the affluent, abundant condition of the postwar arts was fine in itself but less than satisfying in terms of art's larger purposes. John Martin, for example, was pleased to note in 1968 that both the federal government and the state of New York now subsidized dance, that the New York City Ballet (originally the American Ballet Company) together with the affiliated School of American Ballet constituted one of the world's great ballet outfits, and that modern dance seemed everywhere to have won the public acceptance he had urged in the thirties. Yet Martin also described the bright new performing arts centers scattered across the country as "large supermarkets of the arts, consisting of sumptuous edifices with nothing specific to put into them."[92] That something specific Martin had once characterized as national expression, the kind of art Americans had to have for themselves because nobody else's art could capture their own experience.

Such thinking—at least as it related to a broadly American national culture—was hard to find in late twentieth-century America. It was a curious fact, though, that after the Second World War, as American cultural nationalism went into sharp decline, there was a marked willingness among intellectuals to identify, examine, and encourage the

cultural expressions of various minority elements within the general population, particularly white southerners, black Americans, and Jewish Americans.[93]

The fifties featured a pronounced critical affinity for contemporary southern literature. Various white southerners, most of all William Faulkner and Tennessee Williams, had supposedly offered an alternative, tragic vision to the "progressivism" and "innocence" of majoritarian America. Meanwhile, in the aftermath of the Holocaust and the founding of the state of Israel, there was an upsurge of Jewish consciousness in all the arts. Suddenly, it seemed, critics discovered the "special case" of the Jewish writer in America, just as they discovered preeminently Jewish qualities in a painter like Max Weber. Then the late sixties brought an awakening black self-awareness. Besides a substantial body of fiction, poetry, drama, and criticism and a strong social consciousness in visual art, manifestations of black awareness included the veneration of blues singing, the celebration of blues-influenced "funky" and "soul" styles in popular music, and the reassertion—this time mainly by black essayists—of the uniquely black origins and essential content of jazz. In all this minority cultural consciousness, the obvious though usually unstated assumption was that artistic expression—insofar as it had to do with a search for group self-identity within the American mass—was intimately related to circumstances of history and the contemporary social environment.

Yet that same assumption, when applied to American national expression, seemed no longer viable. In art as in politics, said a *Nation* essayist in 1966, "nationalism usually strikes us as a taking away of humanity, an aggressive substitution of one kind of relation for all others." Maybe there was no truly national experience. Maybe, as Eric Bentley maintained in 1949, there was no American character, "only an American situation."[94] Maybe the country had always been too big, too socially fragmented, made up of people from too many different backgrounds. Maybe the most that could ever happen was something like the association of diversities Randolph Bourne and subsequent advocates of "cultural pluralism" among social scientists and social philosophers had envisioned.

But once, a big proportion of people involved with the arts had thought that talented, creative Americans should and someday would write novels and poems and plays, compose music, paint and sculpt, design buildings, and even dance in such a way as to capture fundamental American qualities. The American arts, so the theory went, should become the unique utterance of a unique people, a people just coming of age in the early decades of the twentieth century. Not "Western man" or "modern man" but America and Americans should

be the principal subject matter of American-produced expression. The *Seven Arts* essayists had believed that. So had Louis Sullivan and Frank Lloyd Wright, Thomas Hart Benton and Thomas Craven, Roy Harris and George Gershwin, John Howard Lawson and Paul Green. So had a great number of others, from Stuart Sherman at one extreme to Michael Gold at the other.

In terms of artistic accomplishment, America's coming of age was fully evident by mid-century. All the impassioned, sustained calls for an American renaissance had actually worked as a self-fulfilling prophecy. Exhortation had helped inspire exertion; awareness had led to achievement. It was a renaissance more in line with what Ezra Pound or Alfred Stieglitz had wanted than what Van Wyck Brooks or Robert Henri had hoped for. Was that enough? Evidently it was for the many creative artists living in relative comfort in their teaching jobs, on government and foundation grants and fellowships, or off their own work as established figures. Evidently the critics as well were satisfied with the post–World War II version of American cultural fulfillment.

Yet for those in the romantic-nationalist tradition of Emerson and Whitman, the concept of a national coming of age had always meant more than the quantity of art the country produced or even its technical excellence. Art, they believed, was or should be life itself, a transforming, ultimately revolutionizing force. Inasmuch as the problem with America always had been and still was spiritual, then America's coming of age meant nothing less than the spiritual regeneration of the American people.

The history of cultural nationalism in twentieth-century America is ultimately a story of failure—the failure of an idea and a belief to sustain themselves in the face of swift intellectual and social change. That failure, Howard Mumford Jones suggested in 1965, meant "either that the American dream has been universalized or that it has disappeared. . . ."[95] And if Americans of the late twentieth century could glory in their continuing artistic renaissance, they still seemed a long way from their regeneration—through art or otherwise.

# Notes

### Chapter 1: The Genteel Tradition in Sway

1. Edmund Clarence Stedman, ed., *An American Anthology, 1787–1900* (Boston: Houghton Mifflin Company, 1900), xxxiii; William Cranston Lawton, "Cosmopolitan Tendencies in American Literature," *Sewanee Review*, XIV (April 1906), 160.

2. A good treatment of the sources of romantic esthetic nationalism in Europe is Mary M. Colum, *From These Roots: The Ideas That Have Shaped Modern Literature* (New York: Charles Scribner's Sons, 1937).

3. Quoted in Edmund Wilson, "Literary Criticism and History," *Atlantic Monthly*, LXVIII (November 1941), 611.

4. H. A. Taine, "Introduction," to *History of English Literature*, trans. H. Van Laun, 4 vols. (New York: Henry Holt and Company, 1874), I, 1–21; H. Taine, *On Intelligence*, trans. T. D. Haye, 2 vols. (New York: Henry Holt and Company, 1884), I, vii.

5. *Edinburgh Review*, XXXIII (January 1820), 79–80.

6. Edward Waldo Emerson, ed., *The Complete Works of Ralph Waldo Emerson*, 12 vols. (Boston: Houghton Mifflin Company, 1903–1904), I, 81–82, 114.

7. Walt Whitman, "Have We a National Literature?" *North American Review*, CLII (March 1891), 332–38; Benjamin T. Spencer, *The Quest for Nationality: An American Literary Campaign* (Syracuse: University Press, 1957), 219–51.

8. See George Knox, "In Search of the Great American Novel," *Western Review*, V (Summer 1968), 64–77; Herbert R. Brown, "The Great American Novel," *American Literature*, VII (March 1935), 1–14; Charles A. Campbell, Jr., "The Great American Novel: A Study in Literary Nationalism, 1870–1900" (Ph.D. dissertation, University of Minnesota, 1951).

9. Quoted in Spencer, *Quest for Nationality*, 337. See also Spencer, "Nationality during the Interregnum, 1892–1912," *American Literature*, XXXII (January 1961), 434–45.

10. Barr Ferree, "An 'American Style' of Architecture," *Architectural Record*, I (July–September 1891), 45; Donald Pizer, ed., *The Literary Criticism of Frank Norris* (Austin: University of Texas Press, 1964), 123; Cora Lyman, "Our Most Belated Art," *Forum*, LI (March 1914), 435; William Dean Howells, *Literature and Life* (New York: Harper and Brothers, Publishers, 1902), 174.

11. Christian Brinton, "The Case for American Art," *Century*, LXXVII (November 1908), 139; Greenough quoted in F. O. Matthiessen, *American Renaissance: Art and Expression in the Age of Emerson and Whitman* (New York: Oxford University Press, 1941), 145–46; Lowell quoted in Bradford Torrey, "The Demand for an American Literature," *Atlantic Monthly*, LXXIX (April 1897), 573.

12. Lorado Taft, *The History of American Sculpture*, 2d ed. (New York: Macmillan Company, 1924), 537.

13. Matthew Arnold, "Numbers, or the Majority and the Remnant," *Nineteenth Century,* XV (April 1884), 669–85. See also John Henry Raleigh, *Matthew Arnold and American Culture* (Berkeley: University of California Press, 1957).

14. Henry F. May, *The End of American Innocence: A Study of the First Years of Our Own Time,* 1912–1917 (New York: Alfred A. Knopf, Inc., 1949).

15. Malcolm Cowley, ed., *After the Genteel Tradition: American Writers since 1910* (New York: W. W. Norton and Company, 1937), 17.

16. Stow Persons, *The Decline of American Gentility* (New York: Columbia University Press, 1973), 55–59.

17. "The Great American Novel," *Dial,* XXI (December 1, 1896), 319. See also Bernard Duffey, *The Chicago Renaissance in American Letters* (East Lansing: Michigan State College Press, 1954); Helen Lefkowitz Horowitz, *Culture and the City: Cultural Philanthropy in Chicago from the 1880s to 1917* (Lexington: University Press of Kentucky, 1976).

18. William Dean Howells, *Criticism and Fiction* (New York: Harper and Brothers, Publishers, 1892), 188.

19. Ibid., 128–29; Hamlin Garland, *Crumbling Idols: Twelve Essays on Art . . .* (Chicago: Stone and Kimball, 1894), 44, 93; Clara M. Kirk, "Toward a Theory of Art: A Dialogue between W. D. Howells and C. E. Norton," *New England Quarterly,* XXXVI (September 1963), 297.

20. Richard E. Cauger, "The Concept of the Puritan in American Literary Criticism, 1890–1932" (Ph.D. dissertation, Northwestern University, 1964); R. B. Hovey, "George Edward Woodberry: Genteel Exile," *New England Quarterly,* XXIII (December 1950), 504–26.

21. Susan Hobbs, "John LaFarge and the Genteel Tradition" (Ph.D. dissertation, Cornell University, 1974); Kenyon Cox, "The American School of Painting," *Scribner's Magazine,* L (December 1911), 765–68. See also William Crary Brownell, *Standards* (New York: Charles Scribner's Sons, 1917).

22. H. Houston Peckham, "Lopsided Realism," *South Atlantic Quarterly,* XV (July 1916), 280, 299.

23. Howard Mumford Jones, "The Genteel Tradition," *Harvard Library Bulletin,* XVIII (January 1970), 6; Jones, *The Age of Energy: Varieties of American Experience, 1865–1915* (New York: Viking Press, Inc., 1971), 216–58.

24. For a characteristic statement on this issue, see "Art for Art's Sake: Its Fallacy and Viciousness," *Art World,* II (May 1917), 98–102.

25. Quoted in Matthiessen, *American Renaissance,* 187.

26. Francis Fisher Browne to Hamlin Garland, October 18, 1893, Francis Fisher Browne Papers, Newberry Library, Chicago.

27. See Charles Fenton, "A Note on American Expatriation," *Western Humanities Review,* XIV (Summer 1960), 323–39.

28. Lyman, "Our Most Belated Art," passim.

29. Charles Fenton, "The American Academy of Arts and Letters against All Comers: Literary Rags and Riches in the 1920's," *South Atlantic Quarterly,* LVIII (Autumn 1959), 585. See also Fenton, "The Founding of the National Institute of Arts and Letters in 1898," *New England Quarterly,* XXXII (December 1959), 435–54.

30. Charles Eliot Norton, *Letters of Charles Eliot Norton, with Biographical Commentary by His Daughter Sara Norton and M. A. DeWolfe Howe,* 2 vols. (Boston: Houghton Mifflin Company, 1913), II, 166; Norton, "The Educational Value of the History of the Fine Arts," *Educational Review,* IX (March 1895), 346; Jones, *Age of Energy,* 238–41; Kirk, "Toward a Theory of Art," 291–319.

31. James Brander Matthews to William Petersfield Trent, March 2, 1896; July 24, 1898, William Petersfield Trent Papers, Special Collections, Baker Library, Columbia University, New York City; Brander Matthews, "American Literature," *Harper's Weekly,* XL (July 11, 1896), 683f; Matthews, "Suggestions for Teachers of American Literature," *Educational Review,* XXI (January 1901), 11–16. Curiously, while in his published writings Matthews emphasized the subordination of American to English letters, in private correspondence he could assert "the claim for us Ameri-

cans of a whole and individual half in English literature. . . ." Matthews to Trent, August 12, 1897, Trent Papers.

32. "The Editor's Study," *Harper's Monthly Magazine,* CVII (September 1903), 646–48.

33. Malcolm Cowley, *Exile's Return: A Literary Odyssey of the 1920's,* 2d ed. (New York: Viking Press, Inc., 1951), 28; Van Wyck Brooks, *An Autobiography* (New York: E. P. Dutton and Company, Inc., 1965), 399; Matthiessen, *American Renaissance,* xvii.

34. Fred Lewis Pattee, "Is There an American Literature?" *Dial,* XXI (November 1, 1896), 244; Howard Mumford Jones, *The Theory of American Literature* (Ithaca: Cornell University Press, 1948), 97–100. See also Percy H. Boynton, "The American Neglect of American Literature," *Nation,* CII (May 4, 1916), 480.

35. On More, see Francis Xavier Duggan, *Paul Elmer More* (New York: Twayne Publishers, Inc., 1966); Richard Ruland, *The Rediscovery of American Literature: Premises of Critical Taste, 1900–1940* (Cambridge: Harvard University Press, 1967), 11–56; Morton Dauwen Zabel, "An American Critic," *Poetry,* LC (September 1937), 330–36.

36. Paul Elmer More, *Shelburne Essays, Fifth Series* (Boston: Houghton Mifflin Company, 1908), 136. See also Francis Xavier Duggan, "Paul Elmer More and the New England Tradition," *American Literature,* XXXIV (October 1962), 542–61.

37. Ambrose Bierce, *The Collected Works of Ambrose Bierce,* 12 vols. (New York: Neale Publishing Company, 1909–12), VII: *The Devil's Dictionary,* 74; Huneker quoted in Walter Prichard Eaton, *The American Stage of To-day* (Boston: Small, Maynard, and Company, 1908), 6.

38. John Corbin, "The American Drama," *Forum,* XXXIV (July 1902), 70.

39. James Brander Matthews to William Petersfield Trent, August 12, 1897, Trent Papers; Jack E. Bender, "Brander Matthews: Critic of the Theatre," *Educational Theatre Journal,* XII (October 1960), 169–76.

40. Ernest Knaufft, "American Painting To-day," *Review of Reviews,* XXXVI (December 1907), 689; Katharine de Forest, "The Triumph of American Sculptors," *World's Work,* I (December 1900), 187.

41. See Lillian B. Miller, *Patrons and Patriotism: The Encouragement of the Fine Arts in the United States, 1790–1860* (Chicago: University of Chicago Press, 1966); Neil Harris, *The Artist in American Society: The Formative Years, 1790–1860* (New York: George Braziller Company, 1966).

42. E. P. Richardson, *Painting in America: From 1502 to the Present,* 2d ed. (New York: Thomas Y. Crowell Company, 1965), 360.

43. Samuel Isham, *The History of American Painting,* 2d ed. (New York: Macmillan Company, 1915), 562; Charles L. Buchanan, "American Painting versus Modernism," *Bookman,* XLVI (December 1917), 422; "The Promise of American Painting," ibid., XXXIV (December 1911), 352; Cox, "American School of Painting," 767; "A 'Purely American' Art," *Nation,* XCII (May 4, 1911), 441.

44. See Walter E. Kidney, *The Architecture of Choice: Eclecticism in America, 1880–1930* (New York: George Braziller, Inc., 1974); William H. Pierson, Jr., and William H. Jordy, *American Buildings and Their Architects,* 4 vols. to date (Garden City: Doubleday and Company, 1970–), III: Jordy, *Progressive and Academic Ideals at the Turn of the Century,* 314–75.

45. Charles Forcey, *The Crossroads of Liberalism: Croly, Weyl, Lippmann and the Progressive Era, 1900–1925* (New York: Oxford University Press, 1961), 36–49.

46. Herbert Croly, "American Artists and Their Public," *Architectural Record,* X (January 1901), 261–62; Croly and Henry W. Desmond, "The Work of McKim, Mead and White," ibid., XX (September 1906), 246; Croly, "The New World and the New Art," ibid., XII (June 1902), 151–53; Croly, "American Architecture of To-day," ibid., XIV (December 1903), 435.

47. Croly and Desmond, "Work of McKim, Mead and White," 182; Croly, "American Architecture of To-day," 430–35.

48. George W. Maher, "A Plea for an Indigenous Art," *Architectural Record,* XXI (June 1907) , 429–33; Croly, "What Is Indigenous Architecture?" ibid., 434–42.

49. Henry T. Finck, *My Adventures in the Golden Age of Music* (New York: Funk and Wagnalls Company, 1927) , 401; W. S. B. Mathews, "The Nineteenth Century and National Schools of Music, *Music,* XIX (February 1901) , 347.

50. The irony is that while Dvorák did not make literal use of spirituals, William Armes Fisher, one of his American students, adapted the melody of the Largo portion of the *New World Symphony* to the words of the poem "Goin' Home." The result was an enduring popular song—a pseudospiritual! See Gilbert Chase, *America's Music: From the Pilgrims to the Present,* 2d ed., rev. (New York: McGraw-Hill Book Company, 1966) , 387–88.

51. Antonin Dvorák, "Music in America," *Harper's Monthly Magazine,* XC (February 1895) , 428–34.

52. On MacDowell, see Lawrence Gilman, *Edward MacDowell* (New York: John Lane Company, 1908) ; John Erskine, "Edward MacDowell," in Alan Johnson and Dumas Malone, eds., *The Dictionary of American Biography,* 20 vols. (New York: Charles Scribner's Sons, 1928–36) , XII, 24–27; John F. Porte, *Edward MacDowell* (New York: E. P. Dutton and Company, Inc., 1922) ; Neil Leonard, "Edward MacDowell and the Realists," *American Quarterly,* XVIII (Spring 1966) , 175–82; Chase, *America's Music,* 346–64.

53. Quoted in Gilman, *MacDowell,* 83–85.

54. MacDowell quoted in Leonard, "Edward MacDowell and the Realists," 176; Chase, *America's Music,* 363; Finck quoted in "The One American Composer of World Rank," *Current Literature,* XLIV (March 1908) , 314; Charles L. Buchanan, "The National Music Fallacy," *Bookman,* XLV (March 1917) , 82.

55. Vincent d'Indy, "Impressions of Musical America," *Independent,* LXI (October 11, 1906) , 847–55; *Etude* quoted in "Is There a Distinctive Note in American Music?" *Current Literature,* XL (June 1906) , 636–37; Henry C. Lahee, *Grand Opera in America* (Boston: L. C. Page and Company, 1902) , 312–39; Henry W. Savage, "Opera in English for Americans," *Independent,* LII (May 10, 1900) , 1109–11; "Why Students Should Study in America," *American Review of Reviews,* XLV (April 1912) , 496; "A Musical Declaration of Independence," *Current Opinion,* LVI (March 1914) , 192.

56. Henry E. Krehbiel, "Music in America," in John Knowles Paine et al., eds., *Famous Composers and Their Works,* 16 vols. (Boston: J. B. Millet and Company, 1909) , II, 960; David Bispham, "The American Idea in Music," *Craftsman,* XV (March 1909) , 680.

57. See Morton White, *Social Thought in America: The Revolt against Formalism* (New York: Viking Press, Inc., 1949) .

58. "Our National Genius and Our National Art," *Harper's Weekly,* XLVII (February 28, 1903) , 349; Charles Leonard Moore, "The American Literary Instinct," *Dial,* XXXVIII (February 16, 1905) , 716.

59. Quoted in Stanley J. Kunitz and Howard Haycraft, eds., *Twentieth Century Authors: A Biographical Dictionary of Modern Literature* (New York: G. W. Wilson Company, 1942) , 1230.

60. Ibid., 1231. On Santayana, see also Paul K. Conkin, *Puritans and Pragmatists: Eight Eminent American Thinkers* (New York: Dodd, Mead, and Company, 1968) , 405–74; M. M. Kirkwood, *Santayana: Saint of the Imagination* (Toronto: University of Toronto Press, 1961) ; James Ballowe, "Introduction: Biography and Criticism," in Ballowe, ed., *George Santayana's America: Essays on Literature and Culture* (Urbana: University of Illinois Press, 1967) , 1–34; Gary Stoltz, "Santayana in America," *New England Quarterly,* L (March 1977) , 53–67; and Santayana's autobiography, *Persons and Places,* 3 vols. (New York: Charles Scribner's Sons, 1944–53) .

61. George Santayana, "The Genteel Tradition in American Philosophy," in *Winds of Doctrine: Studies in Contemporary Opinion* (New York: Charles Scribner's Sons, 1913) , 187–88.

62. Ibid., 188–200, 210.
63. Ibid., 192, 202–12.

## Chapter 2: **The Genteel Tradition at Bay**

1. Inasmuch as there was no general agreement at the time on whether there had been any prior "naissance," "nascence," or "surgence" in America, I prefer the interchangeable terms Insurgency and Rebellion as overall designations for the attitude of protest and innovation in all the American arts in the period beginning roughly around 1905–10.

2. George Santayana, "The Genteel Tradition at Bay," in Douglas L. Wilson, ed., *The Genteel Tradition: Nine Essays* (Cambridge: Harvard University Press, 1967), 151–96; originally published in *Saturday Review of Literature,* VII (January 3–17, 1931), 502–503, 518–19, 534–35.

3. Christopher Lasch, *The New Radicalism in America (1889–1963): The Intellectual as a Social Type* (New York: Alfred A. Knopf, Inc., 1965), ix–xiv and passim.

4. John S. McCormick, "A Beleaguered Minority: The Young Intellectuals and American Mass Society, 1910–1920" (Ph.D. dissertation, University of Iowa, 1973).

5. Carl Van Doren, *Contemporary American Novelists, 1900–1920* (New York: Macmillan Company, 1922), 146.

6. Kenneth S. Lynn, "The Rebels of Greenwich Village," *Perspectives in American History,* VIII (1974), 363–72.

7. Quoted in *Camera Work,* nos. 42–43 (April–July 1913), 43.

8. See Henry F. May, *The End of American Innocence: A Study of the First Years of Our Own Time* (New York: Alfred A. Knopf, Inc., 1957).

9. *Vanity Fair,* II (May 1914), 19. On the *Masses* see William O'Neill, ed., *Echoes of Revolt:* The Masses, *1911–1917* (Chicago: Quadrangle Books, Inc., 1966); O'Neill, *The Last Romantic: A Life of Max Eastman* (New York: Oxford University Press, 1978), 30–67; Thomas Alan Maik, "A History of *The Masses Magazine*" (Ph.D. dissertation, Bowling Green State University, 1968). For a characterization of the pre–World War I "Lyrical Left," as opposed to the Old Left of the 1930s and the New Left of the 1960s, see John Diggins, *The American Left in the Twentieth Century* (New York: Harcourt Brace Jovanovich and Company, 1973), 73–106.

10. "Colonialism Again," *Poetry,* X (May 1917), 92–97. The best account of *Poetry*'s first thirty years is in Frederick J. Hoffman et al., *The Little Magazine: A History and a Bibliography* (Princeton: Princeton University Press, 1947), 34–44. See also Harriet Monroe, *A Poet's Life: Seventy Years in a Changing World* (New York: Macmillan Company, 1938).

11. *Craftsman,* XI (October 1906), 128.

12. Ezra Pound to Harriet Monroe, August 18, 1912, in D. D. Paige, ed., *The Letters of Ezra Pound, 1907–1941* (New York: Harcourt, Brace and Company, 1950), 9–10; George Cram Cook to Susan Glaspell, Memorial Day, 1912, in Susan Glaspell, *The Road to the Temple* (New York: Frederick A. Stokes Company, 1927), 224–25. J. B. Yeats's "fiddles are tuning" remark has been quoted in many places, among them Van Wyck Brooks, "America's Coming-of-Age," in Claire Sprague, ed., *Van Wyck Brooks: The Early Years: A Selection from His Works, 1908–1921* (New York: Harper Torchbooks, 1968), 148.

13. Walt Whitman, "Have We a National Literature?" *North American Review,* CLII (March 1891), 336.

14. See Richard Schlatter, "The Puritan Strain," in John Higham, ed., *The Reconstruction of American History* (New York: Harper and Bros., Publishers, 1962), 25–45; William W. Abbot, "The Colonies to 1763," in Richard L. Cartwright and Richard B. Watson, Jr., eds., *The Reinterpretation of American History* (Washington: National Council for the Social Sciences, 1973), 248–58; Michael McGiffert,

"American Puritan Studies in the 1960's," *William and Mary Quarterly*, Third Series, XXVII (January 1970), 36–67.

15. The best treatment of both pro-Puritan and anti-Puritan thought is Richard E. Cauger, "The Concept of the Puritan in American Literary Criticism, 1890–1932" (Ph.D. dissertation, Northwestern University, 1964).

16. Robert Henri, "My People," *Craftsman*, XXVII (February 1915), 462, 468; Percy MacKaye, *The Playhouse and the Play, and Other Addresses Concerning the Theatre and Democracy in America* (New York: Macmillan Company, 1909), 148; Esther Peck, "Dancing and Democracy," *Craftsman*, XX (December 1916), 224. See also Randolph Bourne, "The Puritan Will to Power," *Seven Arts*, I (April 1917), 631–37; [Sadakichi Hartmann], "Puritanism: Its Grandeur and Shame," *Camera Work*, no. 32, (October 1910), 17–18.

17. H. L. Mencken, "Puritanism as a Literary Force," in *A Book of Prefaces* (New York: Alfred A. Knopf, Inc., 1917), 197–283. This essay was a reworking and expansion of "The American: His New Puritanism," *Smart Set*, XXX (February 1914), 87–94.

18. Mencken, "Puritanism as a Literary Force," 211–61.

19. See Carl Bode, Mencken (Carbondale and Edwardsville: Southern Illinois University Press, 1969); William Manchester, *Disturber of the Peace: The Life of H. L. Mencken* (New York: Harper and Bros., Publishers, 1951); Douglas C. Stenerson, *H. L. Mencken: Iconoclast from Baltimore* (Chicago: University of Chicago Press, 1971); W. H. A. Williams, *H. L. Mencken* (New York: Twayne Publishers, 1977).

20. *H. L. Mencken, George Bernard Shaw: His Plays*, reprint ed. (New Rochelle: E. Glaser, 1969); Mencken, *The Philosophy of Friedrich Nietzsche* (Boston: Luce and Company, 1908); Mencken, *The American Language* (New York: Alfred A. Knopf, Inc., 1919).

21. James Hoopes, *Van Wyck Brooks: In Search of American Culture* (Amherst: University of Massachusetts Press, 1977), 6.

22. Van Wyck Brooks, *New England: Indian Summer* (New York: E. P. Dutton and Company, 1940), 195.

23. Van Wyck Brooks, *An Autobiography* (New York: E. P. Dutton and Company, 1965), 150; Claire Sprague, "Van Wyck Brooks: Pioneer Cultural Historian," paper, American Historical Association, 84th Annual Meeting, Washington, D.C., December 1969; Malcolm Cowley, "Van Wyck Brooks: A Career in Retrospect," *Saturday Review*, XLI (May 25, 1963), 17–18f.

24. Van Wyck Brooks, "The Wine of the Puritans," in Sprague, ed., *Van Wyck Brooks*, 1–59. Italics in original.

25. Van Wyck Brooks, *The Malady of the Ideal* (London: A. C. Fifield, 1913); Brooks, *John Addington Symonds: A Biographical Study* (New York: Mitchell Kennerley, 1914); Brooks, *The World of H. G. Wells* (New York: Mitchell Kennerley, 1914).

26. Brooks, "America's Coming-of-Age," in Sprague, ed., *Van Wyck Brooks*, 84–95, 117.

27. Ibid., 84, 95–96; Brooks, *Autobiography*, 533. On the matter of Brooks's socialism, see also Peter W. Dowell, "Van Wyck Brooks and the Progressive Frame of Mind," *Midcontinent American Studies Journal*, XI (Spring 1970), 30–44.

28. Brooks, "America's Coming-of-Age," 148–58.

29. Sherwood Anderson to Van Wyck Brooks, May 23, 1918, Van Wyck Brooks Papers, Rare Books Collection, Van Pelt Library, University of Pennsylvania, Philadelphia.

30. See Hoopes, *Van Wyck Brooks;* Peter W. Dowell, "Van Wyck Brooks and the Mind of His Generation" (Ph.D. dissertation, University of Minnesota, 1965).

31. Brooks, *Autobiography*, 150.

32. Van Wyck Brooks to Waldo Frank, May 22, 1919, Waldo Frank Papers, Rare Books Collection, Van Pelt Library, University of Pennsylvania, Philadelphia.

33. Sherwood Anderson, *A Story Teller's Story*, ed. Ray Lewis White (Cleveland: Case Western Reserve University Press, 1968), 207; Sherwood Anderson to Paul

Rosenfeld, c. September 1921, in Jerome Mellquist and Lucie Wiese, eds., *Paul Rosenfeld: Voyager in the Arts* (New York: Creative Age Press, 1948), 207; Paul Grzybowski, "Plight of the American Artist," *Art World*, I (February 1917), 363; Malcolm Cowley, *Exile's Return: A Literary Chronicle of the 1920s*, 2d ed. (New York: Viking Press, Inc., 1951), 32-33.

34. Gustave Stickley, "A Great Sincerity Necessary . . . ," *Craftsman*, XVI (April 1909), 57-59. See also Stickley, "Why More French Art in America?" ibid., XXII (June 1912), 319-21.

35. Montgomery Schuyler, "United States, Architecture of," in Russell Sturgis, ed., *A Dictionary of Architecture and Building*, 3 vols. (New York: Macmillan Company, 1902), III, 927.

36. For Sullivan's work, see Hugh S. Morrison, *Louis Sullivan: Prophet of American Architecture* (New York: Museum of Modern Art and W. W. Norton and Company, 1935); Sherman Paul, *Louis Sullivan: An Architect in American Thought* (Englewood Cliffs: Prentice-Hall, Inc., 1962); John Burchard and Albert Bush-Brown, *The Architecture of America: A Social and Cultural History*, rev. ed. (Boston: Little, Brown and Company, 1966), especially 144-47, 171-234; William H. Pierson, Jr., and William H. Jordy, *American Buildings and Their Architects*, 4 vols. to date (Garden City: Doubleday and Company, 1970-), III: Jordy, *Progressive and Academic Ideals at the Turn of the Century*, 83-179.

37. Morrison, *Sullivan*, 152.

38. Louis Sullivan, *Kindergarten Chats and Other Writings* (New York: Wittenborn, Schultz, Inc., 1947), 139-40; Sullivan, untitled address to Chicago Architectural Club, May 30, 1899, quoted in Morrison, *Sullivan*, 259-60. Italics in original.

39. David F. Burg, *Chicago's White City of 1893* (Lexington: University Press of Kentucky, 1976); Dimitri Tselos, "The Chicago School and the Myth of the 'Lost Cause'," *Journal of the Society of Architectural Historians*, XXVI (December 1967), 259-68; David H. Crook, "Louis Sullivan and the Golden Doorway," ibid., 250-58.

40. See, for example, "Louis Sullivan, 'the First American Architect,'" *Current Literature*, LIII (June 1912), 703-707; A. N. Rebori, "An Architecture of Democracy: Three Recent Examples from the Work of Louis Sullivan," *Architectural Record*, XXXIX (May 1916), 436-65; "California's Contribution to a National Architecture," *Craftsman*, XXII (April 1912), 532-47.

41. Sullivan, *Kindergarten Chats*, 31, 78, 229-30, 238; Sullivan, *Democracy: A Man-Search* (Detroit: Wayne State University Press, 1961), 120-25; "Louis H. Sullivan Emphatically Supports the Viewpoint of Gutzon Borglum toward American Art," *Craftsman*, XV (December 1908), 338; Sullivan, "Is Our Art a Betrayal Rather than an Expression of American Life?" ibid. (January 1909), 402-404.

42. Sullivan, untitled address to Chicago Architectural Club, quoted in Morrison, *Sullivan*, 259-60; Sullivan, *Kindergarten Chats*, 32.

43. Frederick A. Gutheim, ed., *Frank Lloyd Wright: Selected Writings, 1894-1940* (New York: Duell, Sloan, and Pearce, Inc., 1941), 85.

44. Alan Gowans, *Images of American Living: Four Centuries of Architecture and Furniture as Cultural Expression* (Philadelphia: J. B. Lippincott Company, 1964), 395-96. See also Donald D. Egbert, "The Idea of Organic Expression and American Architecture," in Stow Persons, ed., *Evolutionary Thought in America* (New Haven: Yale University Press, 1950), 336-96; Kenneth G. Johnston, "The Organic Principle in Industrial America: A Study of the Architecture and Social Philosophy of Frank Lloyd Wright" (Ph.D. dissertation, University of Minnesota, 1966).

45. Frank Lloyd Wright, "In the Cause of Architecture," *Architectural Record*, XXIII (March 1908), 158; Wright, "The Architect," *Brickbuilder*, IX (June 1900), 127. On Wright's career, see Henry-Russell Hitchcock, *In the Nature of Materials, 1887-1914: The Buildings of Frank Lloyd Wright* (New York: Duell, Sloan, Pearce, Inc., 1942); Robert Twombly, *Frank Lloyd Wright: An Interpretive Biography* (New York: Harper and Row, Inc., 1973); Norris Kelly Smith, *Frank Lloyd Wright: A Study in Architectural Content* (Englewood Cliffs: Prentice-Hall, Inc., 1966);

Grant C. Manson, *Frank Lloyd Wright to 1910: The First Golden Age* (New York: Reinhold Company, 1958) ; Jordy, *Progressive and Academic Ideals*, 180–216.

46. Frank Lloyd Wright, "In the Cause of Architecture: Second Paper," *Architectural Record*, XXXV (May 1914) , 405–13.

47. William G. Purcell and George L. Elmslie, "The American Renaissance?" *Craftsman*, XXI (January 1912) , 430–35; Irving K. Pond, "Let Us Embody the American Spirit in Our Architecture," ibid., XVIII (April 1910) , 67–68.

48. Giles Edgerton, "American Art Scores a Triumph at the International Exhibition of Painting at Pittsburgh," *Craftsman*, XIV (August 1908) , 464; Edgerton, "Is America Selling Her Birthright in Art for a Mess of Pottage?" ibid., XI (March 1907) , 657; "American Artists Whose Vital Work Shows the Inspiration of Native Subjects, as Seen in the Recent Water Color Exhibit in New York," ibid., XVI (August 1909) , 510.

49. The best study of Henri's life and work is William Innes Homer, *Robert Henri and His Circle* (Ithaca: Cornell University Press, 1969) . See also Joseph J. Kwiat, "Robert Henri and the Emerson-Whitman Tradition," *PMLA*, LXXI (September 1956) , 617–36.

50. On Henri and the dissident painters he led, see Mahonri Sharp Young, *The Eight: The Realist Revolt in American Painting* (New York: Watson and Guptill Publishers, 1973) ; Milton W. Brown, *American Painting from the Armory Show to the Depression* (Princeton: Princeton University Press, 1955) , 9–38; Lloyd Goodrich and John I. H. Baur, *American Art of Our Century* (New York: Frederick A. Praeger, Publishers, 1961) , 16–28; Van Wyck Brooks, *John Sloan* (New York: E. P. Dutton and Company, 1955) ; Ira Glackens, *William Glackens and the Ashcan Group* (New York: Crown Publishers, 1957) ; Barbara Rose, *American Art since 1900* (New York: Frederick A. Praeger, Publishers, 1967) ; Sam Hunter, *Modern American Painting and Sculpture* (New York: Dell Publishing Company, Inc., 1959) , 28–40.

51. Matthew Josephson, *Infidel in the Temple: A Memoir of the Nineteen-Thirties* (New York: Alfred A. Knopf, Inc., 1966) , 388.

52. Sloan quoted in Innes, *Henri and His Circle*, 84; Shinn quoted in Louis Baury, "The Message of Manhattan," *Bookman*, XXXIII (August 1911) , 594. See also John Spargo, "George Luks," *Craftsman*, XII (September 1907) , 599–607.

53. Goodrich and Baur, *American Art of Our Century*, 24–25; Brown, *American Painting*, 33–36; Charles Morgan, *George Bellows* (New York: Reynal and Company, 1965) .

54. Robert Henri, "The New York Exhibition of Independent Artists," *Craftsman*, XVIII (May 1910) , 161 (italics in original) ; Henri, "Progress in Our National Art Must Spring from Individuality of Ideas and Freedom of Expression," ibid., XV (January 1909) , 388.

55. Henri, "Progress in Our National Art," *Craftsman*, XIV (June 1908) , 342; Henri, "My People," 462.

56. For the background and significance of the Armory Show, see Walt Kuhn, *The Story of the Armory Show* (New York: privately printed, 1938) ; Brown, *American Painting*, 47–67; Oliver Larkin, *Art and Life in America*, rev. ed. (New York: Holt, Rinehart and Winston, 1961) , 360–66; Rose, *American Art since 1900*, 67–83; Hunter, *Modern American Painting and Sculpture*, 62–79; Meyer Schapiro, "Rebellion in Art," in Daniel Aaron, ed., *America in Crisis* (New York: Alfred A. Knopf, Inc., 1952) , 204–42; Ann Uhry Abrams, "Catalyst for Change: American Art and Revolution, 1906–1915" (Ph.D. dissertation, Emory University, 1975) , 150–210.

57. Schapiro, "Rebellion in Art," 228–29.

58. Royal Cortissoz to Stuart P. Sherman, December 11, 1925, Royal Cortissoz Papers, American Literature Collection, Yale University, New Haven;  Glackens, *William Glackens and the Ashcan Group*, 184; Jerome Meyers, *Artist in Manhattan* (New York: American Artists Group, Inc., 1940) , 36; Larkin, *Art and Life in America*, 364; Schapiro, "Rebellion in Art," 230.

59. On this point see Rose, *American Art since 1900*, 76–78.

60. Brown, *American Painting*, 60.

61. For Stieglitz's life, work, and associates, see William Innes Homer, *Alfred Stieglitz and the American Avant-Garde* (Boston: New York Graphic Society, 1977) ; Arthur Frank Wertheim, *The New York Little Renaissance: Iconoclasm, Modernism, and Nationalism in American Culture, 1908–1917* (New York: New York University Press, 1976) , 113–30; Rose, *American Art since 1900*, 35–66; Joseph Schiffman, "The Alienation of the Artist: Alfred Stieglitz," *American Quarterly*, III (Fall 1951) , 244–58.

62. "From the Writings and Conversations of Alfred Stieglitz," *Twice-a-Year* (double number) VIII–IX (Spring–Summer 1942, Fall–Winter 1942) , 142.

63. Frederick S. Wight, *Milestones of American Painting in Our Century* (New York: Chanticleer Press, 1949) , 13. See also Neil Leonard, "Alfred Stieglitz and the Realists," *Art Quarterly*, XXIX (Fall 1966) , 277–86.

64. Rose, *American Art since 1900*, 66.

65. Alfred Stieglitz to Gertrude Stein, November 3, 1913, in Donald Gallup, ed., *The Flowers of Friendship: Letters Written to Gertrude Stein* (New York: Alfred A. Knopf, Inc., 1953) , 88; *The Forum Exhibition of Modern American Painters, Anderson Galleries, March Thirteenth to March Twenty-fifth, 1916* (New York: Hugh Kennerley, 1916) , 35.

66. Benjamin de Casseres, "American Indifference," *Camera Work*, no. 27 (July 1909) , 24; Marius de Zayas, "From '291'—July–August Number, 1915," ibid., no. 48 (October 1916) , 69–70; [Hartmann], "Puritanism, Its Grandeur and Shame," 17–19. See also Roger Piatt Hull, *"Camera Work:* An American Quarterly" (Ph.D. dissertation, Northwestern University, 1970) .

67. On the *Forum* and SIA shows, see Brown, *American Painting*, 65–67; Larkin, *Art and Life in America*, 366–67; Willard Huntington Wright, "The Forum Exhibition," *Forum*, LV (April 1916) , 457–71; William Glackens, "The Biggest Art Exhibition in America and Incidentally War," *Touchstone*, I (June 1917) , 164–73.

68. For the origins and character of ragtime and the careers of Scott Joplin and other ragtime composers, see William J. Schafer and Johannes Riedel, *The Art of Ragtime: Form and Meaning of an Original Black American Art* (Baton Rouge: Louisiana State University Press, 1973) ; Rudi Blesh and Harriet Janis, *They All Played Ragtime* (New York: Alfred A. Knopf, Inc., 1950) ; Gilbert Chase, *America's Music: From the Pilgrims to the Present*, 2d ed., rev. (New York: McGraw-Hill Book Company, 1966) , 429–47; Eileen Southern, *The Music of Black Americans: A History* (New York: W. W. Norton and Company, 1971) , 311–32; Joshua Rifkin, liner notes to *Scott Joplin: Piano Rags*, Nonesuch H-71248.

69. Schafer and Riedel, *Art of Ragtime*, 205.

70. Rupert Hughes, "A Eulogy of Rag-time," *Musical Record and Review*, no. 447 (April 1899) , 157–59.

71. Hiram K. Moderwell, "Ragtime," *New Republic*, IV (October 16, 1915) , 284–86; Moderwell, "Two Views of Ragtime: I: A Modest Proposal," *Seven Arts*, II (July 1917) , 368–76; Carl Van Vechten, "The Great American Composer," *Vanity Fair*, VIII (April 1917) , 75f. See also Mary Fanton Roberts, "The Dance of the People," *Craftsman*, XXII (May 1912) , 195–99; John N. Burk, "Ragtime and Its Possibilities," *Harvard Musical Review*, II (January 1914) , 11–13.

72. Charles L. Buchanan, "Two Views of Ragtime: II: Ragtime and American Music," *Seven Arts*, II (July 1917) , 376–77; Daniel Gregory Mason, "Concerning Ragtime," *New Musical Review and Church Musical Review*, XVIII (March 1918) , 115–16. See also Mason, "Folk-Song and American Music: (A Plea for the Unpopular Point of View) ," *Musical Quarterly*, IV (July 1918) , 323–32.

73. John A. Lomax, *Cowboy Songs and Other Frontier Ballads* (New York: Sturgis and Walton, 1910) ; Henry E. Krehbiel, *Afro-American Folksongs: A Study in Racial and National Music* (New York: G. Schirmer, Inc., 1914) ; Cecil Sharp, *English Folk Songs from the Southern Appalachians* (London: Oxford University Press, 1917) ; Donald Knight Wilgus, *Anglo-American Folksong Scholarship since 1898* (New Brunswick: Rutgers University Press, 1959) , 110–23.

74. See, for example, Alice C. Fletcher, *Indian Story and Song from North America* (Boston: Small, Maynard and Company, 1900) ; Frederick R. Burton, *American Primitive Music, with Especial Attention to the Songs of the Ojibways* (New York: Moffat, Yard, and Company, 1909) ; Frances Densmore, *Chippewa Music* (Washington: Bureau of American Ethnology, 1910) ; Densmore, *Teton Sioux Music* (Washington: Bureau of American Ethnology, 1918) . See also Natalie Burlin, "A Plea for Our Native Art," *Musical Quarterly*, VI (April 1920) , 175–78; Frances Densmore, "The Study of Indian Music," *Smithsonian Institution, Annual Report, 1941* (Washington: Smithsonian Institution, 1942) , 527–50.

75. Henry F. B. Gilbert, "Nationalism in Music," *International: A Review of Two Worlds*, December 1913, pp. 367–69; Gilbert, "The American Composer," *Musical Quarterly*, I (April 1915) , 169–80; Gilbert, "Folk-Music in Art-Music," ibid., III (October 1917) , 577–601.

76. Quoted in Edward N. Waters, "The Wa-Wan Press: An Adventure in Musical Idealism," in Gustave Reese, ed., *Birthday Offering to Carl Engel* (New York: G. Schirmer and Company, 1943) , 216–19. For Farwell's life and work, see also Edgar L. Kirk, "Toward an American Music: A Study of the Life and Music of Arthur George Farwell" (Ph.D. dissertation, University of Rochester, 1958) ; Stephen K. Kelly, "Arthur Farwell and the Wa-Wan Press" (M.A. thesis, Rutgers University, 1969) ; Arthur Farwell, "The National Movement for an American Music," *American Review of Reviews*, XXXVIII (December 1908) , 721–24; Farwell, *"Wanderjahre* of a Revolutionist," series of 25 articles in *Musical America*, IX–X (January 23, 1909–July 10, 1909) ; Chase, *America's Music*, 391–96.

77. Quoted in Waters, "Wa-Wan Press," 219. See also "The Future of American Music," *Current Literature*, XXXIX (August 1905) , 191–92; Arthur Farwell, "The Relation of Folksong to American Musical Development," *Music Teachers National Associates Proceedings*, Series 2 (1908) , 197–205.

78. Quoted in Waters, "Wa-Wan Press," 223.

79. Farwell, "National Movement for an American Music," 724.

80. The fullest analysis of Farwell's music compositions is in Kirk, "Toward an American Music."

81. Arthur Farwell, *A Letter to American Composers* (Newton Center, Mass.: Wa-Wan Press, 1903) , quoted in Kelly, "Arthur Farwell and the Wa-Wan Press," 80; Farwell, "The Struggle toward a National Music," *North American Review*, CLXXXVI (December 1907) , 569; Farwell to Arthur Shepherd, November 20, 1907, quoted in Kirk, "Toward an American Music," 30.

82. Arthur Farwell and W. Dermot Darby, *Music in America* (New York: National Society of Music, 1915) .

83. For Ives's life see Frank R. Rossiter, *Charles Ives and His America* (New York: Liveright, 1975) ; Rosalie Sandra Perry, *Charles Ives and American Culture* (Kent, Ohio: Kent State University Press, 1974) ; Alfred F. Rosa, "Charles Ives: Music, Transcendentalism, and Politics," *New England Quarterly*, XLIV (September 1971) , 433–43.

84. Musicologically the best treatment of Ives is Henry and Sidney Cowell, *Charles Ives and His Music* (New York: Oxford University Press, 1954) . See also Chase, *America's Music*, 403–28; Henry Bellamann, "Charles Ives: The Man and His Music," *Musical Quarterly*, XIX (January 1933) , 45–58; Raymond H. Geselbracht, "Evolution and the New World Vision in the Music of Charles Ives," *Journal of American Studies*, VIII (August 1974) , 211–27; H. Wiley Hitchcock, *Music in the United States: A Historical Introduction*, 2d ed. (Englewood Cliffs: Prentice-Hall, Inc., 1974) , 149–72.

85. Charles Ives, *Essays before a Sonata and Other Writings*, ed. Howard Boatright (New York: W. W. Norton and Company, 1962) , 80–81. The essays were first published privately and separately by Ives in 1919.

86. Paul Rosenfeld, "The American Composer," *Seven Arts*, I (November 1916) , 91.

87. Arthur Farwell, "Community Music-Drama: Will Our Country People in

Time Help Us to Develop the Real American Theater?" *Craftsman,* XXVI (July 1914) , 422; William Chauncey Langdon, quoted, ibid.

88. Mary Fanton Roberts, "The Value of Outdoor Plays to America: Through the Pageant Shall We Develop a Drama of Democracy?" *Craftsman,* XVI (August 1909) , 491–506; Randolph Bourne, "Pageantry and Social Art," undated ms. [c. 1914] in Randolph Silliman Bourne Papers, Special Collections, Baker Library, Columbia University, New York City.

89. Thomas H. Dickinson, *The Case of American Drama* (Boston: Houghton Mifflin Company, 1915) , 127.

90. See Duncan James Rollo, "Percy MacKaye's Vision of the National Drama as an Expression of the American Identity" (Ph.D. dissertation, Kent State University, 1974) .

91. Percy MacKaye to Grenville Vernon, March 12, 1907, quoted ibid., 220.

92. MacKaye himself always insisted that his community plays were "masques," or interpretations of events, as opposed to "pageants," which were presentations of events. See ibid., 186–88. The distinction hardly seems an absolute one.

93. Percy MacKaye, *The Civic Theatre in Relation to the Redemption of Leisure* (New York: Mitchell Kennerley, 1912) , 42; MacKaye, *Community Drama: Its Method of Neighborliness: An Interpretation* (Boston: Houghton Mifflin Company, 1917) , 11, 45.

94. MacKaye, *Playhouse and the Play,* 20–21, 192. Italics in original.

95. Ibid., 26.

96. See Wertheim, *New York Little Renaissance,* 54–57.

97. MacKaye, *Playhouse and the Play,* 97–98; Hamilton quoted in "Too Much New York in Our Drama," *Literary Digest,* LII (February 26, 1916) , 504.

98. See Constance d'Arcy Mackay, *The Little Theatre Movement in the United States* (New York: Henry Holt and Company, 1917) ; Alan S. Downer, *Fifty Years of American Drama* (Chicago: Henry Regnery Company, 1951) , 76.

99. On the spread of the little-theater movement, see Mackay, *Little Theatre Movement;* Glenn Hughes, *A History of the American Theatre, 1700–1950* (New York: Samuel French, 1951) , 362–76; Thomas H. Dickinson, *The Insurgent Theatre* (New York: B. W. Huebsch, 1917) ; "The People and the Theater," *Craftsman,* XXIX (October 1915) , 52–63ff: Bernard F. DuKore, "Maurice Browne and the Chicago Little Theatre," *Theatre Survey,* III (1962) , 54–78; Wertheim, *New York Little Renaissance,* 149–63. For Baker's influence, see Wisner Payne Kinne, *George Pierce Baker and the American Theatre* (Cambridge: Harvard University Press, 1954) .

100. Quoted in Lawrence Langner, *The Magic Curtain* (New York: E. P. Dutton and Company, 1951) , 94.

101. Quoted in Wertheim, *New York Little Renaissance,* 156.

102. Sheldon Cheney, *The New Movement in the Theatre* (New York: Mitchell Kennerley, 1914) , passim.

103. Joseph Wood Krutch, *The American Drama since 1918: An Informal History* (New York: Random House, Inc., 1939) , 10–11.

## Chapter 3: **Thorough Malcontents**

1. The standard account of the *New Republic*'s early years and its three founders is Charles Forcey, *The Crossroads of Liberalism: Croly, Weyl, Lippmann and the Progressive Era, 1900–1925* (New York: Oxford University Press, 1961) . See also Paul F. Bourke, "The Status of Politics, 1909–1919: *The New Republic,* Randolph Bourne and Van Wyck Brooks," *Journal of American Studies,* VIII (August 1974) , 171–202; George Austin Test, "The Vital Connection: A Study of the *New Republic* as a Literary Journal, 1914–1922" (Ph.D. dissertation, University of Pennsylvania, 1960) .

2. Cf. James Hoopes, "The Culture of Progressivism: Croly, Lippmann, Brooks, Bourne, and the Idea of American Artistic Decadence," *Clio,* VII (Fall 1977) , 91–111, for a treatment arguing for the essential similarity of the cultural views of Croly and Lippmann as well as Van Wyck Brooks and Randolph Bourne.

3. "Our Literary Poverty," *New Republic,* I (November 21, 1914) , 10–11; John R. Dos Passos, Jr., "Against American Literature," ibid., VIII (October 14, 1916) , 269–71; George Soule, "Irrevelant Art," ibid., X (April 28, 1917) , 374–76. See also Horace Holley, "The Artist in America," ibid., III (June 5, 1915) , 113–15.

4. For the *New Republic's* policy toward the First World War, see Forcey, *Crossroads of Liberalism,* 221–86; Christopher Lasch, *"The New Republic* and the War: 'An Unanalyzable Feeling.' " in *The New Radicalism in America (1889–1963) : The Intellectual as a Social Type* (New York: Alfred A. Knopf, Inc., 1965) , 181–224.

5. Waldo Frank, *Memoirs of Waldo Frank,* ed. Alan Trachtenberg (Amherst: University of Massachusetts Press, 1973) , 54, 83.

6. On the founding of the *Seven Arts,* see Arthur Frank Wertheim, *The New York Little Renaissance: Iconoclasm, Nationalism, and Modernism in American Culture, 1908–1917* (New York: New York University Press, 1976) , 173–83; Claire Sacks, "The *Seven Arts* Critics: A Study of Cultural Nationalism in America, 1910–1930" (Ph.D. dissertation, University of Wisconsin, 1955) ; Charles L. P. Silet, *"The Seven Arts:* The Artist and the Community" (Ph.D. dissertation, Indiana University, 1973) ; James Oppenheim, "The Story of the *Seven Arts," American Mercury,* XX (June 1930) , 156–64. For Waldo Frank, see Paul J. Carter, *Waldo Frank* (New York: Twayne Publishers, 1967) ; Jerome W. Kloucek, "Waldo Frank: The Ground of His Mind and Art" (Ph.D. dissertation, Northwestern University, 1958) ; Dennis Michael Martin, "Modern American Literary Nationalism" (Ph.D. dissertation, University of California at Los Angeles, 1973) , 130–79; John R. Willingham, "The Achievement of Waldo Frank," *Literary Review,* I (Summer 1958) , 465–77; Gorham Munson, "Herald of the Twenties: A Tribute to Waldo Frank, Avant-Courier for New Values," *Forum,* III (Fall 1961) , 4–14. For Rosenfeld, see Bruce Augustus Butterfield, "Paul Rosenfeld: The Critic as Autobiographer" (Ph.D. dissertation, University of Illinois, 1975) ; Jerome Mellquist and Lucie Wiese, eds., *Paul Rosenfeld: Voyager in the Arts* (New York: Creative Age Press, 1948) ; Hugh McClellan Potter, III, "The Romantic Nationalists of the 1920's" (Ph.D. dissertation, University of Minnesota, 1965) , passim; Potter, "Paul Rosenfeld: Criticism and Prophecy," *American Quarterly,* XXII (Spring 1970) , 82–94; Sherman Paul, "Portrait of Paul Rosenfeld," *Accent,* XX (Spring 1960) , 99–111.

7. Ms., "To Writers [July 1916], in James Oppenheim Collection, New York Public Library, New York City.

8. James Oppenheim, editorial, *Seven Arts,* I (January 1917) , 268–69.

9. Waldo Frank, "Concerning a Little Theater," *Seven Arts,* I (December 1916) , 157–66; Frank, "Vicarious Fiction," ibid., January 1917, pp. 294–303.

10. Paul, "Portrait of Paul Rosenfeld," 99–105.

11. Paul Rosenfeld, "The American Composer," *Seven Arts,* I (November 1916) , 89–94.

12. See Van Wyck Brooks, *Letters and Leadership* (New York: B. W. Huebsch, 1918) . My citations will be to the original *Seven Arts* essays.

13. Brooks, "Young America," *Seven Arts,* I (December 1916) , 151.

14. Brooks, "The Splinter of Ice," *Seven Arts,* I (January 1917) , pp. 270–80.

15. Brooks, "Toward a National Culture," *Seven Arts,* I (March 1917) , pp. 540–44; Brooks, "The Culture of Industrialism," ibid., April 1917, pp. 663–64; Brooks, "Our Critics," ibid., II (May 1917) , 109–110.

16. Brooks, "Toward a National Culture," 546–47.

17. Van Wyck Brooks, *An Autobiography* (New York: E. P. Dutton and Company, 1965) , 286.

18. In the sizable literature on Bourne, the best items are Louis Filler, *Randolph Bourne* (Washington: American Council on Public Affairs, 1943) ; John A. Moreau, *Randolph Bourne* (Washington: Public Affairs Press, 1966) ; Carl Resek, "Introduc-

tion" to Resek, ed., *War and the Intellectuals: Essays by Randolph Bourne, 1915–1919* (New York: Harper Torchbooks, 1964), vii–xv; Lasch, "Randolph Bourne and the Experimental Life," in *New Radicalism in America*, 69–103; Van Wyck Brooks, "Introduction" to Randolph Bourne, *The History of a Literary Radical*, ed. Van Wyck Brooks (New York: B. W. Huebsch, 1920), ix–xxxv; Martin, "Modern American Literary Nationalism," 68–120; Silet, *"Seven Arts,"* 153–82; Paul Rosenfeld, *Port of New York: Essays on Fourteen American Moderns* (New York: Harcourt, Brace and Company, 1924).

19. Randolph S. Bourne, *Youth and Life,* reprint ed. (Freeport, N.Y.: Books for Libraries Press, 1967).

20. Randolph S. Bourne, "Our Cultural Humility," *Atlantic Monthly,* CXIV (October 1914), 503–507; reprinted in Bourne, *History of a Literary Radical,* 31–44.

21. Randolph S. Bourne, "Trans-National America," *Atlantic Monthly,* CVIII (July 1916), 86–97; reprinted in Bourne, *History of a Literary Radical,* 266–99. In his discussion of Bourne's ideas, Van Wyck Brooks, as James Hoopes has pointed out, misunderstood Bourne's argument in the "Trans-National America" essay, thinking Bourne was talking about the ideal of a higher loyalty above ethnic loyalty. See Brooks, "Introduction," ibid., xvi; James Hoopes, *Van Wyck Brooks: In Search of American Culture* (Amherst: University of Massachusetts Press, 1977), 133.

22. "To the Friends of The Seven Arts," *Seven Arts,* II (October 1917), n.p.

23. Randolph Bourne, "A War Diary," *Seven Arts,* II (September 1917), 546; Bourne, "Twilight of Idols," ibid., October 1917, 700. Bourne's remaining *Seven Arts* essays are reprinted in Resek, ed., *War and the Intellectuals.*

24. Bourne, "Twilight of Idols," 700–701.

25. Nicholas Joost, The Dial: *Years of Transition, 1912–1900* (Barre, Mass.: Barre Publishers, 1967), 54–189; Frederick J. Hoffman et al., *The Little Magazine: A History and a Bibliography* (Princeton: Princeton University Press, 1947), 196–97.

26. Van Wyck Brooks, "On Creating a Usable Past," *Dial,* LXIV (April 11, 1918), 337–41. On the parallelism between Brooks's "usable past" and the New History, see Richard Ruland, *The Rediscovery of American Literature: Premises of Critical Taste, 1900–1940* (Cambridge: Harvard University Press, 1967), 5–6; Warren I. Susman, "History and the American Intellectual: Uses of the Usable Past," *American Quarterly,* XVI (Summer 1964), 243–63.

27. Randolph Bourne, "A Letter to Van Wyck Brooks, March 27, 1918," *Twice-a-Year,* I (Fall–Winter 1938), 55; Bourne, "Traps for the Unwary," *Dial,* LXIV (March 28, 1918), 277–79.

28. "National Art in the Making," *Nation,* CV (September 13, 1917), 286.

29. Pitts Sanborn, "The War and Music in America," *Vanity Fair,* IX (January 1918), 88. See also Frederic Dean, "The Opera—by, for and with Americans," *Bookman,* XLVI (November 1917), 260–66; "American Opera by American Singers," *Musician,* XXII (August 1917), 622; Charles Henry Meltzer, "The Coming of American Opera," *Forum,* LIX (January 1918), 61–67; "Music and Patriotism," *Outlook,* CXVII (November 14, 1917), 407; "The Teacher's Obligations toward Native Music," *Musician,* XXIV (May 1919), 7; Walter R. Spaulding, "The War in Its Relation to American Music, *Musical Quarterly,* IV (January 1918), 7–11.

30. Milton W. Brown, *American Painting from the Armory Show to the Depression* (Princeton: Princeton University Press, 1955), 71.

31. Brooks, *Autobiography,* 258; Paul Rosenfeld, "American Painting," *Dial,* LXXI (December 1921), 669–70; Waldo Frank to Van Wyck Brooks, November 27 [1918], Van Wyck Brooks Papers, Rare Books Collection, Van Pelt Library, University of Pennsylvania, Philadelphia; Brooks to Frank, September 23, 1919, Waldo Frank Papers, ibid.

32. F. Scott Fitzgerald, *This Side of Paradise* (New York: Charles Scribner's Sons, 1920), 304; Ernest Hemingway, *The Sun Also Rises* (New York: Charles Scribner's Sons, 1926), n.p.; Frederick Lewis Allen, *Only Yesterday: An Informal History of the 1920's* (New York: Harper and Bros., Publishers, 1931), 240–41.

33. On the persistence of the Allenite influence in historians' views of the twenties, see Roderick Nash, *The Nervous Generation: American Thought, 1917–1930* (Chicago: Rand McNally and Company, 1970), 5–32.

34. Henry F. May, *The End of American Innocence: A Study of the First Years of Our Own Time, 1912–1917* (New York: Alfred A. Knopf, Inc., 1957), viii.

35. Waldo Frank, *Our America* (New York: Boni and Liveright, 1919), 5.

36. Ibid., 8–10, 191, 210, 230.

37. Van Wyck Brooks to Waldo Frank, November 27, 1919, Frank Papers.

38. Harold Stearns, *Liberalism in America: Its Origins, Its Temporary Collapse, Its Future* (New York: Boni and Liveright, 1919); Louis Untermeyer, *The New Spirit in American Poetry* (New York: Henry Holt and Company, 1919).

39. Bourne, *History of a Literary Radical*.

40. *Freeman,* I (March 31, 1920), 52–53.

41. Susan J. Turner, *A History of the* Freeman: *Literary Landmark of the Twenties* (New York: Columbia University Press, 1963), 128–58.

42. "An Intellectual Eggshell Period," *Freeman,* I (September 8, 1920), 607–608.

43. "The Quality of Life," *Freeman,* III (June 8, 1921), 295; Mary M. Colum, review of Sherwood Anderson, *The Triumph of the Egg,* ibid., IV (November 30, 1921), 281.

44. Frederick Jackson Turner, "The Significance of the Frontier in American History," in *The Frontier in American History* (New York: Henry Holt and Company, 1947), 1–38.

45. "The Migratory Artist," *Freeman,* II (March 9, 1921), 607–608; "A Hopeful Sign," ibid., V (August 2, 1922), 484–85.

46. Stanley J. Kunitz and Howard Haycraft, ed., *Twentieth Century Authors: A Biographical Directory of Modern Literature* (New York: H. W. Wilson Company, 1942), 1330–31; Marc Pachter, "Harold Edmund Stearns," in Edmund T. James, ed., *The Dictionary of American Biography: Supplement Three, 1941–1945* (New York: Charles Scribner's Sons, 1973), 730–31; Stearns's autobiography, *The Street I Know* (New York: Lee Furman, Inc., 1935).

47. Harold Stearns, *America and the Young Intellectual* (New York: George H. Doran Company, Inc., 1921), 14, 22, 159–66.

48. Harold Stearns to H. L. Mencken, September 22, 1920, H. L. Mencken Collection, New York Public Library, New York City.

49. Harold Stearns, ed., *Civilization in the United States: An Inquiry by Thirty Americans* (New York: Harcourt, Brace and Company, 1922), iii–vii.

50. Deems Taylor, "Music," in Stearns, ed., *Civilization in the United States,* 210–14 (italics in original); Van Wyck Brooks, "The Literary Life," ibid., 180–81, 197; Conrad Aiken, "Poetry," ibid., 218–26.

51. Brooks, *Autobiography,* 426.

52. Van Wyck Brooks, *The Ordeal of Mark Twain,* reprint ed. (New York: Meridian Books, 1955), 25, 77, 142.

53. H. L. Mencken, "The Burden of Humor," *Smart Set,* XXXIX (March 1913), 151–52; Sherwood Anderson to Van Wyck Brooks, undated [1920], Waldo Frank to Brooks, undated [1920], Brooks Papers; Hemingway quoted in Frederick J. Hoffman, *The Twenties: American Writing in the Postwar Decade* (New York: Viking Press, Inc., 1955), 188n.

54. Van Wyck Brooks, *The Pilgrimage of Henry James* (New York: E. P. Dutton and Company, 1925), 37 and passim.

55. Van Wyck Brooks, *Emerson and Others* (New York: E. P. Dutton and Company, 1927).

56. Van Wyck Brooks et al., *The American Caravan: A Yearbook of American Literature,* 3 vols. (New York: Macaulay Company, 1927–29). Brooks's name appeared on the title page of only the 1927 volume. On Mumford see Eddy Weber Dow, "Lewis Mumford's First Phase: A Study of His Work as a Critic of the Arts in America" (Ph.D. dissertation, University of Pennsylvania, 1965).

57. Lewis Mumford, *Sticks and Stones: A Study of American Architecture and Civilization* (New York: W. W. Norton and Company, 1924).

58. Lewis Mumford, *The Golden Day: A Study in American Experience and Culture* (New York: Boni and Liveright, 1926) , 275 and passim; Mumford, "The Emergence of a Past," *New Republic*, XLV (September 25, 1925) , 19.

59. Mumford, *Golden Day*, 244–45.

60. Mumford, "Emergence of a Past," 19.

61. Van Wyck Brooks to Lewis Mumford, July 26, 1926, in Robert E. Spiller, ed., *The Van Wyck Brooks–Lewis Mumford Letters* (New York: E. P. Dutton and Company, 1970) , 40. Italics in original.

62. Lewis Mumford, *Herman Melville* (New York: Harcourt, Brace and Company, Inc., 1929) .

63. Raymond M. Weaver, *Herman Melville: Mariner and Mystic* (New York: George H. Doran and Company, Inc., 1921) . For the critical rediscovery of Melville and the transformation of his reputation, see Michael P. Zimmerman, "Herman Melville in the 1920's: A Study in the Origin of the Melville Revival" (Ph.D. dissertation, Columbia University, 1963) ; O. W. Riegel, "The Anatomy of Melville's Fame," *American Literature*, III (June 1931) , 195–205.

64. Brooks, *Emerson and Others*, 205.

65. George D. Murphy, "The New Biographers of the 1920's and Their Revaluation of the American Tradition" (Ph.D. dissertation, University of Pennsylvania, 1964) , 342.

66. Lewis Mumford, "Introduction" to Spiller, ed., *Brooks-Mumford Letters*, 2.

67. Oswald Spengler, *The Decline of the West*, trans. Charles Francis Atkinson, 2 vols. (New York: Alfred A. Knopf, Inc., 1926–28) ; Henry Adams, *The Education of Henry Adams* (Boston: Houghton Mifflin Company, 1918) . Adams's *Education* had earlier been published privately in a small edition, but was not made available to the general public until after Adams's death in 1918.

68. Van Wyck Brooks, *The Confident Years, 1885–1915* (New York: E. P. Dutton and Company, 1952) , 588–91.

69. Kloucek, "Waldo Frank," 431–34.

70. Edmund Wilson to H. L. Mencken, May 12, 1922, Mencken Papers.

71. On the issue of "lostness," see Nash, *Nervous Generation*, 33–125; and the different view in Stuart Irwin Rochester, "The Dynamics of Disillusionment in the American Liberal Community, 1914–1920" (Ph.D. dissertation, University of Virginia, 1973) .

72. Edmund Wilson, Jr., "The Gulf in American Literature," *Vanity Fair*, XV (September 1920) , 96.

73. See D. H. Lawrence, *Studies in Classic American Literature*, reprint ed. (New York: Viking Press, Inc., 1964) .

74. See Hoffman, *Twenties*, 327–35.

75. St. John Ervine, "Literary Taste in America," *New Republic*, XXIV (October 6, 1920) , 145–46; Shaw quoted in Brooks, *Confident Years*, 589.

76. Warren I. Susman, "A Second Country: The Expatriate Image," *Texas Studies in Literature and Language*, III (Summer 1961) , 171–83; reprinted in Robert Allen Skotheim and Michael McGiffert, ed., *American Social Thought: Sources and Interpretations*, 2 vols. (Reading, Mass.: Addison-Wesley Publishing Company, 1972) , II, 275–80.

77. Malcolm Cowley in the New York *Evening Post*, quoted in James F. Muirhead, "Must American Literature Defy Its Traditions?" *Independent*, CVIII (March 18, 1922) , 268.

78. Malcolm Cowley, *Exile's Return: A Literary Odyssey of the 1920's*, 2d ed. (New York: Viking Press, Inc., 1951) , 9, 94, 215. See also Robert A. Hipkiss, "The Values of Expatriation for the Major American Novelists, 1914–1941" (Ph.D. dissertation, University of California at Los Angeles, 1966) .

79. Harold Loeb, *The Way It Was* (New York: Criterion Books, 1958) , 81; Alfred Kreymborg, *Troubadour: An Autobiography* (New York: Boni and Liveright, 1925) , 360–65.

80. For the *Dial* in the twenties, see Nicholas Joost, *Schofield Thayer and the Dial* (Carbondale and Edwardsville: Southern Illinois University Press, 1964) ; Wil-

liam Wasserstrom, *The Time of the* Dial (Syracuse: Syracuse University Press, 1963) ; Hoffman, et al., *Little Magazine,* 197–206.

81. Hoopes, *Brooks,* 154, 158–60.

82. William Carlos Williams, *Selected Essays* (New York: Random House, Inc., 1954) , 174; William Carlos Williams to Dwight Macdonald, December 14, 1942, *Partisan Review* Collection, Rutgers University Library, New Brunswick, New Jersey; William Carlos Williams, *Selected Letters,* ed. John C. Thirwall (New York: McDowell, Obolensky, 1957) , 335. See also James Edward Breslin, "The Poetry of Celebration: William Carlos Williams and Walt Whitman" (Ph.D. dissertation, University of Minnesota, 1964) ; Joseph E. Slate, "William Carlos Williams' Image of America" (Ph.D. dissertation, University of Wisconsin, 1957) .

83. William Carlos Williams, "Introduction" to Waldo Frank et al., *America and Alfred Stieglitz: A Collective Portrait* (New York: Literary Guild, Publishers, 1934) , 29.

84. William Carlos Williams, *In the American Grain: Essays,* reprint ed. (New York: New Directions Books, 1956) , 189 and passim; Susman, "History and the American Intellectual," 259. See also Williams's essay "The Writers of the American Revolution," written in 1925 but unpublished until its appearance in *Selected Essays.*

85. May, *End of American Innocence,* 394.

86. On Sherman's career see Ernest Sutherland Bates, "Stuart Pratt Sherman," in Dumas Malone, ed., *The Dictionary of American Biography,* 20 vols. (New York: Charles Scribner's Sons, 1928–1936) , XVII, 91–92; Jacob Zeitlin and Homer Woodbridge, *Life and Letters of Stuart P. Sherman,* 2 vols. (New York: Farrar and Rinehart, Inc., 1929) .

87. Stuart P. Sherman, *On Contemporary Literature* (New York: Henry Holt and Company, 1917) , 10; Stuart P. Sherman to Brander Matthews, January 16, 1917, James Brander Matthews Papers, Special Collections, Baker Library, Columbia University, New York City.

88. Quoted in Bates, "Stuart Pratt Sherman," 91. See also Ruland, *Rediscovery of American Literature,* 63–69; Richard E. Cauger, "The Concept of the Puritan in American Literary Criticism, 1890–1932" (Ph.D. dissertation, Northwestern University, 1964) , 52–56, 126–32.

89. Stuart P. Sherman to Brander Matthews, May 16, 1922, Matthews Papers.

90. Ruland, *Rediscovery of American Literature,* 95–96; Stuart P. Sherman to W. C. Brownell, February 1922, in Zeitlin and Woodbridge, *Life and Letters of Stuart P. Sherman,* II, 522.

91. See J. David Hoeveler, Jr., *The New Humanism: A Critique of Modern America, 1900–1940* (Charlottesville: University of Virginia Press, 1977) ; Glenn S. Weight, "The Humanist Controversy in American Literature, 1900–1932" (Ph.D. dissertation, Pennsylvania State University, 1956) ; Cauger, "Concept of Puritan in American Literary Criticism," 167–223.

92. Paul Elmer More, "The Modern Current in American Literature," *Forum,* LXXIX (January 1928) , 135–36. See also Irving Babbitt, "The Critic and American Life," ibid., February 1928, pp. 161–76; Paul Elmer More, *The Demon of the Absolute* (Princeton: Princeton University Press, 1928) .

93. Norman Foerster, ed., *Humanism and America: Essays on the Outlook of Modern Civilization* (New York: Farrar and Rinehart, Inc., 1930) , vii–ix.

94. C. Hartley Grattan, ed., *The Critique of Humanism* (New York: Brewer and Warren, Inc., 1930) .

## Chapter 4: This Hot Chaos of America

1. Dorothy Norman, *Alfred Stieglitz: Introduction to an American Seer* (New York: Duell, Sloan, and Pearce, Inc., 1960) , 23.

2. Alfred Stieglitz to Waldo Frank, November 5, 1928, Waldo Frank Papers, Rare Books Collection, Van Pelt Library, University of Pennsylvania, Philadelphia;

George Jean Nathan, *The House of Satan* (New York: Alfred A. Knopf, Inc., 1926), 241.

3. Robert Henri, "What about American Art?" *Arts and Decoration*, XXIV (November 1925), 75.

4. Frederick Lewis Allen, *Only Yesterday: An Informal History of the 1920's* (New York: Harper and Brothers, Publishers, 1931), 241; Randolph S. Bourne, "Our Cultural Humility," *Atlantic Monthly*, CXIV (October 1914), 507; reprinted in Bourne, *The History of a Literary Radical*, ed. Van Wyck Brooks (New York: B. W. Huebsch, 1920), 42.

5. "Editorial," *American Mercury*, I (January 1924), 30.

6. Ernest Boyd, "Mencken, or Virtue Rewarded," *Freeman*, II (February 2, 1921), 491–92.

7. Charles Henry Meltzer, "The Ring That Rules Our Opera," *American Mercury*, III (December 1924), 462–64; Lewis Mumford, "The Poison of Good Taste," ibid., VI (September 1925), 92–94; Mumford, "Symbolic Architecture," ibid., VIII (June 1926), 183–86; Thomas Craven, "The Decline of Illustration," ibid., XII (October 1927), 204–207; Craven, "Contemporary American Sculpture," ibid., XIII (March 1928), 365–68.

8. "The Show of the Painters-Gravers," *Vanity Fair*, VIII (May 1917), 46.

9. Carroll Laverty, *"Vanity Fair:* The Voice of the Twenties," *Journal of the American Studies Association of Texas*, III (1972), 14–20.

10. *American Parade*, I (January 1926), 6, 25–26; ibid., April 1926, 6; ibid., October 1926, 6.

11. Harold Loeb, "Foreign Exchange," *Broom*, II (June 1922), 176–81. On *Broom's* esthetics, see Marjorie Rose Smelstor, *"Broom* and American Cultural Nationalism in the 1920's" (Ph.D. dissertation, University of Wisconsin, 1975); Matthew Josephson, *Life among the Surrealists: A Memoir* (New York: Holt, Rinehart and Winston, Inc., 1962), passim.

12. Matthew Josephson, "The Great American Billposter," *Broom*, III (November 1922), 305, 311; Smelstor, *"Broom* and American Cultural Nationalism," 97.

13. "Will Bray" [Matthew Josephson], "Comment," *Broom*, V (September 1923), 123; Malcolm Cowley, "Pascin's America," ibid., IV (January 1923), 137.

14. Harold Loeb, "Comment: *Broom:* 1921–1923," ibid., V (August 1923), 57; Matthew Josephson, "Poets of the Catacombs," ibid., 49.

15. Smelstor, *"Broom* and American Cultural Nationalism," 149–52; Hoffman et al., *Little Magazine*, 106.

16. Matthew Josephson, *Portrait of the Artist as American*, reprint ed. (New York: Octagon Books, 1964), 308; Oliver M. Sayler, *Revolt in the Arts: A Survey of the Creation, Distribution, and Appreciation of the Arts in America* (New York: Brentano's, 1930), 62; Paul Rosenfeld, *Port of New York: Essays on Fourteen American Moderns* (New York: Harcourt, Brace and Company, 1924), 80; Waldo Frank, *The Rediscovery of America: An Introduction to a Philosophy of American Life* (New York: Charles Scribner's Sons, 1929), 70.

17. Ibid., 231; Robert L. Duffus, *The American Renaissance* (New York: Alfred A. Knopf, Inc., 1928), 321.

18. Frank E. Purdy, "American Art for America," *Arts and Decoration,* XVI (February 1922), 269–71; Richard F. Bach, "Art and the National Ideal," *Forum,* LXVIII (July 1922), 562; Albert Sterner, "Purposeless Art and Insincere Craftsmanship," *Arts and Decoration*, XX (November 1923), 12–14; Warren E. Cox, "The Fine vs. the Applied Art," *American Mercury*, XVIII (October 1929), 198.

19. Barbara Rose, *American Art since 1900* (New York: Frederick A. Praeger, Publishers, 1967), 100–12; Milton Brown, *American Painting from the Armory Show to the Depression* (Princeton: Princeton University Press, 1955), 113–23; Sam Hunter, *Modern American Painting and Sculpture* (New York: Dell Publishing Company, 1959), 98–106; John I. H. Baur, ed., *New Art in America: Fifty Painters of the Twentieth Century* (New York: Frederick A. Praeger, Publishers, 1957), 50–

55, 63–64, 94–98, 103–107; Constance Rourke, *Charles Sheeler: Artist in the American Tradition* (New York: Harcourt, Brace and Company, 1938).

20. Robert Henri, *The Art Spirit* (Philadelphia: J. B. Lippincott and Company, 1923).

21. Royal Cortissoz, *Personalities in Art* (New York: Charles Scribner's Sons, 1925).

22. Alfred Stieglitz to Waldo Frank, November 26, 1920; July 1, 1921, Frank Papers; Royal Cortissoz to Alfred Stieglitz, November 6, 1925, Royal Cortissoz Papers, American Literature Collection, Yale University, New Haven.

23. For the American Scene movement, see the following general items: Matthew Baigell, *The American Scene: Painting of the 1930's* (New York: Frederick A. Praeger, Publishers, 1974); Baigell, "The Beginnings of the 'American Wave' and the Depression," *Art Journal*, XXVII (Summer 1968), 387–96f.; Baigell, "Grant Wood Revisited," ibid., XXXVI (Winter 1966–67), 116–22; Baigell, "Thomas Hart Benton in the 1920's," ibid., XXXIX (Summer 1970), 422–29; Nancy Helber and Julia Williams, *The Regionalists* (New York: Watson-Guptill Publications, 1976); Martha O. Cruz, "The Regionalist Triumvirate and the 'American Program': Thomas Hart Benton, Grant Wood and John Steuart Curry" (Ph.D. dissertation, Saint Louis University, 1975); special issue on Thomas Hart Benton, *Kansas Quarterly*, I (Spring 1969); Thomas Hart Benton, *An Artist in America* (New York: Robert M. McBride and Company, 1937); James M. Dennis, *Grant Wood: A Study in American Art and Culture* (New York: Viking Press, Inc., 1975); Virgil Barker, Americanism in Painting," *Yale Review*, XXV (June 1936), 778–93; Brown, *American Painting from the Armory Show to the Depression*, 173–95; Martha Candler Cheney, *Modern Art in America* (New York: Whittlesey House, 1939), 105–28; E. P. Richardson, *Painting in America: From 1502 to the Present* (New York: Thomas Y. Crowell Company, 1965), 392–405.

24. Cheney, *Modern Art in America,* 106.

25. On this point, see Brown, *American Painting from Armory Show to Depression,* 173.

26. Charles Burchfield, "On the Middle Border," *Creative Art*, III (September 1928), xxv–xxxii.

27. Edward Hopper, "Charles Burchfield," *Arts*, XIV (July 1928), 10–12.

28. Quoted in Sayler, *Revolt in the Arts*, 116.

29. Thomas Craven, *Modern Art: The Men, the Movements, the Meaning* (New York: Simon and Schuster, Inc., 1934), 312, 316.

30. On Craven see "Man of Art," *Scribner's Magazine*, CIII (April 1938), 6; Stanley J. Kunitz and Howard Haycraft, eds., *Twentieth Century Authors: A Biographical Dictionary of Modern Literature* (New York: H. W. Wilson Company, 1942), 326.

31. Thomas Craven, "The Progress of Painting," *Dial*, LXXIV (April, June 1923), 357–67, 581–93.

32. Thomas Craven, "An American Painter," *Nation*, CXX (January 7, 1925), 22; Craven, "Men of Art: American Style," *American Mercury*, V (December 1925), 427–32; Craven, "Decline of Illustration," 207.

33. See Thomas Craven, "An American Master," *American Mercury*, XII (December 1927), 490–97.

34. Kunitz and Haycraft, eds., *Twentieth Century Authors*, 326.

35. C. Howard Walker, "America's Titantic Strength Expressed in Architecture," *Current History*, XXI (January 1925), 556–57; William A. Starrett, *Skyscrapers and the Men Who Build Them* (New York: Charles Scribner's Sons, 1928), 1–2; Thomas E. Tallmadge, *The Story of Architecture in America*, 2d ed. (New York: W. W. Norton and Company, 1936). The first edition of Tallmadge's book was published in 1927.

36. Thomas E. Tallmadge, "The Advance of Architecture," *Atlantic Monthly*, CXXXVI (August 1925), 225–29. See also Rufus Town Stephenson, "A Challenge to the American Architect," *Art and Archaeology*, XXX (October 1930), 133–39; Talbot F. Hamlin, *The American Spirit in Architecture* (New Haven: Yale University Press, 1926).

37. Randolph W. Sexton, *The Logic of Modern Architecture* (New York: Architectural Book Publishing Company, 1929), 5; Herbert Croly, editorial, *Architectural Record*, LVI (October 1924), 381.

38. Henry-Russell Hitchcock, "Traffic and Building Art," *Architectural Record*, LXVII (June 1930), 555–59.

39. Lewis Mumford, "Architecture and the Machine," *American Mercury*, III (September 1924), 78.

40. Roy Lubove, *The Urban Community: Housing and Planning in the Progressive Era* (Englewood Cliffs: Prentice-Hall, Inc., 1967), 17–21; Lewis Mumford, "American Architecture: The Mediaeval Tradition," *Freeman*, VIII (December 19, 1923), 394–96. See also Roy Lubove, *Community Planning in the 1920's: The Contribution of the Regional Planning Association of America* (Pittsburgh: University of Pittsburgh Press, 1964).

41. Lewis Mumford, *Sticks and Stones: A Study of American Architecture and Civilization* (New York: W. W. Norton and Company, 1924), 30, 225.

42. Ibid., 177 and passim.

43. Lewis Mumford, "Introduction" to *Sticks and Stones: A Study of American Architecture and Civilization*, reprint ed. (New York: Dover Books, Inc., 1955), n.p.

44. Lewis Mumford, *The Brown Decades: A Study of the Arts in America, 1865–1895* (New York: Harcourt, Brace and Company, 1931), 165 and passim. See also Eddy Weber Dow, "Lewis Mumford's First Phase: A Study of His Work as a Critic of the Arts in America" (Ph.D. dissertation, University of Pennsylvania, 1965).

45. Lewis Mumford, review of Henry-Russell Hitchcock, *Frank Lloyd Wright*, in *Architectural Record*, LXV (April 1929), 414–16.

46. Frank Lloyd Wright to H. L. Mencken, August 6, 1926, H. L. Mencken Collection, New York Public Library, New York City. On Wright's California houses, see A. N. Rebori, "Frank Lloyd Wright's Textile-Block Slab Construction," *Architectural Record*, LII (December 1927), 449–56.

47. Frank Lloyd Wright, "In the Cause of Architecture," *Architectural Record*, LXI–LXIII (May–June, August, October 1927, January–February, April–June 1928).

48. Sayler, *Revolt in the Arts*, 123, 328.

49. Louis Sullivan, *The Autobiography of an Idea* (New York: American Institute of Architects, 1924).

50. Louis Sullivan, "The Chicago Tribune Competition," *Architectural Record*, LIII (February 1923), 151–57.

51. H. Harold Kent, "The Chicago Tribune Competition," *Architectural Record*, April 1923, 379.

52. Frank Lloyd Wright, "Louis Sullivan, Beloved Master," *Western Architect*, June 1924, pp. 64–66; Wright, "Louis Sullivan: His Work," *Architectural Record*, LVI (July 1924), 31; Fiske Kimball, "Louis Sullivan: An Old Master," ibid., LVII (April 1925), 289–304.

53. Richard J. Neutra, "Architecture Conditioned by Engineering and Industry," ibid., LXVI (September 1929), 272–74.

54. Oscar Saenger, "This Is the Golden Age of Music in the United States," *Musician*, XXXIII (July 1928), 10.

55. On Damrosch see Frederick Theodore Himmelein, "Walter Damrosch: A Cultural Biography" (Ph.D. dissertation, University of Virginia, 1972); Walter Damrosch, *My Musical Life* (New York: Charles Scribner's Sons, 1926).

56. Arthur Farwell, "The Zero Hour in Musical Evolution," *Musical Quarterly*, XIII (January 1927), 96; statistics from *Singing* cited in Henrietta Straus, "A Blow for Musical Democracy," *Nation*, CXXVI (March 21, 1928), 328–29.

57. Daniel Gregory Mason to Arturo Toscanini, January 31, 1928; Mason to Edward Mackay, December 19, 1928, Daniel Gregory Mason Papers, Special Collections, Baker Library, Columbia University, New York City. See also Mason to Lawrence Gilman, March 12, 1931, ibid.

58. Daniel Gregory Mason, *The Dilemma of American Music and Other Essays* (New York: Macmillan Company, 1928), 37–39, 78–79.

59. Daniel Gregory Mason, "Is American Music Growing Up?" *Arts and Decoration,* XIV (November 1920) , 40B.

60. Charles Henry Meltzer, "Music for Americans," *Forum,* LXIX (May 1923) , 1535; Meltzer, "The National Movement in Music," *Independent,* CIX (November 11, 1922) , 273; Meltzer, "Ring That Rules Our Opera," 464 and passim; Henrietta Straus, "Opera in English," *Nation,* CX (April 3, 1920) , 437–38. See also Straus, "The American Composer and Opera," ibid., March 6, 1920, pp. 309–10; Straus, "On Our Way," ibid., CXXXVI (February 22, 1928) , 219–20.

61. Olga Samaroff, quoted in "A Triumph for American Opera," *Literary Digest,* XCII (March 19, 1927) , 27.

62. Edward E. Hipsher, *American Opera and Its Composers* (Philadelphia: Theodore Presser Company, 1927) , 385.

63. Roger Sessions, *Reflections on the Music Life in the United States* (New York: Merlin Press, 1956) , 140.

64. Aaron Copland, *Music and Imagination* (Cambridge: Harvard University Press, 1952) , 99–100. See also Copland, "Making Music in the Star-Spangled Manner," *Music and Musicians,* VIII (August 1960) , 9; Arthur Berger, *Aaron Copland* (New York: Oxford University Press, 1953) ; Julia Smith, *Aaron Copland: His Work and Contribution to American Music* (New York: E. P. Dutton and Company, 1955) ; Arnold Dobrin, *Aaron Copland: His Life and Times* (New York: Thomas Y. Crowell Company, 1967) .

65. Copland, *Music and Imagination,* 100–106.

66. Sessions, *Reflections on Music Life in United States,* 125–32.

67. Paul Rosenfeld, "A View of Modern Music," *Dial,* LXXIX (November 1925) , 395–96; Rosenfeld, *An Hour with American Music* (Philadelphia: J. B. Lippincott Company, 1929) , 26–32, 60.

68. Gilbert Chase, *America's Music: From the Pilgrims to the Present* 2d ed., rev. (New York: McGraw-Hill Book Company, 1966) , 495–99, 582–84; Hugo Leichtentritt, *Serge Koussevitzky, the Boston Symphony Orchestra, and the New American Music* (Cambridge: Harvard University Press, 1946) , 70–75; Randall Raley, "American Elements in the Music of Aaron Copland" (M.A. thesis, University of Texas, 1950) , passim.

69. Carl Sandburg, ed., *The American Songbag* (New York: Harcourt, Brace and Company, 1927) , viii.

70. Newman White, *American Negro Folk-Songs* (Cambridge: Harvard University Press, 1928) , 17; Donald Knight Wilgus, *Anglo-American Folksong Scholarship since 1898* (New Brunswick: Rutgers University Press, 1959) , 350–56.

71. In the vast literature on jazz, some of the most helpful general items are: Barry Ulanov, *A History of Jazz in America* (New York: Viking Press, 1952) ; Marshall W. Stearns, *The Story of Jazz* (New York: Oxford University Press, 1956) ; Wilder Hobson, *American Jazz Music* (New York: W. W. Norton and Company, 1939) ; Winthrop Sergeant, *Jazz: A History,* rev. ed. (New York: McGraw-Hill Book Company, 1964) ; Samuel B. Charters, *Jazz: New Orleans, 1885–1957* (New York: Walter C. Allen, 1958) ; Gunther Schuller, *Early Jazz: Its Roots and Musical Development* (New York: Oxford University Press, 1968) ; Chadwick C. Hansen, "The Ages of Jazz: A Study of Jazz and Its Cultural Context" (Ph.D. dissertation, University of Minnesota, 1956) ; Thomas Joseph Hennessey, "From Jazz to Swing: Black Jazz Musicians and Their Music, 1917–1935" (Ph.D. dissertation, Northwestern University, 1973) ; Ross Russell, *Jazz Style in Kansas City and the Southwest* (Berkeley: University of California Press, 1971) ; Ronald L. Davis, "Early Jazz: Another Look," *Southwest Review,* LVIII (Winter–Spring 1973) , 1–13, 114–54.

72. Ulanov, *History of Jazz in America,* 115.

73. On the white encounter with jazz in the twenties and white efforts to uplift and dignify the music, see Neil Leonard, *Jazz and the White Americans: The Acceptance of a New Art Form* (Chicago: University of Chicago Press, 1962) ; LeRoi Jones, *Blues People* (New York: William Morrow and Company, 1963) ; Morroe Berger, "Jazz: Resistance to the Diffusion of a Culture Pattern," *Journal of Negro*

*History*, XXXII (October 1947), 461–94. For the other side of the story, the encounter of black jazz musicians with white culture, see Hennessey, "Jazz to Swing." On the general question of the relation of jazz to formal music, see David Ross Baskerville, "Jazz Influence on Art Music to Mid-Century" (Ph.D. dissertation, University of California at Los Angeles, 1965).

74. Samuel Chotzinoff, "Jazz: A Brief History," *Vanity Fair*, XX (June 1923), 69ff.; Alfred V. Frankenstein, *Syncopating Saxophones* (Chicago: R. O. Ballou Company, 1925), 44 and passim; Henry Osborne Osgood, *So This Is Jazz* (Boston: Little, Brown and Company, 1926), 218, 250, and passim.

75. Aaron Copland, "Jazz Structure and Influence," *Modern Music*, IV (January–February 1927), 9–14.

76. Mason, *Dilemma of American Music*, 37; Clive Bell, "Plus de Jazz," *New Republic*, XXVIII (September 21, 1921), 92–96; Rosenfeld, *Hour with American Music*, 11–17.

77. For Van Vechten, see Bruce Kellner, *Carl Van Vechten and the Irreverent Decades* (Norman: University of Oklahoma Press, 1968); Edward Leuders, *Carl Van Vechten and the Twenties* (Albuquerque: University of New Mexico Press, 1955); Hugh M. Glouster, "The Van Vechten Vogue," *Phylon*, VI (Fourth Quarter 1945), 310–14.

78. Carl Van Vechten to H. L. Mencken, November 30, 1925, Mencken Collection, NYPL; Van Vechten, *Nigger Heaven* (New York: Alfred A. Knopf, Inc., 1926).

79. Quoted in S. P. Fullinwider, *The Mind and Mood of Black America: 20th Century Thought* (Homewood, Ill.: Dorsey Press, 1969), 116. The best study of Locke is Clare Bloodgood Crane, "Alain Locke and the Negro Renaissance" (Ph.D. dissertation, University of California at San Diego, 1971).

80. Alain Locke, ed., *The New Negro: An Interpretation* (New York: Alfred and Charles Boni, 1925); Johnson quoted in Fullinwider, *Mind and Mood of Black America*, 89.

81. James Weldon Johnson, *The Autobiography of an Ex-Coloured Man* (New York: Alfred A. Knopf, Inc., 1927); Nathan Irvin Huggins, *Harlem Renaissance* (New York: Oxford University Press, 1971), 10–11 and passim. See also Alain Locke, *The Negro and His Music*, reprint ed. (New York: Kennikat Press, 1968); Bernard Bell, "Folk Art and the Harlem Renaissance," *Phylon*, XXXVI (June 1975), 155–63.

82. See Carl Van Vechten, "The Black Blues," *Vanity Fair*, XXV (August 1925), 57f.; Van Vechten, "The Folksongs of the American Negro," ibid., July 1925, pp. 52f.; Van Vechten, "Negro 'Blues' Singers," ibid., XXVI (March 1926), 67ff.

83. Quoted in Kellner, *Carl Van Vechten*, 192.

84. For Gershwin's life see Isaac Goldberg, *George Gershwin: A Study in American Music* (New York: Simon and Schuster, Inc., 1931); David Ewen, *Journey to Greatness: The Life and Music of George Gershwin* (New York: Henry Holt and Company, 1956); Merle Armitage, *George Gershwin: Man and Legend* (New York: Duell, Sloan and Pearce, 1958); Armitage, ed., *George Gershwin* (New York: Longman's, Green and Company, 1938); Charles M. Schwartz, "The Life and Orchestral Works of George Gershwin" (Ph.D. dissertation, New York University, 1969); Linda Diane Gutowski, "George Gershwin's Relationship to the Search for an American Culture during the Nineteen-Twenties" (M.A. thesis, University of Maryland, 1967). On the popular-music ambience in which Gershwin thrived, see Edward Jablonski and Lawrence D. Stewart, *The Gershwin Years* (New York: Doubleday and Company, 1958).

85. Carl Van Vechten, "George Gershwin: An American Composer Who Is Writing Notable Music in the Jazz Idiom," *Vanity Fair*, XXIV (March 1925), 40; Van Vechten to Gershwin, letter quoted in Goldberg, *Gershwin*, 154; Virgil Thomson, "The Cult of Jazz," *Vanity Fair*, XXIV (June 1925), 54; Samuel Chotzinoff, "George Gershwin's 'Rhaposdy in Blue,' " ibid., XXIII (August 1924), 28f; Damrosch, *My Musical Life*, 268.

86. Paul Whiteman, "In Defense of Jazz and Its Makers," *New York Times Magazine*, March 13, 1927, 22; Whiteman and Mary Margaret McBride, *Jazz* (New York:

J. M. Sears and Company, 1926), 131, 150–55. For Whiteman's music, see Leonard, *Jazz and White Americans*, 79–81, 86–87; Schuller, *Early Jazz*, 191–93.

87. Don Knowlton, "The Anatomy of Jazz," *Harper's Magazine*, CLII (April 1926), 578–85; Paul F. Laubenstein, "Jazz: Debit and Credit," *Musical Quarterly*, XV (October 1929), 624; Abbe Niles, "Jazz 1928: An Index Expurgatorius," *Bookman*, LXVIII (January 1929), 570.

88. Hiram K. Moderwell, "Hitching Jazz to a Star," *Musical America*, XLIX (March 10, 1929), 13f.; Waldo Frank, "Jazz and Folk Art," *New Republic*, XLIX (December 1, 1926), 43; Charles E. Smith, "Jazz: Some Little Known Aspects," *Symposium*, I (October 1930), 502–17.

89. Gilbert Seldes, *The Seven Lively Arts* (New York: Harper and Bros., 1924).

90. Gilbert Seldes, "The Position of Jazz in American Musical Development," *Arts and Decoration*, XX (April 1924), 21f.

91. For Seldes, see Kunitz and Haycraft, eds., *Twentieth Century Authors*, 1261.

92. Seldes, *Seven Lively Arts*, 252, 294, and passim.

93. Ibid., 102, 309–41, 356–57.

94. Ibid., 4–54; Seldes, *An Hour with the Movies and the Talkies* (Philadelphia: J. B. Lippincott Company, 1929), 7.

95. "Moving Pictures and the National Character," *Review of Reviews*, XLII (September 1910), 320; Randolph S. Bourne, "The Heart of the People," *New Republic*, III (July 3, 1915), 233; Vachel Lindsay, *The Art of the Motion Picture* (New York: Macmillan Company, 1915), rev. ed., Macmillan, 1922. See also Myron Osborn Lounsbury, "The Origins of American Film Criticism, 1909–1939" (Ph.D. dissertation, University of Pennsylvania, 1966).

96. Warner quoted in Sayler, *Revolt in the Arts*, 224.

97. Arthur Hornblow, *A History of the Theatre in America from Its Beginnings to the Present Times*, 2 vols. (Philadelphia: J. B. Lippincott Company, 1919), II, 351.

98. George Jean Nathan, "The American Prospect," *American Mercury*, XV (October 1928), 248–49.

99. Kenneth Macgowan, "America's Best Season in the Theatre," *Theatre Arts Magazine*, IV (April 1920), 91–104; Oliver M. Sayler, "Our Awakening Theater: A Survey of the Season, 1920–1921," *Century*, CII (August 1921), 515; Ludwig Lewisohn, "Drama: Harvest: I," *Nation*, CXIV (May 10, 1922), 574; Arthur Hobson Quinn, "National Ideals in the Drama, 1922–1923," *Scribner's Magazine*, LXXIV (July 1923), 63.

100. Oliver M. Sayler, *Our American Theatre* (New York: Brentano's, 1923), 1–9.

101. Ibid., 1: "An American Paradox," *Nation*, CXXI (November 11, 1925), 531–32.

102. Walter Prichard Eaton, "Broadway and National Life," *Freeman*, I (March 17, 1920), 18; Eaton, *The Theatre Guild: The First Ten Years* (New York: Brentano's, 1929); Hammond quoted in "America Neglected by Drama," *Literary Digest*, LXXIX (December 15, 1923), 29.

103. Alfred E. Bernheim, "The Theater: A Depressed Industry," *New Republic*, LVII (February 13, 1929), 341–43; Earl May, "A Calamitous Stage Slump," *World's Work*, LVIII (May 1929), 58–61ff.; Clayton Hamilton, "On the Stage: A Diagnosis of Our Times," *Century*, CXIX (October 1929), 21–28.

104. Walter Prichard Eaton, "Towards a New Theatre," *Freeman*, V (July 12, 1922), 418–19; Kenneth Macgowan, *Footlights across America: Towards a National Theatre* (New York: Harcourt, Brace and Company, 1929), 4–6, 22, 208. See also Montrose J. Moses, "The Social Significance of Little Theatres," *North American Review*, CCXXIV (March 1927), 128–39.

105. Macgowan, *Footlights across America*, 10–20; John Anderson, *Box Office* (New York: Johnathan Cape and Harris Smith, 1929), 113.

106. Joseph Wood Krutch, "The New American Drama," *Nation*, CXXX (June 11, 1930), 678.

107. Bartlett Cormack, "Hail Columbia! The *Encyclopedia Britannica* and American Literature," *Bookman*, LXIV (January 1927), 568–72; Fred Lewis Pattee, *The New American Literature, 1890–1930* (New York: Century Company, 1930), vii (italics in original).

108. Jay B. Hubbell, "Foreword," *American Literature*, I (March 1929), 2; Hubbell, *South and Southwest: Literary Essays and Reminiscences* (Durham: Duke University Press, 1965), 22–42; Willard Thorp, "Exodus: Four Decades of American Literary Scholarship," *Modern Language Quarterly*, XXVI (March 1965), 40–61.

109. For Lewis's Nobel Prize address see the New York *Times*, December 13, 1930, 12.

110. Malcolm Cowley, "Foreword," to Cowley, ed., *After the Genteel Tradition: American Writers since 1910* (New York: W. W. Norton and Company, 1937), 16.

111. Joseph Wood Krutch, *The Modern Temper: A Study and a Confession* (New York: Harcourt, Brace and Company, 1929), 139 and passim.

112. Lionel Trilling, "Is Literature Possible?" *Nation*, CXXXI (October 15, 1930), 405–406.

## Chapter 5: The Decade of Convictions

1. Frederick Lewis Allen, *Only Yesterday: An Informal History of the 1920's* (New York: Harper and Bros., Publishers, 1931), 338; John Chamberlain, review of Allen, *Only Yesterday*, New York *Times Book Review*, December 6, 1931, 1. On the reputation of the twenties, see Henry F. May, "Shifting Perspectives on the 1920's," *Mississippi Valley Historical Review*, XLIII (December 1956), 405–27.

2. For the influence of Allen's book, see Darwin Payne, *The Man of Only Yesterday: Frederick Lewis Allen* (New York: Harper and Row, Publishers, 1975), 99–105 and passim.

3. Malcolm Cowley, *Exile's Return: A Literary Odyssey of the 1920's*, 2d ed. (New York: Viking Press, Inc., 1951), 144 (italics in original); Budd Schulberg, *What Makes Sammy Run?* (Garden City: Sun Dial Press, 1941), 303.

4. On Calverton, see Stanley J. Kunitz and Howard Haycraft, eds., *Twentieth Century Authors: A Biographical Directory of Modern Literature* (New York: H. W. Wilson Company, 1942), 239–40; Charles I. Glicksberg, "V. F. Calverton: Marxism without Dogma," *Sewanee Review*, XLVI (July 1938), 338–51; Haim Genizi, "The *Modern Quarterly*, 1923–1940: An Independent Radical Magazine," *Labor History*, XV (Spring 1974), 199–215.

5. V. F. Calverton, "The Decade of Convictions," *Bookman*, LXXI (August 1930), 486–90.

6. Harold Clurman, *The Fervent Years: The Story of Group Theatre and the Thirties*, rev. ed. (New York: Alfred A. Knopf, Inc., 1957), 271; Frederick J. Hoffman, *The Twenties: American Writing in the Postwar Decade* (New York: Viking Press, Inc., 1955), 72.

7. Malcolm Cowley, "Farewell to the 1930's," *New Republic*, CI (November 8, 1939), 43; Maxwell Geismar, "No Man Alone Now," *Virginia Quarterly Review*, XVII (September 1941), 530.

8. Harold Stearns, *Rediscovering America* (New York: Liveright Publishing Corporation, 1934), 21, 136, and passim.

9. Ludwig Lewisohn, "An American Comes Home," in William H. and Kathryn Cordell, eds., *American Points of View, 1934–1935* (New York: Doubleday, Doran and Company, 1936), 144–55.

10. Ruth Suckow, "The Folk Idea in American Life," *Scribner's Magazine*, LXXXVIII (September 1930), 245–55.

11. See Arthur A. Ekirch, Jr., *Ideologies and Utopias: The Impact of the New Deal on American Thought* (Chicago: Quadrangle Books, Inc., 1969), 177–207.

12. Albert Jay Nock, "The Return of the Patriots," *Virginia Quarterly Review*, VIII (April 1932), 161–74; H. L. Mencken, "The New Architecture," *American Mercury*, XXII (February 1931), 164–65.

13. Alfred Stieglitz to Waldo Frank, July 6, 1935, Waldo Frank Papers, Rare Books Collection, Van Pelt Library, University of Pennsylvania, Philadelphia.

14. Aline Kistler, "We Are What We Are," *American Magazine of Arts*, XXVIII (October 1935) , 620; Ruth Pickering, "Grant Wood: Painter in Overalls," *North American Review*, CCXL (September 1935) , 273; Montrose J. Moses, "The American Note in Drama," *Current History*, XXXIX (October 1933) , 63–68.

15. Russell Blankenship, *American Literature as an Expression of the National Mind* (New York: Henry Holt and Company, 1931) , vii–x.

16. For Parrington, see George Harvey Genzmer, "Vernon Louis Parrington," in Dumas Malone, ed., *The Dictionary of American Biography*, 20 vols. (New York: Charles Scribner's Sons, 1928–36) , XIV, 253–54; Richard Hofstadter, *The Progressive Historians: Turner, Beard, Parrington* (New York: Alfred A. Knopf, Inc., 1968) , 349–434; Robert Allan Skotheim, *American Intellectual Histories and Historians* (Princeton: Princeton University Press, 1966) , 124–48.

17. Vernon Louis Parrington, *Main Currents in American Thought*, 3 vols. (New York: Harcourt, Brace and Company, 1927–30) , I, iii.

18. Michael Gold, "Two Critics in a Bar-room," *Liberator*, IV (September 1921) , 30; Gold, "Wilder: Prophet of the Genteel Christ," *New Republic*, XLIV (October 22, 1930) , 266–68.

19. Richard Pells, *Radical Visions and American Dreams: Culture and Social Thought in the Depression Years* (New York: Harper and Row, Publishers, 1973) , 176 (italics in original) ; James B. Gilbert, *Writers and Partisans: A History of Literary Radicalism in America* (New York: John Wiley and Sons, Inc., 1968) , 93–94; Solomon Fishman, *The Disinherited of Art* (Berkeley: University of California Press, 1953) , 66. See also Howard Lee Hertz, "Writer and Revolutionary: The Life and Works of Michael Gold, Father of Proletarian Literature in the United States" (Ph.D. dissertation, University of Texas, 1974) .

20. See John Diggins, *The American Left in the Twentieth Century* (New York: Harcourt Brace Jovanovich and Company, 1973) , 73–121.

21. V. F. Calverton, *The Liberation of American Literature* (New York: Charles Scribner's Sons, 1932) , passim.

22. V. F. Calverton, "Can We Have a Proletarian Literature?" *Modern Quarterly*, VI (Autumn 1932) , 49–50 and passim.

23. Granville Hicks, *The Great Tradition: An Interpretation of American Literature since the Civil War*, rev. ed. (New York: Macmillan Company, 1935) . The first edition was published in 1933. On Hicks, see Kunitz and Haycraft, eds., *Twentieth Century Authors*, 649–50; Hicks, *Part of the Truth* (New York: Harcourt, Brace and World, Inc., 1964) .

24. On the intellectual fascination with economic planning in the thirties, see Charles C. Alexander, *Nationalism in American Thought, 1930–1945* (Chicago: Rand McNally and Company, 1969) , 5–17; Pells, *Radical Visions and American Dreams*, 61–76.

25. Edmund Wilson, "An Appeal to Progressives," *New Republic*, XLV (January 14, 1931) , 238; Wilson, "Marxism and Literature," *Atlantic Monthly*, CLX (December 1937) , 741–50. On the non-Communist Left in the thirties, see Frank A. Warren, *Liberals and Communism: The 'Red Decade' Revisited* (Bloomington: Indiana University Press, 1966) ; Peter G. Filene, *Americans and the Soviet Experiment, 1917–1933* (Cambridge: Harvard University Press, 1967) .

26. Joseph Wood Krutch, "The Usable Past," *Nation*, CXXXVIII (February 14, 1934) , 191–97.

27. Van Wyck Brooks, *The Life of Emerson* (New York: E. P. Dutton and Company, 1932) .

28. Van Wyck Brooks, *The Flowering of New England* (New York: E. P. Dutton and Company, 1936) ; Brooks, *New England: Indian Summer, 1865–1915* (New York: E. P. Dutton and Company, 1940) .

29. Van Wyck Brooks to Waldo Frank, January 12, 1935, Frank Papers; Frank to Brooks, January 4, May 10, 1935, Van Wyck Brooks Papers, Rare Books Collection, Van Pelt Library, University of Pennsylvania, Philadelphia.

30. Paul Green, "Needed! A Native American Drama," *Drama Magazine*, XXI (October 1930) , 5.

31. Lois Johnson Faucette, "Paul Green and the American Dream" (Ph.D. dissertation, Howard University, 1975) .

32. Quoted in Gerald Rabkin, *Drama and Commitment: Politics in the American Theatre of the Thirties* (Bloomington: Indiana University Press, 1964) , 134. See also Darwin T. Turner, "Jazz-Vaudeville Drama in the Twenties," *Educational Theatre Journal*, XI (May 1959) , 110–12.

33. John Dos Passos, "The American Theatre, 1930–1931: Is the Whole Show on the Skids?" *New Republic*, LXVI (April 1, 1931) , 171–75.

34. On the Left movement in the American Theater in the thirties, see Rabkin, *Drama and Commitment;* Malcolm Goldstein, *The Political Stage: American Drama and Theater of the Great Depression* (New York: Oxford University Press, 1974) ; Jay Williams, *Stage Left* (New York: Charles Scribner's Sons, 1974) ; Morgan Y. Himmelstein, *Drama Was a Weapon: The Left-Wing Theater in New York, 1929–1941* (New Brunswick: Rutgers University Press, 1963) ; Sam Smiley, *The Drama of Attack: Didactic Plays of the American Depression* (Columbia: University of Missouri Press, 1972) .

35. Quoted in Kay Irene Johnson, "Playwrights as Patriots: A History of the Playwrights Producing Company, 1938–1960" (Ph.D. dissertation, University of Wisconsin, 1974) , 555.

36. Ben Blake, *The Awakening of the American Theatre* (New York: Tomorrow Publishers, 1935) . See also Hallie Flanagan, "A Theatre Is Born," *Theatre Arts Monthly*, XV (November 1931) , 908–15.

37. Himmelstein, *Drama Was a Weapon*, 218.

38. Harold Clurman to Waldo Frank, December 22, 1927 (italics in original) ; subsequent Clurman letters to Frank, undated, Frank Papers.

39. For the founding and subsequent development of Group Theatre, see Clurman, *Fervent Years;* Rabkin, *Drama and Commitment*, 71–92; Goldstein, *Political Stage*, 75–100, 300–37; Himmelstein, *Drama Was a Weapon*, 155–81.

40. Clurman, *Fervent Years*, 73, 127, 152–53.

41. Rabkin, *Drama and Commitment*, 169–212; Smiley, *Drama of Attack*, 167–73; Pells, *Radical Visions and American Dreams*, 259–61.

42. "Is There a Future for Opera in America?" *Literary Digest*, CXVII (March 31, 1934) , 20; Grace Overmyer, "The Musician Starves," *American Mercury*, XXXIII (June 1934) , 473–78.

43. Aaron Copland, *The New Music, 1900–1968* (New York: W. W. Norton and Company, 1968) , 161–62; Virgil Thomson, *American Music since 1910* (New York: Holt, Rinehart, and Winston, Inc., 1971) , 8–10; Irving Kolodin, "Concert Hall into Theatre," *Theatre Arts Monthly*, XXII (October 1938) , 727–32.

44. Herman S. Hettinger, ed., "New Horizons in Radio," *Annals of the American Academy of Political and Social Science*, CCXIII (January 1941) , 12; John T. Howard and George K. Bellows, *A Short History of Music in America* (New York: Thomas Y. Crowell Company, 1957) , 366.

45. John T. Howard, "Better Days for Music," *Harper's Magazine*, CLXXIV (April 1937) , 483–91; Dickson Skinner, "Music Goes into Mass Production," ibid., CLXXVIII (April 1939) , 484–90; Lucien Price, "Music in Shirt Sleeves," *Atlantic Monthly*, CLVI (July–December 1940) , 106–108.

46. Frederick P. Keppel and Robert L. Duffus, *The Arts in American Life* (New York: McGraw-Hill Book Company, 1933) , 175; W. J. Henderson, "Why No Great American Music?" *American Mercury*, XXXII (July 1934) , 301; Henderson, "Anniversary Postbag," *Yale Review*, XXV (September 1935) , 26–27; Howard Hanson, "Conditions Affecting the Development of an American Music," *Etude*, L (April 1932) , 247; Aaron Copland, *Our New Music: Leading Composers in Europe and America* (New York: McGraw-Hill Book Company, 1941) , 131.

47. Copland, *Our New Music*, 133; Roy Harris, "Does Music Have to Be European?" *Scribner's Magazine*, XCI (April 1932) , 208–209; Randall Thompson, "The

Contemporary Scene in American Music," *Musical Quarterly,* XVIII (January 1932), 12.

48. Hanson, "Conditions Affecting the Development of an American Music," 248; Hanson, "Developing an American School of Music," *Musician,* XXXIX (December 1934), 4; Daniel Gregory Mason, *Tune in America! A Study of Our Coming Musical Independence* (New York: Alfred A. Knopf, Inc., 1931), 34-35; Mason to Ernst Bacon, May 9, 1933, Daniel Gregory Mason Papers, Special Collections, Baker Library, Columbia University, New York City.

49. Roger Sessions, *Reflections on the Musical Life in the United States* (New York: Merlin Press, 1956), 162.

50. Mason, *Tune in America!* 144.

51. Ibid., 139, 194-95; Mason, *Music in My Time* (New York: Macmillan Company, 1938), 366.

52. Roy Harris, "American Music Enters a New Phase," *Scribner's Magazine,* XCVI (October 1934), 218-21; Harris, "Does Music Have to be European?" 219.

53. Thomson, *American Music since 1910,* 9; Paul Rosenfeld, *Discoveries of a Music Critic* (New York: Harcourt, Brace, and Company, 1936), 315-19, 357.

54. See Charles Seeger, "On Proletarian Music," *Modern Music,* XI (March-April 1934), 120-27.

55. Aaron Copland, "The Composer and His Critic," *Modern Music,* IX (May 1932), 143-47. On the Composers' Collective, see Richard A. Reuss, "American Folklore and Left-wing Politics, 1927-1957" (Ph.D. dissertation, Indiana University, 1971), 56-65.

56. See Aaron Copland, "The American Composer Gets a Break," *American Mercury,* XXXIV (April 1935), 488-92.

57. David Ewen, "Speaking of American Opera," *Theatre Arts,* XXIV (January 1940), 51-54; Herbert Graf, *The Opera and Its Future in America* (New York: W. W. Norton and Company, 1941), 270-75.

58. On *Porgy and Bess,* see Chase, *America's Music,* 642-45; Merle Armitage, *George Gershwin: Man and Legend* (New York: Duell, Sloan and Pearce, 1958), 147-70; David Ewen, *George Gershwin: His Journey to Greatness* (New York: Prentice-Hall, Inc., 1970), 218-65; Charles M. Schwartz, "The Life and Orchestral Works of George Gershwin" (Ph.D. dissertation, New York University, 1969), 203-19; Frank Durham, "The Opera That Didn't Get to the Metropolitan," *South Atlantic Quarterly,* LIII (October 1954), 497-507. In the 1942 revival and subsequent productions, Gershwin's often-clumsy recitative was abandoned in favor of spoken connecting dialog.

59. Otis Ferguson, " 'The Man I Love,' " *New Republic,* XCI (July 21, 1937), 293.

60. Carl Van Vechten, postcard from Vienna to H. L. Mencken, October 5, 1932, H. L. Mencken Collection, New York Public Library.

61. Sigmund Spaeth, *The Facts of Life in Popular Song* (New York and London: Whittlesey House, 1934), iii-iv. Cf. Theodor W. Adorno, "On Popular Music," *Studies in Philosophy and Social Science,* IX (1941), 17-48.

62. Hugues Panassié, *Hot Jazz: The Guide to Swing Music,* trans. Lyle and Eleanor Dowling (New York: Witmark Publishing Company, 1936).

63. Ralph Vaughan Williams, *National Music and Other Essays* (London: Oxford University Press, 1963), 71; Winthrop Sargeant, *Jazz: Hot and Hybrid,* 2d ed. (New York: E. P. Dutton and Company, 1946), 257-64.

64. Louis Armstrong, *Swing That Music!* (London and New York: Longmans, Green and Company, 1936), 124.

65. Barry Ulanov, *A History of Jazz in America,* 2d ed. (New York: Viking Press, Inc., 1957), 187.

66. See Barry Ulanov, *Duke Ellington* (New York: Creative Age Press, 1946); Peter Gammon, *Duke Ellington and His Music* (New York: Roy Publishers, 1958); Raymond Horricks, *Count Basie and His Orchestra* (New York: Citadel Press, 1957).

67. Irving Kolodin, "No. 1 Swing Man," *Harper's Magazine,* CLXXIX (September 1939), 431-40.

68. See Chadwick Hansen, "The Ages of Jazz: A Study of Jazz and Its Cultural Context" (Ph.D. dissertation, University of Minnesota, 1956), passim.

69. Armstrong, *Swing That Music!*, 122; Louis Harap, "The Case for Hot Jazz," *Musical Quarterly*, XXVII (January 1941), 47–61.

70. See Robert Vitz, "Painters, Pickets, and Politics: The Artist Moves Left, 1925–1940" (Ph.D. dissertation, University of North Carolina, 1971); Frances T. Feldman, "American Painting during the Great Depression, 1929–1939" (Ph.D. dissertation, New York University, 1963).

71. See Oliver Larkin, *Art and Life in America*, rev. ed. (New York: Holt, Rinehart and Winston, Inc., 1960), 430–41; Barbara Rose, *American Art since 1900* (New York: Frederick A. Praeger, Inc., 1967), 114–29; Henry Geldzahler, *American Painting in the Twentieth Century* (New York: Metropolitan Museum of Art, 1965), 111–18.

72. Whitney Museum of American Art, *Catalogue of the Collection* (New York: Whitney Museum of American Art, 1931), 11; Daty Healy, "A History of the Whitney Museum of American Art, 1930–1954" (Ph.D. dissertation, New York University, 1960).

73. Larkin, *Art and Life in America*, 408; E. P. Richardson, *Painting in America: From 1502 to the Present* (New York: Thomas Y. Crowell Company, 1965), 386.

74. *American Folk Art: The Art of the Common Man* (New York: Museum of Modern Art, 1932); Jerome Mellquist, "Life in America," *Nation*, CXLIX (September 9, 1939), 274–76.

75. Alfred Frankenstein, "Paul Sample," *Magazine of Art*, XXXI (July 1938), 387.

76. Quoted in Martha Candler Cheney, *Modern Art in America* (New York and London: Whittlesey House, 1939), 123.

77. Cheney, *Modern Art*. 136–37 (italics in original); Forbes Watson, "The Return to the Facts," *American Magazine of Art*, XXIX (March 1936), 151; Ruth Pickering, "American Art Comes Home," *Forum*, XCIV (September 1935), 182. See also Virgil Barker, "Americanism in Painting," *Yale Review*, XXV (June 1936), 778–93.

78. Quoted in Cheney, *Modern Art in America*, 132.

79. See David Lilienthal, *TVA: Democracy on the March* (New York: Harper and Bros., Publishers, 1944); Paul K. Conkin, *Tomorrow a New World: The New Deal Community Program* (Ithaca: Cornell University Press, 1959); Alexander, *Nationalism in American Thought*, 14–16.

80. Thomas Hart Benton, *An Artist in America* (New York: R. M. McBride and Company, 1937), 268; Forbes Watson, "The Innocent Bystander," *American Magazine of Art*, XXIX (June 1936), 399.

81. Benton, *Artist in America*, 260–66.

82. Thomas Hart Benton, "Art and Nationalism," *Modern Quarterly*, VIII (May 1934), 233–63; Ruth Pickering, "Thomas Hart Benton: On His Way Back to Missouri," *Arts and Decoration*, XLII (February 1935), 19–20. See also Benton, "America and/or Alfred Stieglitz," *Common Sense*, IV (January 1935), 22–25; Benton, "American Regionalism: A Personal History of the Movement," *University of Kansas City Review*, XVIII (Autumn 1951), 41–75.

83. Benton, *Artist in America*, 260.

84. Forbes Watson, "The Innocent Bystander," *American Magazine of Art*, XXVIII (May 1935), 285ff.; Joan Muyskens, "Stone City, Iowa," *Annals of Iowa*, XXXIX (Spring 1968), 261–74; Richard C. Beer, "Wanted: An American School of Art," *Country Life*, LXVII (April 1935), 73–77; Matthew Baigell, "Grant Wood Revisited," *Art Journal*, XXXVI (Winter 1966–67), 116–22. On Wood's technique, see James M. Dennis, "An Essay into Landscapes: The Art of Grant Wood," *Kansas Quarterly*, IV (Fall 1972), 12–56.

85. Thomas Craven, "John Steuart Curry," *Scribner's Magazine*. CIII (January 1938), 36–41ff. See also "Rural Art," *Life*, X (March 31, 1941), 76–79.

86. Thomas Craven, "Politics and the Painting Business," *American Mercury,* XXVII (December 1932) , 469; Craven, *Men of Art* (New York: Simon and Schuster, Inc., 1931) , 508.

87. Thomas Craven, "Nationalism in Art," *Forum,* XCV (June 1936) , 359–61.

88. Thomas Craven, *Modern Art: The Men, the Movements, the Meaning* (New York: Simon and Schuster, Inc., 1934) , 355–58; Craven, "Our Art Becomes American," *Harper's Magazine,* CLXXI (September 1935) , 430–41.

89. Craven, "Politics and Painting Business," 469–71.

90. Belasario R. Contreras, "The New Deal Treasury Art Program and the American Artist, 1933 to 1943" (Ph.D. dissertation, American University, 1967) , passim; Richard D. McKinzie, *The New Deal for Artists* (Princeton: Princeton University Press, 1973) , 3–50; Joel H. Bernstein, "The Artist and the Government: The P.W.A.P.," in Ray B. Browne et al., eds., *Challenges in American Culture* (Bowling Green: Bowling Green State University Popular Press, 1970) , 69–84; Olin Dows, "Art for Housing Tenants," *Magazine of Art,* XXXI (November 1938) , 616–23ff.

91. Larkin, *Art and Life in America,* 419–24; Homer Saint Gaudens, *The American Artist and His Times* (New York: Dodd, Mead and Company, 1941) , 248–53; McKinzie, *New Deal for Artists,* 105.

92. Boardman Robinson, "Regionalism in Art," in *Four Lectures on the Fine Arts* (Colorado Springs: Colorado College, 1936) , 23; George Biddle, "Mural Painting in America," *American Magazine of Art,* XXVII (July 1934) , 366; Forbes Watson, "Introduction" to *American Painting Today* (Washington: American Federation of Arts, 1939) , 21; Craven, *Modern Art,* 364.

93. James Watrous, "Mural Painting, Sculpture, and Architecture, 1890–1915," *American Quarterly,* II (Fall 1950) , 227.

94. Talbot Hamlin, "The Architect and the Depression," *Nation,* CXXXVII (August 9, 1933) , 152; John Burchard and Albert Bush-Brown, *The Architecture of America: A Social and Cultural History,* rev. ed. (Boston: Little, Brown and Company, 1966) , 317–18.

95. Michael A. Mikklesen, "The Problem of the Architectural Profession," *Architectural Record,* LXX (September 1931) , 148.

96. Richard J. Neutra, "How America Builds, 1937–1938," ibid., LXXXIII (January 1938) , 60–61. See also W. Pope Barney, "Changes in Architecture, 1907–1956," *Journal of the American Institute of Architects,* XXVII (January 1957) , 30–33; Margaretta Jean Darnall, "From the Chicago Fair to Walter Gropius: Changing Ideas in American Architecture" (Ph.D. dissertation, Cornell University, 1975) , 86–129.

97. James Marston Fitch, "The Rise of Technology, 1929–1939," *Journal of the Society of Architectural Historians,* XXIV (March 1965) , 76–77. Italics in original.

98. Robert L. Duffus, "The Architect in a Modern World," *Architectural Record,* LXXX (September 1936) , 192.

99. Claude Bragdon, *The Frozen Fountain: Being Essays on Architecture and the Art of Design* (New York: Alfred A. Knopf, Inc., 1932) , 26.

100. Henry-Russell Hitchcock and Philip Johnson, *The International Style: Architecture since 1922* (New York: W. W. Norton and Company, 1932) ; James Marston Fitch, *American Building: The Forces That Shape It* (Boston: Houghton Mifflin and Company, 1948) , 141; Fitch, *Architecture and the Esthetics of Plenty* (New York: Columbia University Press, 1961) , 255–56; Lowell Tozer, "A Century of Progress, 1833–1933: Technology's Triumph over Man," *American Quarterly,* IV (Spring 1952) , 78–81.

101. On this point, see Fitch, *Architecture and Esthetics of Plenty,* 257–59.

102. Lewis Mumford, *The Brown Decades: A Study of the Arts in America, 1865–1895* (New York: Harcourt, Brace and Company, 1931) , 173; Mumford, *Technics and Civilization* (New York: Harcourt, Brace and Company, 1934) ; Mumford, *The Culture of Cities* (New York: Harcourt, Brace and Company, 1938) ; Roy Lubove, "New Cities for Old: The Urban Reconstruction Program of the 1930's" *Social Studies,* LIII (November 1962) , 203–12.

103. Douglas Haskell, "Architecture of the TVA," *Nation,* CLII (May 17, 1941), 592–93.

104. William Lescaze, "New Deal Architecture," *New Republic,* LXXV (July 26, 1933), 278–80.

105. C. W. Short and R. Stanley-Brown, *Public Buildings . . . Constructed by Federal and Other Governmental Bodies . . . 1933 . . . 1939* (Washington: U.S. Government Printing Office, 1939), II–III; Frederick A. Gutheim, "Seven Years of Public Building," *Magazine of Art,* XXXIII (July 1940), 424–25. See also Gutheim, "The Quality of Public Works," ibid., XXVII (April 1934), 183–87.

106. Frederick A. Gutheim, ed., *Frank Lloyd Wright: Selected Writings, 1894–1940* (New York: Duell, Sloan, and Pearce, Inc., 1941), 264. Italics in original.

107. Larkin, *Art and Life in America,* 445–46; Robert W. Twombly, *Frank Lloyd Wright: An Interpretive Biography* (New York: Harper and Row, Publishers, 1973), 204–12; Henry-Russell Hitchcock, *In the Nature of Materials, 1887–1941: The Buildings of Frank Lloyd Wright* (New York: Duell, Sloan, and Pearce, Inc., 1942), 89–93.

108. Frank Lloyd Wright, *Modern Architecture* (Princeton: Princeton University Press, 1931), 60; Wright, *Autobiography* (New York: Longman, Green and Company, 1932); Wright, "Architecture and Life in the U.S.S.R.," *Architectural Record,* LXXXII (October 1937), 59–63.

109. Twombly, *Wright,* 181–84; Frank Lloyd Wright, "Broadacre City: A New Community Plan," *Architectural Record,* LXXVII (April 1935), 243–54.

110. See Twombly, *Wright,* 218–19.

111. See Merrill Peterson, *The Jefferson Image in the American Mind* (New York: Oxford University Press, 1960), 355–76.

112. Lewis Mumford et al., "The Jefferson Memorial," *New Republic,* XC (April 7, 1937), 265–66; "Jefferson Memorial Raises Stormy Discussion," *Architectural Record,* LXXI (June 1937), 25–26; William Lescaze, "America Is Outgrowing Imitation Greek Architecture," *Magazine of Art,* XXX (June 1937), 369; Joseph Hudnut, "Twilight of the Gods," ibid., August 1937, 480.

113. Arthur Upham Pope, "In Defense of the Jefferson Memorial," *Magazine of Art,* June 1937, 363–65; "Jefferson Memorial Raises Stormy Discussion," 26.

114. Burchard and Bush-Brown, *Architecture of America,* 391–92; "What Williamsburg Means to Architecture," *House and Garden,* LXXII (November 1937), 42–47; James Marston Fitch, *American Building: The Forces That Shape It* (Boston: Houghton Mifflin Company, 1948), 141.

## Chapter 6: **This Question of the National Tradition**

1. Frank A. Warren, *Liberals and Communism: The "Red Decade" Revisited* (Bloomington: Indiana University Press, 1966), 41–46.

2. See Irving Howe and Lewis Coser, *The American Communist Party: A Critical History (1919–1957)* (Boston: Beacon Press, 1957), 319–86; Daniel Bell, "The Background and Development of Marxian Socialism in the United States," in Donald D. Egbert and Stow Persons, eds., *Socialism and American Life,* 2 vols. (Princeton: Princeton University Press, 1952), I, 354–65.

3. Michael Gold in *Daily Worker* (New York), October 17, 1935, June 14, 1943, quoted in Howard Lee Hertz, "Writer and Revolutionary: The Life and Work of Michael Gold, Father of Proletarian Literature in the United States" (Ph.D. dissertation, University of Texas, 1974), 681, 697.

4. Malcolm Goldstein, *The Political Stage: American Drama and Theater of the Great Depression* (New York: Oxford University Press, 1974), 269–70.

5. Daniel Gregory Mason to Adolfo Betti, July 17, 1936, Daniel Gregory Mason Papers, Special Collections, Baker Library, Columbia University, New York City;

306 *Notes for Pages 194-200*

Gilbert Chase, *America's Music: From the Pilgrims to the Present,* rev. ed. (New York: McGraw-Hill Book Company, 1966), 380; Stephen Vincent Benét, *John Brown's Body* (New York: Doubleday, Doran and Company, 1928); Carl Sandburg, *Abraham Lincoln: The Prairie Years,* 2 vols. (New York: Harcourt, Brace and Company, 1926); Sandburg, *Abraham Lincoln: The War Years,* 4 vols. (New York: Harcourt, Brace and Company, 1939); Stephen B. Oates, *Our Fiery Trial: Abraham Lincoln, John Brown, and the Civil War Era* (Amherst: University of Massachusetts Press, 1979), 99–110.

6. Alfred Haworth Jones, *Roosevelt's Image Brokers: Poets, Playwrights, and the Use of the Lincoln Symbol* (Port Washington: Kennikat Press, 1974), passim; Eleanor Sickels, "Stephen Vincent Benét," *College English,* XIV (May 1953), 440–46.

7. Larkin, *Art and Life in America,* 408; Barbara Rose, *American Art since 1900* (New York: Frederick A. Praeger, Inc., 1967), 115.

8. Gilbert Seldes, *The Years of the Locust* (Boston: Little, Brown and Company, 1933); Edmund Wilson, *The American Jitters: A Year of the Slump* (New York: Charles Scribner's Sons, 1932); Louis Adamic, *My America, 1928–1938* (New York: Harper and Brothers, Publishers, 1938); Erskine Caldwell and Margaret Bourke-White, *You Have Seen Their Faces* (New York: Viking Press, 1937); Caldwell and Bourke-White, *Say, Is This the U. S. A.* (New York: Duell, Sloan and Pearce, Inc., 1941).

9. William Stott, *Documentary Expression and Thirties America* (New York: Oxford University Press, 1973), 241, 256.

10. Goldstein, *Political Stage,* 357–62; James Agee and Walker Evans, *Let Us Now Praise Famous Men* (Boston: Houghton Mifflin Company, 1941); Thomas Wolfe, *You Can't Go Home Again* (New York: Harper and Bros., Publishers, 1940), 741. Wolfe's other novels were *Look Homeward Angel* (New York: Charles Scribner's Sons, 1929), *Of Time and the River* (New York: Charles Scribner's Sons, 1935), and *The Web and the Rock* (New York: Harper and Bros., Publishers, 1939).

11. Goldstein, *Political Stage,* 188–190; Carl Sandburg, *The People, Yes* (New York: Harcourt, Brace and Company, 1936); John Steinbeck, *The Grapes of Wrath* (New York: Viking Press, 1939), 383; Richard Pells, *Radical Visions and American Dreams: Culture and Social Thought in the Depression Years* (New York: Harper and Row, Publishers, 1973), 215–19.

12. Joan Shelley Rubin, "A World Out of a Wilderness: Constance Rourke and the Search for a Usable Past" (Ph.D. dissertation, Yale University, 1972), 197; Mary Hornaday, "Melting Pot of Architecture," *Christian Science Monitor,* June 2, 1937, 8–9; Douglas Haskell, "Architecture on Routes U.S. 40 and 66," *Architectural Record,* LXXXI (May 1937), 15–22; Thomas Craven, *A Treasury of American Prints* (New York: Simon and Schuster, Inc., 1939), n.p.

13. Harold Stearns, ed., *America Now: An Inquiry into Civilization in the United States* (New York: Charles Scribner's Sons, 1938), viii.

14. H. L. Mencken to Harold Stearns, October 1, 1937, H. L. Mencken Collection, New York Public Library, New York City.

15. Stearns, ed., *America Now,* 37, 48–61, 71, 92, 103, 115–16.

16. Van Wyck Brooks, *An Autobiography* (New York: E. P. Dutton and Company, 1965), 421; Harold Clurman to Waldo Frank, March 9, 1938, Waldo Frank Papers, Rare Books Collection, Van Pelt Library, University of Pennsylvania, Philadelphia.

17. See Allen Guttmann, *The Wound in the Heart: America and the Spanish Civil War* (New York: Free Press of Glencoe, 1962).

18. Mumford quoted in Larkin, *Art and Life in America,* 430. See also Sam Smiley, "Friends of the Party: American Writers' Congresses," *Southwest Review,* LIV (Summer 1969), 290–300.

19. Editorial, *Partisan Review,* IV (December 1937), 3.

20. John Dos Passos to Philip Rahv, undated [winter 1937–38], *Partisan Review* Collection, Rutgers University, New Brunswick, New Jersey. For the early history of *Partisan Review,* see Frederick J. Hoffman et al., *The Little Magazine: A History*

*and a Bibliography* (Princeton: Princeton University Press, 1947), 166–68, 325; James B. Gilbert, *Radicals and Partisans: A History of Literary Radicalism in America* (New York: John Wiley and Son, Inc., 1968), 118–252; Pells, *Radical Visions and American Dreams*, 334–43; William Phillips, "What Happened in the 1930's," *Commentary*, XXXIV (September 1962), 204–12.

21. Lionel Trilling, "Is Literature Possible?" *Nation*, CXXXI (October 15, 1930), 405–406.

22. Pells, *Radical Visions and American Dreams*, 343.

23. Max Eastman, *Artists in Uniform: A Study of Literature and Bureaucratization* (New York: Alfred A. Knopf, Inc., 1934); Eastman, *Art and the Life of Action* (New York: Alfred A. Knopf, Inc., 1934); James T. Farrell, *A Note on Literary Criticism* (New York: Vanguard Press, 1936), 215; Farrell, "Social Themes in American Realism," *English Journal*, XXXV (June 1946), 310; Christopher Lazare, "American Art on Exhibit," *North American Review*, CCXLVIII (December 1939), 394–400.

24. Robert E. Spiller, "Literature and the Critics," in Spiller and Eric Larrabee, eds., *American Perspectives: The National Self-Image in the Twentieth Century* (Cambridge: Harvard University Press, 1961), 35–58; William Van O'Connor, *An Age of Criticism, 1900–1950* (Chicago: Henry Regnery Company, 1952); John Crowe Ransom, *The New Criticism* (Norfolk, Conn.: New Directions, 1941); Charles I. Glicksberg, ed., *American Literary Criticism, 1900–1950* (New York: Hendricks House, Inc., 1952), 450–81; Richard Foster, *The New Romantics: A Reappraisal of the New Criticism* (Bloomington: Indiana University Press, 1962). See also Cleanth Brooks and Robert Penn Warren, eds., *Understanding Poetry: An Anthology for College Students* (New York: Henry Holt and Company, 1938).

25. Norman Holmes Pearson, "The Nazi-Soviet Pact and the End of a Dream," in Daniel Aaron, ed., *America in Crisis* (New York: Alfred A. Knopf, Inc., 1952), 327–48; Aaron, *Writers on the Left: Episodes in American Literary Communism* (New York: Harcourt, Brace and World, Inc., 1961), 354–64; Warren, *Liberals and Communism*, 193–215; Willard Thorp, "American Writers on the Left," in Donald D. Egbert and Stow Persons, eds., *Socialism and American Life*, 2 vols. (Princeton: Princeton University Press, 1952), 601–20; Hilton Kramer, "The Summer of '39," *New York Times Book Review*, August 12, 1978, 7ff.

26. Michael Gold, *The Hollow Men* (New York: International Publishers, 1941); Hertz, "Writer and Revolutionary," 681–97.

27. For the overall record of the WPA arts projects, see William F. McDonald, *Federal Relief Administration and the Arts* (Columbus: Ohio State University Press, 1969); Ray Allen Billington, "Government and the Arts: The W.P.A. Experience," *American Quarterly*, XIII (Winter 1961), 466–79; "Unemployed Arts," *Fortune*, XV (May 1937), 108–11ff.; Francis V. O'Connor, ed., *The New Deal Art Projects: An Anthology of Memoirs* (Washington: Smithsonian Institution, 1972); Jane DeHart Mathews, "Arts for the People: The New Deal Quest for a Cultural Democracy," *Journal of American History*, LXII (September 1975), 316–39.

28. Lewis Mumford, "The Writers' Project," *New Republic*, XCII (October 20, 1937), 306; Suzanne LaFollette, "Toward an American Art," *Nation*, CXLIII (October 10, 1936), 429; James Wechsler, "Record of the 'Boondogglers': II," ibid., CXLV (December 25, 1937), 715–17.

29. "Conference on the Arts Program of the Works Projects Administration, Library of Congress, Washington, D.C., October 8–9, 1941," typescript in Holger Cahill Papers, Archives of American Art, Washington, D.C. By 1941, as a result of the reorganization and decentralization of federal work-relief efforts, the Works Progress Administration had become the Works Projects Administration.

30. B. A. Botkin, "WPA and Folklore Research," *Southern Folklore Quarterly*, III (March 1939), 7–14.

31. Monty Noam Penkower, *The Federal Writers' Project: A Study in Government Patronage of the Arts* (New York: Columbia University Press, 1977), 115. For the general history of the Federal Writers' Project, see, besides Penkower's book, Kath-

leen O'Connor McKinzie, "Writers on Relief, 1935–1942" (Ph.D. dissertation, Indiana University, 1970); Daniel M. Fox, "The Achievement of the Federal Writers' Project," *American Quarterly,* XIII (Spring 1961), 3–19; Bernard DeVoto, "The Writers' Project," *Harper's Magazine,* CLXXXIV (January 1942), 221–24; Jerre Mangione, *The Dream and the Deal: The Federal Writers' Project, 1933–1943* (Boston: Little, Brown and Company, 1972).

32. For the history of the Federal Music Project, see Cornelius Baird Canon, "The Federal Music Project of the Works Progress Administration: Music in a Democracy" (Ph.D. dissertation, University of Minnesota, 1963); Canon, "Art for Whose Sake: The Federal Music Project of the WPA," in Ray B. Browne et al., eds., *Challenges in American Culture* (Bowling Green: Bowling Green University Popular Press, 1970), 85–100; Janelle Jedd Warren, "Of Tears and Need: The Federal Music Project, 1935–1943" (Ph.D. dissertation, George Washington University, 1973).

33. Ashley Pettis, "WPA and the American Composer," *Musical Quarterly,* XXVI (January 1940), 101–12; Nikolai Sokoloff, "America's Vast New Musical Awakening," *Etude,* LV (April 1937), 221–22.

34. Daniel Gregory Mason to Van Wyck Brooks, February 25, 1936; Ernst Bacon to Mason, March 4, 1936, Mason Papers.

35. Carter, "Forecast and Review," 37; Harry L. Hewes, "Indexing America's Composers," *Christian Science Monitor Weekly Magazine Section,* April 5, 1941, 7f.

36. Canon, "Federal Music Project," 165–66; Robert A. Simon, "American Music Everywhere," *New Yorker,* XVI (March 30, 1940), 58.

37. Canon, "Federal Music Project," 147–50.

38. Donald Knight Wilgus, *Anglo-American Folksong Scholarship since 1898* (New Brunswick: Rutgers University Press, 1959), 185–88; John A. Lomax, "Sinful Songs of the Southern Negroes," *Musical Quarterly,* XX (April 1934), 177–87; John and Alan Lomax, *American Ballads and Folk Songs* (New York: Macmillan Company, 1934); Dorothy Scarborough, *A Song Catcher in Southern Highlands: American Folk Songs of British Ancestry* (New York: Columbia University Press, 1937).

39. Quoted in Donald Day, "John Lomax and His Ten Thousand Songs," *Saturday Review of Literature,* XXVIII (September 22, 1945), 5.

40. B. A. Botkin, "The Archive of American Folk-Song: Retrospect and Prospect," *Library of Congress Journal of Current Acquisitions,* II (1945), 62. See also Charles Seeger, "Folk Music as a Source of Social History," in Caroline F. Ware, ed., *The Cultural Approach to History* (New York: Columbia University Press, 1940), 316–23; Gene Bluestein, "The Lomaxes' New Canon of American Folksong," *Texas Quarterly,* V (Spring 1962), 49–59.

41. "Bow with Antic Ways Put Hillbilly Fiddler at Top of Bill," *Newsweek,* V (May 18, 1935), 20; Sarah Gertrude Knott, "I Hear America Singing," *Survey Graphic,* XXVIII (March 1939), 235; Jean Thomas, *Traipsin' Woman* (New York: E. P. Dutton and Company, 1933).

42. Bill C. Malone, *Country Music, U.S.A.: A Fifty-Year History* (Austin: University of Texas Press, 1968), 104–106; Richard Reuss, "American Folklore and Left-wing Politics, 1927–1957" (Ph.D. dissertation, Indiana University, 1971), 105–51. For an early recognition of the expanding hillbilly music field, see Kyle Crichton, "Thar's Gold in Them Hillbillies," *Collier's,* CI (April 30, 1938), 24ff.

43. Lawrence Gellert, *Negro Songs of Protest* (New York: American Music League, 1936); "Songs of Protest," *Time,* XXVII (June 15, 1936), 51; Reuss, "American Folklore and Left-wing Politics," 152–96; Reuss, "The Roots of American Left-wing Interest in Folksong," *Labor History,* XII (Spring 1971), 250–79; R. Serge Denisoff, *Great Day Coming!: Folk Music and the American Left* (Urbana: University of Illinois Press, 1971), 56–76; Denisoff, "The Proletarian Renaissance: The Folkness of the Ideological Folk," *Journal of American Folklore,* LXXXII (January–March 1969), 51–65.

44. Reuss, "American Folklore and Left-wing Politics," 197–248; Denisoff, *Great Day Coming!,* 77–129; Denisoff, *Sing a Song of Social Significance* (Bowling Green:

Bowling Green University Popular Press, 1972) , 97–106; Malone, *Country Music U.S.A.*, 106.

45. Holger Cahill to Rosalind C. Lohrfinck, February 25 [1955], Mencken Collection, NYPL; *American Folk Art: The Art of the Common Man in America, 1750–1900* (New York: Museum of Modern Art, 1932) .

46. Holger Cahill, "American Folk Art," *American Mercury*, XXIV (September 1931) , 39–46.

47. Holger Cahill, undated speech in Cahill Papers; Cahill, summary paper for House of Representatives committee investigating WPA, 1939, ibid. (italics in original) ; V. F. Calverton, "Cultural Barometer," *Current History*, XLVI (July 1937) , 94. See also Thomas C. Parker, Assistant National Director, Federal Art Project, "Federally Sponsored Community Art Centers," speech to Art Reference Round Table of American Library Association, Kansas City, Missouri, June 14, 1938, copy in Cahill Papers. For Cahill's background see Richard P. McKinzie, *The New Deal for Artists* (Princeton: Princeton University Press, 1973) , 75–80.

48. McKinzie, *The New Deal for Artists*, 105, 179.

49. Ibid., 75–182; "Incalculable Record," *Magazine of Art*, XXXII (August 1939) , 460–71ff.; Murdock Pemberton, "American Portrait," *Travel*, LXXII (February 1939) , 6–13ff.; Katherine McHarg, "Clay of Your Community," *School Arts*, XLII (September 1942) , 30–31.

50. Larkin, *Art and Life in America*, 427; Charles Alpheus Bennett, "The Index of American Design and What It Suggests," *Industrial Education Magazine*, XL (March 1938) , 87–88. See H. J. Keyes, "American Folk Art Rediscovered," *Christian Science Monitor*, February 3, 1937, 8–9; McKinzie, *New Deal for Artists*, 135–41.

51. Jean Lipman, *American Primitive Painting* (London and New York: Oxford University Press, 1942) , 18; Sidney E. Janis, *They Taught Themselves: American Primitive Painters of the Twentieth Century* (New York: Dial Press, 1942) , 6–9.

52. Janis, *They Taught Themselves*, 3–6; Alice E. Ford, *Pictorial Folk Art: New England to California* (New York: Studio Publications, 1949) , 40–50; Anita Brenner, "American Primitives," *New York Times Magazine*, April 6, 1941, 10–11ff.; "Grandma Moses," *Time*, XXXVI (October 21, 1940) , 56.

53. For Rourke's life and work see Rubin, "World Out of a Wilderness," passim; Rubin, "Constance Rourke in Context: The Uses of Myth," *American Quarterly*, XXVIII (Winter 1976) , 574–88; Margaret Marshall, "Constance Rourke in the Critics' Den," *Nation*, CLV (October 24, 1942) , 418–20; Van Wyck Brooks, "Preface," to Constance Rourke, *The Roots of American Culture and Other Essays* (New York: Harcourt, Brace and Company, 1942) , v–xii; Marie Caskey, "Constance Mayfield Rourke," in Edward T. James, ed., *Dictionary of American Biography: Supplement Three, 1941–1945* (New York: Charles Scribner's Sons, 1973) , 672–73.

54. Rubin, "World Out of a Wilderness," 66–70; Marshall, "Constance Rourke in the Critics' Den," 420.

55. Constance Rourke, "The Significance of Sections," *New Republic*, LXXVI (September 20, 1933) , 148–51; Rubin, "World Out of a Wilderness," 51–65, 78–81. On the development of cultural anthropology and national character studies in the United States during the thirties and forties, see Charles C. Alexander, *Nationalism in American Thought, 1930–1945* (Chicago: Rand McNally and Company, 1931) , 131–32, 216.

56. Constance Rourke, *American Humor: A Study of the National Character* (New York: Harcourt, Brace and Company, 1931) , 235–36 and passim.

57. Constance Rourke, *Davy Crockett* (New York: Harcourt, Brace and Company, 1934) , passim; Rourke, *Charles Sheeler: An Artist in the American Tradition* (New York: Harcourt, Brace and Company, 1938) , 114–15, 186–87, and passim. See also Rourke, *Audubon* (New York: Harcourt, Brace and Company, 1936) .

58. Brooks, "Preface," to Rourke, *Roots of American Culture*, vi–viii; Brooks, *The World of Washington Irving* (New York: E. P. Dutton and Company, 1944) ; Brooks, *The Times of Melville and Whitman* (New York: E. P. Dutton and Com-

pany, 1947) ; James Hoopes, *Van Wyck Brooks: In Search of American Culture* (Amherst: University of Massachusetts Press, 1977) , 47, 270.

59. Rourke, *Roots of American Culture,* 26, 49–50, 295, and passim.

60. Max Eastman, "Humor and America," *Scribner's Magazine,* C (July 1936) , 12; Walter Blair, ed., *Native American Humor* (New York: American Book Company, 1937) ; Sculley Bradley, "Our Native Humor," *North American Review,* CCXLII (December 1936) , 351–62. See also Bernard DeVoto, "The Lineage of Eustace Tilley," *Saturday Review of Literature,* XVI (September 25, 1937) , 3–4ff.

61. DeLancey Ferguson, "On Humor as One of the Fine Arts," *South Atlantic Quarterly,* XXXVIII (April 1939) , 186.

62. William Murrell, *A History of American Graphic Humor,* 2 vols. (New York: Whitney Museum of American Art, 1933–38) , I, 9, II, 261. Italics in original.

63. William Berchtold, "Men of Comics," *New Outlook,* CLXV (April 1935) , 36; Lovell Thompson, "America's Day-dream," *Saturday Review of Literature,* XVII (November 13, 1937) , 3–4ff.; Thomas Craven, ed., *Cartoon Cavalcade* (New York: Simon and Schuster, Inc., 1943) , 7. On the development of comic strips, see Russel Nye, *The Unembarrassed Muse: The Popular Arts in America* (New York: Dial Press, 1970) , 216–41.

64. For Disney and the development of his art, see Richard Schickel, *The Disney Version* (New York: Simon and Schuster, Inc., 1968) ; Bob Thomas, *Walt Disney: The Art of Animation* (New York: Golden Press, 1958) ; Christopher Finch, *Walt Disney: From Mickey Mouse to the Magic Kingdom* (New York: Harry N. Abrams, Inc., 1973) ; Leonard Martin, *The Disney Films* (New York: Crown Publishers, 1973) .

65. Gilbert Seldes, "Disney and Others," *New Republic,* LXXI (June 8, 1932) , 101–102; Dorothy Grafly, "America's Youngest Art," *American Magazine of Art,* XXVI (July 1933) , 337–38, 342; Jean Charlot, "But Is It Art? A Disney Disquisition," *American Scholar,* VIII (July 1939) , 270. See also "Mouse and Man," *Time,* XXX (December 27, 1937) , 19–21; Claude Bragdon, "Mickey Mouse and What He Means," *Scribner's Magazine,* XCVI (July 1934) , 43.

66. See "Snow White and Escape from Reality," *Christian Century,* LV (July 20, 1938) , 886–87; Otis Ferguson, "Walt Disney's Grimm Reality," *New Republic,* XCIII (January 26, 1938) , 339–40; V. F. Calverton, "Cultural Barometer," *Cu.rent History,* XLVIII (June 1938) , 45; Gilbert Seldes, "Motion Pictures," *Scribner's Magazine,* CIII (March 1938) , 65–66.

67. On this matter, see Pells, *Radical Visions and American Dreams,* 276–77.

68. Goldstein, *Political Stage,* 39–40, 156–61, 190–91; Norris Houghton, *Advance from Broadway: 19,000 Miles of American Theatre* (New York: Harcourt, Brace and Company, 1941) , 272–73.

69. For the Federal Theatre Project, see Jane DeHart Mathews, *The Federal Theatre, 1935–1939: Plays, Relief, and Politics* (Princeton: Princeton University Press, 1967) ; Hallie Flanagan Davis, *Arena* (New York: Duell, Sloan and Pearce, Inc., 1940) ; Goldstein, *Political Stage,* 241–92; Gerald Rabkin, *Drama and Commitment: Politics in the American Theatre of the Thirties* (Bloomington: Indiana University Press, 1964) , 95–123; Robert Holcomb, "The Federal Theatre in Los Angeles," *California Historical Society Quarterly,* XLI (June 1962) , 131–47.

70. See, for example, "A Revolt against Broadway," *Literary Digest,* LXXXVII (December 26, 1925) , 20; John Mason Brown, "Our Island Theatre," in Fred J. Ringel, ed., *Americans as Americans See It* (New York: Literary Guild, 1932) , 79–80; Houghton, *Advance from Broadway,* 11.

71. John Anderson and Rene Fülop-Miller, *The American Theatre: The American Motion Picture* (New York: Dial Press, 1938) , 74–78; Edwin Duerr, "Tributary Theatre Inventory," *Theatre Arts Magazine,* XXI (July 1937) , 547. See also Irving Pichel, "The Present Day Theatre," in Herschel L. Bricker, ed., *Our Theatre Today* (New York: S. French, 1936) , 145–54.

72. Flanagan published her impressions of European theater as *Shifting Scenes from the Modern European Theatre* (New York: Coward-McCann, Inc., 1928) .

73. On Flanagan's life and early career, see Mathews, *Federal Theatre Project*, 14–23.

74. Hallie Flanagan, "Theatre and Geography," *Magazine of Art*, XXXI (August 1938) , 466–68; Flanagan, *Arena*, 23, 44–45.

75. V. F. Calverton, "Cultural Barometer," *Current History*, XLVI (June 1937) , 93.

76. The basic compilation of FTP plays is *Federal Theatre Plays*, 2 vols. (New York: Random House, Inc., 1938) . For the Harlem unit's work see John Houseman, *Run-through: A Memoir* (New York: Simon and Schuster, Inc., 1972) , 173–210.

77. Mathews, *Federal Theatre Project*, 197.

78. Malcolm Cowley, "The People's Theatre," *New Republic*, CIV (January 13, 1941) , 57–58.

79. Rabkin, *Drama and Commitment*, 33.

80. Ibid., 249–50, 255–57; Goldstein, *Political Stage*, 141–42, 397–98; Elmer Rice, *Minority Report: An Autobiography* (New York: Simon and Schuster, Inc., 1963) , 328–29.

81. See John T. Flanagan, "The Folk Hero in Modern American Drama," *Modern Drama*, VI (February 1964) , 402–16.

82. Goldstein, *Political Stage*, 386–87, 394–95; Edmund Fuller, "Thornton Wilder: The Notation of the Heart," *American Scholar*, XXVIII (Spring 1959) , 210–17.

83. Kay Irene Johnson, "Playwrights as Patriots: A History of the Playwrights Producing Company, 1938–1960" (Ph.D. dissertation, University of Wisconsin, 1974) , 56–276; Goldstein, *Political Stage*, 390–91, 400, 413; Glenn Hughes, *A History of the American Theatre, 1700–1950* (New York: Samuel French, 1951) , 440–41, 450–53.

84. Harold Clurman, "The Theatre of the Thirties," *Tulane Drama Review*, IV (December 1959) , 3–11; Houghton, *Advance from Broadway*, 272–75; Johnson, "Playwrights as Patriots," 276–392.

85. Louis Reid, "Amusements: Radio and Movies," in Stearns, ed., *America Now*, 3.

86. Edward Robinson, "The Cradle of American Music," *Vanity Fair*, XXXVI (July 1931) , 27. See also Jay Elmer Morgan, "A National Culture: A By-Product or Objective of National Planning?" in Tracy F. Tyler, ed., *Radio as a Cultural Agency: Proceedings of a National Conference on Use of Radio as a Cultural Agency in a Democracy* (Washington: National Committee on Education by Radio, 1934) , 27; J. M. McKibbin, Jr., "A New Way to Make Americans," *Radio Broadcasting*, II (January 1923) , 238–39; Waldemar Kaempffert, "The Social Destiny of Radio," *Forum and Century*, LXXI (June 1924) , 764–72; Bruce Bliven, "How Radio Is Remaking Our World," *Century*, CVIII (June 1924) , 147–54; Gordon Allport and Hadley Cantril, *The Psychology of Radio* (New York: Harper and Bros., Publishers, 1935) .

87. Allport and Cantril, *Psychology of Radio*, 233; John Wallace, "The Listener's Point of View: Wanted: A Radio Shakespeare!" *Radio Broadcast*, VIII (March 1926) , 577–78.

88. Wallace, "The Listener's Point of View," 578; R. Dickson Skinner, *Our Changing Theatre* (New York: Lincoln MacVeagh, Dial Press, 1931) , 309–14.

89. Davidson Taylor, "Good Radio," *Theatre Arts*, XXV (March 1941) , 219; John Erskine, "When Will the Poets Speak?" *American Scholar*, X (January 1941) , 59–66.

90. See Erik Barnouw, *A History of Broadcasting in the United States*, 3 vols. (New York: Oxford University Press, 1966–70) , II: *The Golden Web, 1933–1953*, 65–66; Gilbert Seldes, *The Public Arts* (New York: Simon and Schuster, Inc, 1956) , 70–72; Merrill Denison, "Radio and the Writer," *Theatre Arts Magazine*, XXII (May 1938) , 365–70.

91. Barnouw, *Golden Web*, 66–69; New York *Times*, April 18, 1937, sec. XI, p. 12; April 28, 1937, 21; Colin C. Campbell, "The Poet as Artist and Citizen: A Study of the Life and Writings of Archibald MacLeish through 1958" (Ph.D. dissertation, University of Pennsylvania, 1960) , 182–86. Oliver Larkin, in "Air Waves and Sight Lines," *Theatre Arts Magazine*, XXII (December 1938) , 893, questioned whether

MacLeish's play did not have antidemocratic overtones in suggesting that the masses were stupid and spineless.

92. Archibald MacLeish, *The Fall of the City* (New York: Farrar and Rinehart, Inc., 1937) , v.

93. See Milton Allen Kaplan, *Radio and Poetry* (New York: Columbia University Press, 1949) for a discussion of particular radio poetic dramas and a roster of scripts, 1936–45. Titles are in italics for scripts subsequently published, in quotes for those unpublished.

94. Albert N. Williams, "The Radio Artistry of Norman Corwin," *Saturday Review of Literature*, XXV (February 14, 1942) , 6. On Corwin's career, see Stanley Kunitz and Howard Haycraft, eds., *Twentieth Century Authors: A Biographical Directory of Modern Literature: First Supplement* (New York: H. W. Wilson Company, 1955) , 232–33.

95. Quoted in Kaplan, *Radio and Poetry*, 10.

96. "Hate?" *Time*, XXXIX (May 18, 1942) , 54; Kaplan, *Radio and Poetry*, 11, 17–18, 46, 235, 237; Barnouw, *Golden Web*, 211–14.

97. Quoted in Kaplan, *Radio and Poetry*, 21, and Charles I. Glicksberg, "Poetry on the Radio," *Education*, LXII (October 1941) , 89–95. See also Norman Corwin, "The Sovereign Word," *Theatre Arts*, XXIV (February 1940) , 130–36.

98. Barnouw, *Golden Web*, 214–15; Seldes, *Public Arts*, 72; Kunitz and Haycraft, eds., *Twentieth Century Authors: First Supplement*, 233.

99. Reid, "Amusement: Radio and Movies," 22, 24.

100. See, for example, Dwight Macdonald, "Eisentein, Pudovkin, and Others," *Miscellany*, I (March 1931) , 18–46; Ruth Suckow, "Hollywood Gods and Goddesses," *Harper's Magazine*, CLXXIII (July 1936) , 200; Seymour Stern, "The Bankruptcy of Cinema as Art," in William J. Perlman, ed., *The Movies on Trial* (New York: Macmillan Company, 1936) , 113–40.

101. For the economic and political circumstances affecting motion pictures in the thirties, see Lewis Jacobs, *The Rise of the American Film* (New York: Harcourt, Brace and Company, 1939) ; Margaret Farrand Thorp, *America at the Movies* (New Haven: Yale University Press, 1939) ; Arthur Mann, "The American Theatre Goes Broke," *American Mercury*, XXVIII (April 1933) , 417–23; Dalton Trumbo, "The Fall of Hollywood," *North American Review*, CCXXXVI (August 1933) , 140–47.

102. See Arthur M. Schlesinger, Jr., "When the Movies Really Counted," *Show*, I (April 1963) , 46–51; Andrew Bergman, *We're in the Money: Depression America and Its Movies* (New York: New York University Press, 1971) ; Robert Sklar, *Movie-Made America: How the Movies Changed American Life* (New York: Random House, Inc., 1975) ; Michael Wood, *America at the Movies* (New York: Basic Books, Inc., 1975) ; Charles Higham, *The Art of the American Film, 1900–1971* (New York: Doubleday and Company, 1973) ; Jeffrey Morton Paine, "The Simplification of American Life: Hollywood Films of the 1930's" (Ph.D. dissertation, Princeton University, 1971) ; Pells, *Radical Visions and American Dreams*, 165–85.

103. Charles J. Maland, "American Visions: The Films of Chaplin, Ford, Capra, and Welles, 1936–1941" (Ph.D. dissertation, University of Michigan, 1975) , passim.

104. Reid, "Amusement: Radio and Movies," 33.

105. Suckow, "Hollywood Gods and Goddesses," 200; Mark Van Doren, "Let the Movies Be Natural," *American Scholar*, VI (October 1937) , 436; Clifford Odets, " 'Democratic Vistas' in Drama," New York *Times*, November 21, 1937, sec. IX, p. 1f. See also Ralph Willett, "Clifford Odets and Popular Culture," *South Atlantic Quarterly*, LXIX (Winter 1970) , 68–78.

106. V. F. Calverton, "Cultural Barometer," *Current History*, XLVIII (February 1938) , 54–56; Myron Osborn Lounsbury, "The Origins of American Film Criticism, 1909–1939" (Ph.D. dissertation, University of Pennsylvania, 1966) , 379–403, 429–32, 444–54; Frances Taylor Patterson, "Bread and Cinemas," *North American Review*, CCXLVI (December 1938) , 265–66.

107. Walter Wanger, "The Role of Movies in Morale," *American Journal of Sociology*, XLVII (November 1941) , 378–83.

108. Margaret Lloyd, "Instigation to the Dance," *Christian Science Monitor Weekly Magazine,* October 7, 1936, 4–5.

109. See, for example, Mary Fanton Roberts, "The Dance of the Future as Created and Illustrated by Isadora Duncan," *Craftsman,* XV (October 1908) , 48–56; Roberts, "The Dance of the People," ibid., XXII (May 1912) , 195–99.

110. See Roberts, "Dance of the Future"; Gaspard Etscher, "The Renaissance of the Dance: Isadora Duncan," *Forum,* XLVI (September 1911) , 322–28; "Isadora Duncan's Art," *Literary Digest,* L (May 1, 1915) , 1018–19; Esther Peck, "Dancing and Democracy," *Craftsman,* XXX (December 1916) , 224–33.

111. For a detailed firsthand account of a Duncan performance, see Ernest Newman, "The Dances of Isadora Duncan," *Living Age,* CCCIX (June 4, 1921) , 606–607. For Duncan's life and career see Victor Seroff, *The Real Isadora* (New York: Dial Press, 1971) ; Walter Terry, *Isadora Duncan* (New York: Dodd, Mead and Company, 1964) ; Irma Duncan, *Isadora Duncan* (New York: New York Publishing Company, 1958) ; Alan Ross Macdougall, *Isadora: A Revolutionary in Art and Love* (New York: T. Nelson and Sons, 1960) ; William Botilho, "Isadora Duncan," in Paul Magriel, ed., *Chronicles of the American Dance* (New York: Henry Holt and Company, 1948) , 191–202; Ernest Sutherland Bates, "Isadora Duncan," in Dumas Malone, ed., *The Dictionary of American Biography,* 20 vols. (New York: Charles Scribner's Sons, 1928–36) , V, 508–10.

112. Isadora Duncan, *My Life* (New York: Boni and Liveright, 1927) , 340–42. See also Duncan, "Dancing in Relation to Religion and Love," *Theatre Arts Magazine,* XI (August 1927) , 584–93.

113. On St. Denis and the Denishawn influence, see Walter Terry, *Miss Ruth: The "More Living Life" of Ruth St. Denis* (New York: Dodd, Mead and Company, 1969) ; Ruth St. Denis, *An Unfinished Life* (New York: Harper and Bros., Publishers, 1939) ; Olga Maynard, *American Modern Dancers: The Pioneers* (Boston: Little, Brown and Company, 1965) ; Baird Hastings, "The Denishawn Era, 1914–1931," in Magriel, ed., *Chronicles of American Dance,* 225–38; Marcia B. Siegel, *The Shapes of Change: Images of American Dance* (Boston: Houghton Mifflin Company, 1979) , 11–22; Elizabeth Kendall, *Where She Danced* (New York: Alfred A. Knopf, Inc., 1979) , 18–52, 74–131, 154–75.

114. Ted Shawn, *The American Ballet* (New York: Henry Holt and Company, 1926) , v, 26, 64, and passim. For reasons unexplained, Shawn so entitled his book, although he and St. Denis had no more use for ballet than had Duncan.

115. John Martin, *Introduction to the Dance* (New York: W. W. Norton and Company, 1939) , 288.

116. Oliver M. Sayler, *Revolt in the Arts: A Survey of the Creation, Distribution and Appreciation of the Arts in America* (New York: Brentano's, 1930) , 251–55.

117. Goldstein, *Political Stage,* 195; Mathews, *Federal Theatre Project,* 103, 115, 120.

118. Lincoln Kirstein, "Martha Graham at Bennington," *Nation,* CXLVII (September 3, 1938) , 230–31; "The Fifth Bennington Festival of the Modern Dance," *Theatre Arts Magazine,* XXII (October 1938) , 725–26; Goldstein, *Political Stage,* 196–97.

119. On Martin, see Thomas Barnes Herthel, "John Martin, Dance Critic: A Study of His Critical Method in the Dance as a Theater Art" (Ph.D. dissertation, Cornell University, 1966) .

120. John Martin, *American Dancing: The Background and Personalities of the Modern Dance* (New York: Dodge Publishing Company, 1936) , 28, 32, 66; Martin, "The Dance: The Pioneer American Art," *North American Review,* CCXLIV (December 1937) , 242.

121. Martin, *American Dancing,* 38–46; Martin, "Dance," 243, 250.

122. Martin, *American Dancing,* 17; Martin, *Introduction to the Dance,* 238–41 and passim.

123. Paul Love, "New Forms of the Dance," *Nation,* CXLIV (June 12, 1937) , 680; Sherman Conrad, "Bennington Festival, 1941," ibid., CLIII (August 30, 1941) , 187; George W. Beiswanger, "The New Theatre Dance," *Theatre Arts Magazine,* XXIII

(January 1939), 41–51. See also Elizabeth A. Douglas, "The Dance Captures America," *Magazine of Art*, XXX (August 1937), 498–505; Siegel, *Shapes of Change*, 89–98, 177–83.

124. Sayler, *Revolt in the Arts*, 258.

125. Leonard Greenbaum, The Hound and Horn: *The History of a Literary Quarterly* (The Hague: Mouton and Company, 1966), passim; Ruth Eleanor Howard, *The Story of the American Ballet* (New York: Ihra Publishing Company, 1936), 1–5; John Townsend Barrett, "Analysis and Significance of Three American Critics of the Ballet: Carl Van Vechten, Edwin Denby, and Lincoln Kirstein" (M.A. thesis, Columbia University, 1955), 33–34.

126. Lincoln Kirstein, *Dance: A Short History of Classic Theatrical Dancing* (New York: G. P. Putnam's Sons, Inc., 1935), passim; Kirstein, "Crisis in the Dance," *North American Review*, CCXLIII (March 1937), 98–102; Kirstein, *Blast at Ballet: A Corrective for the American Audience* (New York: Marston Press, 1938), 11–12; Kirstein, "The Popular Style in American Dancing," *Nation*, CXLVI (April 14, 1938), 450–51.

127. Quoted in Barrett, "Three American Critics of the Ballet," 34.

128. Howard, *Story of the American Ballet*, 5–6; Barrett, "Three American Critics of the Ballet," 34–35; "Ballet: A New Art Form for America," *Literary Digest*, CXVIII (July 14, 1934), 24; "The American School of Ballet Swings into Action," *Newsweek*, IV (December 15, 1934), 16; David Fawkes, "The Future of the American Ballet," *Vanity Fair*, XLII (May 1934), 32.

129. Barrett, "Three American Critics of the Ballet," 35–36; Goldstein, *Political Stage*, 388–89; Otis Ferguson, "Billy the Kid: I" and "The Caravan and Abe," *New Republic*, XCIX (June 14, June 21, 1939), 160, 189; Julia Smith, *Aaron Copland: His Work and Contribution to American Music* (New York: E. P. Dutton and Company, 1955), 187–90; Randall Raley, "Americanist Elements in the Music of Aaron Copland" (M.A. thesis, University of Texas, 1950), 53–55; "All-American Ballet," *Time*, XXXV (January 8, 1940), 36. See also Siegel, *Shapes of Change*, 113–25.

130. Chase, *America's Music*, 502; Smith, *Aaron Copland*, 190–93; Goldstein, *Political Stage*, 389; George Beiswanger, "The Enigma of Ballet," *Theatre Arts*, XXVI (December 1942), 745–53; Siegel, *Shapes of Change*, 125–31.

131. Beiswanger, "New Theatre Dance," 43.

132. Roger Hale Newton, "The Pressing Challenge of Our Native American Culture," *Journal of the American Society of Architectural Historians*, II (January 1942), 33 (italics in original); Thomas S. Holden, "To Civilize Is to Build: The New Frontiers of Architecture," *Architectural Record*, LXXXVII (March 1940), 88; George Biddle, "Can Artists Make a Living?" *Harper's Magazine*, CLXXXI (September 1940), 397.

133. Turpin C. Bannister, "Architectural Development of the Northeastern United States," *Architectural Record*, LXXXIX (June 1941), 61; John Martin, "The Folk-Dance Boom," *New York Times Magazine*, February 23, 1941, 10–11; "I Hear America Singing," *Time*, XXXVI (July 8, 1940), 46.

134. Biddle, "Can Artists Make a Living?" 397.

Chapter 7: **Renaissance Not Regeneration**

1. For pro-Russian influences in American wartime opinion, see Ralph B. Levering, *American Opinion and the Russian Alliance, 1939–1945* (Chapel Hill: University of North Carolina Press, 1976), passim; John Lewis Gaddis, *The United States and the Origins of the Cold War, 1941–1947* (New York: Columbia University Press, 1972), 34–40. On continuing public hostility toward Communism, see Hadley Cantril, ed., *Public Opinion, 1933–1946* (Princeton: Princeton University Press, 1951), 130–31.

2. Arthur Berger, "Music in Wartime," *New Republic*, CX (February 7, 1944), 175–78; Gilbert Chase, *America's Music: From the Pilgrims to the Present*, rev. ed. (New York: McGraw-Hill Book Company, 1966), 500–502, 508–509, 513–14.

3. Arthur F. McClure, "Hollywood at War: The American Motion Picture and World War II, 1939–1945," *Journal of Popular Film*, I (Spring 1972), 123–35; Clayton R. Koppes and Gregory D. Black, "What to Show the World: The Office of War Information and Hollywood, 1942–1945," *Journal of American History*, LXIV (June 1977), 87–105; Richard Lingeman, *Don't You Know There's a War On? The Home Front, 1941–1945* (New York: G. P. Putnam's Sons, 1970), 168–210, 223–33.

4. John Gassner, "The Theatre's Need," *Current History*, new series, II (July 1942), 381–85; Malcolm Goldstein, *The Political Stage: American Drama and Theater of the Great Depression* (New York: Oxford University Press, 1974), 414–15; Chester E. Eisinger, *Fiction of the Forties* (Chicago: University of Chicago Press, 1963), 1–101; Oliver Larkin, *Art and Life in America*, rev. ed. (New York: Holt, Rinehart and Winston, 1960), 464–65.

5. Julia Smith, *Aaron Copland: His Work and Contribution to American Music* (New York: E. P. Dutton and Company, 1955), 194–98; Chase, *America's Music*, 500–502, 633–34; Marcia B. Siegel, *The Shapes of Change: Images of American Dance* (Boston: Houghton Mifflin Company, 1979), 125–37; Deems Taylor, *Some Enchanted Evenings* (New York: Harper and Bros., Publishers, 1953), 167–74; Timothy P. Donovan, "'Oh, What a Beautiful Mornin'; The Musical *Oklahoma!* and the Popular Mind in 1943," *Journal of Popular Culture*, VIII (Winter 1974), 477–88.

6. See, for example, G. E. Kidder Smith, "The Tragedy of American Architecture," *Magazine of Art*, XXXVIII (November 1945), 279; John Burchard and Albert Bush-Brown, *The Architecture of America: A Social and Cultural History*, rev. ed. (Boston: Little, Brown and Company, 1966), 332–35; Percival and Paul Goodman, "Architecture in Wartime," *New Republic*, CIX (December 20, 1943), 878–82.

7. For the refugee intellectual phenomenon, see Laura Fermi, *Illustrious Immigrants: The Intellectual Migration from Europe, 1930–1941* (Chicago: University of Chicago Press, 1968); H. Stuart Hughes, *The Sea Change: The Migration of Social Thought, 1930–1945* (New York: Harper and Row, Inc., 1975); Charles I. Glicksberg, "The Culture of the Refugees in the United States," *South Atlantic Quarterly*, XL (January 1941), 73–83.

8. Paolo Milano, "A Free Theatre for a Free People," *Theatre Arts*, XXVI (March 1942), 206; John Gassner, "Broadway 1941: Europe and the American Theatre," *Atlantic Monthly*, CLXVII (March 1941), 337; Aaron Copland, *Our New Music: Leading Composers in Europe and America* (New York: McGraw-Hill Book Company, 1941), 125; Roger Hale Newton, "The Pressing Challenge of Our Native American Culture," *Journal of the American Society of Architectural Historians*, II (January 1942), 33 (italics in original).

9. H. L. Mencken, "The National Literature," *Yale Review*, IX (July 1920), 814.

10. Waldo Frank to Van Wyck Brooks, July 13, 1934, Van Wyck Brooks Papers, Rare Books Room, Charles Van Pelt Library, University of Pennsylvania, Philadelphia; Lewis Mumford to Waldo Frank, August 15, 1934, Waldo Frank Papers, ibid.; Van Wyck Brooks to Royal Cortissoz, October 26, 1941, Royal Cortissoz Papers, American Literature Collection, Yale University, New Haven; Van Wyck Brooks to Bliss Perry, November 23, 1941, Bliss Perry Papers, Houghton Library, Harvard University, Cambridge (italics in original).

11. Van Wyck Brooks, *An Autobiography* (New York: E. P. Dutton and Company, 1966), 544.

12. Lewis Mumford, "The Corruption of Liberalism," *New Republic*, CII (April 29, 1940), 568–73; Mumford, *Faith for Living* (New York: Harcourt, Brace and Company, 1940), passim; Waldo Frank, *Chart for Rough Water: Our Role in a New World* (New York: Doubleday and Company, 1940), 120–28, 156–60, and passim.

13. Frank, *Chart for Rough Water*, 162; Lewis Mumford, "The Passive Barbarian," *Atlantic Monthly*, CLXVI (September 1940), 275.

14. Howard Mumford Jones, "Patriotism—But How?" *Atlantic Monthly*, CLXII (November 1938), 585–92; Jones, "Nobility Wanted," ibid., CLXIV (November 1939), 641–49.

15. Archibald MacLeish, *The Irresponsibles* (New York: Duell, Sloan and Pearce, Inc., 1940), 1–25; MacLeish, "Post-War Writers and Pre-War Readers," *New Republic*, CII (June 10, 1940), 178–79; Colin C. Campbell, "The Poet as Artist and Citizen: A Study of the Life and Writings of Archibald MacLeish through 1958" (Ph.D. dissertation, University of Pennsylvania, 1960), 198–209. See also MacLeish, *The American Cause* (New York: Duell, Sloan and Pearce, Inc., 1941); MacLeish, *A Time to Speak* (Boston: Houghton Mifflin Company, 1943) and *A Time to Act* (Boston: Houghton Mifflin Company, 1943).

16. Van Wyck Brooks to James T. Farrell, November 1, 1939, James T. Farrell Papers, Rare Books Room, Charles Van Pelt Library, University of Pennsylvania, Philadelphia; Brooks to Malcolm Cowley, October 31, 1939, Brooks Papers (italics in original); Brooks to Lewis Mumford, February 7, 1940, in Robert E. Spiller, ed., *The Van Wyck Brooks–Lewis Mumford Letters* (New York: E. P. Dutton and Company, 1970), 180; Brooks to Waldo Frank, May 1, 1940, Frank Papers (italics in original).

17. Van Wyck Brooks to Oswald Garrison Villard, August 6, 1940, Oswald Garrison Villard Papers, Houghton Library, Harvard University, Cambridge.

18. Brooks, *Autobiography*, 326.

19. Van Wyck Brooks, *The Opinions of Oliver Allston* (New York: E. P. Dutton and Company, 1941), 120, 195–96, 239–40. *Allston* incorporated versions, revised to fit the book's journal format, of three Brooks essays in the *New Republic*, CIV, CV (1941), as well as "What Is Primary Literature?" *Yale Review*, XXXI (September 1941), 25–37, and *On Literature Today* (New York: E. P. Dutton and Company, 1941), an address published separately. See also Brooks, "Fashions in Defeatism," *Saturday Review of Literature*, XXIII (March 22, 1941), 3–4ff.

20. Brooks, *Opinions of Oliver Allston*, 201–11, 256, 272.

21. Ibid., 127–36.

22. Morton Dauwen Zabel to Dwight Macdonald, November 7, 1941, *Partisan Review* Collection, Rutgers University, New Brunswick; Zabel, "The Poet on Capitol Hill," *Partisan Review*, VIII (January–February 1941), 2–19, 128–45; Dwight Macdonald, "*Kulturbolshewismus* Is Here," ibid. (November–December 1941), 442–51; James T. Farrell to Van Wyck Brooks, November 14, 1939, March 24, 1941, Brooks Papers; Farrell, *The League of Frightened Philistines and Other Papers* (New York: Vanguard Press, 1945), 11, 104, and passim.

23. Dwight Macdonald, *Memoirs of a Revolutionist: Essays in Political Criticism* (New York: Farrar, Straus and Cudahy, 1957), 25–32; Campbell, "Poet as Artist and Citizen," 195–212.

24. Alfred Kazin, *New York Jew* (New York: Alfred A. Knopf, Inc., 1978), 37.

25. For DeVoto, see Wallace Stegner, *The Uneasy Chair: A Biography of Bernard DeVoto* (Garden City: Doubleday and Company, 1975); Stegner, "Bernard Augustine DeVoto," in John Garraty, ed., *The Dictionary of American Biography: Supplement Five, 1951–1955* (New York: Charles Scribner's Sons, 1977), 168–69; John Melvin Gill, "Bernard DeVoto and Literary Anticriticism: Theory and Experience" (Ph.D. dissertation, New York University, 1964).

26. Quoted in Stegner, *Uneasy Chair*, 34.

27. Bernard DeVoto to Melville Smith, September 25, 1922, in Wallace Stegner, ed., *The Letters of Bernard DeVoto* (Garden City: Doubleday and Company, 1975), 6–7.

28. Gill, "Bernard DeVoto and Literary Anticriticism," passim.

29. Quoted ibid., 6.

30. Bernard DeVoto, *Mark Twain's America* (Boston: Little, Brown and Company, 1932), passim; DeVoto, "A Generation beside the Limpopo," *Saturday Review of Literature*, XIV (September 26, 1936), 3–4f.

31. Lewis Mumford to Van Wyck Brooks, December 27, 1932; Brooks to Mumford, December 30, 1932, in Spiller, ed., *Brooks-Mumford Letters*, 84–87.

32. Bernard DeVoto, *The Year of Decision: 1846* (Boston: Little, Brown and Company, 1942).

33. Bernard DeVoto, *The Literary Fallacy* (Boston: Little, Brown and Company, 1944), 124–50, 161–68, and passim.

34. See especially ibid., 20–21.

35. Bernard DeVoto to Dorothy Thompson, December 11, 1942, in Stegner, ed., *Letters of Bernard DeVoto*, 119.

36. While DeVoto sneered at the "crisis patriotism" of the interventionist intellectuals of 1938–1941, he himself was very much on the patriotic bandwagon well before Pearl Harbor. See especially DeVoto, "Main Street Twenty Years After," *Harper's Magazine*, CLXXXI (November 1940), 580–87.

37. Malcolm Cowley, "In Defense of the 1920's" and "The War against Writers," *New Republic*, CX (April 24, May 8, 1944), 564–65, 631–32; Sinclair Lewis, "Fools, Liars and Mr. DeVoto," *Saturday Review of Literature*, XXVII (April 15, 1944), 9–12; Philip Rahv, "The Progress of Cultural Bolshevism (con't)," *Partisan Review*, XI (Summer 1944), 361–63; Granville Hicks, "Some Literary Fallacies," *College English*, VI (November 1944), 69–75.

38. Philip Rahv to Malcolm Cowley, August 4, 1944, Malcolm Cowley Papers, Newberry Library, Chicago.

39. Ibid.; Stanley Edgar Hyman, "Van Wyck Brooks and Biographical Criticism," *Accent*, VII (Spring 1947), 131; also published in Hyman, *The Armed Vision: A Study in the Methods of Modern Literary Criticism* (New York: Vintage Books, 1955), 92–114.

40. Van Wyck Brooks, *The Confident Years, 1885–1915* (New York: E. P. Dutton and Company, 1952), 492 and passim; James Hoopes, *Van Wyck Brooks: In Search of American Culture* (Amherst: University of Massachusetts Press, 1977), 243–48. Brooks's full-scale rehabilitation of Howells was *Howells: His Life and Work* (New York: E. P. Dutton and Company, 1959).

41. Brooks, *Autobiography*, 378. For Brooks's further opinions on postwar criticism and the avant-garde, see Brooks, *The Writer in America* (New York: E. P. Dutton and Company, 1953); Brooks, "Reflections on the Avant-Garde," *New York Times Book Review*, December 30, 1956, 1ff.

42. W. H. Auden, "New Year Letter (January 1, 1940)," in Edward Mendelson, ed., *W. H. Auden: Collected Poems* (New York: Random House, Inc., 1976), 112. Reprinted by permission of the publisher.

43. Floyd Stovall, "Introduction" to Stovall, ed., *The Development of American Literary Criticism* (Chapel Hill: University of North Carolina Press, 1955), 12.

44. Alfred Kazin, *On Native Grounds: An Interpretation of Modern American Prose Literature* (New York: Harcourt, Brace and Company, 1942); F. O. Matthiessen, *American Renaissance: Art and Expression in the Age of Emerson and Whitman* (London and New York: Oxford University Press, 1941).

45. Robert E. Spiller et al., *Literary History of the United States*, 2 vols. (New York: Macmillan Company, 1948).

46. Warren I. Susman, "History and the American Intellectual: Uses of the Usable Past," *American Quarterly*, XVI (Summer 1964), 243–63; Howard Mumford Jones, *The Theory of American Literature*, 2d ed. (Ithaca: Cornell University Press, 1966), 204.

47. Paul Rosenfeld, *Discoveries of a Music Critic* (New York: Harcourt, Brace and Company, 1936), 98–99. Rosenfeld himself denied that cultural nationalism need pose such a danger; true nationalism was always democratic and anti-totalitarian, aiming to unite individuals spiritually in opposition to tyranny.

48. See Robert A. Divine, *Second Chance: The Triumph of Internationalism in America during World War II* (New York: Atheneum Publishers, 1967).

49. "Our Country and Our Culture," *Partisan Review*, XIX (May 1952), 282, 285.

50. James T. Farrell, *Reflections at Fifty* (New York: Vanguard Press, 1954), 12. On intellectual aspects of the Cold War consensus, see Christopher Lasch, "The Cultural Cold War: A Short History of the Congress for Cultural Freedom," in Lasch,

*The Agony of the American Left* (New York: Alfred A. Knopf, Inc., 1969), 63–114; John P. Diggins, *The American Left in the Twentieth Century* (New York: Harcourt, Brace, Jovanovich, Inc., 1973), 136–52; Charles C. Alexander, *Holding the Line: The Eisenhower Era, 1952–1961* (Bloomington: Indiana University Press, 1975), 148–56; Marian Morton, *The Terrors of Ideological Politics: Liberal Historians in a Conservative Mood* (Cleveland: Case Western Reserve University Press, 1972), passim.

51. Kazin, *On Native Grounds*, abridged ed. (New York: Doubleday Anchor Books, 1956), 410–11; Granville Hicks, "Our Novelists' Shifting Reputations," *English Journal*, XL (January 1951), 7.

52. Perry Miller, "Europe's Faith in American Fiction," *Atlantic Monthly*, CLXXXVIII (December 1951), 56.

53. See, for example, Philip Roth's hilarious *The Great American Novel* (New York: Holt, Rinehart and Winston, Inc., 1973).

54. George Knox, "The Great American Novel: Final Chapter," *American Quarterly*, XXI (Winter 1969), 667–82.

55. Granville Hicks, "The Fighting Decade," *Saturday Review of Literature*, XXII (July 6, 1940), 3–5ff.; Maxwell Geismar, *American Moderns: From Rebellion to Conformity* (New York: Hill and Wang, Inc., 1958), ix; Geismar, "Henry James and the Jacobites," *American Scholar*, XXXI (Summer 1962), 378–79; John W. Aldridge, *In Search of Heresy: American Literature in an Age of Conformity* (New York: McGraw-Hill Book Company, 1956), 2–5; Kazin, *On Native Grounds* (1956), 411.

56. Malcolm Cowley to Robert E. Spiller, March 20, 1945, Cowley Papers; Jones, *Theory of American Literature*, 195.

57. Solomon Fishman, *The Disinherited of Art* (Berkeley: University of California Press, 1953), 70–74; Cyril Connolly, "On Englishmen Who Write American," *New York Times Book Review*, December 18, 1949, 1; Stanley T. Williams, "Who Reads an American Book? *Virginia Quarterly Review*, XXVIII (Autumn 1952), 531; Harry Levin, "Some European Views of Contemporary American Literature," in Margaret Denny and William H. Gilman, ed., *The American Writer and the European Tradition* (Minneapolis: University of Minnesota Press for the University of Rochester, 1950), 168–69; Richard Rovere, "The Writer's Lot," *Harper's*, CCI (October 1950), 280–82.

58. Wallace Stegner, "The Anxious Generation," *College English*, X (January 1949), 83–89; John W. Aldridge, "The American Writer," *Nation*, CLXXIX (October 16, 1954), 328–31.

59. Jay B. Hubbell, *South and Southwest: Literary Essays and Reminiscences* (Durham: Duke University Press, 1965), 44; James Woodress, *Dissertations in American Literature, 1891–1966* (Durham: Duke University Press, 1968); Woodress, "American Writers and the Professor," *College English*, XVIII (January 1957), 218–21; Randall Stewart, "Present Trends in the Study and Teaching of American Literature," ibid., 207–11. Stewart estimated that as yet only about 20 percent of the courses taught in English departments in the nation's colleges and universities were in the field of American literature.

60. Hubbell, *South and Southwest*, 44; Robert Gorham Davis, "The Continuing American Ideal," *Commentary*, XXV (May 1958), 375.

61. Eric Bentley, *The Dramatic Moment: An American Chronicle* (New York: Horizon Press, 1954), 150; Harold Clurman, "Theatre: The Laggard Art," *Nation*, CCI (September 20, 1965), 224–25.

62. Lois Johnson Faucette, "Paul Green and the American Dream" (Ph.D. dissertation, Howard University, 1975), 225–73.

63. Norris Houghton, *Advance from Broadway: 19,000 Miles of American Theatre* (New York: Harcourt, Brace and Company, 1941), 398; Julius Novick, "Touring the Hinterland," *Nation*, CCII (May 23, 1966), 626–27; Novick, "Hinterland III: Pacific Coast," ibid. (June 20, 1966), 755–58.

64. Bentley, *Dramatic Moment*, 247; Novick, "Touring the Hinterland," 628–29. See also Joseph Golden, *The Death of Tinker Belle: American Theatre in the Twentieth Century* (Syracuse: Syracuse University Press, 1967); Martin Gottfried, *A Theater Divided: The Postwar American Stage* (Boston: Little, Brown and Company, 1967).

65. Roger Sessions, *Reflections on the Music Life in the United States* (New York: Merlin Press, 1956), 170–75, 184.

66. Chase, *America's Music*, 509, 512–13, 646, 654–55.

67. Aaron Copland to Oscar Thompson, June 2, 1941, quoted in Smith, *Copland*, 223.

68. Aaron Copland, *The New Music, 1900–1960* (New York: W. W. Norton and Company, 1968), 125; Copland, *Copland on Music* (Garden City: Doubleday and Company, 1960), 175–76; Copland, "Making Music in the Star-Spangled Manner," *Music and Musicians*, VIII (August 1960), 34–35; Virgil Thomson, *American Music since 1910* (New York: Harcourt, Brace and World, Inc., 1971), 12–13.

69. See John Henry Mueller, *The American Symphony Orchestra: A Social History of Musical Taste* (Bloomington: Indiana University Press, 1951), 171.

70. On postwar developments in jazz, see Wilfred Mellers, *Music in a New Found Land: Themes and Developments in the History of American Music* (New York: Alfred A. Knopf, Inc., 1965), 331–91; Marshall W. Stearns, *The Story of Jazz* (New York: Oxford University Press, 1956), 218–56; Chase, *America's Music*, 480–89; Barry Ulanov, *A History of Jazz in America*, 2d ed. (New York: Viking Press, Inc., 1957), 267–348; Dave Dexter, *The Jazz Story from the '90s to the '60s* (Englewood Cliffs: Prentice-Hall, Inc., 1964), 121–60; Martin Williams, *Jazz Masters in Transition, 1957–1969* (New York: Macmillan Company, 1970).

71. John Tasker Howard, "What American Music Is American?" *Vanity Fair*, XXXVIII (April 1932), 51.

72. See Arnold Shaw, *The Rockin' '50s* (New York: Hawthorn Books, Inc., 1974), passim; Douglas T. Miller and Marion Nowak, *The Fifties: The Way We Really Were* (Garden City: Doubleday and Company, 1977), 291–313; H. Wiley Hitchcock, *Music in the United States: A Historical Introduction* (Englewood Cliffs: Prentice-Hall, Inc., 1974), 257–63.

73. Thomas Candor Tritschler, "The American Abstract Artists, 1937–1941" (Ph.D. dissertation, University of Pennsylvania, 1974); Susan Carol Larsen, "The American Abstract Artists Group: A History and Evaluation of Its Impact upon American Art" (Ph.D. dissertation, Northwestern University, 1975).

74. Samuel Koontz, *New Frontiers in American Painting* (New York: Hastings House, 1943), 6; Laurence Gowing, "Paint in America," *New Statesman*, May 24, 1958, 699–700, in John W. McCoubrey, ed., *American Art, 1900–1960: Sources and Documents* (Englewood Cliffs: Prentice-Hall, Inc., 1965), 222–26.

75. Adolph Gottlieb and Mark Rothko, letter to the editor, New York *Times*, June 13, 1943, in McCoubrey, ed., *American Art*, 211–12; Robert Motherwell quoted in Matthew Baigell, *The American Scene: American Painting of the 1930's* (New York: Frederick A. Praeger Publishers, 1974), 182; Jackson Pollock in *Arts and Architecture*, LXI (February 1944), 14–15, in McCoubrey, ed., *American Art*, 212.

76. Motherwell quoted in Sam Hunter, *Modern American Painting and Sculpture* (New York: Dell Publishing Company, 1959), 122; Oliver Larkin, *Art and Life in America*, 2d ed. (New York: Holt, Rinehart and Winston, Inc., 1960), 429.

77. For the rise of American abstract expressionism in the forties and fifties, see Thomas B. Hess, *Abstract Painting: Background and American Phase* (New York: Viking Press, 1951); Andrew Carnduff Ritchie, *Abstract Painting and Sculpture in America* (New York: Museum of Modern Art, 1951); Virgil Barker, *From Realism to Reality in Recent American Painting* (Lincoln: University of Nebraska Press, 1959); Irving Sandler, *The Triumph of American Painting; A History of Abstract Expressionism* (New York: Frederick A. Praeger, Publishers, 1970); Dore Ashton, *The New York School: A Cultural Reckoning* (New York: Viking Press, 1973).

78. Jane deHart Mathews, "Art and Politics in Cold War America," *American Historical Review,* LXXXI (October 1976) , 762–87.

79. See E. A. Carmean, Jr., ed., *The Great Decade of American Abstraction: Modernist Art, 1960 to 1970* (Houston: Museum of Fine Arts, 1974) , passim; Barbara Rose, *American Art since 1900: A Critical History* (New York: Frederick A. Praeger, Publishers, 1967) , 211–37; Joshua C. Taylor, *America as Art* (New York: Harper and Row, Inc., 1978) , 287–312.

80. Martha Candler Cheney, *Modern Art in America* (New York: Whittlesey House, 1939) , 170. For a postwar statement of basically the same view, see Lloyd Goodrich, "What Is American in American Art?" *Art in America,* No. 4 (1963) , 24–39.

81. Adolph Gottlieb, "Artist and Society: A Brief Case History," *College Art Journal,* XIV (Winter 1955) , 96–101.

82. On Wright's post–World War II career and influence, see Robert W. Twombly, *Frank Lloyd Wright: An Interpretive Biography* (New York: Oxford University Press, 1973) , 221–306.

83. For the postwar impact of the International Style, see Burchard and Bush-Brown, *Architecture of America,* 393–443; William H. Pierson, Jr., and William H. Jordy, *American Buildings and Their Architects,* 4 vols. to date (Garden City: Doubleday and Company, 1970–) , IV: Jordy, *The Impact of European Modernism in the Mid-Twentieth Century.*

84. Alvin Toffler, *The Culture Consumers: A Study of Art and Affluence in America* (New York: St. Martin's Press, 1964) , 5–6, 231, and passim.

85. Gilbert Seldes, *The Public Arts* (New York: Simon and Schuster, Inc., 1956) , 93; Seldes, *The Great Audience* (New York: Viking Press, 1950) , passim.

86. Philip Rahv, *Image and Ideal: Twenty Essays on Literary Themes* (Norfolk, Conn.: J. Laughlin, 1957) , 230; William Phillips, "What Happened in the 1930's," *Commentary,* XXXIV (September 1962) , 211; Trilling quoted in Fishman, *Disinherited of Art,* 151. See also Richard Hofstadter, *Anti-intellectualism in American Life* (New York: Alfred A. Knopf, Inc., 1963) .

87. Dwight Macdonald, "Masscult and Midcult," *Partisan Review,* XXVII (Spring, Fall 1960) , 203–33, 589–631; reprinted in Macdonald, *Against the American Grain* (New York: Random House, Inc., 1962) , 3–75. Cf. Harold Rosenberg, *The Tradition of the New* (New York: Horizon Press, Inc., 1959) ; Rosenberg, *The Anxious Object: Art Today and Its Audience* (New York: Horizon Press, Inc., 1964) .

88. Bernard Rosenberg and David Manning White, eds., *Mass Culture: The Popular Arts in America* (Glencoe, Ill.: Free Press, 1957) and the sequel volume, Rosenberg and White, eds., *Mass Culture Revisited* (New York: Van Nostrand Reinhold Company, 1971) , offer an instructive contrast in changing intellectual attitudes toward popular culture in the 1950s and 1960s.

89. The *Journal of Popular Culture* has been published since 1967 by the Popular Culture Association at Bowling Green State University, where the spinoff publications, *Journal of Popular Music* and *Journal of Popular Film,* have also originated.

90. See the interview with Livingston Biddle, Jr., chairman of the National Endowment for the Arts, in Columbus (Ohio) *Sunday Dispatch,* October 22, 1978, A-14; Michael Straight, *Twigs for an Eagle's Nest: Government and the Arts, 1965–1978* (Berkeley, Cal.: Devon Press, 1979) .

91. Hans Meyeroff, "An American Odyssey," *Partisan Review,* XXV (Summer 1958) , 453.

92. John Martin, "Foreword" to Martin, *American Dancing: The Background and Personalities of the Modern Dance,* reprint ed. (Brooklyn: Dance Horizons, 1968) , n.p.

93. See especially David A. Stewart, "The Decline of WASP Literature in America," *College English,* XXX (March 1969) , 403–17; Lewis P. Simpson, "Southern Spiritual Nationalism: Notes on the Background of Modern Southern Fiction"; O. B. Emerson, "Cultural Nationalism in Afro-American Literature"; Allen Guttmann, "The Conversion of the Jews," in Ernest H. Lewald, ed., *The Cry of Home:*

*Cultural Nationalism and the Modern Writer* (Knoxville: University of Tennessee Press, 1972) , 189–210, 211–44, 245–67; Guttmann, *The Jewish Writer in America: Assimilation and the Crisis of Identity* (New York: Oxford University Press, 1972) ; Harold Cruse, *The Crisis of the Negro Intellectual* (New York: William Morrow and Company, Inc., 1967) .

94. Michael Goldman, "The Shoe in the Shark," *Nation,* CCII (February 28, 1966) , 247; Eric Bentley, "A Note on American Culture," *American Scholar,* XVIII (Spring 1949) , 182.

95. Jones, *Theory of American Literature,* x.

# Index